TV WRITING ON DEMAND

TV Writing On Demand: Creating Great Content in the Digital Era takes a deep-dive into writing for today's audiences, against the backdrop of a rapidly evolving TV ecosystem. Amazon, Hulu and Netflix were just the beginning. The proliferation of everything digital has led to an ever-expanding array of the most authentic and engaging programming that we've ever seen. No longer is there a distinction between broadcast, cable and streaming. It's all *content*. Regardless of what new platforms and channels will emerge in the coming years, for creators and writers, the future of entertainment has never looked brighter.

This book goes beyond an analysis of what makes great programming work. It is a master course in the creation of entertainment that does more than meet the standards of modern audiences—it challenges their expectations. Among other essentials, readers will discover how to:

- **Satisfy the binge viewer**: Analysis of the new genres, trends and how to make smart initial decisions for strong, sustainable story. Plus, learn from the rebel who reinvented an entire format.
- **Develop iconic characters**: How to foster audience alignment and allegiance, from empathy and dialogue to throwing characters off their game, all through the lens of authenticity and relatability.
- **Create a lasting, meaningful career in the evolving TV marketplace**: How to overcome trips, traps and tropes; the pros and cons of I.P.; how to use the Show Bible as a sales tool and make the most of the plethora of new opportunities out there.

Neil Landau is a bestselling author, producer and award-winning screenwriter who runs the Writing for Television program in the UCLA Department of Film, Television and Digital Media (his alma mater). Credits include *Don't Tell Mom the Babysitter's Dead*, *Melrose Place*, *The Magnificent Seven*, *Doogie Howser, M.D.*, *The Secret World of Alex Mack*, *Twice in a Lifetime*, MTV's *Undressed* and one-hour drama pilots for CBS, ABC, Freeform, Warner Bros., Disney, Lifetime and Fremantle. Neil has served as Executive Script Consultant for Sony Pictures Television and Columbia Pictures. Among his animated films are *Tad: The Lost Explorer*, which earned him a Spanish Academy "Goya" Award for Best Adapted Screenplay, *Tad Jones and the Secret of King Midas* (he is working on the sequel, *Tad 3*), *Capture the Flag* for Paramount and *Sheep & Wolves* for Wizart Animation. Neil penned the bestselling *101 Things I Learned in Film School*, *The Screenwriter's Roadmap*, *The TV Showrunner's Roadmap* and *TV Outside the Box: Trailblazing in the Digital Television Revolution*, which was the first book sponsored by the National Association of Television Program Executives (NATPE).

TV WRITING ON DEMAND
CREATING GREAT CONTENT IN THE DIGITAL ERA

NEIL LANDAU

Routledge
Taylor & Francis Group

NEW YORK AND LONDON

First published 2018
by Routledge
711 Third Avenue, New York, NY 10017

and by Routledge
2 Park Square, Milton Park, Abingdon, Oxon OX14 4RN

Routledge is an imprint of the Taylor & Francis Group, an informa business

Library of Congress Cataloging-in-Publication Data
Names: Landau, Neil, author.
Title: TV writing on demand : creating great content in the
 digital era / Neil Landau.
Description: New York : Routledge, 2018. | Includes index.
Identifiers: LCCN 2017035358 (print) | LCCN 2017042721 (ebook) |
 ISBN 9781315202150 (E-book) | ISBN 9781138705692 (hardback) |
 ISBN 9781138705715 (pbk.)
Subjects: LCSH: Television authorship. | Interactive television. | Video on
 demand. | Television—Technological innovations. | Convergence
 (Telecommunication)
Classification: LCC PN1992.7 (ebook) | LCC PN1992.7 L25 2018 (print) |
 DDC 808.2/25—dc23
LC record available at https://lccn.loc.gov/2017035358

ISBN: 978-1-138-70569-2 (hbk)
ISBN: 978-1-138-70571-5 (pbk)
ISBN: 978-1-315-20215-0 (ebk)

Typeset in Avenir
by Apex CoVantage, LLC

Visit the companion website: www.routledge.com/cw/landau

For my mother, Evelyn

CONTENTS

INTRODUCTION

Since I began researching for this book, two things happened that I couldn't predict: the rise of Trumpism and the toppling of the Hollywood patriarchy of predators. The ripple effects continue to have statewide and global implications. From Silicon Valley to anti-sexism movements in France, the fallout is impacting all strata of culture. This revolution is being televised, streamed and shared; it's cultural *Black Mirror* with real life causes and consequences that range from disturbing and tragic to felonious and monstrous. I'm still struggling to comprehend their gravity.

There is no, as 19th century historian Martin Jay put it, "aesthetic alibi" for bad behavior. The art made by those accused has turned radioactive.[1] As much as we want to separate the man from the art, we cannot. Celebrating their work is what gives these power abusers more power. Formal investigations are being conducted and in most cases, career achievements and lifelong bodies of work are justifiably being erased and irreparably damaged. In other cases, time will tell. While assault is a clear issue of right and wrong, for others the alleged transgressions land in a morally gray area. I'm not going to mention the names involved, as giving them space here prolongs their power. I, and my editors, have made every effort to be sensitive but if there are any names included that post-publication woefully turn out to be transgressors, I ask for your understanding.

The ground is unstable beneath us. Nothing, nowhere and no one are safe. It's incredible that it's taken until 2017 for such issues to come to light. Now everything we watch will be viewed through a different prism. Hopefully, the long range implications will lead to improved conditions both in front of and behind the camera. As Ben Travers, TV critic at IndieWire said, "A lot of people are hoping this is more of a turning point, that the work that's being lost won't be missed because the work that's being gained will be better . . . The people who were silenced and thrown out and kept from working by these predators will be able to go forward and thrive."[2]

PEAK TV VS. PIQUE TV

The Streaming Smorgasbord

Great storytelling on television hasn't changed all that much in 50+ years. We still need someone to root for and invest in. But the radical shift in the TV ecosystem—from traditional broadcast and cable network brands to digital streaming giants (Netflix, Amazon, Hulu)—has led to an ever-expanding array of the most authentic TV shows we've ever seen. The legacy networks have skin in the game, too, with all-access, on-demand options. Those willing to pay the monthly subscription fees can get everything—450+ shows—commercial-free. It's game on, with fierce competition between all players to produce the boldest and freshest content and win subscribers. What's more, there's no longer a distinction between broadcast, cable and streaming. Now it's all just called *content*.

As a society, our relationship to time—arguably the most valuable commodity—has changed, significantly impacting viewership. We manage and attempt to maximize our time by adopting more and more efficient technologies, which have enabled us to multitask and squeeze *more* than 24 hours of work/consumption/play into each day. How? Our gadgets deliver what we want and when we need it: email, texts, calendars and our favorite TV series, available to us 24/7, at our fingertips. We're shaving off commercials, skipping intros, earning from web ad bucks instead of commuting, all meaning we cram more than a day of 20th-century living into each 21st-century day. As TV continues to evolve, there is no going back, only forward faster. With TV content so accessible, it's easy to get addicted and hard to pull ourselves away from what's up next. You don't even need to move a muscle for the next episode to play automatically; we're now in a culture where we consume more by doing *less*. Netflix's breakout hit, *Stranger Things*, offered up the best thrill ride in town—and we didn't even have to leave the house.

Are we in a bloated content bubble that's inevitably going to burst? I can foresee some attrition, but more choices are always preferable to today's channel and app surfers—that's you and me. What is happening is that the TV ecosystem is continuing to, just like the real-world ecosystem, evolve. Disney is to end its theatrical distribution deal with Netflix in 2019, with

Bob Iger announcing that Disney- and ESPN-branded streaming services are to launch that same year, with access to Pixar, Marvel and *Star Wars* content. More studios may follow suit, retaining exclusive rights for their own, new streaming services. The streaming giants will begin relying more on original content. But of course, they'd already foreseen that. Showrunner/writer/creator Shonda Rhimes and her producing partner Betsy Beers signed a multi-year deal at Netflix, ending their long relationship with ABC (which is owned by Disney). These are the echoes of the HBO story in the 1980s, when studios pushed back against its rapid growth and success. HBO made new deals and flourished. In fact, in 2017, Netflix made the first acquisition of its 20-year history, of comic book publisher Millarworld (which created *Kingsman* and *Kick-Ass*). Again, it's reminiscent of Disney's 2009 acquisition of Marvel. In 2017, Disney bought longtime rival 20th Century Fox's TV and movie studios, and gained majority control of Hulu. "Content is the weapon of choice in this over-the-top game," says Peter Csathy, chairman of CREATV Media.[3] Others are rethinking their strategy internally, such as CBS' Les Moonves, who surprised many with his announcement that *The Twilight Zone* reboot will stream exclusively on the digital CBS All Access platform. This follows All Access' streaming of NFL games and *Star Trek: Discovery*—whose premiere and second episode resulted in the biggest ever increase in platform subscribers. Streaming "is a more profitable business model," Moonves declares.[4]

What may be truly game changing—as FX Networks chief and industry savant John Landgraf puts it—is the "titanic struggle" on the cards between Netflix, Amazon, Facebook and Apple. The latter Silicon Valley giants are moving into the scripted TV space, with Facebook's launch of its "Watch" premium video platform; Apple's high-profile hires of Sony TV, Channel 4 and Amazon execs to oversee its scripted content; even Snapchat has partnered with NBCUniversal to produce programming. The joint venture signed its first deal with Mark and Jay Duplass, whose first series for the app is set to debut in 2018. In contrast, "Watch" will be a platform for anyone who adheres to Facebook's community guidelines to upload their shows. Facebook is also developing a drama with Kerry Washington plus an English language version of the Scandinavian hit teen show *Scam*. Then there's YouTube TV, which is entering the living room via its new app that integrates with smart TVs and connected devices, including Apple TV, Roku and Xbox. YouTube Red Originals, encompassing web series to feature-length movies, are already growing in scope and reach.

Landgraf compares the sheer financial weight of the digital behemoths to a tsunami or a water cannon, "like being shot in the face with money every day," he says. "Wait for the epic titanic fight for talent . . . Beyond television we're all watching an epic battle unfold for who will control human attention. For who controls attention, controls its monetizing."[5] We may see new business models emerge, even before the end of the decade. Certainly there will be winners and losers.

On-demand viewership provides us with the illusion that we're in control, if not of the existential Big Picture then of the little ones via our flat screens, laptops, tablets, smart phones. Indeed we, and our devices, are locked in a symbiotic, co-dependent relationship, especially when we get hooked on a great new series. Jill Soloway summed it up best at the Variety TV Summit in June 2017, when she mused that when we stay up all night watching a show, it's like meeting someone special and wanting to stay up all night talking. It's like falling in love.

It all comes back to story. Given the political landscape, the need for niche representation on TV is ever more urgent. "History doesn't repeat itself, but it does rhyme," goes the saying. It's the stories we tell that can transform a generation. In my last book, TV Outside the Box, I posited that "Niche Is the New Mainstream," which positively reflects how diverse we truly are and which arose from our need—a demand—for inclusivity. Politically, the idea of going back and reconnecting to "the good old days" appeals to some, while it excludes and outrages others. These are divisive, incendiary times, and the huge volume of content today simultaneously enthralls and pacifies us. For many, Stranger Things was the right show at the right time. We needed a dose of innocence and nostalgia to combat all the cynicism and "fake news." We continue to need pure escapism. We need those heroes. "I want to thank the great algorithm that put us all here," Donald Glover declared in his Emmy acceptance speech in 2017, as he made history. He was joking, but it's true: Despite digital's threats to the more traditional TV industry, it can bring us closer together. His show Atlanta is on FX—Landgraf's network. Their game is far from over, and so is our political struggle. Today more than ever, we need to tell the stories that connect us and bring us closer together. This book presents how. And after all, as Charlie Brooker said as he accepted his second Emmy for the technological thriller Black Mirror, "Love will win."

HOW TO NAVIGATE
TV WRITING ON DEMAND

This book is structured like an on-demand app: It's part overview of the changes in the TV business that are affecting writers and creative entrepreneurs in the digital age, part layered, nuanced, deep-dive into the tools we need to help create the strongest possible scripts. It's a "how to" guide with a new perspective for today's leading-edge innovators. Pick and choose what interests you most. You can read each chapter in any order, whenever and however you choose. I've intended to cover several strata of the new and evolving TV landscape in which the walls between film and TV have crumbled, and genres and tones have mercifully blurred. We are rapidly approaching 500 scripted series across multiple platforms; it's Digital Darwinism out there. *TV Writing On Demand* highlights the best of the best—and why—on demand. With serialized content all the rage, we tune in to stay connected and to avoid FOMO (the Fear Of Missing Out). The tide has turned away from the formulaic. These are uncertain times, which also form the backdrop for what I believe are the five most exciting words in digital storytelling: *Anything can happen any time.*

Spoiler Alerts—and Learning from the Masters

Rather than interrupting the flow of your reading experience with a peppering of spoiler alerts throughout this text, please heed this global caveat: If I mention a series that you haven't seen yet, do presume that my discussion will likely contain spoilers, some whodunits, how and why, and *proceed with caution*. In a few chapters, I've withheld spoiling the solution to the central mystery. On occasion, I've included spoilers to illustrate specific analytical points, to help with learning from the masters who write these shows.

Notes

[1] Sarah Lyall and Dave Itzkoff, "Charlie Rose, Louis C.K., Kevin Spacey: Rebuked. Now What Do We Do With Their Work?," *The New York Times*, November 24, 2017, https://www.nytimes.com/2017/11/24/arts/charlie-rose-kevin-spacey-louis-ck-art.html?emc=eta1.

[2] Ibid.

[3] Dawn C. Chmielewski and Dade Hayes, "Fox-Disney Deal Would Redraw Battle Lines: 'Content Is The Weapon Of Choice,'" *deadline.com*, November 6, 2017, http://deadline.com/2017/11/foxdisney-merger-content-is-weapon-of-choice-1202203208.

[4] Matt Pressberg, "'Twilight Zone' Reboot to Land on CBS All Access," *The Wrap*, November 2, 2017, https://www.thewrap.com/cbs-ceo-les-moonves-streaming-profitable-business-model.

[5] Nellie Andreeva, "FX CEO John Landgraf On TV Business' Transformation, Yet-To-Peak TV & Upcoming Battle For Talent – TCA," Deadline, August 9, 2017, http://deadline.com/2017/08/fx-john-landgraf-tv-business-peak-tv-update-battle-for-talent-apple-tca-1202145714.

PART I
SATISFYING THE BINGE VIEWER
New Genres, Formats and Trends

"Nothing's straight comedy, nothing's straight drama. In drama there are always elements of comedy. In black culture, you are always trying to laugh through the sadness, and it's a testament to the experiences that we go through."[1]

—ISSA RAE
WRITER/CO-CREATOR/EXECUTIVE PRODUCER/ACTRESS
INSECURE

CHAPTER 1
BLURRING THE LINES

Redefining Genre and
Tone in the Dramedy

s it a comedy or a drama? Or is it a genre-bending *dramedy*?
I say, as long as it's good, does it matter?
It depends on whom we ask. For the broadcast and basic cable networks that are still scheduled in rigid timeslots and beholden to advertisers and commercial breaks, categorization still matters a lot.

At NBC, where everything old is new again, scheduling sitcoms in comedy blocks on the same night continues to be a viable programming strategy. Tune in Thursdays and we'll have a night of laughter, anchored by their reboot of *Will & Grace*. ABC, CBS and Fox all program their sitcoms in compatible pairs, presuming that if we've tuned in to *Modern Family* or *Brooklyn Nine-Nine*, we're probably going to stick around for the complementary shows that follow.

Broadcast networks still need to fill their primetime schedules with series that work in particular timeslots, and they'll often utilize a proven ratings hit as a launching pad for a new show. Traditionally, the 8:00 to 9:00 p.m. timeslot has been called the "family hour" and offers softer-edged shows that appeal to the whole family, followed by more sophisticated sitcoms and reality TV at 9:00 p.m. and darker, harder-edged crime, legal and/or medical procedurals in the 10:00 p.m. timeslot. But besides sports and live events, who even bothers to watch TV in timeslots anymore? The answer is twofold:

1. Generally, viewers over the age of 40.
2. Viewers who can't afford a subscription to a streaming, on-demand service and/or those who simply prefer free TV.

Will & Grace isn't the only classic sitcom getting a revival, bolstered by the tug of nostalgia; ABC has plans to reboot *Roseanne* as well. The multi-camera hit series *The Big Bang Theory* (from the fertile imagination of TV's successful funnyman, Chuck Lorre) still garners large ratings for CBS (its 2017 season finale scored more than 12.5 million viewers). Nevertheless, its prequel/spinoff, entitled *Young Sheldon*, is shot single-camera style—without a live studio audience. This delightful dramedy has more in common with nostalgic series *The Wonder Years* than with its mothership laugh riot sitcom *The Big Bang Theory*.

Is this a sign of the times that the multi-camera sitcom is on the wane? It's alive but leaning in that direction, as TV shows have become more cinematic and less static/contained. The big ratings numbers of *Big Bang Theory* certainly attest to audiences' enjoyment of three-jokes-per-page traditional sitcoms—especially if the jokes are funny. But having the freedom to follow characters outside of large apartments, office spaces and coffeehouses tends to feel more liberating and surprising. If the characters can go *anywhere* and not be limited to two "permanent" sets and a "swing" set (an interchangeable set depending on that week's episode), the episode can feel more organic and authentic—like life.

Like the dramedy that's between genres, viewers today fall somewhere between traditional and online platforms. NBCUniversal's niche digital comedy network Seeso announced its closure at barely 19 months old, having struggled to win subscribers. Some Seeso Originals moved to streaming service VRV, while comedies on NBC's traditional broadcast network continue to flourish. Perhaps Seeso was ahead of its time.

HOW DID WE GET HERE?

James L. Brooks is best known for his Emmy Award-winning MTM Enterprises[2] sitcoms; the equally lauded sitcom *Taxi*; and Oscar-bait movies (*Terms of Endearment, Broadcast News, As Good As It Gets*). He's also an executive producer of TV's longest-running primetime comedy series, *The Simpsons*, but his roots in half-hour dramedy actually go way back to his groundbreaking series *Room 222*, which aired on ABC from 1969–1974. This single-camera dramedy was time-slotted among traditional sitcoms but features a diverse cast and centers on Pete Dixon (Lloyd Haynes), an African-American social studies teacher at the fictional Los Angeles school Walt Whitman High, and his core group of inquisitive students in Room 222. A far cry from the broad, zany antics of high school "sweat hogs" on *Welcome Back Kotter* (1975–1979), *Room 222* explores contemporary themes with light comedy, nuance and the trials and tribulations of coming-of-age, during the

tumult of the late 1960s and early to mid-'70s (including the Vietnam War, feminism, racism, homophobia and even Watergate). *Room 222* is my earliest memory of a sitcom that straddles the line between comedy and drama, with an emphasis on authenticity and subtlety, obliquely addressing issues of our times without ever feeling preachy/pedantic.

The half-hour dramedy also has its roots in the TV version of the 1970 Robert Altman film *M*A*S*H,*[3] adapted by Larry Gelbart (*Tootsie*). The much celebrated, Emmy and Peabody Award-winning TV series aired from 1970 through 1983. Scheduled and packaged by CBS as a sitcom, the series is set in the 4077th mobile army surgical hospital during the Korean War. The early seasons are bloodier and grittier, with laughter interrupted by artillery shells and bombings; the latter seasons feel somewhat slicker, with less gore and more quips. It is inherently a political series that avoids glamorizing war but often makes it look like a whole lot of fun (just add sex, booze and an unfortunate laugh track). And then Gelbart and his team floor us with a shocking, tragic turn, including the deaths of beloved characters, to remind us of reality (these outlier episodes were sans laugh track). Always a delicate balancing act between comedy and tragedy, the show finds its greatest success by reminding us that despite the worst situations imaginable, laughter truly is the best medicine.

If *M*A*S*H* and *Room 222* are half-hour dramedies masquerading as sitcoms, *The Wonder Years* (on ABC from 1988–1993) is pure dramedy from the get-go and an anomalous period piece to boot. Like *Room 222*, *The Wonder Years* retrospectively explores the tumult of the 1960s/early 1970s through the lens of innocence: the coming-of-age story and, in this case, puppy love. The main focus is the Arnold family's youngest child, Kevin (Fred Savage), and delves into his school life, home life and blossoming love life. The critically acclaimed hit series' signature style is in employing voice-over (Daniel Stern, as off-screen narrator/adult Kevin, providing us with insight into young Kevin's state of mind). Although at ABC's insistence the show was set in Anytown, USA, the show's suburban setting and authenticity gave series creator/showrunners Carol Black and Neal Marlens the opportunity to explore controversial political themes—the draft, Vietnam, women's liberation, race relations—but as background and counterpoint. *The Wonder Years* is consistently funny but never just goes for the laugh and is devoid of contrived jokes. Instead, it is a character-driven slice of nostalgia and idealism that reminds us of the possibility and wonder that baby-boomers all once felt.

There were other precursors to today's dramedies: *United States* (Gelbart's follow up to *M*A*S*H*); *Hooperman* (created by Steven Bochco and Terry Louise Fisher); *Doogie Howser, M.D.* (from Bochco and David E. Kelley); *The Days and Nights of*

Molly Dodd (created by Jay Tarses)—most of which would be considered successful in today's TV ecosystem. Alas, back in their time (and timeslots), they were relatively short-lived but are all definitely worth a second look.

What differentiates a dramedy from a comedy?

Norman Lear pushed the envelope on his classic multi-camera sitcoms in the 1970s (*All in the Family, The Jeffersons, Maude, Good Times, One Day at a Time*) by balancing laugh-out-loud jokes and funny situations in front of a live studio audience, while also dealing with the controversial issues of race, religion, gender and politics. But Lear went even further with more personal dramatic storylines that encompass divorce, infidelity, cancer, abortion and even rape. These more serious episodes were the exception, not the rule. The broadcast networks have always been more comfortable with funny comedies (with heart) and emotionally resonant dramas with (easily solvable) moral dilemmas.

Most dramedies are not giant ratings champs, but they do have a fiercely loyal, niche fan base. If authenticity is the most desired commodity in the digital TV era, then the dramedy hits that sweet spot by getting real, and rarely sacrificing a raw, emotionally impactful moment for an easy laugh.

Multi-camera sitcoms are, by design, formulaic, familiar and reassuring and must be funny. If the table read in front of the network and studio executives doesn't generate consistent laughs, the writers will need to stay up all night rewriting the script. A multi-camera sitcom with flat jokes is deadly.

Single-camera sitcoms also need to generate laughs, but through funny, ironic situations and character quirks, more than punch lines. Of course, single-cam sitcoms are also required to be funny.

A sitcom with fewer jokes is . . . what? That depends. It could be a bad sitcom, or it could be a version of the seminal, genre-bending, tone-blurring *dramedy* series—either half-hour or one-hour.

> # *Good rules of thumb . . .*

MULTI-CAMERA SITCOM: Half-hour. Funny is money. Mainly interiors, 2–3 main sets; lots of entrances and exits from rooms. Minimum of 3 jokes per page (setups and

punch lines); escalate chaos to solve a small problem writ large (a/k/a "tremendous trifles"); restore stasis and love by the end of the episode. A/B/C stories usually have a unifying theme. Little to zero character development. Examples: *The Big Bang Theory*, *Two and a Half Men*, *Fuller House*, *One Day at a Time*.

SINGLE-CAMERA SITCOM: Half-hour. Mixture of jokes and funny situations. Approximately 60/40 split between interiors and exteriors; humiliate the protagonist(s) and challenge their comfort zones; restore stasis and love by the end of the episode; flashbacks and flash cuts to past moments of embarrassment are employed for comedic effect. Mockumentary and confessionals (a/k/a breaking the fourth wall) are sometimes employed. Usually have a unifying theme. Little, no or slow character development. *Modern Family*, *Silicon Valley*, *Brooklyn Nine-Nine*, *Unbreakable Kimmy Schmidt*, *The Good Place*, *The Last Man on Earth*, *Black-ish*, *Veep*, *Curb Your Enthusiasm*, *Grace & Frankie*, *Ballers* and *Fresh Off the Boat* as well as Ricky Gervais' groundbreaking comedy/dramedy series including *The Office*, *Extras* and *Derek*.[4]

DRAMEDY: Half-hour or one-hour. Honest, raw, uncomfortable relationship issues are explored with nuance and subtext. Generic and familiar plotlines are eschewed entirely. The tone can be funny or tragic but is intentionally off-putting, especially when offering an inconvenient truth. Characters have hyper-specific personality quirks and are more psychologically and emotionally complex. Characters tend to make irrational decisions and are less likable. Avoid formula, with each episode individually crafted to feel distinctive and one-of-a-kind. Can be expansive and cinematic, often featuring multiple locations and fragmented plotlines; usually have an indie movie sensibility and avoid mainstream, obvious/manipulative music choices; the visuals tell the story more than expositional dialogue; usually tell the story in the cut[5] to create a tapestry of interwoven storylines; particular music, montages, flashbacks, voice-over, fantasies and magic realism might be utilized. Thematic through-lines may unify each episode, but more likely there's a season-long theme. Most dramedies are heavily serialized and utilize DPUs[6] from episode to episode.

DRAMEDIES AND LIFE ON THE *CRINGE*

The pure dramedy may serve up a wholly serious episode, followed by a more broadly comedic one. There's less of a consistent comedic or dramatic tone, and more of the creator's sensibility. Authenticity trumps easy laughs. Subtext and nuance are mined for maximum cringe and relatability. If traditional sitcoms are about likably flawed characters getting into and out of trouble, then dramedies are

more about coping with the ongoing hardships and moral complexities of relationships.

Sitcoms generally offer well-intentioned characters caught up in their own self-generated chaos; they offer up a problem and a solution—or moral—by the end of the episode.

Dramedies are generally much more ambiguous, and their characters tend to be self-involved, self-destructive, and while forgiveness and love are still the currency required to solve a dilemma, dramedies don't offer up easy answers.

FEMALE-DRIVEN DRAMEDIES

HBO's *Sex and the City* indeed blazed the trail for women-focused dramedies such as *Girls* (also HBO) and *Crazy Ex-Girlfriend* (The CW). While *SATC* is about the search for love, *Girls* is about self-actualization (or the lack of it), and *Crazy Ex-Girlfriend* centers around self-delusion. The protagonists are smart, funny women—as well as being relatable, lovable and sexy, they make us laugh. It almost seems unfair to demand so much from female protagonists in dramedies, but it's a standard we've come to expect. Carrie Bradshaw (Sarah Jessica Parker), Hannah Horvath (Lena Dunham) and Rebecca Bunch (Rachel Bloom) have deep-rooted vulnerabilities, grow through transformational arcs and always with a good dose of humor, all of which puts them squarely in the hybrid dramedy category.

What also connects these female-driven dramedies, not only to each other but to their audiences, is their authenticity, with their writers drawing on personal experience to create endearing characters who feel real. *Sex and the City* was originally based on Candace Bushnell's book about her own 30-something experiences of dating in New York in the '90s; *Girls* creator/writer/director/actress Dunham freely admits the show is essentially about herself and her friends; *Crazy Ex-Girlfriend* is partly based on co-creator/writer/actress Rachel Bloom's personal struggle with mental well-being. Authenticity is also the female-driven dramedy's common ground with quality female-driven, half-hour comedies. Creator/writer/actress Issa Rae's *Insecure* (HBO) is partly based on her past awkward experiences; the same is true of Ilana Glazer and Abbi Jacobson, who created, write and act in *Broad City* (Comedy Central). And co-creator/writer Whitney Cummings' multi-cam sitcom *2 Broke Girls* (CBS) was informed by the time she spent penniless in her 20s. All six female-driven shows ring

true to their time and place; in *Insecure/Girls/Broad City/Crazy-Ex/SATC*, there is authenticity to the point of rawness: Issa writes from her own experience of being accused of "not being black enough." In *Girls*, Lena Dunham confronts stereotypes as a young woman who is highly sexual. Such dramedies and comedies continue to push the kinds of jokes and subject matter that women are broaching on television. Both the female-driven dramedy and comedy recognize the importance of being able to laugh at ourselves even when things go wrong.

Funnily enough, location is also a character in all these shows, which exist in heightened realities: turn-of-the-century Manhattan, the satirical take on hipster Brooklyn/Queens in *Girls* and *Broad City*, the fetishized suburbia of West Covina, urban LA and View Park, a/k/a "The Black Beverly Hills" and more. Even the set of the multi-cam *2 Broke Girls* is memorable for its brightly colored diner and the girls' work uniforms. The highs and lows of female friendship are also featured throughout these female-driven shows—from Issa's bust-up with Molly (Yvonne Orji), to Rebecca's realizing she's found a much-needed true friend for life (and maternal figure) in co-worker Paula (Donna Lynne Champlin).

The female-driven dramedy traffics in real human emotions; the characters evolve and reevaluate throughout the series. Although *SATC* owes some of its DNA to *The Mary Tyler Moore Show*, the major difference is the dramedy's willingness to challenge and push female characters to grow. When Mary Richards (Mary Tyler Moore) breaks up with a man she is largely unscathed, appearing in the next episode as if nothing happened. Carrie, on the other hand, wears the scars of every heartache, embarrassment and post-it note inflicted on her during her search for love, as do *SATC*'s viewers. The emotions that Carrie *et al.* experience feel genuine, and we recognize them, recalling our past relationships and choices too. The female protagonist's mistakes and how she learns from them define her and bring us closer together with some laughs to bond us, for good measure.

> ## *Express the truth—while finding humor throughout.*

Streaming has ushered in a new crop of half-hour dramedies, available on-demand, across multiple platforms. The half-hour dramedy is polarizing, with some veteran sitcom writers lamenting and deriding them as unfunny, plot-less comedies. It's a

matter of opinion. They're among my favorite shows on television: fresh, authentic and always surprising. If the high-end cable drama series' sweet spot is exploring taboos, then the half-hour dramedy is all about the cringe.

Here are some of the best recent half-hour dramedies (and their creators):

- *Atlanta* (Donald Glover)
- *Baskets* (Zach Galifianakis, Jonathan Krisel and Louis C.K.)
- *Better Things* (Pamela Adlon and Louis C.K.)
- *Casual* (Zander Lehmann)
- *Catastrophe* (Sharon Horgan and Rob Delaney)
- *Chewing Gum* (Michaela Coel)
- *Crazy Ex-Girlfriend* (Aline Brosh McKenna and Rachel Bloom)
- *Dear White People* (Justin Simien)
- *Fleabag* (Phoebe Waller-Bridge)
- *Girls* (Lena Dunham)
- *GLOW* (Liz Flahive and Carly Mensch)
- *I Love Dick* (Jill Soloway and Sarah Gubbins)
- *Insecure* (Issa Rae and Larry Wilmore)
- *Love* (Judd Apatow, Lesley Arfin and Paul Rust)
- *Master of None* (Aziz Ansari and Alan Yang)
- *Mozart in the Jungle* (Roman Coppola, Jason Schwartzman, Alex Timbers and Paul Weitz)
- *Transparent* (Jill Soloway)
- *You're the Worst* (Stephen Falk)

Following is an analysis of a selection of these shows, while *Insecure* is featured in Chapter 7.

YOU'RE THE WORST: THE ANTI-ROMANTIC DRAMEDY

There's a misconception that "dramedy" means "a show with unlikable characters." Look at early iterations of modern dramedy such as *Weeds*, *Nurse Jackie*, *Californication*, *Rescue Me*, *Girls*, *Orange Is the New Black* or *Transparent*: Constant references were made to the "unlikable" characters at the core of these series (it would be naïve not to note that this comes up more often with female characters, whose sole purpose for many years was to be *likable*). But

audiences are realizing that this signifier has a broader definition, welcoming dramedies about flawed nice people (*Master of None, Better Things, Insecure*) and comedies featuring morally challenged characters who rant, criticize, judge and lash out: *Atlanta, Baskets, Fleabag, Casual*. I suppose *Seinfeld*, which featured lovably selfish neurotics, was an outlier sitcom, and *It's Always Sunny in Philadelphia* featured (funny) horrible jerks. And neither was ever considered a dramedy.

The "likability" factor takes an interesting turn in FXX's *You're the Worst*. Just from the title, viewers know they're in for a show about characters they might like to watch, but wouldn't want at their house for dinner. What makes *You're the Worst* different, however, is how the show takes the trope about horrible people and turns it into a sweet, empathetic and heart-wrenching story about two people desperately trying to learn how to love one another. Unlike its dramedy soulmate *Catastrophe*, whose leads often make bad and selfish choices but are generally trying their best, *You're the Worst* follows three truly terrible characters who constantly hurt those around them. (I'm not including ensemble cast member Edgar, played by Desmin Borges, because he is objectively a delight.) But at the end of the day, Jimmy (Chris Geere), Gretchen (Aya Cash) and Lindsay (Kether Donohue) always harm themselves most of all. *You're the Worst* does a masterful job of showing the pain behind the characters' selfish actions. We get an especially good look at this pain in the Season 2 arc, where Gretchen sinks into a deep depression. It's a touching portrayal not only of what it's like to constantly live with a mental illness, but also the reality of loving someone with a mental illness. Creator Stephen Falk gives Jimmy, Gretchen and Lindsay rich backstories and internal lives that make their actions understandable but not redeemable.

By the end of the pilot, Jimmy has behaved terribly after his one-night stand with Gretchen. Actually they both have, but he was worse. He calls while she happens to be in the bathroom of the LA mansion belonging to douchey director Ty (Stephen Schneider). They've just had sex but Gretchen isn't feeling it tonight. Perhaps because Ty was appalled when Gretchen revealed she burned down her high school to get out of a math test. Clothed in the bathtub, after stashing some of his coke in a take-home baggie, she can't resist snorting some straight away, using tweezers she's found. Ty remains in the bedroom, oblivious.

Her phone rings. She looks at the display and reacts in this order: surprised, pleased, then apprehensive. She answers, speaking quietly.

 GRETCHEN
 Hello?

 CUT TO:

INT. JIMMY'S BEDROOM - SAME TIME

Jimmy is sitting on his bed.

> JIMMY
> What are you doing?

<div align="right">CUT TO:</div>

INT. TY'S BATHROOM - SAME TIME

Gretchen is frozen. Lying in the bathtub. Clutching the bag of coke. The tweezers. The phone.

> GRETCHEN
> Nothing. Just... reading?

INTERCUT AS NEEDED:

> JIMMY
> Hey you won't believe this. Someone stole my car.

> GRETCHEN
> Oh? God, that's awful.

> JIMMY
> Yeah. I have to file a police report in the morning.

> GRETCHEN
> (shutting her eyes)
> I may have borrowed it.

> JIMMY
> I know.

> GRETCHEN
> Oh. Well, sorry. I told you I'm the worst.

> JIMMY
> Actually no, you said that I was the worst and that I was lucky to "get" you.

She cringes lower in the tub.

> GRETCHEN
> Yeah. About that...

> JIMMY
> No. Don't apologize. It was a great speech. It was funny and true and mean. My favorite kind.

```
                    GRETCHEN
               (pleased)
          I set my school on fire to get
          out of a math test.

                    JIMMY
               (laughs)
          That's genius.
```

Gretchen smiles. A comfortable silence.

```
                    JIMMY (CONT'D)
          Oh and... I lied to you before. I do
          have a foot thing.

                    GRETCHEN
          Seriously?

                    JIMMY
          Yeah. In fact I was just trying to
          find the right clip online to, you
          know... so that I could fall asleep.
          But nothing's quite right.

                    GRETCHEN
          Oh.
               (beat)
          Do you want me to try?
```

BASKETS AND LIVES IN DISARRAY

FX's quiet, dark dramedy *Baskets* has its main characters constantly begging the question: "What the hell am I doing with my life?" In the beginning of the series, we meet our protagonist, Chip Baskets (Zach Galifianakis) at a crossroads. He's flunked out of a fancy French clown school in Paris, only to return home to Bakersfield, California, and work as a lowly rodeo clown. In their hometown, twin brother Dale Baskets (also played by Galifianakis) literally sells the possibility of success at the cut-rate Baskets Career College. But it's Chip and Dale's mother, Christine Baskets (Louie Anderson), whose journey steals the show. And not by playing a transgendered mom—the series never comments on the fact that a man is playing mom. *Baskets* just *is*.

Christine is the epitome of a mother trying to do her best. Left alone by her husband after he jumped from a bridge when the twins were young, Christine has

tried to support her sons in all of their endeavors. (This includes Christine's adopted set of African-American twins, the rarely seen but often bragged about Logan and Cody, played by Jason and Garry Clemmons.) Although the show finds numerous ways for Chip to pursue his true purpose, mess it up and start all over again, it's often Christine's hopes and dreams that go unrealized—even though one of her trademarks is her effusiveness for particular, sometimes trivial things: "I LOVE carpeting!" "I LOVE smart animals!" "I LOVE Denver!"

As we see in Season 1, Episode 4, entitled "Easter in Bakersfield," all Christine wants is a nice Easter brunch with her mother (Ivy Jones), Chip and friend Martha's (Martha Kelly) family. But when Chip's selfish obsession with his life gone awry takes over the meal and Grandma criticizes Christine's weight and begins to tell the whole table about her daughter's reliance on food as an emotional crutch, Christine's simple request for a nice Easter meal becomes heartbreaking. Just as Christine's character is used to inform the audience more about Chip, Christine's mother is used to show us another, sadder side of Christine. Much of this is brought home thanks to Louie Anderson's Emmy-winning performance as Christine (which he has described as heavily influenced by his own mother). The performance is unlike anything else on TV, perfectly landing every joke while still playing scenes such as the Easter brunch with the type of vulnerability and shame that comes from being 60 years old and still having to hear that your mother is disappointed in you.

 GRANDMA
It started when she was a
teenager, I would find these candy
wrappers and what have you in her
backpack.

 CHRISTINE
Mother.

 GRANDMA
And when she was a freshman, she
was poised to be the head of her
cheerleading squad--that just went
out the window.

 CHRISTINE
I sprained my ankle.

 GRANDMA
Why do you think you sprained your
ankle?
 (to the others at the table)

It was all that new excess fat she
had on her. I did everything I
could. I made her write down
everything she ate. We had weigh-in
Wednesday, but somehow she was
always able to get it. So that's
why after a while I just gave up. I
mean, she was so sensitive about
it, and it was really, really sad
because cheerleading meant
everything to her. It's so sad.
Well, eventually, she had to settle
for that husband of hers. He was a
piece of work. Then she just
funneled all of her energy into
motherhood, and you see how well
that turned out. So the sugar just
kept coming.

[Christine leaves the table having not touched her dessert
plate.]

 GRANDMA
 Christine, sit down, honey. Eat
 your desserts.

[LATER]

[After Christine has been so embarrassed by her mother, she
wanders the floor of the hotel casino where she comes upon
Chip at a slot machine. The two have a heart to heart.]

 CHRISTINE
 You okay?

 CHIP
 Yeah. You?

 CHRISTINE
 I've been better. Not my favorite
 Easter brunch. My mother shamed me
 out of a dessert.

[Chip looks understandingly at Christine, two disappointments.
He fishes around his pocket and pulls out an Easter egg
filled with little candies. Christine smiles and begins to
eat the treats.]

 CHIP
 I'm sorry that I didn't tell you
 about getting married.

```
               CHRISTINE
     It's all right. She nice?

               CHIP
     Hm, good question. My life's in
     disarray right now, Mama.

               CHRISTINE
     Whose isn't? Whose isn't?
```

SATIRE AS THE WEAPON OF REASON IN *DEAR WHITE PEOPLE*

*D*ear White People is based on the 2014 indie film and breakout hit of the same title, which was written and directed by showrunner Justin Simien. As Ann Hornaday writes: "[The movie is] relevant, but, in the right hands, entertaining, too: Simien maintains a scrupulously light tone and deft touch throughout *Dear White People*." Both the show and movie are set at Winchester, a fictional, supposedly liberal Ivy League university. "There, African American students—representatives of the 'talented 10' percent—grapple with identity, expectations and ambition."[7] The *Dear White People* series examines polemics by leaning in to the gray areas, layering in sexual chemistry and relationship dynamics. The arc of Season 1 demonstrates that our beliefs—which we *can* control—may incite change and affirm righteous indignation but can also be overwhelmed by inconvenient emotions, which we *can't*.

The half-hour dramedy features a diverse ensemble cast and our protagonist is biracial Samantha White (Logan Browning). On the surface, Sam is a radically politicized activist who hosts the controversial campus radio show, "Dear White People," in which she holds up a mirror to white culture from a black perspective; in most cases, it's a funhouse mirror, as Sam admonishes white people to stop dancing or to stop asking people of color the question, "What are you?" as if they're space aliens. Sam's demeanor ranges from incredulous to outrage, as she rails at the system—particularly at white male privilege. What keeps the show on track is its smart tone that doesn't take itself too seriously. This isn't a preachy series; it's a referendum on ignorance versus respect. In one of Sam's many radio rants, she expresses the show's main theme: Satire is the weapon of reason.

As in the movie, the show makes use of a detached male narrator who observes everything from a humorous, hyper-PC perspective. Simien knows that if we're going to tackle race issues, first we need to be invited to laugh at our cultural and racial sensitivities. He's not preaching to the choir here. The POV is fairly balanced, an equal opportunity offender, and the blame and hypocrisy are somewhat colorblind. Today's politically charged climate is especially intense on university campuses, which can be PC minefields of "micro-aggressions" and "triggers." When it's intimated that Sam might be undermining herself by being "a slave to the cause," it's simultaneously offensive, provocative and probably true. The series also addresses the Black Lives Matter movement via Winchester's voluntarily segregated Armstrong Parker ("AP") House—a haven for the college's (more or less) marginalized African-American students, the place on campus where Sam feels most at home . . . or does she?

Sam had intended to teach Winchester's magazine *Pastiche*, run by white male students, an embarrassing lesson by capturing on video its "Dear Black People" party, with white students in blackface and masks. But when a caucus of black students learns about the event, they storm the place and pandemonium ensues. Sam escapes the melee, satisfied . . . until her neglected, secret white boyfriend, Gabe (John Patrick Amedori), reveals on Instagram that he and Sam are a couple. In both the movie and the TV series' stroke of genius, Sam's relationship with Gabe effectively leaves her torn between her ideology on race inequality and her passion for Gabe, as she hates what he represents in her worldview, even though she loves him.

It's one of the many forms of triangulation Simien employs, not only between Sam's/Gabe's/her own belief systems, but also between Sam and Reggie Green (Marque Richardson), who is black; Reggie truly likes Sam, and Sam *tries* to return his affection, but her feelings for Gabe throw her off her game. Sam wishes love could be (color)blind, but it's complicated. This is but one example of the show's currency of love/hate relationships that generates significant conflict, drama, pain and humor.

Then there is the overachieving beauty, a black student Colandra "Coco" Conners (Antoinette Robertson), who's infatuated with Troy Fairbanks (Brandon P. Bell), the president of the Black Student Union who also happens to be the dean's son. Coco believes she's in love with Troy, but her judgment is clouded, not by emotion, but by her social-climbing ambition. Troy is wildly attracted to Coco, but he also starts to see the cracks in her persona/façade—which creates another triangle: Coco/

Troy/Ambition. Add to that the additional layer of Troy's black roommate, Lionel (DeRon Horton), who's a closeted gay man with a secret crush on Troy.

Dear White People plays the race card as satire, but like the best satire, the target is truth—or its various versions that may not be politically correct, or *too* much so. The show's tone is funny, ironic, bold and unflinching. Barry Jenkins, who won an Academy Award for *Moonlight*, directed Episode 5 (written by Chuck Howard and Jack Moore), which explores the use of the N-word and builds to a white cop pulling a gun on a black college kid.

This groundbreaking series coincides with the mainstream use of the word "woke"—a word intended to challenge white people to wake up to the systemic racism and inequality that still permeates and festers in the US and around the world. We need to be mindful of platitudes. Our words matter. I reached out to two trusted friends for their perspectives: Steven, who's Afro-Latino, Puerto Rican, a writer and identifies as queer, and Tiffany, an African-American female screenwriter (and recovering CNN journalist).

Steven finds the term "woke" problematic. He describes how "woke" was originally a social justice term in the 1960s, resurrected after Michael Brown was shot in Ferguson, Missouri, in 2014. Steven objects to "woke" being appropriated as a catch-all word "that doesn't take into account socioeconomics or the politics of skin color"; he feels that darker-skinned black people suffer greater discrimination than lighter-skinned blacks. He also believes that institutional racism doesn't account for the inequality of other marginalized groups, i.e., the LGBTQ community. To Steven, one can claim to be "woke" but still be prejudiced against other marginalized groups. "We parcel out identity, but we don't acknowledge the intersection," he explains.

In the show, Sam's frenemy Coco is darker-skinned and portrayed as uppity—at the expense of her black identity—but flashbacks show just how much Coco has struggled because of her skin tone. In fact, the night after *that* party, Coco calls Sam out on how she has it easier because of her fairer complexion: "Imagine the reaction if your divisive revolutionary drivel were coming from the mouth of a real sister. You get away with murder because you look more like them than I do." Meanwhile, Troy is portrayed as athletically gifted, excels academically, is privileged and for a while he appears to transcend race; Lionel is a geek hiding behind the façade of his glasses and Afro, writing about other people to take the focus off himself.

Tiffany is a fan of *Dear White People*, which she describes as "nuanced in a way that TV—especially dealing with racial issues—rarely is." To both Steven and Tiffany, the bottom line is that getting "woke" is not a monolith. The show succeeds by shining a light on the intersections between racism, sexism and homophobia, as well as socioeconomic and academic status. It's an important story about the relationship between identity, respect, resistance and solidarity, all delivered with sharp satire.

I LOVE DICK: EXPLORING THE "FEMALE GAZE"

If *American Gods* and *Twin Peaks* are the most bizarre series on TV today, then *I Love Dick* (co-created by showrunner Jill Soloway and Sarah Gubbins) takes the prize for the most emotionally raw and daring. Whether its characters are fully clothed or naked, they bare their souls to us and expose their shame in unexpected and provocative new ways. Based on the book by American artist, author and provocateur Chris Kraus,[8] *I Love Dick* is a hybrid of fiction and memoir and explores the writer's psycho-sexual obsession with a media theorist and sociologist whose name is Dick (played with laconic, low-key, humorous cowboy swagger by Kevin Bacon).

This is extreme cringe dramedy, and a more apt title might be *Diary of a Mad Stalker*. Soloway has said in interviews that her series explores "the female gaze." While movies and TV have explored the male gaze (objectifying women) for generations—from Marilyn Monroe's legs exposed under her billowing white skirt in *The Seven Year Itch*, to every James Bond and action movie ever made— examples of the female gaze in film and television are historically rarer. There are of course notable exceptions: Written by Oscar-winner Callie Khouri, *Thelma and Louise* immediately comes to mind. Movies such as *Magic Mike* and its sequel, touted for featuring male strippers, are essentially designed as bromances, and the men are never exploited. To safeguard your pilot against inadvertent stereotyping and gender inequality, I suggest you put it to the Bechdel test.[9] In an industry where women are drastically underrepresented in all roles and objectification is rife, such awareness is more important than ever.[10]

I Love Dick explores the female gaze in a microcosm, in the small, dusty, hipster town of Marfa, Texas. Our protagonist, Chris (the brilliant, courageous Kathryn Hahn), has just moved here with her professor/author husband Sylvere (Griffin Dunne) for his residency at the local artist colony/institute, helmed by Dick. When Chris sets eyes on Dick, it's lust at first sight. If her gaze isn't telling enough, we

hear her innermost thoughts via voice-over in the form of highly inappropriate, intimate letters to Dick. Her letters are the central narrative device of the series, and lines from these letters appear in large font on the screen, in bright red. The camera also stalks Dick, and lingers, crotch-level, whenever he's near.

Chris is falling hopelessly in love with Dick, even though he barely knows she exists, and she's married. Sylvere knows about the letters, and Chris' sharing her unbridled lust for Dick at first serves to turn up the heat on their sex life—from non-existent/tepid to passionate. But the truth is, even in the midst of mind-blowing orgiastic sex with her husband, Chris is thinking only of Dick. In one of several touches of magic realism in the series, Dick is present in the room while Chris and Sylvere are making love; Chris' eyes remain locked with Dick as he looks on. It's just a delusion in Chris' mind—which she seems to be losing. By Episode 5, Chris is completely out of control, a slave to her desires. And when Sylvere cries foul and demands that she stay away from Dick and stop writing these letters, Chris' painful reply to her husband is: "I don't think I can." Yes, Chris is ready, willing and able to destroy her whole ordered existence in order to be liberated from rules, limitation, sexism and shame. When it comes to Dick, she's all in.

Consider some excerpts from her poetic, wildly provocative letters:

```
          CHRIS (V.O.)
Dear Dick: I was born into a world
that presumes there's something
grotesque, unspeakable about female
desire. And now all I want to be is
undignified, to trash myself. I want
to be a female monster. I want to
have the kind of sex that makes
breathing feel like fucking.
```

And this:

```
          CHRIS (V.O.)
Dear Dick: I'm on a mission to
obliterate the walls of my desire.
```

When her feelings appear to be unrequited by Dick, Chris ramps up her obsession and disregards his pleas to leave him alone. She even prints out her letters and tapes them up all around town for everyone to see. It's partially to get Dick's attention (she succeeds and he's angry and humiliated), but also part of exposing herself. She can't be discreet and hide any longer. She's coming out and to hell with what anybody else thinks about it. This is her truth.

The cast is rounded out with an ensemble of other women and men dealing with similar issues of gender identity, shame and marginalization. The character of Dolores/Devon (Roberta Colindrez) is trans with a less-than-supportive mother; Toby (India Menuez) is a young artist obsessed with porn; Lila (Gabrielle Maiden), one of the few African-American women in Marfa, is the curator of Dick's gallery and yearns to have her taste and vision validated by her white, patriarchal boss. Each woman negotiates identity and liberation on her own terms, with Episode 5 ("A Short History of Weird Girls"), written by Annie Baker and Heidi Schreck and directed by Soloway, the standout of the season; in this anomalous episode, Chris, Devon, Toby and Lily break the fourth wall and directly address the viewer about her/his backstory and first experiences with sexual insecurity and shame.

Once Chris has her sexual awakening, her true self emerges, and there is no going back to her former life of quiet desporation. She's ready to live out loud, and her lustful letters to Dick evolve into a manifesto and, ultimately, into letters to love itself. I won't spoil the sensational Season 1 finale, except to say that it involves an inevitable, sexually charged confrontation between Chris and Dick. Now she has his full attention; he's alert and erect, and the male and female gaze converge in the most shocking and explosive climax I've ever seen on a dramedy—bar none. The series is definitely not for the easily offended. It did not get picked up for a second season, although this may be part of Amazon's bigger shift toward event series (more on this in Chapter 12).

MASTER OF
THE OBSERVATIONAL:
MASTER OF NONE

Aziz Ansari's breakout role was that of Tom Haverford on *Parks and Recreation*. Since Tom the character mostly cares about swagger, networking and being a mogul, it came as a pleasant surprise when Ansari, the actor/writer/producer, and co-creator Alan Yang developed such a sensitive, grounded and unabashedly charming series. Ansari plays Dev Shah, a working actor who is navigating his life as a 30-something, second-generation Indian man in New York.

Now, that premise could lead us to believe *Master of None* is another in a long line of hang-out comedies about hot young people in an apartment who are somehow always just about to kiss. But instead, this personal auteur comedy treats Dev's life and relationships with naturalism and fluidity. Friends show up in an episode, disappear and then reappear three episodes later at a brunch to discuss Dev's texts with a girl, mirroring the real way friends come in and out of our lives. (Unlike many sitcoms, which lead the audience to believe our best friends will always be neighbors or that every night somehow everyone ends up in *one* apartment.)

Dev's relationship with his parents adds another touch of authenticity to the show. Ansari bravely cast his own parents in the roles of Dev's mom and dad Nisha (Fatima Ansari) and Ramesh (Shoukath Ansari). The understanding and empathetic portrait that Aziz and Yang paint of their parents in Season 1, Episode 2 (appropriately titled "Parents") gives viewers a perspective not only on what it's like to be the children of immigrants, but to be parents to those children. *Master of None*'s subtle interpretation of what it's like to be a child of immigrants adds depth to the trope of a struggling actor trying to make it in New York City. The show consciously addresses the lack of minority representation in the media through Dev's struggles (ditto for *GLOW* on Netflix and gender inequality). *Master of None* has also broken new ground: In 2017, actress/writer Lena Waithe (who plays Denise) became the first black woman to win an Emmy for comedy writing, which she shared with co-writer Ansari. The award was for Waithe's incredibly personal episode "Thanksgiving," where Denise comes out to her family. Hers was a profoundly moving acceptance speech:

> My LGBQTIA family, I see each and every one of you. The things that make us different, those are our superpowers. Every day you walk out the door and put on your imaginary cape and go out there and conquer the world, because the world would not be as beautiful as it is if we weren't in it.[11]

"Parents" digs into the privilege allowed the children of immigrants as a result of their parents' sacrifice. The episode starts with Dev's father Ramesh trying to get Dev to help him fix his iPad, but Dev never answers his phone. The scene concludes with Dev brushing off his father, saying he can't mess with his iPad now; he's going to see an *X-Men* movie and doesn't want to miss the trailers. The exchange is relatable, especially for any child who's had to help his or her parent set up some form of technology.

What gives the episode an introspective quality is the series of flashbacks that follows: We go back to India, 1958. A young Ramesh (Tarun Vaidhyanathan) plays enthusiastically with an abacus on the street, that is, until a bully comes up and crushes it under his feet. In another flashback, this time to 1980 New York City, we see Ramesh, straight from medical school, arrive in America to go to work as a doctor. When Ramesh inquires about the steak dinner for his family all new doctors are treated to, the racist doctor giving him a tour tells him there will be no dinner; Ramesh and his family can eat in the cafeteria. The last flashback is to Ramesh gifting a young Dev a desktop computer—a major leap from the abacus Ramesh cherished as a child. We see a similar scene play out between Dev's Taiwanese-American friend—Brian Cheng (Kelvin Yu) and his father. We observe the struggle Brian's father went through to provide a better life for his family and, again, Brian's blindness to that struggle.

Here, creators Ansari and Yang (after whom Brian is modeled) evaluate their own relationship with their parents and acknowledge the struggles they have gone through for their children. Brian and Dev both seek verbal affirmations from their parents that they're proud of them, but in the mind of Ramesh and other immigrant parents, they show their love for their children by creating a better life with better opportunities than they had.

Here, Dev and Brian discuss the difference between Asian parents and white parents as they walk down the street after a movie. Dev's cell phone honks.

> DEV
> Text from my dad: "Please come and
> fix my iPad. Now it won't stop
> dinging." Does your dad always text
> you to fix stuff?
>
> BRIAN
> I don't think my dad knows how to
> text. He also hates talking in
> person. He averages, like, three
> words a week.
>
> DEV
> Our dads are so weird. I told my dad
> I got a callback on *The Sickening*--
>
> BRIAN
> Oh, the black virus movie? That's
> great.

 DEV
 Thank you. I told him. He's like,
 "Uh, okay. Can you fix my iPad?" How
 about, "Hey, son, great work," or,
 "Hey, son, I'm proud of you"?

 BRIAN
 I have never, ever heard my dad say
 the word "proud." It's always like,
 "That's it? So that's all you've
 done?" Like, if I went to the moon,
 he would honestly be like, "When are
 you going to Mars?"

 DEV
 Yeah. "Oh, Brian, you went to the
 moon? That's like graduating from
 community college. When are you
 gonna graduate from Harvard, AKA, go
 to Pluto?"

 BRIAN
 I just feel like Asian parents, they
 don't have the emotional reach to
 say they're proud or whatever.

 DEV
 Have you ever hung out with a white
 person's parents, though? They are
 crazy nice.

 BRIAN
 Yeah. I had dinner once with my last
 girlfriend's mom, and by the end of
 that meal, she had hugged me more
 times than my family has hugged me
 in my entire life.

 DEV
 Yeah, dude, most white families,
 they'd be so psyched to adopt me.

In the first episodes of Season 2, Dev travels to Modena, Italy, to learn how to make pasta. Ansari has said that he learned not only how to cook, but also how to speak conversational Italian. We get the sense that making his show is part of his personal journey, and Ansari and his character Dev both come across as wandering, restless souls who second-guess and overthink everything. But Dev isn't a complaining neurotic; he is much more optimistic. At his core, he is a hopeful, not hopeless, romantic. The show is called *Master of None*, but it might more accurately be called *Lust for Life*—even when life is crushing. No pain, no gain. It is, after all, a dramedy.

BETTER THINGS:
PHILOSOPHICAL VIGNETTES

In *Better Things*, co-creator/showrunner/star Pamela Adlon draws our attention to the internal life of a divorced, single mother trying to raise three daughters by herself. The series is semi-autobiographical, which adds a layer of meta-authenticity: Is this art imitating life, or vice versa? What does it matter, when it's so poignant, relatable, cringe-worthy, sometimes sad and usually very funny? The series has a bemused, sometimes acerbic, comedic sensibility. The opening theme song, "Mother" by John Lennon, perfectly sets the tone for this melancholic slice of life, as it plays over images of Sam and her girls.

What pulls *Better Things* into the dramedy category is that, throughout the episodes, we see Sam navigating her doubts and insecurities while juggling a freelance career as a middle-aged Hollywood actress, trying to find Mr. Right, or at least Mr. Right Now; her complicated teenaged/pre-teen daughters and *their* issues; and her own eccentric, boozy mother (who lives right next door). And don't you dare call Sam or Adlon "brave" for being so plucky and vulnerable—or she might punch you in the face for being patronizing. Moreover, she's *tough*. We root for Sam because she's unapologetically genuine and suffers fools by confronting them—not to attack or shame them, but to understand them. To say her piece. Amidst all the noise in her life, Sam doesn't demand validation or accept bullshit. She just needs to be acknowledged and heard. Yet, she's hardly a control freak. All she ever really wants is to tame the chaos, not conquer it—she's too exhausted for that. And so, for now, she copes and hopes for better things—which for her means happy kids, steady work—and getting laid. In Adlon's show, we might finally have a true comedic portrayal of what it means to try and "have it all."

The realism Pamela Adlon achieves by basing the series directly off of her life is crucial for the emotional beats to land. It makes the show approachable, relatable and equalizing in experience.

LOVE AND DEATH
IN *ATLANTA*

When it comes to authenticity, it's tough to surpass the wry, ironic, gritty, satirical world that is *Atlanta*. Tonally, the show defies categorization but can be best described as an existential comedy, or more accurately a tragicomedy; it's an example of how cognitive dissonance can be rewarding to

viewers. It's not whiplash storytelling for the sake of being provocative; series creator/showrunner/director/star Donald Glover is just keeping it real. But the problem for his alter ego, protagonist Ernest "Earn" Marks, is that life is *too* real. He may have dropped out of Princeton for undisclosed reasons, but he's now enrolled in the School of Hard Knocks. In 2017, Glover became the first black person to win an Emmy for directing for a comedy series, and the first black actor to win lead actor in a comedy series since 1985. "It's pretty obvious people in dystopian societies don't realize they're in dystopian societies," he said after the ceremony. "I just want people to be aware, I think people are aware."[12]

From the opening (teaser) of the funny pilot episode forward, Glover makes it clear to his audience that they're in for a destabilizing ride—so don't get too comfortable. Akin to today's best dystopian and supernatural series, on *Atlanta*, anything can happen. Glover can write funny and score laughs at throwaway one-liners, but much of the show's comic relief comes from Earn's perpetually stoned, eccentric friend, Darius (Lakeith Stanfield)—a walking non sequitur. In the pilot, out of the blue, Darius asks Earn's father if he can measure a tree in his front yard. Earn's mom and dad have perfected the art of the deadpan and manage to steal every scene they're in. There's also a middle-aged woman at the airport shilling Delta Airlines credit cards (the rival of Earn and his friend) who taunts Earn by flirtatiously snagging a male customer and then gyrating doggie-style behind the oblivious customer's back.

But these laugh-out-loud moments are juxtaposed against scenes of police brutality, of negotiating the use of the N-word and of cold-blooded murder. How can a *dramedy* be so gritty and tragic? In today's television landscape, authenticity trumps laughs—even in a half-hour format. Donald Glover shows us the Atlanta he knows, loves and hates. (The city, in all its contradictions, is a character in the series, the way Baltimore is a character in *The Wire*.) One moment Earn and his buddies are laughing it up; the next moment they could be dodging bullets or accused of a crime—in a rush to judgment based on stereotyping—they may or may not have committed.

In the pilot episode, "The Big Bang," an altercation with a pimp/thug leads to a gunshot and probable death. In Episode 2, "Streets on Lock," Earn's rapper cousin Alfred (known as Paper Boi and played by Brian Tyree Henry, Earn's only client as a nascent music manager) and Alfred's sidekick Darius are released on bail for the previous night's melee, but Earn remains in custody. Stuck in jail and hoping that his ex-girlfriend (and mother of his child) Van (Zazie Beetz) will, once again, come to his rescue, Earn witnesses the cruelty of our flawed justice system, as a mentally ill man dances around the waiting area in a hospital gown, then drinks from a toilet and spits the water into the face of a police officer. Earn is horrified by the cop's

immediate, violent beating of the homeless man. Clearly the man needed psychiatric treatment, not brutality.

To counterbalance this harsh moment, Glover layers in a macho guy who discovers that his pretty girlfriend is trans—and plays the guy's cluelessness and trans/homophobia for laughs. Everyone in the jail laughs at him, too—except for Earn, who tries to help:

> EARN
> Sexuality is a spectrum, you can
> really do whatever you want.

The confused, outraged man responds with, "I know what you think she is, but I ain't on that faggot shit." One point for intolerance, zero for Earn. This disconnect is meant to break the tension with humor and, like Paper Boi's earlier refrain of "I hate this place," it's clear that Earn hates this place even more; it represents how oppressed and subjugated Earn feels in his everyday life.

The show's episodes seamlessly and organically swing from comedy to tragedy and back again, but the Season 1 finale, entitled "The Jacket," is the most controversial and inevitable. The episode centers around Earn's lost bomber jacket that he believes he left behind in an Uber after a wild night of partying. We know the jacket has great value to him, and he's on a quest to get it back. But we don't find out until near the end of the episode that it's not the jacket he needs so badly, but actually a key to a storage locker (more on that in a moment).

Meanwhile, Earn tracks down the Uber driver, Fidel Arroyo (Tobias Jelinek) via phone and convinces Paper Boi to give him a ride out to the Atlanta suburbs (with Darius riding along as always). They arrive at Arroyo's address and stake out the house. As they wait, Earn gets a call from popular rapper Senator K (Qaasim Middleton) who invites Paper Boi to go on tour with him. This is their big break! But Earn is skeptical and guarded from a life of disappointments, and Paper Boi is getting antsy: Three black men have been parked in the same spot for too long, and they look suspicious.

As Paper Boi starts to drive away, they're cut off by police vehicles and surrounded by a dozen cops in SWAT gear brandishing assault rifles. It turns out that Fidel Arroyo is a suspected drug and weapons trafficker. As Earn, his cousin and Darius put their hands on the cop car in compliance, Fidel tries to make a hasty escape—and is gunned down by an overzealous white cop. Here we go again: the shooting of an unarmed Hispanic man *in the back*, the spurting of blood, and the dead body

lying on the ground. It's a shocking moment in any context, but this is a *dramedy*. It's beyond provocative. It's horrifying. I counted ten shots.

Understandably, Earn, Paper Boi and Darius are rattled—and relieved at being spared. For the first time since the pilot in which Earn managed to get Paper Boi some airplay on a local radio station, Earn feels lucky to be alive. By now, Earn's sometimes girlfriend and baby momma Van has newfound respect for Earn's principles (bolstered by their bizarre experience in Episode 9, "Juneteenth"), and she invites him to spend the night at her place. But Earn declines. He knows he must stand on his own two feet. He could have easily been killed today, so now he's more determined than ever to be independent and live on his own terms—even if home, for the time being, is a storage locker. Ironically, the key was not in Earn's jacket pocket after all; he'd given it to Darius for safekeeping.

Without the bitter, there's no context for the sweet. Without struggle, the reward feels empty or tinged with fear that it's unsustainable. These shows demonstrate the interstices in our lives. The ellipsis between a dissatisfied "here" and some abstract or idealized notion of "there." We tend to watch TV during our own interstices, and for varied reasons—to pass the time, for distraction, for inspiration—and yes, escape. Seeing fictional characters who are as uniquely flawed as we are also treading water is comforting. We identify with characters who are always yearning and waiting for the next big thing. But every moment matters, and even the insignificant ones are significant in a great half-hour dramedy. It's the accumulation of the smallest details and the struggle between the repression and expression of emotions that pulls us in and keeps us invested in the outcome. In several respects, the dramedy has flourished because it's like life.

● Bonus Content

Further analysis on dramedies, including the rise of the genre and the shows **Catastrophe** and **Casual** is available at **www.routledge.com/cw/landau**.

See also: *Chewing Gum* on Netflix and *Fleabag* on Amazon (a co-production with BBC Four). In *Fleabag*, a pitch-black dramedy, post-traumatic stress disorder (PTSD) and grief have never been funnier or more disturbing. *River* on Netflix is a one-hour, drama/crime-procedural that shares some of *Fleabag's* touching irreverence. And *One Mississippi* is a dark dramedy starring one of the drollest comedians on

Earth, Tig Notaro. The Amazon show is co-created and executive produced by Oscar-winning screenwriter Diablo Cody (*Juno*).

Notes

[1] As "Black" is a politicized term, in this book, I have opted for "black," as per *The Economist* style guide on ethnic groups; however, I fully recognize that "Black" may be others' preference. I deeply respect both viewpoints.

[2] MTM Enterprises was the production company behind such classic sitcoms as *The Mary Tyler Moore Show*, *Rhoda*, *Newhart*, *St. Elsewhere* and *Hill Street Blues*.

[3] The screenplay for the 1970 film *M*A*S*H* was written by Ring Lardner, Jr., based on the novel by Richard Hooker.

[4] My interview with Gervais and full analysis of his show *Derek* can be found in my book *TV Outside the Box*.

[5] Telling the story "in the cut" demonstrates the elliptical nature of cinematic storytelling in which cutting from one scene to another generates story momentum and irony via juxtaposition.

[6] A direct pick-up, or DPU, is the technique of picking up directly where the previous episode left off. This is also known as a contiguous serialized structure.

[7] Ann Hornaday, "*Dear White People* Movie Review: A Satirical and Timely Conversation About Race," *The Washington Post*, October 16, 2014.

[8] Published by Semiotext(e) in 1997.

[9] Named after the American cartoonist Alison Bechdel, the Bechdel test asks whether a work of fiction features at least two women who talk to each other about something other than a man.

[10] Influential filmmakers Ava DuVernay, Ryan Murphy and Melissa Rosenberg have all mandated that their writers' rooms be integrated by race and gender and that at least half of their episodes be directed by women.

[11] Clarisse Loughrey, "Emmys 2017 was a historic night for women and people of color," *The Independent*, www.independent.co.uk/arts-entertainment/tv/news/emmys-2017-historic-record-breaking-donald-glover-atlanta-lena-waithe-the-handmaids-tale-nicole-a7952306.html.

[12] Jessica Gelt, "Donald Glover at the Emmys," latimes.com, September 18, 2017, www.latimes.com/entertainment/tv/la-et-emmys-2017-69th-emmy-awards-live-1505774958-htmlstory.html.

Episodes Cited

"Pilot," *You're the Worst*, written by Stephen Falk; Hooptie Entertainment/FX Networks/ Bluebush Productions/FXX.

"Easter in Bakersfield," *Baskets*, written by Samuel D. Hunter; Pig Newton/Slam Book/3 Arts Entertainment/FX.

"A Short History of Weird Girls," *I Love Dick*, written by Annie Baker and Heidi Schreck; Amazon Studios/Topple Productions.

"Parents," *Master of None*, written by Aziz Ansari and Alan Yang; Universal Television/ Netflix.

"Streets on Lock," *Atlanta*, written by Stephen Glover; RBA/343 Incorporated/MGMT Entertainment/FXP.

"I don't think of it as a procedural. I think of it as a character study—a study of many characters, really."

—STEVEN ZAILLIAN
WRITER/ADAPTER/SHOWRUNNER/DIRECTOR
THE NIGHT OF

"[The lawyers] see each other all the time. They're not enemies. They're in the same business, just like cops and bad guys. . . . They're going to say, 'Hey, how you doing? How's the wife?' That's life. That's real life.

Everything is gray and if you don't respect the gray, what you have is writing with crayons."

—RICHARD PRICE
WRITER/ADAPTER/SHOWRUNNER
THE NIGHT OF

CHAPTER 2
THE SLOW-BURN, SEASON-LONG PROCEDURAL

From *Murder One*
and *Twin Peaks* to
The Night Of, *Fargo*,
Search Party and More

For decades, the most common TV series characters have been doctors, lawyers and cops, especially detectives. The formula is easy to digest: case of the week followed by positive resolution. In the world of the classic procedural, there isn't a disease, legal case or crime that can't be cured/adjudicated/solved within 42 minutes.[1] Many of these formulaic series still exist today because audiences still crave the familiar and reassuring. Like the multi-camera sitcom, it's comfort food. *Law & Order* is TV's most durable franchise for a reason, with its descendants (*CSI*, *NCIS*, *Criminal Minds*) and their legal/medical counterparts now global, multi-billion dollar franchises. The cases are often provocative and/or ripped from the headlines, but the examination of the crimes (or lawsuits or medical ailments) is, by design and dint of constraint, mostly on the surface and easily resolved.

Today, unless writer/creators are doing something fresh and surprising, it can be hard to break through all the noise. The slow-burn, season-long procedural has emerged as one solution to this problem. But let's go back and set its predecessor, the classic procedural, in context. In every era, major technological shifts are accompanied by varying degrees of anxiety, skepticism and fear. The advent of the clunky RCA television set, more than 70 years ago, was no exception. If the radio seemed non-threatening, television felt like an intrusion: *Who are these strangers in the mysterious light box invading our living rooms?* For many, it was an exciting innovation, tantamount to the cell phone and the Internet. Back then, there had never been a more disruptive technology than the "idiot box" or "boob tube"—and nothing would ever be the same again.

It's human nature to fear change. When we segued from radio to television, the TV networks of the day were inclined to offer up programs that were safe, palatable and reassuring. Sitcoms featured "Happy people seeking happy solutions to happy problems,"[2] and dramas encompassed heroes and villains—and the good guys always prevailed. TV sets were in black and white, and so were the storylines. Network mandates in the 1950s and '60s were designed to present shows that were inviting to both audiences and advertisers. Commercials featured soap, floor wax, laundry detergent, coffee and cigarettes. (Of course, this was long before the Surgeon General's warning burst our collective bubble.)

Back then, few wanted controversy and ambiguity on television. We wanted resolution and easy answers. I'm oversimplifying to make a point, but post-World War II, the perception was that America was still a united nation, and TV reflected the aspirations, hopes and dreams of the majority. (Today, we'd tag that White Male Privilege.) Madison Avenue was selling, not only products with names such as Joy, Cheer and Mr. Clean, but a way of life. We generally trusted our news sources, the three major broadcast networks, and anchormen such as Walter Cronkite and Edward R. Murrow, to deliver the same version of the news.

In his controversial book *Primetime Propaganda*, Ben Shapiro makes a case for how "television has been used over the past 60 years by Hollywood writers, producers, actors, and executives to promote their liberal ideals, to push the envelope on social and political issues, and to shape America in their own leftist image."[3] Regardless of Shapiro's conservative standpoint, the advent of television as technological advancement—which was, in itself, neutral—did come with some kind of subliminal political and social agenda. Do characters and storylines on TV series now represent and reflect the lives of all citizens, or are they still just whitewashed versions of Americans as filtered primarily through a white male lens?

In the early decades of television, this wasn't a question any of the power brokers in the TV business wanted to answer. Early TV sets were a luxury the poor and disenfranchised couldn't afford, any more than the products being advertised on the commercial breaks. The struggling underclass, including immigrants, was mostly invisible—when they weren't being stereotyped and stigmatized as perps, thugs, whores and "the help." The white majority's collective need for comfort and reassurance gave rise to the predictable happy ending. Sweet justice was always meted out on a crime series. We always knew 100% who the perp was because the suspected criminal would always confess in the end, express contrition and explain his motives to the cops or superheroes, before being hauled off in cuffs. Resolution and predictability were touchstones of TV series for the last five decades (with the

shows of Norman Lear, Tom Fontana and Steven Bochco as notable exceptions; granted, all are white male showrunner/creators, but their stories are hyperconscious of real-world issues).

With the digital television revolution, audiences have transcended the formulaic and predictable in favor of exploring the nuanced gray areas of complex, heavily flawed heroes, antiheroes and antagonists in series that defy stereotypes or easy resolution. They lean into the chaotic, often irrational world in which we live now. Today's trailblazing content creators are delivering series grounded in gritty realism, uncomfortable, intentionally cringe-worthy humor and irony. Some are perhaps even too clever for their own good. But most challenge our expectations for an established genre by pushing the envelope and provoking us to question the status quo.

> *The season-long procedural has sprouted into the dominant genre of the digital era, which favors serialization and authenticity above all.*

The truth is out there, but it's a slippery and subjective slope. There's a reason *The People v. O.J. Simpson* so captivated the zeitgeist; it was as if we didn't know the outcome of the double murder trial. Now that we have the capacity to videotape everything at our fingertips (along with dashboard, traffic and satellite surveillance cameras), we're convinced that someone somewhere knows something more: If the truth comes too easily, it must be a conspiracy. *The X-Files* has been supplanted by *Mr. Robot* and *The Man in the High Castle* (the latter created by *X-Files* alum Frank Spotnitz). Paranoia plays a key role in the popularity of such shows.

In the past, if we figured out the solution to the mystery and were correct all along, we gave ourselves a pat on the back for being smart. Today, we're more likely to tune out. The way we live now is interactive. A predictable storyline is at best disappointingly derivative; at worst, an insult to our intelligence. One thing is certain in today's on-demand TV landscape: Audiences need choices. Conversely, once we get swept up in an irresistible story, like a great page-turning novel, we don't want it to end. Viewers crave twists and turns. We embrace flashbacks that help clarify and justify unfortunate life choices for their heroes and heroines. Cracking the case, the code, the medical condition, even redemption are all still possible—if they're credibly and proactively *earned*. Audiences enjoy a dash of

magic realism and/or mysticism but reject *deus ex machina*, helpful coincidence and easy remedies. Memorable TV characters work hard and play hard and are often experts with a liability. The heroic ones endeavor to save lives but tend to possess a self-destructive streak.

In my last book, *TV Outside the Box: Trailblazing in the Digital Television Revolution*, I analyzed the difference between the new existential detective story and older, more traditional whodunits. *True Detective* on HBO (Season 1, 2013) isn't the usual detective story; it's *existential*, the conventional genre with a twist, contemplating, "*Who are we?*" Writer/creator/showrunner Nic Pizzolatto learned two valuable lessons: one before the first season began and one after. Pizzolatto got his career start on the AMC one-hour crime drama *The Killing*, which investigated the tragic death of a teenaged girl, Rosie Larsen. When series adapter (from the Danish format, *Forbrydelsen*) and showrunner Veena Sud chose not to reveal Rosie's killer by the end of Season 1, Sud's slow-burn approach proved taxing for its audience. In fact, there was so much viewer backlash that AMC almost pulled the plug on the series. Lesson learned: Reveal whodunit *by the end of the first season*. Pizzolatto also learned the pain of following up the phenomenal success of Season 1 of *True Detective* with a second that fell short of its first. Lesson learned: Breaking up is hard to do, with actors such as Season 1's Matthew McConaughey and Woody Harrelson playing one-of-a-kind, iconic characters. It's hard to follow outstanding originality with more outstanding originality, but maybe time is the key. After a longer break between seasons, we look forward to Pizzolatto's third installment. Season 3 has been green-lit by HBO with Mahershala Ali to star and Jeremy Saulnier to direct. It will be set in the Ozarks, following a gruesome crime and mystery over three different time periods.

Fargo on FX dodged the sophomore jinx with a transcendent second season set in the 1970s. *Fargo* adapter/showrunner Noah Hawley subverted our expectations by adding disco, women's lib, EST self-help programs and UFOs—and we ate it up, like waffles at the now infamous Waffle Hut.

THE SEASON-LONG MYSTERY

Now that we've collectively embraced the medical procedural with a twist: *House, Royal Pains, Grey's Anatomy*; the legal procedural with a twist: *The Good Wife, Suits, The Good Fight*; and the crime-procedural with a twist: *Monk, Hannibal, The Mentalist, Elementary*, the *CSI* franchise (a how-dunit, not a whodunit), and *Person of Interest* (precognition), we're eschewing the formulaic case-of-the-week structure for the season-long mystery.

It helps now that the seasons are shorter, as the Brits have proven time and time again with such high-quality series as *Happy Valley*, *Broadchurch* and *Prime Suspect*. FX gave us the season-long legal procedural in the one-hour drama series, *Damages*, created by Todd A. Kessler, Glenn Kessler and Daniel Zelman. The legal thriller explores a high-stakes civil lawsuit from multiple perspectives and timelines, the sweet spot of the show being the cunning, ruthless machinations of founding senior partner Patty Hewes (Glenn Close).

Damages serves up one juicy case per each 13-episode season, part open and part closed mystery whodunit and how-dunit, with rookie law associate Ellen Parsons (Rose Byrne) as an innocent babe in the woods being prepped for slaughter—unless she's able to turn the tables on Hewes. The show's premise and demographics weren't the best fit for the (at the time) male-skewing FX network, but the critically acclaimed series is taut and suspenseful, with unexpected twists and turns, and flash-forwards to foreshadow the mystery's ultimate payoff.[4]

It's significantly harder to sustain a season-long procedural over 22+ episodes, as trailblazing showrunner Steven Bochco discovered when he created two series that, in hindsight, were ahead of their time. *Murder One*, which premiered on ABC in 1995, stars Daniel Benzali as criminal litigator Ted Hoffman, a fervent defender of his clients. The first season revolves around a single high-profile criminal case: the murder of teenaged Jessica Costello, with Hoffman representing a young Hollywood star played by Jason Gedrick. During the first part of the season, Hoffman's associates also handle smaller, "closed-ended" episodic cases. But the entire season consists of one defense case for Hoffman & Associates.

While groundbreaking in its format (one case, one season), the show struggled to retain viewers. The low ratings were a symptom of audiences not having the ability to catch up on missed episodes—unless they'd remembered to program their VCRs in advance. *Lost* (2004–2010) had similar issues, but the J.J. Abrams/Damon Lindelof series became a must-see phenomenon anyway—although some grew weary of its esoteric storytelling. Flashbacks were welcomed, but flash-forwards and flash-sideways tested the willing suspension of disbelief, and some viewers found themselves lost in the complex plotting of the latter seasons.

With *Murder One*'s slow-burn procedural format flaming out, Daniel Benzali was replaced in the revamped Season 2 by Anthony LaPaglia, who portrays Jimmy Wyler, a former assistant DA who took over Hoffman's firm, and features not 1 but 3 unrelated trials, over 18 episodes. But it was too late to turn the tide; the second season of the show was even less successful. ABC canceled *Murder One* at the end of the 1996–1997 season. LaPaglia went on to star in the successful missing person, case-of-the-week series *Without a Trace* for CBS.

Undeterred and no stranger to experimentation[5] and controversy (Bochco's long-running series *Hill Street Blues* and *NYPD* were notorious for their edgy dialogue and envelope-pushing nude scenes), he tried again with the one-hour detective anthology series *Murder in the First* for TNT in 2014. The series, co-created by Eric Lodal, followed a single case for each full season (Seasons 1 and 3 contained 10 episodes; Season 2 had 12). Despite critical acclaim and a small but loyal audience, TNT pulled the plug on the heavily serialized show after 32 episodes in 2016.

There was a time when "serialization" was a bad word and undesired format at the TV networks, with creators encouraged to avoid "premise pilots" (square one, expositional) and serialized arcs. Of course, a number of nighttime soaps managed to hook viewers early on and retain them (*Dallas, Dynasty, Knots Landing, Melrose Place*), but these escapist shows are slow-moving relationship dramas, featuring archvillains we loved to hate, and steeped in gossip, backstabbing and scandals; they aren't case-of-the-week procedurals. They are sexy, escapist love triangles on steroids, as easy to pick up and put down as a paperback beach read. Nighttime dramas (primetime soaps) were/are more about eye candy and outlandish catfights than a serious representation of the criminal, judicial and medical system; in the nighttime soap genre, realism takes a back seat to juicy, dramatic revelations. Cliffhangers—hinging on convoluted backstories, scandalous secrets and lies, amnesia, long-lost identical twin siblings and torrid forbidden love stories—rule the day.

In today's TV landscape, we like our procedural series grounded in reality. We want to see plaintiffs and defendants put under a microscope, not just in the courthouse, but at home, in their personal lives. CBS' *The Good Wife* was originally conceived as a legal case-of-the-week procedural. But viewers on the message boards were more interested in Alicia Florrick's (Julianna Margulies) personal life than her legal cases. Ditto for the other associates. Consequently, showrunners Robert and Michelle King put the emphasis on their love lives and familial challenges, and most of the cases were settled out of court.

The Good Wife became a hybrid serialized procedural, with season-long, personal character arcs and legal cases of the week. Similarly, ABC's *How to Get Away with Murder* (created by showrunner Peter Norwalk and executive produced by Shonda Rhimes, who later moved to Netflix) offers at least one season-long murder-mystery plotline, along with murder cases of the week for Philadelphia law professor Annalise Keating (Viola Davis) and her ambitious criminal law students to solve. Other "hybrid" shows include *The Mentalist* and *The Good Fight* (which I discuss later in this chapter).

As viewers of law-and-order series know, to have a crime, an investigation and a verdict within 42 minutes is incredible, bordering on ridiculous. What streaming

on-demand TV has ushered in is a slew of season-long procedurals that defy a cookie cutter format and shake things up. The lines between corrupt and righteous are blurred. The crimes are more complex, with the once black-and-white "just the facts, ma'am"[6] approach popularized by *Dragnet* (1951–1959) and *Adam 12* (1968–1975), now analyzed and influenced by issues of corruption, racism, sexism, homophobia, xenophobia, mental illness, cronyism and all manner of morally ambiguous, nuanced mitigating factors. If it's tougher to separate real news from so-called fake news today, devoted viewers of the season-long procedural drama want to know *everything* and draw their own conclusions.

When it comes to ambiguity, intrigue, audacity and a groundbreaking season-long procedural, the impact of the original *Twin Peaks* (created by Mark Frost and David Lynch and launched in 1990 on ABC) cannot be overstated. Series from *Lost* and *The Leftovers* to current shows such as *Stranger Things* and *The OA* owe a great debt to *Twin Peaks* and its central mystery laced with dark, offbeat humor; heightened melodrama, horror and surrealism; and a cinematic style and tone that don't resemble any prior TV series. It remains a disruptive, edgy, disturbing show—a far cry from reassuring and safe. Back in 1990, traditional viewers didn't understand the genre: Was it a satire, a parody or supposed to be taken seriously? Agent Dale Cooper's (Kyle MacLachlan) investigation into the murder of high school homecoming queen Laura Palmer (Sheryl Lee) defied the homogenous broadcast network formula, and genre classification. It made audiences uncomfortable. In a word, it was weird. With its haunting score (composed by Angelo Badalamenti in collaboration with Lynch), the series was a short-lived anomaly lasting barely two seasons: Controversial and polarizing, it has now achieved certified cult status. It was *Northern Exposure*[7] on acid.

The Showtime reboot proves that *Twin Peaks* is a series whose time has come . . . again. The new limited event series is again created by Mark Frost and David Lynch, this time with Lynch directing all 18 episodes. 2017's *Twin Peaks* averaged 2 million viewers per week, matching Showtime's other successes. Its two-hour pilot had the highest number of streaming viewers ever for an "original" series premiere on Showtime.[8] It's distinct from its predecessors—a different blend of genres and not a straightforward sequel. *Twin Peaks: The Return* is its own beast, with its own twists, internal logic and surrealism. Perhaps it's also reflective of our world that has changed in the past 25 years; it's bigger now, and so is the scale of its mystery and horror. *Twin Peaks'* latest iteration remains an extraordinary piece of visual art—consistently surprising and neither film or TV. Before David Lynch was a director, he was a painter.[9]

Consistently brilliant during its run and standing the test of time almost 10 years since the series finale, HBO's *The Wire* utilized the season-long procedural and

season-to-season pivot to perfection; this landmark series will continue to be the benchmark to meet or better, for generations to come. For more on *The Wire's* trailblazing approach, visit **www.routledge.com/cw/landau**.

We now live in a TV ecosystem based on delayed gratification and this delicious paradox:

> ## "I can't wait to find out what happens next, but don't tell me!"

Below is a collection of trailblazing, season-long procedurals that disrupt and/or go beyond the once tried-and-true formula of case of the week, by painting detailed portraits of the characters themselves and their wounds/backstories. For the record, an "open mystery" is where the audience knows who the perpetrator is from the beginning. A "closed mystery" is a whodunit where the perp is not revealed until the end. All great stories pose central questions about the future (i.e., the what's going to happen next) and establish central mysteries about the past (i.e., what happened to each main character) sometimes via flashbacks, sometimes woven into the present action. This forward/backward, push/pull tug-of-war deepens our characters, fuels story engines, stokes the dramatic fires and sets the course of each series' narrative drive (i.e., sense of urgency). Despite the variety of serialized, slow-burn procedurals explored below, notice how the destination in each subgenre is always the same: to arrive at the Truth. Sometimes we get the answer; other times we're left with ambiguity. Sometimes the truth will set you free; sometimes it's obscured by antagonistic forces and/or our flawed justice system—with tragic results.

THE MYSTERY UNDERLYING THE CRIME: *THE NIGHT OF*

THE CRIME: A young heiress named Andrea (Sofia Black-D'Elia) is stabbed to death in her Manhattan brownstone. Naz (Riz Ahmed), the unlucky man who picks her up in his father's cab the night of her death, wakes up in the house the next morning to find her body. He is arrested but insists on his innocence.

THE INVESTIGATORS: Detective Dennis Box (Bill Camp); Defense Attorney John Stone (John Turturro); Lead Defense Attorney Chandra Kapoor (Amara Karan); District Attorney Helen Weiss (Jeannie Berlin).

THE SUSPECTS: Naz; Andrea's stepfather, Don Taylor (Paul Sparks); two punks who make racially charged comments to Naz the night of the murder; an investment counselor, Ray Halle (Paulo Costanzo).

OPEN or CLOSED MYSTERY: Closed. The audience is as much in the dark as the characters themselves.

HOW THE TRUTH COMES TO LIGHT: Detective Box, the arresting officer, gradually comes to believe Naz may be innocent. He pursues several suspects and helps Stone with information.

WHODUNIT: Our lips are sealed.

HBO's acclaimed mini-series *The Night Of* is based on the award-winning British television series *Criminal Justice* (2008–2009) and co-written by novelist and screenwriter Richard Price (*The Color of Money*, *The Wire*) and screenwriter Steven Zaillian (*Schindler's List*, *Gangs of New York*).[10] The writers create empathy for Naz by showing how he loses his innocence at Rikers Island. Practically a virgin when he has sex with young heiress Andrea, he quickly turns to smoking crack in jail just to deal with his grief. The other lead character, Stone, is a divorced, middle-aged attorney who suffers from a horrific case of eczema that causes him to have to walk the streets of New York in sandals. His son is so embarrassed by his dad's condition that he hardly wants to be seen with him. Not many care about Stone any more, but Stone cares about Naz. He doesn't see any way of getting him off—the circumstantial evidence is too great—and begs him to cop a plea, initially hoping to make a quick $25,000 off this case. Standing by his innocence, Naz refuses.

The central mystery is, of course, who killed Andrea? As Naz's drug-addled brain has no recollection of that night, he remains a suspect for the audience. The central question of this provocative, timely series is: Can a Muslim man get a fair trial in the US judicial system? Did the police profile him, and will the jury be prejudiced against him, presuming that he's a radical? Although Naz comes across in the first episode as shy and innocent, as the story unfolds, we learn that he does not have a perfect past. Writers Price and Zaillian also present several alternative prospects for who the killer is.

When Naz's lawyer's feelings cause her to make an illegal maneuver during the course of the trial, the judge removes her as lead attorney and tells Stone that he will now deliver the closing arguments. Stone, whose clients normally consist of prostitutes and petty thieves, has never come close to delivering a closing argument

in a first-degree murder trial. He freaks, and his eczema comes back that night with a vengeance. The next day Stone comes to the courtroom looking like a corpse with a nasty sunburn. But with heroic determination, he gives a powerhouse speech to the jury.

> STONE
> I'm gonna be honest with you. This isn't
> what I normally do. I mean, obviously,
> someone who looks like this doesn't make
> his living doing public speaking. What I
> normally do is, I plea my clients out.
> Because 95% of the time, they did what
> they were charged with. They sold that
> dope, they solicited that guy, they stole
> that iPhone, it's clear to me just
> lookin' at them. So I tell them, "Don't
> be stupid, take the deal." The first time
> I saw Naz, he was sitting alone in a
> holding cell at the twenty-first
> precinct. He'd just been arrested. I
> walked past him, out of the station, and
> then stopped. Turned around, went back.
> Why? Because I didn't see what I see in
> my other clients. And I still don't,
> after all this time. What I see is what
> happens when you put a kid in Rikers and
> say, "Okay, now survive that while we try
> you for something you didn't do." And
> that's how you survive Rikers. There were
> crimes committed that night, no doubt.
> Crime one: Stood up by a friend with a
> car, a young man takes his father's cab
> without permission to go to a party in
> Manhattan. Crime two: a young woman buys
> some powerful, illegal drugs. Crime
> three: On the banks of the Hudson River,
> under the George Washington Bridge, she
> gives him one of those illegal drugs.
> MDMA. Crime four: Later at her house, she
> gives him another illegal drug, ketamine.
> Which with the ecstasy, and enough
> tequila to topple a saguaro cactus,
> knocks him out like the horses vets give
> ketamine to. Crime five: Upon discovering
> the body, instead of reporting it, he
> runs. Crime six: He makes an illegal left
> turn. Crime seven: He resists arrest.
> Those are the crimes committed by these
> two young people that night, and the only
> ones we have proof of. What we don't have
> proof of, is who committed the crime he's
> been charged with. The prosecution has
> presented what it says is proof, but at
> the end of the day, it's circumstance and
> speculation. The rush to judgment against
> Nasir Khan began at the 21st precinct at

4:45 a.m. the night of, and ended ten
seconds later when he was tackled to the
floor. The police investigated no one
else—not the stepfather who had a
tempestuous relationship with the victim,
even though the percentage of killers who
know their victims is five times greater
than that of strangers. And even though
among the fraction of strangers who do
commit murder, there were two individuals
the couple had confrontations with that
night, one with a history of battery, the
other with multiple convictions for
aggravated assault, every time using
a knife from the victim's own home.

[Stone turns and looks at Naz.]

The night Naz was arrested, he lost a
lot. He lost his freedom to return home
to his family, to his school, to his
night job that helps pay for that school.
But what he didn't lose, and what none of
us can lose, were his constitutional
rights to an attorney, to a fair and
impartial trial by you, his peers, and to
the presumption of his innocence beyond a
reasonable doubt. You hear that term a
lot. But what does it really mean, huh?
What's its definition? It doesn't have
one. It's what we think. *And as much as
what we think, what we feel. And what we
feel, what you feel, will determine what
happens to the rest of this young man's
life.* Thank you.

[Stone is almost in tears. He returns to the table and sits
down beside Naz.]

The italics above are mine. The suspense that Price and Zaillian create while making
us wait for the jury's verdict is almost unbearable. In addition, the writers create an
even greater sense of mystery about what will happen to each of the side characters
we're invested in—Stone, Box, Kapoor, Weiss—and even Stone's adopted cat.

In his portrayal of Naz, Riz Ahmed made history as first man of South Asian descent
and the first Muslim to win an Emmy for acting.[11] "It is always strange reaping the
rewards of a story based on real world suffering," Ahmed said in his speech. "But
if this show has shone a light on some of the prejudice in our societies, xenophobia,
some of the injustice in our justice system, then maybe that is something."

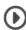

THE GOOD FIGHT: THE PROCEDURAL WITHIN A PROCEDURAL

CRIME(S): A Ponzi scheme that has cost investors, including Diane Lockhart (Christine Baranski), everything.

INVESTIGATORS: Primarily, Maia Rindell (Rose Leslie) who fights to seek the truth and clear her father Henry's (Paul Guilfoyle) name—he managed the fund. Lucca Quinn (Cush Jumbo) and others help Maia. The FBI is also investigating, and Henry is imprisoned from the pilot.

SUSPECTS: Initially, Henry's brother Jax (Tom McGowan), possibly Maia's mother Lenore (Bernadette Peters); they both co-managed the fund with Henry. Henry himself remains a suspect. Maia herself is also under suspicion.

OPEN or CLOSED MYSTERY: Closed.

HOW THE TRUTH COMES TO LIGHT: In a most unexpected fashion, in the season finale. All is not what it seems.

WHODUNIT: Shhh! Our lips are sealed!

Set a year after the series finale of The Good Wife, CBS All Access' spinoff The Good Fight opens on Diane, incredulous as she watches Trump's inauguration on TV in the dark silence of her living room. Perhaps feeling that she would like to escape this real-life version of a Black Mirror episode, she decides to leave her firm for early retirement in the south of France. She announces her exit and pledges to complete her last case over her two weeks' notice period before opting for freedom, forever.

Meanwhile, Diane's protégée and goddaughter Maia passes the bar exam and starts a new role as an associate at the same firm. Maia's parents are the fund managers of a portfolio in the billions. No sooner has Diane signed her exit papers, than Maia's father Henry is arrested on suspicion of running a Ponzi scheme. He's adamant that he's being set up. Diane, who happens to have invested all her savings in the fund, is left with nothing. Her firm also wants nothing to do with her, having already reshuffled the partners, as well as seeing her as tainted by association with the scandal. Diane has, in fact, been introducing the fund to numerous connections, who have now lost everything as well. Broke and with Provence a

distant dream, she needs to earn again and takes a junior partnership at a rival firm, where former employee Lucca now works. Feeling sorry for Maia—who has quickly become a jobless social pariah and receives regular and violent threats from anonymous sources due to the fund scandal—Diane takes Maia with her to the new firm.

The mystery behind the Bernie Madoff-style scheme runs throughout the entire first season of 10 episodes, as Maia sets out to find the truth and exonerate her father, with the assistance of Lucca and a few trusted others. Maia needs to clear her own name, as she sits on the board of a Foundation where, according to the FBI, the money was parked. Surely, Maia would know if she was on the board? *The Good Fight* premiered on CBS before showing its remaining episodes on All Access; the show's narrative drive and our curiosity about what happened in the scandal are enough to make us jump from terrestrial to digital. Fraud and scandal may be familiar territory for showrunners Michelle and Robert King, but the slow-burn, season-long mystery is something different for the franchise. *The Good Wife* did ask if Peter Florrick (Chris Noth) was guilty of political corruption, but that question lay more in the background; we saw new information emerge only sporadically. Maybe we already had the answer we cared most about: Yes, Peter was incontrovertibly and flagrantly guilty of cheating on wife Alicia (Julianna Margulies). On the other hand, *The Good Fight* keeps us guessing about the identity of the fraudster until the season finale, minutes from the end of the episode. It's a slow-burn with a decisive resolution in Episode 10.

The Good Fight also presents topical cases of the week: It operates in the post-truth society and is alert and aware of all that is happening around us. From that teaser with Trump to police brutality, corporate overreach to the war on terror (how it's experienced on the ground in the US), the show delivers weekly procedural stories that feel edgy. The pilot was rewritten to include the latest politics, after Hillary lost in 2016. These meaningful topics and stories (some have a longer arc, such as the police brutality cases Diane's new firm takes on) balance against that season-long mystery of the Ponzi crime. It's a procedural within a procedural. It's also refreshing to see women in all three lead roles, including the 65-year-old Baranski, plus a diverse group of subtly drawn attorneys at her new firm. *The Good Fight* has been renewed for a second season; its season-long mystery, along with its daring and relevant weekly stories, has proved to be an effective combination.

SEARCH PARTY: SOMETHING FROM NOTHING

Season 1

THE CRIME: After coming across a missing persons flier, Dory (Alia Shawkat) becomes obsessed with the disappearance of a college acquaintance, Chantal Winterbottom (Clare McNulty).

THE INVESTIGATORS: Primarily Dory, but she drags her friends Elliott (John Early) and Portia (Meredith Hagner) and her boyfriend Drew (John Reynolds) into the search as well. Dory is not a detective nor in any kind of law enforcement. Actually, she's a recent college grad, working as a personal assistant to a ridiculously wealthy, eccentric housewife, Gail (Christine Taylor).

THE SUSPECTS: *Search Party* supplies a range of possible suspects in Chantal's disappearance, but the most notable are: a cult in Red Hook run out of a store called Bellow & Hare and the Private Investigator supposedly hired by Chantal's family, Keith (Ron Livingston).

OPEN or CLOSED MYSTERY: Closed.

HOW THE TRUTH COMES TO LIGHT: After paying a college friend $5,000 for information, Dory and the gang finally find out that Chantal is staying in a rental house in Montreal. Dory also discovers Keith was *not* hired by the Winterbottoms to look for Chantal, which immediately makes Dory assume Keith got Chantal pregnant as part of the Bellow & Hare cult and is now trying to track her down. Dory confronts Keith, the two fight, and Keith ends up dead—just before Portia returns to the rental house with Chantal. Chantal tells the gang she was dating a married guy named Farley, but he broke her heart, so her friend Agnes let her hide out in her summer house to get over the break-up.

WHODUNIT: Nobody!

Search Party, created by Sarah-Violet Bliss, Charles Rogers and Michael Showalter, supplies the audience with multiple tantalizing theories that could answer Season 1's overarching mystery: What happened to Chantal? The series takes the viewer's obsession with whodunits and fan theories to the next level. We're watching Dory act out her own personal *True Detective*, but *Search Party*'s main thesis seems to be that maybe life isn't always stranger than fiction. Sometimes it's just life. Sometimes there's no murder, no cult, no double-crossing Private Eye—sometimes it's just a self-involved girl who handles a break-up a little too dramatically. *Search Party* acts as a mirror to millennial self-obsession, building a whole season around

Chantal's inability to consider that fleeing to Canada without telling her friends or family would cause alarm.

Existentially, the series is an external manifestation of Dory's own state of post-graduate confusion and restlessness. Chantal is missing, but Dory is the one who's lost and rudderless. The hunt for Chantal provides Dory with her *raison d'etre*. This "case" may not offer life and death stakes, but it is, on a metaphysical level, Dory's lifeline.

The New Yorker's Emily Nussbaum describes the series as a welcome new genre: "sitcom *noir.*" *Search Party* is able to give the audience a whole season of the detective work we crave from slow-burn crime dramas, with a meta, tongue-in-cheek wrap-up worthy of any comedy of manners. It's an excellent example of how to make smart use of the unexpected in our writing.

FARGO IS A STATE OF MIND
Season 1

THE CRIME(S): Lester Nygaard (Martin Freeman) murders his wife; Lorne Malvo (Billy Bob Thornton) murders a slew of people.

THE INVESTIGATORS: Deputy Molly Solverson (Allison Tolman), Policeman Gus Grimly (Colin Hanks), retired State Trooper Lou Solverson (Keith Carradine).

THE SUSPECTS: Lester Nygaard, Lorne Malvo.

OPEN or CLOSED MYSTERY: Open. The audience knows what went down; now it's up to the investigators to figure it out.

HOW THE TRUTH COMES TO LIGHT: Deputy Solverson cracks the case in spite of the incompetence of her boss, Sheriff Bill Oswalt (Bob Odenkirk), and the mistakes of fellow cop Gus Grimly.

Season 2

THE CRIME(S): Rye Gerhardt (Kieran Culkin) kills several people at a diner. As he's leaving the scene of the crime, he's fatally injured in a hit-and-run by Peggy

Blumquist (Kirsten Dunst). Her husband Ed (Jesse Plemons) helps finish the deed when it turns out that Rye isn't completely dead.

THE INVESTIGATORS: State Trooper Lou Solverson (Patrick Wilson).

THE SUSPECTS: The Gerhardt family, led by Floyd Gerhardt (Jean Smart); Peggy and Ed Blumquist; the Kansas City crime syndicate led by Mike Milligan (Bokeem Woodbine) and Joe Bulo (Brad Garrett).

OPEN or CLOSED MYSTERY: Open.

HOW THE TRUTH COMES TO LIGHT: Open season—turf wars and confrontations, police cracking the case.

The creator/showrunner of *Fargo* the series, Noah Hawley, once explained,

> *The funny thing about the movie is that it's only the first scene of the movie that takes place in Fargo; the rest of it takes place in Minnesota. Fargo is a metaphor; it's like a state of mind. It's a word that describes a sort of frozen hinterland that makes you think of a certain type of story.*[12]

I loved Season 1 of *Fargo* and as great as it was, enjoyed Season 2 even more—partly because it's set in the 1970s, and I loved the production design, music, costumes and hairstyles. I think that stylistically—in terms of the editing and split screens too—it's a really fun ride. *Fargo* is a limited anthology series, meaning that, like *American Horror Story* or *True Detective*, each season is a reboot, with new and returning actors playing different roles in a new situation. *Fargo* claims to be based on true crimes (although that is a fiction that the Coen Brothers invented for their 1996 movie, which is also perpetuated by the TV show's creator, Noah Hawley). Each season has its own arc and is a complete entity unto itself. However, the seasons are united by the starkly dismal Minnesota/North Dakota setting and its unique tone—a delightfully wicked mixture of black humor and deadly, almost Satanic, crime sprees.

Season 1 introduces bad-guy-on-steroids Lorne Malvo, who arrives in Bemidji, Minnesota, with murder and mayhem on his mind. He meets henpecked insurance salesman Lester Nygaard in the ER, where both are attending to minor injuries. When Lester reveals that he's just been bullied and insulted by an old high school frenemy, Malvo asks the million-dollar question: "Do you want me to kill him?" Lester doesn't say no, a decision that proves to be a fatal error.

In the first two-thirds of the season, Lester is an atypical protagonist, with his weak morals and lack of conscience. He becomes a plaything in the hands of the

super-evil Malvo, a professional assassin, and gradually Lester becomes a devilish tragic antihero himself. Good guys include Deputy Molly Solverson; Duluth cop Gus Grimly; and Lou Solverson, a retired state trooper who is also Molly's father. In the pilot, Gus pulls Malvo over for speeding, but Malvo threatens to hurt Gus' daughter if he doesn't "do the right thing" and let him go; Grimly caves and releases Malvo without so much as a ticket. Gus hates himself for it but eventually finds his cojones by the end of the season, making for a satisfying conclusion.

In Season 2, we travel back in time to 1979, when state trooper Lou Solverson is a young man. Episode 1 focuses on the hit-and-run death of Rye Gerhardt, son of the dour matriarch of a Fargo crime family (curiously named Floyd). It turns out that the perpetrator of the unintentional hit-and-run is beautician Peggy Blumquist, a selfishly ambitious young woman who is married to a hapless butcher, Ed. The show follows the exploits of the Gerhardt family as they attempt to find and exact revenge on the "murderer" of their son (who has just murdered a number of people at the local Waffle Hut when Peggy hits him). Ed's butchering skills come in handy when Peggy arrives home with Rye's nearly dead body still attached to her car. The plot is ramped up further when a rival crime syndicate led by Joe Bulo and Mike Milligan move in on the Gerhardts' territory.

Both Seasons 1 and 2 of *Fargo* are masterful examples of a crime show that is also a brilliant commentary on human nature.

THE SEASON-TO-SEASON PIVOT

Broadchurch

Series such as Chris Chibnall's *Broadchurch* (BBC America/Netflix) present a closed mystery, which means that the audience only knows as much as the investigators. It's a smoke-and-mirrors game where the writers show the investigators uncovering new pieces of information each "week" (or in each binged episode) in order to solve the mystery. At the end of Season 1 of *Broadchurch*, we find out who killed young Danny Latimer. (Danny's killer turns out to be someone close to detective Ellie Miller, played by Olivia Colman.)

Chibnall then makes a surprising turn in Season 2, which does not introduce a new murder. Instead, it deals with the murderer's trial and the infuriating way that his barrister tries to get him acquitted, even though he's confessed. In the third and final season of *Broadchurch*, the show returns to its whodunit

format. But Season 2 remains suspenseful, because we don't know whether the killer will be convicted, or perhaps be set free and even killed himself by the furious townspeople.

In this way, each season-long procedural faces the challenge of writing themselves out of a corner in new and surprising ways. *Fargo* uses the anthological format with a whole new cast and "true" crime each season. Others introduce a new crime or central mystery and stay the course with the same cast, deepening and/or shifting focus to other characters, such as *The Leftovers*, Season 3.

TRUTH AND CONSEQUENCES

Serious drama or lighter in tone, the driving force that propels each series forward is the Truth. Sometimes we get the answer by the end of the season or series; sometimes we're left with ambiguity. In some cases the truth sets characters free; in others, it leaves lasting, dire consequences. In all cases, characters must reconcile the past with the present.

See also: *Big Little Lies* and *13 Reasons Why* (both in Chapter 7) and *Stranger Things* (Chapter 4).

There are also strong central mysteries in *The OA* (on Netflix, told like a missing persons case, about the past seven years in the life of Prairie, who has reappeared, was blind but can now see); *Mad Men* (on AMC, seasons-long mystery around how Dick Whitman became Don Draper); *The Man in the High Castle* (on Amazon; who is he and what exactly does "The Grasshopper Lies Heavy" mean?); *This Is Us* (on NBC; how did Jack die?); *The Sinner* (on USA; limited eight-part series starring Jessica Biel and Bill Pullman, based on the novel by German crime writer Petra Hammesfahr, about a young woman who kills someone in public but no one, including herself, understands why); and *Goliath* (not a mystery per se but a gripping, season-long trial). *Homeland* also gives interesting examples of slow-burn mysteries; from season to season, Carrie and Saul work to stop terrorism both at home and abroad. *Strike* is the BBC/Cinemax adaptation of the Cormoran Strike series by Robert Galbraith (otherwise known as J.K. Rowling). Each season spans two to three episodes of 60 minutes, in a medium-burn procedural that equals one of Galbraith's books. There are two further books about Strike (Tom Burke), the

modern private detective, with more sequels planned, so we may see more seasons. On the comedy sci-fi side, there's the entertaining and surreal *Dirk Gently's Holistic Detective Agency* (on BBC America and Netflix), based on Douglas Adams' books and adapted by wunderkind Max Landis. It's a broad, quirky, fantastical, existential action-comedy, with buckets of blood and violence, starring Samuel Barnett as the eponymous Dirk and Elijah Wood as his befuddled, put-upon bellhop sidekick.

● Bonus Content

Further analysis on season-long procedurals, including ABC's acclaimed **American Crime** (created by showrunner John Ridley, who won an Oscar for Best Adapted Screenplay for *12 Years a Slave*); **True Detective** Season 1; **Riverdale**; **Medici: Masters of Florence**; **Happy Valley**; **The Fall**; **Bloodline** and **The Expanse** is at **www.routledge.com/cw/landau**.

Notes

[1] The length of a one-hour drama, minus the commercial interruptions.

[2] Ben Stein, *The View from Sunset Boulevard* (Basic Books, 1979).

[3] Ben Shapiro, *Primetime Propaganda: The True Hollywood Story of How the Left Took Over Your TV* (Broadside Books, 2011).

[4] *Damages* ran on FX from 2007 to 2010, when it was canceled by FX but picked up by DirecTV Audience Network, for two additional seasons of ten episodes each.

[5] Steven Bochco's *Cop Rock* (on ABC in 1990) combined the traditional case-of-the-week police procedural with choreographed musical numbers. Its mash-up of serious crime drama bolstered (interrupted) by musical numbers is considered one of the greatest flops in TV history. Until Baz Luhrmann's *The Get Down* for Netflix (canceled after one season), we haven't seen another gritty urban musical drama series (no, *Glee* doesn't count). But we have seen musical one-off episodes on such shows as David E. Kelley's *Chicago Hope* (a memorable episode entitled "Brain Salad Surgery," CBS, 1997), the 200th episode of *Supernatural* on the CW in 2014 and "Once More, With Feeling," Season 6, Episode 7 of *Buffy the Vampire Slayer* (written and directed by Joss Whedon).

[6] This was Police Sergeant Joe Friday's (Jack Webb) signature line of dialogue in every episode of *Dragnet*. Bonus trivia: Jack Webb also created the series.

[7] *Northern Exposure*, created by Joshua Brand and John Falsey, ran on CBS from 1990 to 1995. This fish-out-of-water, one-hour dramedy series won the Emmy for outstanding drama series in 1992, as well as two consecutive Peabody Awards (1991–1992). Its premise: A young doctor, Joel Fleischman (Rob Morrow), is sent to practice in the small town of Cicely, Alaska, to fulfill his obligation after Alaska pays for his medical education. The quirky, eccentric denizens of Cicely provide the centerpiece of the series.

[8] Carli Velocci, "Has 'Twin Peaks: The Return' Been Worth It?" *TheWrap.com*, August 31, 2017, www.thewrap.com/twin-peaks-return-worth-it-critics-ratings.

[9] Manohla Dargis and James Poniewozik, "We Haven't Seen That Before: A Critics' Conversation About Twin Peaks: The Return," *The New York Times*, August 31, 2017, www.nytimes.com/2017/08/31/arts/television/twin-peaks-return-finale-critics-conversation.html?emc=eta1.

[10] The British version of the show, written by Peter Moffat, features Ben Whishaw as Ben Coulter, a young man who is accused of murder after a drunken and drug-addled night out, though he is unable to remember committing the murder. Significantly, the HBO/US remake adds the provocative layer of making the defendant a Pakistani Muslim.

[11] Alice Vincent, "Riz Ahmed makes history as the first Muslim man to win an acting Emmy," *The Telegraph*, September 18, 2017, www.telegraph.co.uk/tv/2017/09/18/riz-ahmed-makes-history-first-muslim-man-win-acting-emmy.

[12] Lesley Goldberg, "*Fargo* Boss on Appeals of Anthology Series, Cable vs. Broadcast and a Future Beyond Season," *The Hollywood Reporter*, April 14, 2014, http://hollywoodreporter.com/live-feed/fargo-boss-appeals-anthology-series-695532.

Episode Cited

"The Call of the Wild," *The Night Of*, written by Richard Price and Steven Zaillian; BBC Worldwide Productions/Bad Wolf/Film Rites/HBO.

ELLIOT (V.O.)

I'm good at reading people. My secret? I look for the worst in them.

—Mr. Robot
BY WRITER/CREATOR/SHOWRUNNER/DIRECTOR
SAM ESMAIL

CHAPTER 3
TRUST ME

The Long Con On-Demand—From
The Riches to *Sneaky Pete*, *Patriot*,
The Americans and More

I n her book *The Confidence Game: Why We Fall for It . . . Every Time*,[1] Maria
Konnikova, a psychologist and contributor to *The New Yorker*, makes the
overarching point about the dark art of the scam: People are instinctively trusting.
"Size someone up well, and you can sell them anything." It's as true of the storefront
psychic who takes advantage of the gullible (*Shut Eye* on Hulu) as of the cult leader
who exploits lost souls (*The Path*, also on Hulu).

The truth is, we all lie, in one form or another, every day. It's social currency to gain
advantage. Flattery may not get you everywhere, but it certainly helps—if it sounds
sincere and convincing. "Does this dress make me look fat?" The answer, no
matter what the situation, should always be an emphatic "no." As Konnikova puts
it, "Con artists, in some sense, merely take our regular white lies to the next level."
And in today's political climate, facts are met with skepticism anyway.

Con artists thrive in times of social and political instability, making it easier for
emotion to trump reason (no pun intended). The Internet has also provided
scammers easy access to our personal information to forge false identities.
Konnikova uses a smart, helpful lexicon for grifters, helpful to our analysis:

THE PUT UP: Sizing up the "mark" (a/k/a setting up the potential target); the more
trusting, gullible and vulnerable the better. An off-kilter or distressed "mark" is
always easier than a well-balanced, clear-headed one. But other positive emotional
states, like jubilation, can also lower our defenses and make us more open to
persuasion, especially if you add booze.

THE PLAY: The con man (or woman) makes his/her approach, customizing his script accordingly. As Konnikova posits, con artists aren't just master manipulators; they are expert *storytellers*. Just as we're intrinsically inclined to trust, we are instinctively drawn to a compelling story. Think of *The OA* (see Chapter 4). And as we all know, truth is often stranger than fiction, bolstering scammers' ability to peddle their tales. "When a story is plausible, we often assume it's true," explains Konnikova. Human nature would suggest that once we've accepted a story as true, we're not likely to question it and may even unconsciously fill in the less-than-credible specifics to conform to the conclusion we've already drawn.

Legendary playwright John Guare wrote about an elaborate con (based on a true story) perpetrated on a wealthy Manhattan couple in his masterpiece *Six Degrees of Separation*. In the Tony- and Pulitzer Prize-winning play and subsequent movie adaptation, Ouisa and Flanders Kittredge are conned by a young African-American man who they're convinced is a college friend of one of their (estranged, entitled) children; he shows up at their Upper East Side apartment in turmoil, having just been mugged and stabbed in Central Park. He tells them his name is Paul Poitier and that he's the son of the iconic movie star Sidney Poitier. Unfortunately, none of it is true; Paul stabbed himself in the abdomen, and Sidney Poitier only has daughters.

So why did these cynical New Yorkers buy into this fiction? Two reasons: "Paul" tells them his dad is in town to discuss directing the movie version of *Cats*! And that he may be so inclined to grant Ouisa and Paul the chance to be in it as extras! So the Kittredges are simultaneously star struck and stage struck. They accept this imposter into their lives because they're not so cynical after all; they still have dreams. They accept him because—despite their wealth (or, as Ouisa tells Paul, "Nobody's rich. We're just hand-to-mouth on a higher plateau")—they want him (and their children) to accept *them*. This example is, sadly, the very definition of "confirmation bias."

A good, juicy story provides the key to the long con, during the course of which the mark finds a way to rationalize or ignore warning signs and red flags. The long con keeps the mark's eyes focused on some kind of promise or desired outcome; that's the shiny object—the dangling carrot—that often overrules objectivity and common sense. In film noir, such as Billy Wilder's classic *Double Indemnity*,[2] the *femme fatale* Phyllis Dietrichson (Barbara Stanwyck) uses the fine art of seduction as the carrot to persuade her unwitting mark, Walter Neff (Fred MacMurray), to kill her husband.

THE ROPE: Drawing in the victim. According to Konnikova, "Ultimately, what a confidence artist sells is hope." It's not a con; it's an *opportunity*. Rather than making the mark feel foolish; the con artist makes the mark feel like he'd be a fool *not* to take advantage of the given situation. The *femme fatale* uses sex to reel in her catch. Or the prospect of sex . . . once they've gotten an inconvenient impediment (the indirect, bigger target) out of the picture. In these cases, the scammer's direct mark serves as the conduit to fleecing or eliminating someone more influential.

Hitchcock's *Strangers on a Train*, Lawrence Kasdan's *Body Heat*, Christopher Nolan's *The Prestige* and Martin Scorsese's *Catch Me If You Can* play by the same deceitful rules. In each case it should be noted that both grifter/seducer and mark/dupe need to characterize themselves as trapped by their limited, unsatisfying and/or untenable circumstances—with the long con their only way out.

THE TOUCH: The moment of the actual fleecing. This is the moment in which the mark feels 100% in control of the outcome. It's a done deal. No problem. Ideally, the scammer will leave his victim ready to sign up for the next opportunity, wanting more.

THE BLOW OFF: When the con artist inevitably disappears with the spoils. David Mamet has written and directed several films based on this strategy: *House of Games* and *The Spanish Prisoner* immediately come to mind. Stephen Frears' classic film noir *The Grifters* (Academy Award-nominated screenplay by Donald E. Westlake) is also worth checking out, but its resolution is darker and less tidy.

A short transactional con is, by design, fast and efficient. "Never give a hot mooch time to cool off," Konnikova quotes one grifter saying, "You want to close him while he is still slobbering with greed." It's the irresistibly drawn-out slow-burn: the strategic long con that can last a full TV season or encompass multiple seasons. As viewers, we too buy into a great compelling story; we're the willing marks, ready to suspend our disbelief if it promises a surprising, satisfying outcome. On TV, we tune in to have our expectations debunked; we want to be wrong, or else the ending of the episode or season is predictable and unsatisfying. If the climax delivers the truth, then we want the truth, but we want the characters to work hard to uncover it. In dramatic storytelling, truth must be proactively earned.

Pulling off a long con requires patience, resourcefulness and the ability to talk and spin one's way out of trouble. The long con only sustains when doubters are turned

into believers and the skeptical naysayers are discredited (or killed off). One of my favorite movies of all time is the 1973 masterpiece *The Sting* written by David S. Ward, starring Paul Newman and Robert Redford as Henry Gondorff and Johnny Hooker, respectively. Primarily set in 1936 Chicago, Hooker starts off as a small-time con man seeking revenge for the murder of his former partner in crime; he needs the renowned but now washed-up Gondorff to come out of retirement for one last big score. A rigged poker game on a fancy train car sets up their smarmy mark: a wealthy Chicago banker/mobster, Doyle Lonnegan (Robert Shaw). This smaller-stakes con ropes Lonnegan in and makes him feel confident that he's the one with the upper hand. Unfortunately for the villainous Lonnegan, not only are Gondorff and Hooker playing him, they've assembled an entire team of role players to "sell" their bogus horse-racing bookie operation—a scheme as well-planned, comedic and intricate as *Ocean's Eleven* and *Argo*. It's not a coincidence that the indelible piano score from *The Sting* is Scott Joplin's "The Entertainer."

The popular and critical success of this Academy Award-winning film is largely attributed to the ending, when the audience is just as stunned by the "sting" as Lonnegan is. Like all successful cons, we should see it coming, but we don't. We're blindsided. The movie, and all of the following examples from TV series, also pull off another hard-to-perform trick on the audience: We're rooting for the deceivers, criminals, spies and grifters. For as slippery as they are, their targets are almost always far worse. Just as *Dexter* was a vigilante serial killer, our con men and women have good intentions. Or if "good" sounds simplistic, then their motives live in the morally gray area where the end justifies the means.

What's key in each case is that we empathize and/or sympathize with the plight of the scammer/criminal as antihero; they do bad things for good reasons. The grifter as underdog, placed between two wrongs, is the ultimate survivor. And we find ourselves roped in to this protagonist's quest by the end of the pilot episode. His or her plight seems reasonable and necessary. In real life, we like to believe that cheaters never prosper, but on TV, they sure have a whole lot of fun. It might not end well, and on the shows with life-and-death stakes, our protagonist can find him/herself up shit creek, incurring the wrath of the antagonist. The smart money is on the scammer. But on the crime drama or espionage thriller TV series, when the stakes are higher, the body count throws off the bottom line of the win. No one walks away unscathed. Long-con TV series are all about close calls, collateral damage and getting out alive or with a modicum of one's dignity intact. Laws are broken, and rules are circumvented in service of the long con. But no matter how hard the "bad" guys play and how well they plan, Murphy's Law prevails.

There have been many memorable TV series that service the scam-of-the-week format, from *Mission: Impossible* to *Charlie's Angels* and *Leverage*. But the groundbreaking, ahead-of-its time *Profit* on Fox, canceled after just four episodes, was a precursor to the trend of edgy, dark dramas featuring morally challenged protagonists that would follow, including *The Sopranos*, *Mad Men*, *The Shield* and *Breaking Bad*. The first long-con TV series on my personal radar was the wry, subversive, criminally under-appreciated FX series *The Riches*, created by Dmitry Lipkin and starring Eddie Izzard and Minnie Driver. The one-hour dramedy that ran from 2007–2008 was set in an upscale, gated community in Baton Rouge, Louisiana. In the pilot, written by Lipkin and Izzard, Dahlia Malloy (Driver) is paroled from prison—but immediately finds herself on the run with her Irish "traveler" con artist family—who are escaping their relatives after avoiding an arranged marriage for their daughter and absconding with the clan's life savings. On the road in their RV, Dahlia, her husband Wayne (Izzard) and their three kids find themselves in a high-speed game of chicken with a rival traveler family . . . that leads to a collision with a wealthy family, the Riches, on a quiet road.

It's a tragic accident that leaves all the Riches dead. Ready to cut and run, Wayne convinces Dahlia that this could be their destiny—and the premise of the series—which sets up the long con: What if you could steal the identity of an entire, privileged family? Could you effectively impersonate them, move into their house and even assume their roles in the workplace and community? And because we can't have a great, juicy con story without the downside of getting caught, there must be potential consequences, a/k/a stakes.

For impersonating the Riches, the stakes for Wayne and ex-con Dahlia are prison and even death. Once they move into the affluent Riches' residence, not erasing but replacing them, they struggle to adjust to their new lives as "buffers," as they call people who are not travelers. These are nomadic swindlers, part of a much larger clan throughout the ages.

The digital television revolution has ushered in season-long, binge-worthy, serialized procedurals: the slow-burn mystery, in which truth is subverted, buried or obscured. Now that viewers can watch what they want, when they want, on-demand, the long-con, one-hour drama, half-hour dramedy or comedy and limited series are all natural extensions of this welcomed trend, as we witness marks being set up, roped in, played and blown off, one TV season at a time.

Here's my run-down on some of the best long-con series out there and what we can learn from them.

THE MASQUERADE:
SNEAKY PETE

THE CON(S): Marius Josipovic (Giovanni Ribisi) steals the identity of his cellmate from prison (the *real* Pete Murphy) in order to scam Pete's family and hide out from ex-cop turned crime boss, Vince Lonigan (Bryan Cranston). Marius and his crew also begin to run a scam called "The Turk" in order to steal more money from Vince and avenge the death of a former co-conspirator. In the meantime, the matriarch of Marius' new fake family, Audrey Bernhardt (Margo Martindale) has fallen for a land investment scam run by her granddaughter Julia Bernhardt's (Marin Ireland) ex-husband Lance Lord (Jacob Pitts). Upon discovering this, Marius begins to run a reverse con on the ex-husband. There are many more small cons and sleights of hand in between.

THE MARKS: Vince, Audrey and Lance. Marius is usually one step ahead.

OPEN or CLOSED CON: Marius' secret identity remains open. What happened to the Bernhardt money is closed.

THE INVESTIGATORS: Most of the "investigating" of what people are up to is done by Marius or his little "cousin" Carly (Libe Barer). The only law enforcement investigating any of the scams is a crooked cop working for Vince named Detective Winslow (Michael O'Keefe).

THE BLOW OFF: In an effort to get his hands on the cash collateral Audrey has "misused," Marius discovers Lance's con. Marius confronts Audrey about the money in Season 1 and then Audrey and Marius team up to get the money back from Lance. The consequence for Audrey, if anyone else finds out about the misuse of collateral, is jail. However, in the last minutes of Season 1, Audrey's granddaughter Julia makes a deal with Chayton Dockery (Chaske Spencer), whose cash collateral Audrey stole, to use bail bonds to launder money for Dockery's criminal enterprises . . . setting up a new engine for Season 2. Stay tuned . . .

Sneaky Pete, created and executive produced by showrunner David Shore (*House*) and Bryan Cranston (yes, Walter White from *Breaking Bad*), demonstrates how season-long mysteries, or "cons" in this case, can be pieced together episode to episode. Each installment of *Sneaky Pete* features small scams and tricks by a cast of confidence men that build on the bigger, season-long scam of "The Turk." We as the audience don't know what "The Turk" will end up being or accomplishing, we just know that Marius must execute the scam to help his brother and avenge the death of a fallen friend. Add to that slow-burn the stream of scams, mysteries

and investigations Audrey and Julia participate in as part of their bail bonds business, and viewers are given scenes rife with deception and intrigue. The sweet spot of the show focuses on Marius' skill as a confidence man. Seeing him slowly build to one major job allows us to piece together the puzzle as we watch.

THE PERIOD POLITICAL MASQUERADE: *THE AMERICANS*

THE CON(S): Elizabeth (Keri Russell) and Philip Jennings (Matthew Rhys) are KGB agents deep undercover as a happy American family in Cold War-era, suburban Washington, DC. Elizabeth and Philip run shorter cons week-to-week, assuming different personalities (and wigs) to complete various missions. The show also features long-con arcs where Elizabeth and Philip pretend to be different characters over multiple episodes, usually to get close to a certain asset.

For example: At the start of the series Philip has assumed the identity of "Clark Westerfeld" to get close to and eventually marry the secretary to an FBI department head, Martha Hanson (Alison Wright). A secondary long con is that Elizabeth and Philip had two kids, Paige (Holly Taylor) and Henry (Keidrich Sellati), during their deep-cover, sham marriage—but their own children don't even know their parents are KGB spies for several seasons. Elizabeth and Philip have bogus day jobs and must con their colleagues at the travel agency. They must also keep up appearances to their neighbors across the street, Stan and Sandra Beeman (Noah Emmerich and Susan Misner).

THE MARKS: The US Government, Stan Beeman, Martha Hanson.

OPEN or CLOSED CON: Open to the viewers and the KGB. Closed to everyone else.

THE INVESTIGATORS: FBI Special Agent Stan Beeman, who is constantly in pursuit of the two KGB spies executing various missions but at first has no idea he's really looking for his neighbors and good friends, Elizabeth and Philip.

THE STAKES: Treason, prison, death.

THE BLOW OFF: Not so fast. This is a slow-burn espionage series. Relax and enjoy the vodka. The viewers know the identity of the spies, but the mystery remains closed to Stan and several others. Through flashbacks the series reveals more about who Elizabeth and Philip truly are based on who they *were* back in the USSR. One of *The Americans'* core themes is, how well do we really know each other?

How well do you know your neighbor, the person you share a bed with, or even your own mother?

As viewers watch Elizabeth and Philip reluctantly allow more people into their lives and in turn trick more and more into thinking they're not stealing weapons plans or assassinating people in the middle of the night, the deeper their lie goes. The added layer that Elizabeth and Philip were strangers, paired together to become lifelong spy partners, means they're constantly looking over their shoulders at each other. After all, once you've seen your "husband" make another woman believe he's someone else and get her to marry him, how could you trust him? (Tellingly, Philip says "I love you" to Elizabeth only once onscreen, in Season 4, Episode 7.) KGB propaganda is another long con, with Philip and Elizabeth deeply divided on their allegiance to the USSR. Philip continues to question their mission, while Elizabeth has complete devotion to the Motherland. Creator and former CIA officer Joseph Weisberg's focus on the gray areas makes the show consistently powerful. Writing in the gray areas will similarly strengthen our own long-con pilots.

ENTRAPMENT AND REVERSALS: *THE NIGHT MANAGER*
(limited series; drama/espionage thriller)

THE CON(S): Arms dealer Richard Roper (Hugh Laurie) is running a multi-million dollar, illegal weapons operation; certain operatives at MI6 (the British intelligence agency) are secretly allied with Roper.

THE CON ARTISTS: Richard Roper; his henchman Corky (Tom Hollander); Freddie Hamid (David Avery), a wealthy playboy working with Roper; Roper's lawyer, Juan "Apo" Apostol (Antonio de la Torre); MI6 double agent Dromgoole (Tobias Menzies) and Langley's Barbara Vandon (Sara Stewart).

THE MARK(S): Richard Roper and his Egyptian buyers.

THE INVESTIGATORS: Jonathan Pine/Andrew Birch/Jack Linden/Thomas Quince (Tom Hiddleston), the titular hotel "night manager" who becomes a spy for the UK; Angela Burr (Olivia Colman), an MI6 agent who becomes Jonathan's boss.

THE STAKES: Terms of dismemberment, and/or death.

OPEN or CLOSED CON: Open and closed; we know what Roper is up to, but it's not immediately clear that rogue MI6 operatives are also working with him.

THE BLOW OFF: Pretending to be working for Roper, Jonathan Pine goes with Roper to demonstrate some weapons for potential buyers at the Syrian border. Angela enlists the US military to inspect Roper's trucks, but they're filled with legitimate agricultural equipment. In a complicated finale, Jonathan and Angela work together to outwit Roper and turn him over to his angry Egyptian buyers.

In *The Night Manager*, an award-winning, six-part mini-series written by David Farr and based on the John LeCarré novel, Jonathan Pine is the seemingly humble, solicitous night manager of a luxury hotel in Cairo. His helpful attitude, especially with beautiful women, gets him caught up in an illegal weapons trade business being conducted by the über-evil arms dealer Richard Roper. Soon Pine finds himself in possession of confidential documents, which he turns in to the International Enforcement Agency in London. A few years later, Pine has relocated to a hotel in Switzerland; it's revealed that he is a former British soldier whose résumé includes a tour of Iraq. Angela Burr, an intelligence officer who's investigating Roper, talks him into working for her. While trying to infiltrate Roper's organization, Pine is seduced by Roper's girlfriend Jed (Elizabeth Debicki) while trying to steer clear of Roper's suspicious associate, Corky. Meanwhile Burr is trying her best to keep the whole operation secret from parts of MI6 (the British CIA) for fear of being shut down. Ultimately Pine and Burr catch Roper, along with the MI6 agents who have betrayed their country by working with him. As writers, keeping our audience guessing with setups, reversals and payoffs makes for edge-of-the-seat viewing.

ALL IS NOT WHAT IT SEEMS: *THE GOOD PLACE*
(half-hour comedy)

THE CON(S): Eleanor Shellstrop (Kristen Bell) has died and ended up in "The Good Place." But after seeing her life play out on review, Eleanor realizes they have the *wrong* Eleanor Shellstrop. Eleanor's presence causes things to go horribly haywire in the heaven-like utopia. Eleanor and her assigned "soul mate" for eternity Chidi Anagonye (William Jackson Harper) try to hide her true identity from everybody, especially the architect of The Good Place, Michael (Ted Danson).

THE MARKS: We think the mark is Michael and everyone else in The Good Place, but soon find out the scammers are the ones getting scammed: Eleanor, Chidi, wealthy philanthropist Tahani Al-Jamil (Jameela Jamil), douchey Florida DJ Jianyu Li (Manny Jacinto) who thinks he's been mistaken for a Buddhist monk.

THE INVESTIGATORS: Michael, Chidi and Eleanor are all constantly in search of answers for what's going on in The Good Place.

THE STAKES: If Eleanor is caught, she will be sent to "The Bad Place."

OPEN or CLOSED CON: Open (we're in on Eleanor's ruse).

THE BLOW OFF: Eleanor exposes her con when Michael threatens to retire because of all the bad things going on in The Good Place. (Retirement is a fate worse than death in the afterlife.) The truth about Michael and the fact that they are actually in The Bad Place comes out when Eleanor and the gang are fighting over who will be sent away. She has an epiphany that fighting with these jerks *is* the torture. Michael acknowledges his strategy needs tweaking and before Eleanor and company can do anything, Michael reboots their entire afterlife.

Created and executive produced by veteran comedy writer Michael Schur (*The Office*, *Parks and Recreation*, *Brooklyn Nine-Nine*), *The Good Place* has one of the most Earth-shattering twists I've experienced in its finale. The central mystery of the show logically never changes—we are always wondering what's going on in The Good Place. But when Eleanor realizes that this isn't The Good Place at all, but rather a creative new way to punish humans for all of eternity (i.e., hell), the slate is immediately wiped clean. It shows how much the POV has to do with a show's ability to align the viewers with a character and their goals. Throughout the whole first season, viewers are focused on Eleanor's hiding of her true, non-heaven-worthy personality and whether or not she'll get caught—no one ever considers what Michael is up to behind the scenes. Flashbacks in the finale show us Michael's Machiavellian side as he sets up most of the drama from previous episodes. This is also a testament to Ted Danson's comedic ability; he can pivot his character from benevolent to goofy to a malicious demon without breaking a sweat. Twists and turns are valuable currency when writing a long-con series, such as the big reveal about the *Bad* Place in the Season 1 finale.

THE FARCE THRILLER:
PATRIOT
(one-hour dark comedy)

THE CON(S): John Tavner (Michael Dorman) is recruited by his father Tom (*Lost's* Terry O'Quinn) for a top-secret government mission. As America's "Director of Intelligence," Tom tasks his son with helping prevent Iran from gaining nuclear weapons; John's long con is to assume the alias "John Lakeman" and to work as an NOC (Non-Official Cover) operative—as an employee at the McMillan Industrial

Piping company in the Midwest, providing him with the ability to deliver large sums of money to allies in Luxembourg (thereby influencing policy in Tehran). John is a quick study but finds himself in way over his head at the Kafkaesque piping company, where executives use technical jargon that sounds like gibberish (it is).

John's brother, Edward (Michael Chernus) participates in the con, assuming the role of a bogus "official Attaché" (replete with fake badge) and from the shadows helps his brother get out of close calls and tough scrapes. The initial mission goes terribly wrong when John loses a bag loaded with $10 million in cash at Luxembourg Airport, which turns out to be stolen by a corrupt baggage handler. In trying to retrieve the money, John (who also happens to be a trained assassin) gets into a violent confrontation with an angry mob of Brazilian wrestlers, leaving one of them dead and prompting an investigation.

THE MARKS: The top brass at McMillan Industrial Piping; the Iranian spies; Stephen Tchoo, a brilliant yet unsuspecting, much better qualified job applicant at McMillan, whom John deliberately shoves in front of a truck to ensure that "John Lakeman" gets the job.

THE INVESTIGATORS: Luxembourg homicide detective, Agathe Albans (Aliette Opheim); John's petty, mistrustful supervisor at the piping company, Leslie Claret (Kirkwood Smith), who feels threatened by John's ease and bonding with their CEO Lawrence Lacroix (Gil Bellows); John's loving, supportive wife, Alice (Kathleen Munroe); Dennis McClaren (Chris Conrad), a McMillan employee who's a restless, wannabe spy. Pothead John, desperate to get hired at McMillan, has no choice but to confide in Dennis in the men's room in order to get Dennis' clean urine for HR's mandated drug test; it's one of several missteps John must take that will come back to haunt him later—when John reluctantly stabs the overzealous Dennis in the thigh for asking too many questions.

THE STAKES: Global destruction, abduction, torture and death.

OPEN or CLOSED CON: Open. With its omniscient POV, the audience knows more than John, but we suspect his dad Tom is withholding vital information and briefing John on a strictly need-to-know basis.

THE BLOW OFF: John retrieves the stolen cash to continue his mission, but Detective Albans is on to him. Instead of arresting him, she offers a deal that's hard to refuse. John could walk away a free man, but his father has other ideas. Season 1 concludes with John and Agathe in a stalemate. But his NOC remains in place.

The life-and-death stakes at the center of the plot are the touchstones of an espionage thriller. But creator/showrunner Steven Conrad (*The Pursuit of Happyness*, *The Secret Life of Walter Mitty*, *The Weatherman*) has delivered not

only a thriller, but an inspired farce. John is a heavily flawed antihero. After accidentally killing a male hotel maid on a botched mission, John begins to suffer from undiagnosed PTSD. He's ruthlessly tough on the outside but quietly unraveling on the inside. What makes him such a great, iconic character is how his repressed rage (at his father), unresolved marital issues and PTSD come out in the form of folk songs. Have guitar, will travel: John Tavner croons his tales of woe out in public squares in Amsterdam and via open mic nights at local pubs in Luxembourg.

John is a loose cannon: aloof, emotionally bereft and as bemused as he is cunning. His eager-to-please elder brother Edward provides comic relief and is John's polar opposite (and he has a suspicious, controlling wife, in contrast to John's permissive, trusting spouse). One of Edward's functions is to prevent John from self-destructively outing himself as a deep-cover spy.

Conrad places a fresh spin on the imposter/spy/long-con game by giving us a glimpse into the CIA's NOC operation. But there's a deeper long con at play within the Tavner family. From its title, *Patriot*—Latin root "pater" translating to "father"— to its distinctive, evocative title sequence (and that music!), with its images depicting classic American masculinity (boys roughhousing, dirt bikes, playing with guns), the true long con of this series is the father-son relationship. When I sat down with Steven Conrad over (what else?) beers, he shared with me the rich subtext of his unique vision for the show.

> Tom raised both his sons, John and Edward, to be government operatives. The boys learned how to fight and never run away from conflict. In exchange for their loyalty and machismo, their father promised them his love. But his love for his country overshadows his paternal love; his love for John is *conditional*, dependent on John carrying out his missions and not asking too many questions. When John has doubts and craves normalcy in his life, his father reels him back via honor, duty, loyalty and his expectation that John be a "man's man." Paternity and fraternity overrule marriage and feelings. There's no wiggle room.

> John (still freaked out from killing the innocent hotel maid) clearly wants out of the McMillan/Iran/Luxembourg mission, but his father never takes no for an answer (in this show's ethos, that's not what men do). But instead of shaming, haranguing or intimidating his son, Tom uses a more potent weapon: father-son bonding—through a nostalgic *song*. Tom starts singing "If I Needed You" by Townes Van Zandt, kind of quietly. Back-porch singing. Then John starts singing it too. It sounds as if they've

played it a few times before. In the lyrics to the song, the text is all love; the subtext (as John already knows and we're soon to find out) is pure manipulation and deception.

But the truth is that the real long con is perpetrated on John and Edward by their uncompromising father. The boys were cultivated to believe that every once in a while, you have to kill someone; it's part of being a man. Edward still wants to believe it's all for love, God and country. But John knows that none of it is true. His own dad has lied to him; his dog is the only one who ever gave him unconditional love. Exacerbating John's PTSD is his acute awareness that he's alone in the world. And yet his Achilles' heel is his loyalty to Tom, so John has chosen to limit his perspective and cherry pick his news—or simply to tune out of current events. Given that John feels trapped under the thumb of his father, and emotionally ill equipped to push back, the less John knows about his specific role in geopolitical politics, the better. If Tom's validation of him hinges on each long-con mission, then John has accepted (for the time being) the terms of his relationship with his dad; it's purely transactional.

To the audience, the subtext in their dysfunctional relationship gives John his humanity and provides our rooting interest and empathy for him to succeed. *Patriot's* marketing campaign shows a befuddled John Tavner, with the tagline "Who Is John Lakeman?" It's a wry nod to the first line of Ayn Rand's *Atlas Shrugged*: "Who is John Gault?" And the honest answer from insecure confidence man John Tavner would most definitely be: "Hell if I know."

Ozark: Who Can a Con Artist Trust?

Intimacy is dangerous.
Capitalism is criminality.
Money is a virus.

So goes Netflix's *Ozark*, which depicts the dark side of the American Dream. A well-to-do suburban couple, Marty and Wendy Byrde (Jason Bateman and Laura Linney) and their two teenaged kids are leading lives of privilege in Chicago, when their transgressions—Marty's money laundering for "Mexico's second biggest drug cartel" and Wendy's marital infidelity—suddenly get exposed. Overnight, their easy Chicago lives are turned upside down.

In the pilot, financial adviser Marty is having a bad day: While interviewing some prospective clients and bored out of his mind, he's simultaneously watching a video of Wendy having an affair. But that's soon topped when Marty's longtime business partner Bruce (Josh Randall) is executed by the cartel in front of Marty for skimming millions of dollars from their profits. Scared shitless and unsure of whom to trust (the series' main theme), Marty comes up with a spur-of-the moment plan to appease the cartel and save his family's lives: He convinces them that he can launder the millions that Bruce misappropriated, plus more. To do that, he decides to relocate his family from upscale Chicago to Lake of the Ozarks, Missouri. There he invests the ill-gotten gains in a series of sham investments and cash businesses (strip club, lakeside bar and grill, evangelical church) while trying to stay one step ahead of the FBI. The Byrdes are thrust into a lawless rural community based on, as one character schools us, the significant difference between "a hillbilly and a red neck." It's a crash course in social Darwinism and forces this once-privileged family to reexamine what it means to be a family. *Ozark* is *Breaking Bad* minus the science teacher with a terminal illness, with a money manager who's cooking the books instead of cooking meth. The show's tone is wry and at times, funny. It lets us vicariously experience how the illusion of security can quickly unravel and the desperate lengths to which our antiheroes will go to stay afloat—as the pot-dealing mom does on Showtime's *Weeds*. Murder, betrayal, violence and surprises lurk around every corner.

The show's creators are Bill Dubuque and Mark Williams (Jason Bateman directed four episodes), who previously wrote and produced *The Accountant* starring Ben Affleck. Their 2016 movie follows a high-functioning autistic math genius who *uncooks* the books for criminal organizations and has to stay one step ahead of the Treasury Department. He's a perpetual fish out of water, particularly when acting as a strip-mall accountant for local clients. To continue the animal analogies, he's a lone wolf who trusts no one. Dubuque and Williams are experts at this niche genre. Meanwhile, *Ozark*'s season-long con has the Byrde family struggling desperately to keep their secrets buried. It's also an exploration of how white-collar criminals can be turned into ruthless felons—sometimes plausibly, other times recklessly and veering into satire. While our rooting interest is tied to the Byrdes, the locals in Ozark live by their own moral code and there's a certain logic and integrity to their actions (even though the Byrdes, at first, tend to underestimate anyone they deem beneath them as "deplorables").

But these first impressions will continue to be debunked and developed in Season 2. Netflix ordered the second season less than a month after Season 1 premiered.

Like Netflix's *Bloodline*, *Ozark* fits nicely into the one-hour subgenre of "family noir." The writers ask questions that challenge the characters and their audience:

When everything turns bad, how can you ever trust goodness again?
Once you cross the line, can you return to "normalcy"? (Especially when the line keeps moving.)
Are forgiveness and redemption possible—and at what cost?

The show is an intriguing exploration into morals and trust, within the framework of the long con.

● Bonus Content

Further analysis on the long con, including **The Path**, **Younger** and **Mr. Robot** is at **www.routledge.com/cw/landau**.

See also: *Shut Eye* on Hulu, *Power* on Starz and *Good Behavior* on TNT. In Season 2 of *Good Behavior*, con artist Letty (Michelle Dockery), hitman Javier (Juan Diego Botto) and Letty's son Jacob (Nyles Steele) pose as a "typical" suburban family (shades of *The Americans*).

Notes

[1] Published by Viking, 2016.

[2] The 1944 film, directed by Billy Wilder and co-written by Wilder and Raymond Chandler, was based on James M. Cain's 1943 novella.

"Utopians believe in progress; dystopians don't. They fight this argument out in competing visions of the future, utopians offering promises, dystopians issuing warnings.

[But there's] one problem with dystopian fiction: forewarned is not always forearmed."

—JILL LEPORE, *THE NEW YORKER*
PROFESSOR OF AMERICAN HISTORY AT HARVARD UNIVERSITY

CHAPTER 4
DYSTOPIAS, MULTIVERSES AND MAGIC REALISM

ystopias are all about the end (or the impending end) of civilization—whether humanity realizes it or not. In many cases, the dystopian world is defined by lack of natural resources, contamination, lives lost, hardcore survival against insurmountable odds—and/or rampaging zombies; it's kill or be killed.

n other cases, the dominant race or class is living in deep denial about the future of humanity. The Gilead setting in *The Handmaid's Tale*, the Wild West-themed amusement park in *Westworld* and the Woodbury, Terminus and Sanctuary cities from *The Walking Dead* each depict unsustainable apocalyptic societies disguised as new beginnings. Of course this is all a matter of perspective. On *The Leftovers*, the Guilty Remnant cult is under no illusions, and its members have chosen to stop talking, abandon their loved ones and take up chain smoking—which seems extreme but also perfectly reasonable when we consider the context: the inexplicable, simultaneous disappearance of 140 million people, 2% of the world's population, on October 14, 2011—a/k/a the Rapture, or "Sudden Departure." The chain smoking is to help them remember, as one GR member puts it, "that the world ended." Their aim going forward (if you can call it that) is not to go back to the status quo. To them, there is no new normal, and trying to adjust is a total waste of time. Their prevailing philosophy is explained to a confused Kevin Garvey (Justin Theroux) by GR cult leader Patti Levin (Emmy-winner Ann Dowd), a parallel-realm Senator in the standout "International Assassin," Season 2, Episode 8:

```
                PATTI
On October the fourteenth,
attachment and love became extinct.
In an instant, it became
cosmically, abundantly clear that
```

> you can lose anyone at any time.
> Our cave collapsed, Kevin. Now we
> can spend time digging through the
> rubble for signs of life, or we can
> *transform*.

What pulls us into Damon Lindelof and Tom Perrotta's *The Leftovers* and other dystopian series are their universal themes of family, community, forgiveness and atonement. The best dystopian series take an abstract, unimaginable global event and make it concrete, hyper-specific, personal and relatable. And that's what makes them so foreboding, creepy and irresistible. We're invited to empathize and judge and ask ourselves: *What if this really happened to me?*

Every technological advance is designed to make our lives easier, faster and more efficient. Except, of course, the health care industry, which is designed to prolong life and slow things down. We live and die in a paradox. Everything in between is entertainment. Alas, the reason we're so drawn to TV series about dystopian civilizations is because *we* have devolved into a dystopia. Science fiction used to make the impossible *seem* possible. Today, many of our dystopian shows are no longer merely science fiction; now they're based in *real* science and social situations. Netflix's Emmy-winning technological thriller series *Black Mirror* gets it right by playing its dystopian settings as the new normal; the scariest, most portentous episodes are also the most plausible.

In this new realistic dystopia, Darwinism has also taken the next step, and we're not just fighting to survive against other humans or beasts; the enemy now is artificial intelligence (A.I.), and we inexorably edge closer and closer to the singularity. In HBO's *Westworld*, we find ourselves rooting *against* the humans, and our sympathy lies with the androids. And yet paradoxically by doing so, it reinforces our humanity and compassion.

Sir Thomas More coined the term "utopia" in his satirical book of the same name, published in Latin in 1516. It described a fictional island society in which everything was perfect. But perfection is in the eye of the beholder. One man's treasure is another man's trash or folly. Perfectionism can be a gift or a curse in our imperfect world. If we're liberal and open-minded, we think of utopia as a place of freedom, equality and community. But cynics might consider these ideals naïve and untenable. For every positive, there's a corresponding (potential) negative. Build an open, democratic society, but then who's going to lead it? What about laws? Could an argument be made in this hypothetical utopian society that a criminal act is nothing more than freedom of expression? Does our utopian world have bridges to connect us, or walls to keep out those deemed undesirable? Is there a

socioeconomic and/or political hierarchy? What are they teaching kids in schools? Is Truth the most valuable currency, or is it the number of likes you get on Facebook? Is your idea of utopia the same as mine? Who's right, who's wrong and what does justice look like when we're all equally idealistic on our own terms?

The role of paradox is paramount in drama and in life. When we look at a battery, with its +/− (positive and negative) charge, it's literally the way energy works. So it stands to reason that, if there is the potential for utopia, then there is also the potential for the converse: dystopia, in which everything is FUBAR (fucked up beyond all recognition). This devolution may have been intentional—the master plan of a powerful madman or terrorist group. But even when it comes to terrorists, it's important to consider perspective. Remember, the terrorists believe that *we're* the terrorists.

In Season 3 of *Black Mirror*, which I described in my last book as *"The Twilight Zone* on digital crack," creator/showrunners Charlie Brooker and Annabel Jones continue to hypothesize worst-case scenarios in both the present day and the near future. In its Season 3 opener, "Nosedive," a young woman who's only rated 4.2 out of 5 on social media becomes so desperate to boost her rating that it ends up plummeting to an unimaginable low. According to its star, Bryce Dallas Howard, we're just a step away from this kind of people-rating system becoming a reality.[1] In the Season 3 finale, "Hated in the Nation" (written by Brooker), when a London journalist publishes a blunt piece disparaging a disabled activist who committed suicide, the reporter finds herself the target of public shaming via social media and hatred. Later she's found brutally murdered. Chief Inspector Karin Park (Kelly Macdonald) and her new cyber savvy partner Blue Colson (Faye Marsay) investigate; when more mysterious murders occur, they suspect a serial killer.

So far, this could be an episode of *CSI* or *Law & Order*, but then, in perfect *Black Mirror* fashion, the narrative expands into a creepy dystopia: It turns out that each victim was executed by killer bees. Well, not exactly bees—*micro bee drones*— invented by a bio-engineer to pollinate. Brooker takes a current environmental issue and puts it on steroids by positing: What if we created drone bees to help solve the inexplicable disappearance of real bees—but then their programs were hacked by cyber terrorists to swarm and kill? Given that each victim was publicly shamed and "hated in the nation," Brooker presents this scenario in the morally gray areas of vigilantism (think Showtime's *Dexter*) and government surveillance. Like almost every *Black Mirror* episode, it's a grounded depiction of technology turned against humanity, akin to Frankenstein's creature turning against his creator; what had originally been designed as a boon to civilization becomes a nightmarish curse.

THE CONSTRUCTIVE/ DESTRUCTIVE POWER OF IDEAS: *THE HANDMAID'S TALE*

Which brings me to the main question at the core of utopias/dystopias: What's more dangerous than any weapon or nuclear bomb?

Answer: An *idea*.

Weapons and bombs are inanimate. It's up to human beings to decide what to do with them. They can be used for offense or defense, as deterrent or attack. Utopias/ dystopias are based on who believes what and why, and it's all messy and subjective.

The multiple Emmy Award-winning *The Handmaid's Tale*, created by Bruce Miller and adapted from the 1985 novel by Margaret Atwood, became the first streaming show (it's a Hulu Original) to win for best drama series. In the atrocious world of this story, the "handmaids" have been brainwashed and/or beaten into submission to accept their roles as baby makers—even if it involves ritualized rape repackaged as celebratory monthly "ceremonies." The obedient ones have drunk the proverbial Kool-Aid and embraced their roles as a blessing, as a means not only for their own survival, but also for the salvation of the human race. Gilead is a hellish police state, regulated by secret police (a/k/a the Eyes) and bands of roaming uniformed soldiers. It's a world in which pollution and STDs have rendered most women *and* men sterile. The Commanders justify their actions with a scientific fact: If human beings don't continue to procreate, they're doomed to extinction.

We bear witness to the atrocities in Gilead, primarily from the POV of "Offred" (née June, played by Elisabeth Moss). Offred is literally now the property of her master, Commander Fred Waterford (Joseph Fiennes). To see her and the other handmaids, who were chosen for their fertility, being treated as sex slaves by their otherwise Puritanical masters and their consenting, barren wives is to see the worst in human nature. And those who resist are exiled to The Colonies, remote work camps in which prisoners are forced to clean up toxic waste, a certain death sentence.

The Handmaid's Tale and other dystopian series demonstrate how the "greater good" is never good for everybody, as depicted in Episode 5, "Faithful":

```
          THE COMMANDER
We only wanted to make the world
better.

          OFFRED
Better?

          THE COMMANDER
Better never means better for
everyone. It always means worse
for some.
```

The "for some" aspect takes on more gravitas in Hulu's game-changing series, as it departs from Atwood's 1985 novel that depicts a whitewashed Gilead—a literal white supremacy. It is worth noting that Margaret Atwood is Canadian; her objectivity on the US is key to the fictional creation of Gilead. Atwood was able to diagnose problems from a distance that Americans inevitably find harder to wrap our heads around. The racial diversity on the TV series has been the target of criticism, with skeptics incredulous that such an oppressive place could be racially integrated. In the series, June's husband Luke (O-T Fagbenle) is black, their young daughter Hannah is biracial, and her closest ally from her previous life in Boston and in Gilead, Moira, is also black. Moira is played by the African-American actress Samira Wiley (Poussey Washington in *Orange Is the New Black*). But whether you agree with adapter/showrunner Bruce Miller's racially inclusive approach or not, the bottom line is that all nations, including the United States, have the potential to turn into horrific dystopias. The show has helped break down barriers not only via its commentary, but when Reed Morano became the first woman in 22 years to win an Emmy for directing for a drama series in 2017.

To me, the most compelling aspects of the creative approach to *The Handmaid's Tale* TV series are its use of voice-over to articulate what our protagonist June/Offred is forbidden to speak aloud and the intermittent flashbacks that show us June's relatively "normal" life in Boston prior to the transition from democracy to totalitarian/theocratic rule.

The Republic of Gilead began via a *coup d'état* that killed the President of the United States and most of Congress. A Bible-based fundamentalist movement known as the "Sons of Jacob" has staged a revolution and created new authoritative/theocratic laws superseding the US Constitution (under the pretense of maintaining law and order); women's assets have been erased, along with their basic human rights (except for "Wives" and "Aunts"), putting men in charge of everything. Women are now forbidden to speak directly to men, to read, or to speak freely/candidly to their male and female superiors. Even OB/GYN doctors are complicit in

the rape ceremonies: When Offred intimates that her master rapes her each month to get her pregnant, the doctor suggests that the Commander might be the infertile one and offers to "help" his patient by impregnating her himself. The consequences of white male privilege dominate all aspects of *The Handmaid's Tale*.

These ceremonies were conceived as a solution to infertility and espoused by former televangelist Serena Joy Waterford (Yvonne Strahovski) to help save the human race. Then the patriarchal males intensified their authority, and Gilead became a totalitarian state. No woman in Gilead is free, not even the wives. But we also discover that outside of Gilead, other women are still in leadership positions, including a female Ambassador, and still live relatively free—but not for long. Dystopias tend to be contagious, even though Gilead was doomed from the start.

Gilead (dys)functions as a caste system with a strict dress code. At the top of the hierarchy are Commanders of the Faithful (a/k/a Husbands); their devoted Wives (in solid blue dresses) are all presumed to be infertile (while men are beyond reproach); below the married couples are "Aunts" (teacher/mentors/enforcers, who dress in brown); "Marthas" (housekeepers/cooks, who must wear drab green smocks); "Jezebels," who are glammed-up sex slaves in a posh, illegal Dionysian whorehouse; and Handmaids (who must wear formless red cloaks and white "winged" hats that resemble nun's habits to shield their faces—the Gilead version of the burka).

In Offred's orbit are the Commander and his intelligent but jealous wife, Serena Joy, who's been stripped of her TV fame and relegated to (allegedly infertile) submissive trophy wife, as well as "Aunt" Lydia (Ann Dowd), the officious headmistress who seems to possess actual mercy for the obedient girls and keeps the rebellious girls in line with a cattle prod. Indeed, in a KCRW interview with Kim Masters, Dowd shared that her character has a genuine fondness and compassion for the handmaids. She sees her role as protector and mentor. We witness Aunt Lydia as a monster, but Dowd shrewdly plays just the opposite. As handmaids are forbidden to go out in public alone (a misogynistic buddy system), they're each assigned another handmaid as a companion—and they're trained to report any indecent thoughts to their superiors—or face harsh punishments. Offred's "buddy" is Ofglen, played by Gilmore Girl Alexis Bledel. It's Ofglen who provides Offred with her first ray of light: Ofglen reveals that she's working for the Resistance. But later, unbeknownst to Offred, Ofglen is arrested—and circumcised!—for her covert actions. In Episode 2, "Birth Day," when Offred approaches the gate to meet Ofglen for their usual shopping day (plus a bit of plotting against the regime), Offred gets a rude awakening when she realizes that Ofglen has been replaced by a new, brainwashed handmaid (née Rita, played by Amanda Brugel). The final lines of the episode hit the "sweet spot" of this addictive series by juxtaposing June's thoughts with Offred's reality:

```
                    OFFRED
          Has Ofglen been transferred to a
          new post so soon?

                    RITA
          I am Ofglen.

                    OFFRED (V.O.)
          Fuck.
```

When Serena Joy suspects that her husband is the infertile one, she arranges a tryst between Offred and the Commander's handsome, young chauffeur Nick (Max Minghella), hoping to save her marriage by getting Offred pregnant at all costs. You might call her the Dystopian Desperate Housewife.

The Commander was integral to the *coup* of the US government. In the name of procreation, he and his entitled male cronies believed they had no better choice than to segregate, persecute and exploit fertile women: a radically inhumane, fascist version of an endangered species act. Offred has learned to trust no one and must exercise extreme caution while trying to tap into/join the rebels known as the Mayday Resistance. But we see her determination in "Night," the powerful season finale, when she says, "They should have never given us uniforms if they didn't want us to be an army."

OUR WORLD WITH A CAUTIONARY TWIST

The before-and-after depictions of June/Offred are shocking, and show us how a society can change, virtually overnight, unless we're vigilant. The events in *The Handmaid's Tale* seem improbable, even impossible, until we look back to the Nazi occupation of Europe prior to World War II—or today's Trumpian/draconian policies on and treatment of immigrants and refugees. Each dystopian series, from *The Walking Dead* and *The Leftovers* to *The Handmaid's Tale*, *Orphan Black*, *Humans*, *American Gods* and the sitcom *The Last Man on Earth*, is an example of taking an ordinary setting and pushing it to the realm of the extraordinary. We're living in a world where anything can happen at any time.

How can such horror be entertainment or even escapism? Well, misery loves company, and I suppose it can be somewhat reassuring to see others much worse off than we are. But dystopian series are a popular phenomenon, now more than ever. Are we incorrigible nihilists seeking validation for our pessimism? Or is there something more?

On *The Walking Dead*, humans can kill zombies by stabbing them in the brains and/or decapitating them. This is an ultra-violent horror/drama, but despite the gore, there is pathos. Like all long-running TV series, it's based on family dynamics. In this case, it's a family of survivors. Is there hope? Small victories (finding food and medical supplies) and rays of light (a newborn baby, spiritual faith, romance, friendship) occur amid relentless grief and darkness. Where there is love, community and compassion, there is the possibility for renewal.

Nevertheless, in today's America, our democratic ideals are currently being encroached on by a new kind of dystopia. Women's reproductive rights, our civil liberties, and the fourth and fifth estates (the press, electronic media) are all under attack. Truth has been supplanted by "alternative facts" and legitimate reporting is called "fake news" by a misguided conservative patriarchy. Our modern dystopia is also rooted in religious hypocrisy, political corruption and radical wealth disparity, fueled by corporate greed and capitalism run amok (*Mr. Robot*'s Elliot Alderson refers to the greediest as "the 1% of the 1%" who collectively have more wealth than the bottom 99% of the world's population, *combined*"). *Mr. Robot* and Showtime's *Homeland* show us a rapidly emerging dystopia—a work-in-progress revolution—with cyber hacking as the most insidious and pervasive form of resistance and terrorism (again, depending on one's perspective). We're attracted to great dystopian TV series because they reflect a version of our own world. And, like George Orwell's classic *1984* and Paddy Chayefsky's *Network*, *The Handmaid's Tale* is also a cautionary tale. We're tuning in, but are we paying attention?

The common denominators among good dystopian TV series are determination, resistance and revolution. We want our equality and freedom back, or at least *answers*. In the third and final season of *The Leftovers*, Nora (Carrie Coon), who's stuck in grief from the inexplicable disappearance of her husband and two children insists, "I fucking want closure." Life has become too painful for her to endure, and the show is almost too painful for us to watch. And yet, the crucial element of the dystopian TV series remains *hope*. The doom and gloom can be overcome by the proactive survivors who band together—and refuse to believe it's The End.

We have explored how the masters created fully realized fantastical and dystopian realms, but how did they begin? For my students working on supernatural and/or heightened reality series, I strongly recommend that they first construct a world building mythology document to keep the rules of the special world as simple as possible, clear and credible.

CRAFTING THE SUPERNATURAL/DYSTOPIAN PILOT

n science fiction, we're presented with a world that bears *some* resemblance to our own. But how does this sci-fi world differ from ours?

Here are some basic questions to consider when developing a series' mythology:

- Are we in the present day or in the near or distant future?
- Is it a post-apocalyptic, dystopian world?
- Is it a space colony?
- Is it overpopulated, or are there very few survivors?
- Is the environment sustainable?
- Is the air toxic?
- Is the Earth burning up or flooding or arid or arctic?
- Do animals and/or other anomalous creatures live among us?
- Are humans the dominant species?
- Are food and supplies in abundance or is there poverty and famine?
- Is this version of the future or this alternative world light or dark?
- Who governs?
- What kinds of laws keep the order?
- Is it a militant state? Anarchy? Somewhere in between?
- Who enforces the laws?
- What kinds of weapons exist?
- What kind of special abilities do the police and citizens have?
- Is there a class or caste system or equality?
- Does artificial intelligence exist?
- Is the world on the verge of the singularity?

> ## In a supernatural series that's more fantasy than dystopian, the mythology deals with the rules of magic.

Here are some basic questions to ponder while conjuring the show:

- Who has special powers?
- How do they work?

- What is their limitation?
- How are they activated?
- Can they be neutralized or reversed?
- Is there a totem or book of spells or amulet or material device needed to invoke the magic?

MICROCOSMIC DYSTOPIAS AND THE MONSTER MASH: *AMERICAN GODS*

Starz is now a legitimate player in the SVOD (Streaming Video On Demand) TV landscape. Early buzz-worthy series, including *Spartacus*, *Outlander* and *Power* certainly put Starz on the map, but *American Gods* demonstrates its willingness to take big swings—and this insanely provocative series is a visual orgy that does justice to the global bestselling, award-winning novel by Neil Gaiman (first published in 2001). The size, scope and cost of this ambitious series are tantamount to HBO's *Game of Thrones* (albeit without the cast of thousands) and Amazon's gambit on *Lord of the Rings*. In fact, the budget and differing visions for the future of the show may have contributed to why exec producers Bryan Fuller and Michael Green departed after Season 1 (at press time, new showrunners were yet to be confirmed).

American Gods enters the semi-grounded/supernatural/digital acid trip canon that includes *Twin Peaks*, *The OA*, *Stranger Things* and *The Leftovers*. Starz, however, known for pushing the envelope into NC-17 territory for explicit scenes of sex and violence (with buckets of blood), is even more graphic. *American Gods* features an Egyptian goddess named Bast who has a man-eating (and woman-eating) vagina. The show is literally *awesome*—a word overused in the vernacular sense—but apt when you consider its etymology. The word "awesome" used to be related to the divine and the feeling of wonder and terror that mortals feel in its presence.

The series has a multilayered approach to storytelling. With its mythic planes, it transcends the rules of time, space and mortality and straddles the line between realism and surrealism. The protagonist is an ex-con named Moon Shadow (Ricky Whittle) and his recently deceased wife Laura (who's now a pretty, talkative zombie, played by Emily Browning); there's also an old Slavic god who murders cows and people with a giant hammer. Throw in spiders that can pick locks, violent trees that come to life and a raven that can communicate telepathically.

The central conceit of the novel is that gods and mythological creatures are given strength through people's worship of them; for example, Bast makes her sexual partners worship her before vagina-devouring them. The idea is that people's beliefs birthed them into existence, much like the new gods—who didn't exist before the technology did. In the novel's ethos, immigrants bring their beliefs with them into the US because the gods are tied to their worshippers. (It could be argued that *American Gods* was as prescient as *The Handmaid's Tale* in predicting today's political climate.) But the book explores how the belief in and influence of these mythological beings is fading in our modern dystopia. And so, new gods have emerged, heralding the insatiable American appetites for technology, fame, pharmaceuticals and narcotics—part Don DeLillo's *White Noise*, part David Foster Wallace's *Infinite Jest*—and so much more.

The story's hook is: What if ancient gods found themselves dying off and being replaced by new gods in present-day America, including a god that can control the weather and one that controls the media? (The character of Media is played by Gillian Anderson of *The X-Files* fame.) Media is a shapeshifter of sorts, who can segue from Lucy Ricardo and David Bowie to Marilyn Monroe in her billowy white dress from *The Seven Year Itch*. The structure of the series can best be described as kaleidoscopic—which is hard to pull off and can be challenging for viewers. Showrunners Bryan Fuller and Michael Green succeed by honoring the source material and finding thematic links to craft each one-of-a-kind episode. What keeps us hooked are empathy and sympathy for what makes each god and demigod human. None of these special effects is worth a damn without emotion.

Like its TV series predecessors (Showtime's *Penny Dreadful*, ABC's *Once Upon a Time*, AMC's *Preacher* and the now-defunct *Grimm* on NBC), *American Gods* deftly capitalizes on the idea that multiple gods, fairy tale characters, superheroes, villains and monsters are better than one. The show's cinematic style evokes Tarantino's *Pulp Fiction*, Zach Snyder's *300*, the Wachowskis' *Matrix* and *Cloud Atlas*, Fuller's previous series *Pushing Daisies* (with its black comedy, saturated colors and surreal yet suburban setting) and the stylized gore of *Hannibal*. At times we're in a graphic novel; other times we're in a superhero comic book. But there are also two-hander scenes: quiet, precise interactions between just two characters, that evoke Kubrick. The style also draws on gaming culture, taking us into special worlds that feel 3D and almost interactive. It's a mélange of taste and tones that shouldn't work—and probably wouldn't have worked, prior to the digital television revolution. It's niche TV writ large.

In one sequence, the god Mr. Wednesday (Ian McShane) picks up a dandelion and blows it into the wind; its wisps float upward and transform into pinwheels (very *Fantasia*), then morph into fireworks in the night sky, then into bolts of lightning. It's

just a flourish: Is Mr. Wednesday trying to impress us or maybe just goofing off? Such phantasmagoria is followed by a grounded, mundane scene in a Walmart (or is it Costco?). It's a show of contrasts in bulk.

For me, the most satisfying aspect of the series is the stylistic flourishes: A pack of Virginia Slims tumbles out of a cigarette machine. A vintage lighter in extreme close-up sparks it up. The pervasive flash and buzz of neon and fire. The writers give us mythological beings who observe ancient rituals, juxtaposed against 21st-century characters and their modern conveniences, set to a score that mixes classical music with electronica, jazz, hip hop and new wave. The gods of *American Gods* are truly in the details.

PORTALS AND MULTIVERSES: CHILDLIKE WONDER IN *STRANGER THINGS*

Hawkins, Indiana, 1983. In the opening scene of the *Stranger Things* pilot, "Chapter One: The Vanishing of Will Byers," a nerdy-looking guy in a white lab coat bursts out of a door and runs like a jackrabbit down a hallway under flickering fluorescent lights. As an alarm blares, the terrified man makes it to a freight elevator and gets in, frantically pounding the buttons to close the doors. But before they shut, he hears an animal-like noise, looks up at the ceiling, and sees—what? The thing he's been running from sucks him upward, and he's gone without a trace.

As it turns out, this man is—or was—a scientist at Hawkins National Laboratory, a government facility that's been conducting top-secret experiments and raising children as slave guinea pigs, for some nefarious purpose. The experiments, we'll soon find out, seem to have accidentally opened a portal into an alternate universe called The Upside Down. After gobbling up the scientist, the slimy, terrifying creature (who rivals the monster in *Alien*) will soon kidnap 12-year-old Will Byers (Noah Schnapp), one of a group of four young dudes who happen to be "Dungeons and Dragons" fans. (Chapter 10 includes an excerpt of the boys' interaction during their game.) On the night in question, Will draws the "Demogorgon" and is later abducted by a tall, thin creature without a face. Coincidence?

First-time showrunners/creators/brothers Ross and Matt Duffer pay unabashed homage to shows such as *The Twilight Zone*, *The X-Files*, Spielberg movies such as *E.T. the Extra-Terrestrial* and cult movies *The Goonies* and *Stand By Me*, with elements of All Things Stephen King. *Stranger Things* managed to rise above the competition in 2016 with its fresh approach to the sci-fi/horror genre.

The funny, irreverent police chief Jim "Hop" Hopper (David Harbour) mentions that, up until Will's disappearance, the last crime committed in Hawkins was when an owl flew into a local woman's hair. Hop plays the unruffled tough guy, but we'll learn that he's still grieving over the tragic death of his young daughter. He's still a shell of his former self, understands loss all too well and drowns his sorrows in booze. He and Will's mom—divorced, single parent Joyce (Winona Ryder)—are both traumatized and broken kindred spirits. While searching hysterically for her son, Joyce even says she's changed her mind about letting him see *Poltergeist*—a Spielberg movie that itself features an epic portal. In comparison, the special effects of *Stranger Things* seem modest: The Upside Down is a sad, dark world that looks just like ours, if life as we know it had been destroyed by a nuclear disaster. It's an alternate universe that could be hiding behind the bedroom wall. It's believable, because Will's young friends, the down-to-earth characters of Mike (Finn Wolfhard), Dustin (Gaten Matarazzo) and Lucas (Caleb McLaughlin) believe it.

There's more than one portal—the big, gooey one at Hawkins Laboratory, one that briefly opens in the wall of Joyce's house, and another at the base of a tree in the forest, which seems to open and close at will. The monster itself, a hairless, shrieking deformity with a face that opens up like a flower when it's feeding time, is scarier than a zombie because he stalks in fast motion and looks like a human whose skin has been peeled off. This creature is destroyed in the Season 1 finale by Eleven (Millie Bobby Brown), a young girl who's unfortunately one of the lab's guinea pigs. Eleven has psychokinetic powers and an appetite for Eggo waffles, thus returning Will and the idyllic town of Hawkins back to relative stability . . . except maybe that skinless mutant isn't the only monster? There's also the mysterious disappearance of redheaded high school wallflower Barb (Shannon Purser)—who was abducted by (perhaps) an even more heinous creature that we never see. One minute Barb wanders out of a house party and is sitting poolside under the moonlight, by herself; the next minute we hear horrendous growls and she's vanished.

Stranger Things is an irresistible mash-up of horror, suspense and coming-of-age drama with healthy doses of humor and nostalgia. But the show's success relies on the chemistry between the kids, supported by the overarching theme that friends are honest and loyal—no matter what. It's Eleven who reminds the guys of the importance of their bond. She's laconic but offers up one enduring piece of advice: "Friends don't lie." The thrills and chills wouldn't add up to much without these bonds and also the power of community and family to overcome crises. Emotion, again, is key. We relate to Joyce over the loss of her missing son and understand how desperate she is to believe in the supernatural in order to find him. When she strings up Christmas lights and tapes the alphabet on her living room wall in order

to try to communicate with her son from the beyond, everyone thinks she's crazy—except us. Finding Will is the driving force of the whole season. And its accompanying emotional stakes keep the suspense taut and our nerves frazzled. Whoever thought a living nightmare could be so much fun to watch?

Structurally, *Stranger Things* uses the *Jaws* strategy: The greatest suspense comes not from what we see, but rather from what we anticipate and dread. After the initial shark attack in *Jaws* (we don't see the shark, by the way, just the carnage), the story earns the right to slow down and orient us before it ramps up again. *Stranger Things* takes this same approach. The pacing is vital to both the show's narrative drive and its time period. The Duffers nailed the production design and musical choices of the early 1980s. How great is a wall-mounted landline phone with its twisted spiral cord and limited reach? In case you're too young to remember 1983, the pace of life was much slower. It could take a whole minute to dial the phone, especially if it contained an "0" or "9," and if you were expecting a call (like Joyce is throughout the series), you had to literally sit by the phone and wait for it to ring. There were no computers, email, texts, voicemail, Facebook or Instagram. For some of us who remember those days, *Stranger Things'* lack of personal technology was a whole lifetime ago.

The Duffer Brothers didn't let the fact that their show (originally set in and entitled Montauk) was rejected by 15 networks stop them; they kept pitching it because they knew they had something special. Finally, Netflix gave them their chance. Portals and monsters never go out of style, as they add dimension and the unexpected to the mundane. *Stranger Things* is pure escapism—a thrill ride—since it retains its sense of innocence. Unlike the realistic horrors of dystopian series such as *The Handmaid's Tale* and *Black Mirror*, we cringe at the scary scenes, but none of *Stranger Things* actually impinges on our world. The 1980s setting provides us with a safe vantage point—from a distance. Some horror series are too real for us to settle in and enjoy. *Stranger Things* keeps us on the edge of our seats, full of childlike wonder. We laugh, we hide our eyes and we can't wait to come back for more.

SURPRISE AND SHIFTING POV: *THE OA*

The supernatural drama series *The OA* is a masterclass in the unexpected, keeping us guessing, with moments of pure wonder sprinkled throughout Season 1. It's a show of big existential and metaphysical ideas, told in an

intimate, old-fashioned campfire story way. And as bizarre and surreal as it gets, *The OA's* tone is grounded and matter-of-fact, more akin to the nuance of *The Leftovers* than the quirky, often funny, fright fest that is *Stranger Things*. Here are my mostly spoiler-free takeaways from the journey:

- ***Tell the story the way you want to tell it***. *The OA* is truly a novel approach to storytelling, with one episode as long as 71 minutes and another just 31 minutes, flexible like chapters in a book. With the freedom of writing for an online platform, co-creator/co-writer/director Zal Batmanglij explains that he and co-creator/actress/long-term collaborator Brit Marling indeed wanted to tackle *The OA* like a novel, and for it to be a transformative experience over eight episodes.[2] We not only watch in awe at times; we care: Their slow-burn approach means we get that precious time to go into the backstories of the main characters and to bond with them.

- ***The unreliable narrator***: Nina/Prairie (Marling) was blind before disappearing for seven years; when she returns to her family, she can see, and reintroduces herself not as the daughter they once knew, but as simply "The OA" (which we later learn stands for "Original Angel"). Her explanation of events, which she first recounts exclusively to a group of four disparate teens and their teacher, involves portals and multiverses; for skeptics, it's hard to believe. Perhaps that's why she takes time to open up to others outside of this group of five? Her story involves trauma, and we sympathize and empathize. But PTSD may also play a part in OA's recollections: She even doubts herself at times, wondering if she could have made up Homer (Emory Cohen), her beloved companion during her time away. Is it mind-bending and has she spun this tale from her imagination, with story as a way of processing traumatic events, or . . . is it real?

- ***Connecting with shifting points of view***. Although most of the scenes are from our protagonist, OA's, point of view, the show shifts between her POV and those of all the main characters. As audience, we identify with their unique takes on what they experience, which is often startling. Empathy plays a part here. For example, we feel for the five people to whom OA recounts her tale— for lonely teacher Betty Broderick-Allen/BBA (played by Phyllis Smith from *The Office*, who also voiced the role of Sadness in *Inside Out*); angry and frustrated teen Steve (Patrick Winchell), trans teen Buck/Michelle (Ian Alexander), whose father refuses to understand him; French (Brandon Perea), who struggles to look after his family because of his alcoholic mom; and Jesse (Brendan Meyer), who's effectively an orphan. When we see the world through their eyes, we can't help but feel their pain, general mistrust and also marvel at their displays of courage.

- **Push to the extremes, but only when it feels organic**. There are several scenes that are uncomfortable to watch or make us wince, involving severe physical, mental and emotional pain or danger for the characters. We're pushed to the limits, but never beyond; the writers are provocative but set boundaries to avoid scenes that feel unwarranted or a step too far. They understand the importance of keeping the audience in the story, rather than having us snap out of a moment because it feels forced or staged.

- **The inevitable ending**. By far the most polarizing aspect of *The OA* is its ending—which critics and audience members either loved or hated. Some appreciated its ambiguity. Others were left scratching their heads in exasperation at what they considered to be a contrived, unearned, anticlimactic resolution. Given the long run-up to this conclusion, it's always a major challenge to satisfy and manage viewers' expectations. In the on-demand streaming ecosystem, viewers stamp their sense of ownership on their favorite shows; it's like an evolving long-term relationship. Even when we're in love, our mates can sometimes disappoint us, but that frisson can also infuse a relationship with vitality. For it's in vigorous debate that series enter the zeitgeist and generate heat and buzz. To me, this ending sparked a fruitful, global water cooler conversation—and the controversy has succeeded in *The OA's* scoring a Season 2 renewal, in which Marling and Batmanglij have promised answers to a lot of our questions. Stay tuned. . . .

> *The writers' use of surprise, doubt and shifting points of view simultaneously keeps us guessing and opens the door for us to believe.*

ADJOINING REALMS IN: *THE MAN IN THE HIGH CASTLE*

Diverse arenas exist in *The Man in the High Castle*, even before the characters start crossing to alternate realities. Based on the Philip K. Dick dystopian novel, the series was adapted for Amazon by Frank Spotnitz (*X-Files*, *Medici*) and the current showrunner is Eric Overmyer (*Bosch*, *The Wire*). I interviewed both Frank and Eric in my last book, *TV Outside the Box*. In the alternative history of *The Man in the High Castle*, the Allies lost the Second World War to the Axis powers,

who dropped an atomic bomb on Washington, DC. Now, New York and the eastern seaboard fall under the Greater Nazi Reich; the West Coast forms part of the Japanese Pacific States, with the Japanese controlling from San Francisco; and the middle is a Neutral Zone. The rest of the world is divided between Nazi and Japanese rule, but the two "master races" hover on the brink of war as both vie for supremacy. When everyone's existence is tightly controlled, down to the music they're allowed to listen to, and all live under the constant threat of execution if they don't comply with the rules (and sometimes even if they do), it's no surprise that many yearn to escape.

Japanese Trade Minister Tagomi (Cary-Hiroyuki Tagawa), a gentle pacifist who's greatly disturbed when his secret plan for peace goes awry, begins to meditate with the encouragement of his assistant Kotomichi (Arnold Chun). Tagomi misses his late wife terribly and longs for a better world. After deeply meditating in the Season 1 finale, he opens his eyes to find himself in what appears to be another San Francisco—another reality where the United States has won the war. Is Tagomi dreaming? Has he found a portal? Does he possess a superpower? It's a superb season cliffhanger, with a touch of magic. Tagomi learns, devastated, the great cost of the Allies' victory in this alternate reality: Hiroshima and Nagasaki. He discovers his alter ego in this world is a bitter man (who's, incidentally, nowhere to be found). His family resents him, wishing he would leave, but this Tagomi finds ways to mend their estrangement. Living in American society, he begins to understand the beauty and possibility of being both American and Japanese. But when Tagomi sees terrifying footage of the US hydrogen bomb tests and experiences the narrow escape of the Cuban Missile Crisis, he takes it as a sign to try again to bring peace to his own world. Upon return, he discovers that Kotomichi too can traverse alternate realities. Kotomichi had escaped the tragedy of Nagasaki by deeply meditating while badly burned, hoping, wishing, longing for his family who were killed in the atomic blast. He then found himself in the reality where Japan had won the war, his family alive and well. So, Tagomi is not the only one capable of traveling between realms, and hope and meditation are seemingly the keys to opening a portal between realities.

The different realities may also explain the depictions in the mysterious films created by "The Man in the High Castle" himself, Hawthorne Abendsen (Stephen Root). At the end of Season 2, Abendsen may have even transported protagonist Juliana Crain (Alexa Davalos) to an alternate reality where her late sister Trudy (Conor Leslie) is still alive. We're still learning the rules and fathoming the mysteries of this multiverse, but Tagomi and Kotomichi's experiences show there are shades of gray in both alternate realities. It's something to take away as writers: We can give our audiences the choices and let them make up their own minds. The show is

so on point that, given the current administration in the US and problems across the world, we can't help but wonder while watching: Could *we* be living in an alternate reality? Whatever the rules of our own world, hope holds the key here, too.

⬤ Bonus Content

Further analysis on magical realism, including **Atlanta**, **Man Seeking Woman**, **The Good Place**, **Game of Thrones** and **The Young Pope** plus my take on "**The Neurotic Superhero**" is at **www.routledge.com/cw/landau**.

See also: CBS All Access' *Star Trek: Discovery* (from Bryan Fuller and Alex Kurtzman) and Adult Swim's *Rick and Morty* (from Dan Harmon and Justin Roiland). *Rick and Morty* is an animated series which is part dysfunctional, edgy family comedy and part intergalactic, multiversal space adventure, plus lots of booze and belching. As young Morty (voiced by Roiland) explains in Season 1 to his older sister, who's just discovered that she was an unplanned pregnancy and may have cost her parents their happiness: "Nobody exists on purpose. Nobody belongs anywhere. Everybody's gonna die. Come watch TV?" It's the *post*-post-modern television comedy, and as Troy Patterson describes, a timely show for the American apocalypse.[3]

Notes

[1] Jackie Strause, "Bryce Dallas Howard Says Her *Black Mirror* Social Media Nightmare Is Happening Already," *The Hollywood Reporter*, October 26, 2016 www.hollywoodreporter. com/live-feed/bryce-dallas-howard-talks-black-mirror-season-3-social-media-cyber-attack-941327.

[2] Emma Dibdin, "*The OA* Creators Brit Marling and Zal Batmanglij Break Down the Mysteries of Netflix's Surprise Series," *Esquire*, December 19, 2016. www.esquire.com/ entertainment/tv/news/a51648/the-oa-netflix-interview-brit-marling-zal-batmanglij.

[3] Troy Patterson, "Rick and Morty" Is Just the Show We Need for the American Apocalypse, *The New Yorker*, October 18, 2017, https://www.newyorker.com/culture/ cultural-comment/rick-and-morty-is-just-the-show-we-need-for-the-american-apocalypse.

Episodes Cited

"International Assassin," *The Leftovers*, written by Damon Lindelof and Nick Cuse; White Rabbit Productions/Film 44/Warner Bros; Television/HBO Entertainment.

"Faithful," *The Handmaid's Tale*, written by Dorothy Fortenberry; MGM Television/Hulu.

"Birth Day," *The Handmaid's Tale*, written by Bruce Miller; MGM Television/Hulu.

"There's a real different feeling to the meetings [at Amazon], there's that kind of love of iteration. . . . There isn't this adherence to whatever the first draft was or the first pitch was. I remember the feeling back in the day when we were developing at a network and we'd settle on something, but then of course the characters are alive, and the process is very much alive, and you would rewrite based on the feeling that you're having with the characters, the souls of the characters, and then you'd get notes, like 'We like the thing from the last draft, can you go back a draft?' And then you think, 'I can't go back a draft. I can't go back in my time machine and not know what I now know as a human being.'"

—JILL SOLOWAY, CREATOR/SHOWRUNNER/DIRECTOR, TRANSPARENT, I LOVE DICK

"We're also talking a lot in the room about planting seeds that can grow over the course of the season, knowing that people might be watching them in bulk. We'd like to bury some Easter eggs and let people find them, later on."

—JENJI KOHAN, WRITER/CREATOR/SHOWRUNNER, ORANGE IS THE NEW BLACK, WEEDS

CHAPTER 5
STORY TENTACLES

Making Surprising Choices
That Yield More Story

When making choices as storytellers of a television series, our priority needs to be those choices that will give us more story. Sometimes a storyline we come up with feels interesting and could sustain for some episodes, but when we beat it out, it fizzles or we hit a dead end. Even if we know it might be a good story for a while, we need to choose the option that could take us on a road that can continue, perhaps indefinitely. It's essential to make those story choices in our show that give our characters goals, arcs and someplace to expand and grow as people. One of our primary jobs as TV storytellers is to create a show that can sustain over a long period of time. The more seasons a show is able to last while also maintaining the quality, the more valuable it is as a property to a studio and network.

How do we sustain a show over multiple seasons, without repeating ourselves? This is a strategy that starts early in the process, as early as in the pilot. Even when writing on spec, most networks and studios now ask for more than just a pilot script. They often require a series "bible" for the show that explains where the show will go in future episodes, character by character, plus how the story is going to expand and grow. A lot of networks will now also want a second episode, which could be Episode 2, or sometimes they'll ask for Episode 5. The execs want to see how the characters and show will evolve, once it's all set up. (See Chapter 12.)

INEVITABLE YET UNPREDICTABLE

There are several strong television series that illustrate this point, but let's begin with an excellent movie example: *Groundhog Day*. It's about Phil (Bill Murray), a guy who's trapped in the same day. Every day he wakes up and is forced to

repeat the same day, over and over again. The sly irony of the movie, which is a cult classic (and now a Broadway musical), is that every day Phil wakes up, he experiences the world in a different way. He learns things from each previous day, so that every time the day repeats, he has different touchstones. He may run into the same people, but he also develops ways to adjust his behavior in relation to the situations. What we end up seeing is a character who, yes, is trapped in the same day—and by virtue of the premise, it is a movie about repetition—yet it never gets dull or redundant, because he grows and evolves. Phil starts off as a misanthrope; he's a grouchy, selfish, immature playboy, and it's all about him. As the movie progresses, he starts to undergo an existential transformation. One of the things he realizes is that he *can* learn and grow; he doesn't have to keep making the same mistakes over and over again. He can learn from them, move on and erase history—which many of us wish we could do. There are countless times I've wished I could rewind and rewrite history when I've blown a situation, failed a test or said something I wish I hadn't.

In Phil's case, he's able to have multiple do-overs. He realizes that being stuck in the same day isn't necessarily a curse; it can also be a blessing. He keeps getting another chance. It starts off feeling like a nightmare, but one of the ways it evolves is that he starts to realize that this is actually cool. It's a blessing, because now he has the home court advantage. He uses all this information to manipulate his unrequited love interest and has fun with it. Initially, this is comedy gold for the movie. It also feeds into his narcissism, selfishness and some of the flaws he has at the beginning.

Where the movie takes off and goes deeper is the moment he realizes he's immortal. Based on the fact that he's stuck in the same day, he can't die. So he can dive into a quarry but will just wake up the next morning and start the day over again. He can take countless risks in his life. As a result of taking new risks, even with relationships and going places he was unable to go before emotionally (because it was too scary), he's transformed into a virtual prophet. He rises above day-to-day reality, and he starts to become, not just smarter, but more spiritually attuned to the universe. It's a brilliant twist because what could have been a one-joke, on-repeat movie ends up taking us on a spiritual journey. By the end, we are in territory we never anticipated we would visit, based on that initial setup. Where the movie eventually ends up going is inevitable, though not predictable.

Predictability is what we always need to avoid, particularly now, because audiences have so much choice and content at their fingertips. Viewers are so sophisticated that many plotlines seem familiar; sometimes it feels as if we've seen it all. A huge challenge is, how do we come up with a fresh, original idea? The truth is, we're

probably not going to, because most ideas have already been done. The challenge then becomes, how do we take an idea that perhaps we've seen before, but put a fresh spin on it? How do we take it to a place nobody is anticipating, yet when we get there, to a resolution at the end of the season or even at the end of the series, that feels inevitable and satisfying, while never feeling predictable? The answer lies in considering all the options available and making smart initial choices.

KEEP YOUR FRENEMIES CLOSE: *ORANGE IS THE NEW BLACK*

There are a few adaptations that have taken the source material—in some cases, memoirs—and made smart story adjustments. They thereby created pathways for more and more story. In the case of the memoir *Orange Is the New Black*, the showrunner/creator Jenji Kohan's key adjustment actually became the centerpiece and central relationship at the core of the first season. It added tons of conflict and created subsequent love triangles, danger, suspense, sexual chemistry and tension.

Orange Is the New Black is based on the memoir by Piper Kerman, who was incarcerated for a drug trafficking bust in her past and served time at a minimum-security women's prison. The memoir is a tell-all diary of what Piper's life was like in prison. She writes about being a fish out of water, about the different prisoners in the population, what she had to avoid, alliances and friends she made, then "friends" who turned out to be false friends and later betrayed her.

When reading the book, we learn that Piper's girlfriend, the drug smuggler Alex Vause (fictionalized name), who turns out to be the reason she's in prison, is in the background. She doesn't play a significant part in the story. In real life, Piper only briefly crossed paths with her former lover, Nora Jansen (another fictionalized name), when they both had to testify during a trial in Chicago and were housed in the same federal jail for a short time. "Nora" also looks totally different physically than the actress Laura Prepon, who plays tough, sexy Alex in the series. What Jenji Kohan did when adapting the memoir, which in the end wasn't so much an adaptation as an inspiration for the show, was to take the backstory, do plenty of research about what happens in women's prisons, then make the show her own. There are plenty of aspects of the memoir she drew upon, things she tossed out and much she created from scratch to serve the dramedy of the show. The choice

she made in the pilot, which ended up being such a wise move—that story tentacle—was Piper's discovery that Alex is in the same prison.

It's a great moment. At the very end of the pilot, Piper (Taylor Schilling) has already had one of the worst days of her life and steps outside to just get some air and regroup. In her daze, she sees somebody standing there. Sure enough, it's Alex. That sets the love triangle in motion between Piper, ex-girlfriend Alex and fiancé Larry (Jason Biggs). As the show progresses, Larry ends up betraying Piper with her best friend, another inmate comes into the story who Piper develops feelings for, Alex ends up being transferred, Alex ends up getting out, Piper ends up betraying Alex . . . you get the idea. There's an infinite number of storylines because there are many different inmates, rich backstories and nuanced characters, including the prison personnel. Yet, that centerpiece of *Orange Is the New Black*, certainly for the first three seasons, is Alex and Piper. Alex herself is a story tentacle. That was a story choice made in the pilot; that was the gift that kept on giving to the writers of the show. It's a story that led to more story—and it's smart.

YOU CAN'T ALWAYS GET WHAT YOU WANT . . . *MOZART IN THE JUNGLE*

The half-hour dramedy from Amazon, *Mozart in the Jungle*, is also based on a memoir—this time, written by an oboist in the New York Philharmonic, Blair Tindall. It's about the real drama behind the scenes and how this oboist functioned within the musical bureaucracy. When we sit in the audience at the Lincoln Center watching the orchestra play, we think everything is beautiful, elegant, harmonious and serene. But behind the scenes, it's ruthlessly competitive and political. There are alliances, betrayals, sexual hook-ups—all kinds of unexpected behaviors behind the curtain are real. The way into this world for the creators, Roman Coppola, Jason Schwartzman, Paul Weitz and Alex Timbers, is the Hailey character (Lola Kirke). Like the real-life Tindall, Hailey was initially going to become second chair in the oboe section right away. We were going to get her point of view from within the orchestra.

What the writers discovered when they started to develop the show was that, if Hailey immediately gets into the orchestra, there wouldn't be enough conflict nor room for her to grow. It's her aspiration to play in this great orchestra, but the

creators felt rightly that if they put her in that chair from the beginning, the heat of the dramatic situation, which would in turn fuel the comedy, would die. Desperation fuels comedy more than harmony and the show would run out of gas too soon. Instead, they chose to actualize Hailey's worst nightmare. She gets her chance to play for the new, eccentric, charismatic conductor, Rodrigo (Gael García Bernal). But she pushes herself too hard, akin to the drummer in *Whiplash*, who literally bleeds from rehearsing constantly. Hailey is so nervous on the day of her audition that her hands are sweating, and the oboe slips and flies out of her hands. She blows her big shot in front of the whole orchestra and is not given another chance. She feels humiliated.

But Rodrigo feels that Hailey has potential and plays "with the blood," so he offers her a job as his personal assistant. What this does is put her on the inside of the world, but she's not yet a part of it. Hailey still has something to aspire to: one day, second chair and then first chair. In the whole first season, that challenges her and her confidence. Hailey gets to learn about the realities of what it would have been like had she been accepted to the orchestra. This was another smart choice by the creators, because her self-esteem takes a beating and she's constantly reminded how close, yet how far, she is from where she wants to be. Hailey feels that she blew it, plus she's such a Type A person that, for her, the worst thing that could have ever happened to her actually *happened*. How does she pick up the pieces and continue to move forward? How does she keep her ego in check?

As Rodrigo's personal assistant, Hailey is in a subservient position. She has to do menial things for him because he's her boss. He's beyond eccentric, which can be frustrating when that person is managing you. However, on the plus side, Rodrigo constantly sees the world in an auditory manner, which is fascinating. The sounds around him and everything he hears, whether he's riding in a taxi on the Brooklyn Bridge or just walking across the street, create a personal musical landscape. It's as if he sees with his ears. Hailey has the unparalleled chance to learn directly from Rodrigo, even though she doesn't yet play in the orchestra, and she realizes the value of this unique access. She absorbs, first-hand, his perspective of the world, plus her senses are being heightened. It's ultimately going to make her a better musician, but at the same time, she has to put up with the eccentric Rodrigo as well as his crazy ex-wife, Anna Maria (Nora Arnezeder), when she returns. In this job, Hailey gets caught up in all the behind-the-scenes drama of the orchestra that she's desperately hoping to get another shot at playing with. Hailey's arc continues to progress in subsequent seasons, but it was a smart choice *not* to give her what she wants in the pilot.

A WINDOW ONTO A NEW WORLD: SWITCHED AT BIRTH

Another example of story that generates more story is in *Switched at Birth*, which ran on Freeform (formerly ABC Family) for five seasons. *Switched at Birth* was created by Lizzy Weiss, the screenwriter of the surfer-girl movie *Blue Crush*. In her 2012 article, "Seen But Not Heard," Emily Nussbaum, television critic for *The New Yorker*, wrote:

> The show is rarely discussed among the TV digerati, possibly because many people assume from the title that it's an exploitative reality show. It isn't—it's fiction—but the premise is just what it sounds like: Two teenaged girls discover that, as babies, they were switched in a Kansas City hospital, probably by a nurse. The situation becomes a local scandal. Yet the show doesn't approach that splashy premise as camp, but it mines it instead for sly, existential insights. When Switched at Birth *hits its groove, particularly in those silent exchanges between Daphne and Emmett, whose timing has never allowed them to be together, but whose unconsummated love feels like the show's long game, its undertow is as strong as anything on TV.*

Daphne and Emmett have those silent exchanges because they are deaf; it was layering in this characteristic that proved to be the story tentacle—and centerpiece—of the show.

Nussbaum writes about *The Deuce*, *Breaking Bad*, *Scandal*—the highest-quality television shows—so I took what she said seriously and ended up checking out all the episodes. Lizzy Weiss is a super-talented writer I worked with years ago on another show. When she came to speak with my class at UCLA, she explained that the deafness was not part of her original conception but instead came from a network note, which she instinctively knew was a fascinating element to explore. The smart showrunner/creator knows not only how to take a smart note, but how to transcend it.

In the show, Bay (Vanessa Marano) is a high school girl from a privileged family who lives in a wealthy, Kansas City suburb. In the pilot—via an economical teaser, in which everything happens quickly—Bay's science classmates are doing a blood test to determine blood type. She comes home and tells her parents and brother

what her blood type is, but her parents are confused, because that doesn't fit. It's not their blood type, and this starts to make Bay wonder why she doesn't look like her parents. In fact, she's always felt as if maybe something was wrong. She does a little research and convinces her parents they should do a DNA test. Sure enough— again, it's all in the teaser—it's confirmed: Bay is not their daughter. They must have taken the wrong baby girl home. They go through the hospital records and contact the mother of Daphne (Katie Leclerc), the other girl. When Bay meets Daphne, Daphne's with her mother Regina (Constance Marie), Bay's with her parents and we discover that Daphne is deaf. And she's been deaf from a young age, because of spinal meningitis. End of teaser.

So the revelation about the DNA test is what brings Daphne, Bay and the families together and is the catalyst that jumpstarts the show. But, as soon as the story reveals Daphne is deaf, it opens up the world to further story possibilities. It's a story that we as audience have not seen before on TV and it's fascinating. *Switched at Birth* isn't just a show about a deaf girl who's comfortable being deaf and has adapted well to the world; it's also a show about socioeconomic status and entitlement. Daphne's single mom Regina is a recovering alcoholic and addict; Daphne's Italian dad left them because he thought Regina had cheated, as baby Daphne looked so different to them. She grew up without her father and essentially learned to do without. She goes to an all-deaf high school. Her mother works hard just to put food on the table, just scraping by. Daphne's grandmother also lives with them. On the other hand, Bay's family, who are well off, live a privileged lifestyle and send her to an elite private school.

The show also thematically brings up the idea of normalcy. When Bay's parents discover Daphne is actually their biological daughter, they have the money and could provide her with cochlear implants, so that she could hear. Daphne's mother is resistant. She says she loves her daughter the way she is and doesn't need to fix her. She also resents that the "perfect family," the mom and dad with all their money and privilege, are going to disrupt their lives and try to "rescue" her. Daphne's mom is Puerto Rican, and her Latina grandmother has always felt as if they were outsiders, that they had to work harder and prove themselves. We also have the legal issue of who will get custody of the girls, when the DNA test proves that Daphne is Bay's parents' biological daughter (and Bay is Regina's). Bay's father gets into an argument with Daphne's mother, because she's so resistant to him providing Daphne with every advantage he would like to be able to grant her. He gets pushback from Regina. In later seasons, we see how this all plays out, but early on, we wonder: Will Bay's parents push for custody of their biological daughter?

At its core, the show is about nature vs. nurture. Biologically, the kids were switched. How much of who we are comes from genetics? How much from how we were raised and nurtured? The central question of the show is around this blended, unexpected family that is brought together by the switch. By the end of the pilot, Daphne, her mother and grandmother move into the guesthouse of Bay's family. (If you're thinking a little cottage, you'd be wrong. Their guesthouse is more palatial than most people's main houses.) So they all live, although not quite under the same roof, on the same property. We also have the war between past and present. There is friction between the two moms, over what's right for each kid. Bay is a rebellious artist—we discover in the pilot that she puts up graffiti images around the community and pretends she doesn't know who's doing it. But we know she's the one and start to see that she's rebelling against her parents and the pressures of her privilege. She wants to be freer, more artistic and bohemian and finds this with her biological mother, whom she didn't even know she had. Again, this creates more story around Bay, as she explores that side of herself which she feels is her true nature. Now it explains to her why she felt she didn't fit in all that time.

In subsequent seasons, what ends up happening, ironically, is that Daphne is interested in going to Bay's fancy, private school. There's tension around her wish because her mother is against it. She doesn't want her daughter to be the "deaf girl" in class, who always has to have an interpreter. She wants her daughter to be in a high school where all her fellow students are deaf, because she doesn't want her daughter to feel stigmatized in a general population, even if it's an elite private school that will provide her with the extra accommodation to be able to keep up. Then, in an act of rebellion, Bay says she wants to go to the deaf school. This creates a whole other scandal, which is a cool story. In real life, there's a university for the deaf and hard of hearing called Gallaudet, where a controversy arose when hearing students wanted to attend. The school president wanted to admit them, but the deaf students staged a protest. *Switched at Birth* paid homage to this story in one episode.

The show also cleverly plays around with forms of communication, which is another reason I recommend you check it out. There is an episode in which the characters use only sign language, as some of them start to learn how to sign. There are scenes where there's no dialogue; it's all American Sign Language with subtitles. It gives us a glimpse into a world that most of us don't know—as all great shows do—and enthralls us as viewers. We have an endless fascination with shows that "let us in" behind the scenes at the Philharmonic, or to daily life in a women's prison, or the deaf and hard-of-hearing culture. What it means to

be "normal," vs. stigmatized, what it means to feel judgment from people who assume that if someone is deaf, they're "less than," when maybe they're just different. It's a captivating show that gives us insight into and empathy with a whole other culture that lives and walks among us all. It presents a different perspective on deaf subculture than we would have had otherwise. When Lizzy Weiss pitched the story about the two girls who were switched at birth, she did have the economic differences and there was a little ethnic tension, but it was the choice to add the deaf culture that affected the show beautifully and profoundly. It's become its signature and the whole centerpiece, in a positive and interesting way.

TABOO RELATIONSHIPS IN COMEDIES

Often in comedies, there are two characters who are in love but can't be together, because of various forms of neuroses that keep them apart. The trick is always to keep them apart for as long as possible. On *Cheers*, the writers managed to keep Sam and Diane, and later Sam and Rebecca, apart for as long as possible. They knew that as soon as they got together, the show would be over. In *New Girl*, we thought it was going to be a slow-burn between the two characters of Jess and Nick, but the writers got them together before the audience is ready. In real life, there was a lot of backlash from the audience. When we write a taboo relationship, in terms of story tentacles, we need to keep the two characters apart for as long as we can. Unless bringing them together is going to *add* tension and conflict, most likely the conflict is going to dissipate as soon as their secret comes out and they admit they're in love. So, sustaining the taboo relationship is key.

In *Groundhog Day*, Phil's situation (which is a secret to everyone around him) is on repeat, but we get different perspectives, based on what the other characters learn. Similarly in TV shows, even if the characters don't have some deep, dark secret or scandalous, taboo relationship, they can learn from what's happening in their relationships. They can take their insights, epiphanies and how events influence them, then apply that knowledge to their own relationships. It all depends on what feels organic for the story. No writers should force secrets, lies or life lessons onto our characters, but if these feel true and consistent with the tone and basic idea we started with, we can marry multiple elements and open up whole new veins of gold for our stories.

POINTS OF VIEW:
THE AFFAIR

Showtime's *The Affair* is an example of how points of view create story tentacles—in this case, because the show uses a *Rashomon* style. In Season 1, we see the affair between Alison (Ruth Wilson) and Noah (Dominic West) from their two points of view. They're different: We have a classic "he said, she said." The way Noah sees Alison, from the moment he lays eyes on her when she's waiting on the family at the restaurant, the way he remembers their first encounter, is very unlike how she remembers it. There's his version of reality, her version of reality and then there's the truth. And it keeps us invested, as we wonder what's really happening.

In Season 2, the perspective expands, so we don't just get Alison and Noah's point of view, we also experience that of Alison's husband Cole (Joshua Jackson) and Noah's wife Helen (Maura Tierney). And as we enlarge the perspective, we continue to generate richer story, because we see the same situation, much as in *Groundhog Day*, from a different point of view and agenda. The *Rashomon* style of seeing the same event—this affair that takes place during a summer in Montauk—from multiple different perspectives, lends itself to more story as it unfolds.

ENSEMBLES AND BACKSTORIES

When we conceive an ensemble, we can look at what characters do for a living as well as what they do outside the workplace. Even if it doesn't enter into the storylines, it informs who they are, what their priorities are, how they think about life both in and outside the office. We can then make those story choices that bring in more choices. *The Office*, *Parks and Recreation*, *Modern Family* and *Community* are all solid examples of story-rich ensembles. In *Community*, each character comes into the college with a backstory that's nuanced, so even though we spend our time in the study room at the college, we have places to go when we need to expand the story.

When we conceive a series, early in the process, we need to create such options as much as possible. We have to consider what's going to be a dead end, versus what's going to give us more story, then always choose the second option. That may require digging into the premise of the show, plus it may mean combining characters or tossing a character out who's not going to generate enough story. When we're in the writers' room, in the 4th or 5th season of our show, after already having created numerous episodes, we'll still be looking for more story. It's beyond

helpful to start the show on the strongest possible footing, from where we have as many exciting places as possible to go.

WHEN A FLAW BECOMES AN ASSET: *GIRLS*

HBO's controversial, love-to-hate-it, hate-to-love-it show *Girls* introduces numerous character quirks and flaws as story tentacles in its first season. These run right through to the end of the series, six seasons on. They include:

Career Insecurity

(Hannah/Jessa/Marnie/Shoshanna/Adam/Elijah/Ray)

- Will Hannah (Lena Dunham, also the show's writer, director and producer) ever be a successful writer?
- Will Jessa (Jemima Kirke) get her shit together for long enough to stick with any career?
- Will Marnie (Allison Williams) get beyond the "I'm an artist who doesn't know what my art is" phase and make it as an arts professional—or later on, as a singer?
- Will Shoshanna (Zosia Mamet) find a job she loves that she's also good at?
- Will Adam (Adam Driver) and Elijah (Andrew Rannells) make it as successful actors?
- Will Ray (Alex Karpovsky) get beyond his "failure to launch" and figure out how to apply his talents to paid work?

Planting these seeds of goals, doubts and limitations in the first season continues to bear fruit throughout the entire series.

Relationship Insecurity

(Hannah/Jessa/Marnie/Shoshanna/Adam/Elijah)

- Will Hannah/Jessa/Marnie/Shoshanna/Adam/Elijah find lasting love, without screwing it up?

For all the characters' self-destructive behavior around love, sex and relationships—at times conscious, sometimes unconscious—it is their norm. Their poor choices (and sometimes karmic ill treatment by their other halves in relationships) lead to awkward, painful story tentacle after story tentacle. They crescendo to the show's pinnacle of heartache for Hannah, when Jessa gets together with Hannah's ex, Adam. Instantly, narcissistic Hannah sees it as both the loss of her best friend and any chance of future happiness with her one true love. It's all about her—forget the happiness of two people who didn't plan to fall in love.

Selfishness and Narcissism

(Hannah/Marnie; to a lesser extent, Jessa/Adam/Elijah; to a lesser extent still, Shoshanna/Ray)

In life, people don't change, right? That's certainly true of the four girls, plus the three guys, but some eventually grow up and self-actualize more than others, namely Shoshanna and Ray. In the penultimate episode of the series, Shoshanna calls out the three other girls on their narcissism; they realize, caught in inertia and unable to change, that she's right.

Anxiety

(Hannah/Shoshanna)

From more serious episodes such as Hannah's OCD to Shosh's lost-in-translation episode in Tokyo, anxious feelings run throughout the series. Hannah also has regular bouts of anxiety and doubt and feels out of her depth when she gets pregnant—and, in the series finale, when she has a small, hungry baby who refuses to breastfeed.

Hypersensitivity to Parental and Societal Expectations

(Hannah/Marnie/Shoshanna/Ray)

The story tentacle of Hannah's baby boomer parents cutting her off financially in the pilot is the gift that keeps on giving, as she struggles to find her way as a writer. The show comes full circle in the final season, when her mom Loreen (Becky Ann Baker) flies high on edibles and eventually throws up on the table at a busy

Chinese restaurant—bucking all societal expectations of the mom of an adult child. Growing up is hard to do, and we all reach adulthood and self-acceptance in our own way (or sometimes, never).

Naturally, *Girls* serves up all this angst with a good sense of humor. There are also characters who become story tentacles, especially Elijah, who is first introduced as Hannah's gay ex-boyfriend but ends up being her roommate and one of her closest and most trusted friends. He becomes a regular cast member with numerous storylines of his own, from rejection in love to career doubts. Then there are Hannah's parents, Loreen and Tad (Peter Scolari), who end up creating the ultimate plot twist that rocks Hannah's world (again, it's all about her) when *he* comes out as gay. Loreen's difficulty in coming to terms with how her life changes is heartbreaking, but it all ends on a hopeful note when she too self-actualizes and imparts her wisdom about finding happiness to Marnie, who has put her life on hold to help out Hannah for a while. "I don't need to be happy. It's just not my time. This is important. Hannah's my best friend," Marnie recites to Loreen. "Has it ever occurred to you that the best thing for you and your friendship would be if *you* were happy too?" Loreen counters.

Love it or hate it, the show has secured a place in television history, as a microcosm of New York life for post-college twenty-somethings of a certain social milieu in the early 21st century.

THE MACRO/MICRO APPROACH:
THE YOUNG POPE

The Vatican is a paradox: It's a tiny, isolated, particular place that also has far-reaching international impact. By exploring this dichotomy, *The Young Pope* expands the initial premise set up in its first few episodes into various and fascinating nooks and crannies of the Catholic Church. The setup for HBO's stylish series finds a young and rebellious new Pope at the church's helm. At first, viewers watch as this new, stricter Pope Pius XIII (Jude Law) sends waves through the Vatican. The reverberations are felt by every member of the institution. Almost immediately, Cardinal Voiello (Silvio Orlando), Cardinal Michael Spencer (James Cromwell) and others start making power moves to unseat the king.

But as the season moves on, creator Paolo Sorrentino expands the impact of the new Pope globally. Sorrentino is able to examine the history of molestation in the Catholic Church, by dispatching Cardinal Gutierrez (Javier Cámara) to investigate

suspicious behavior by Archbishop Kurtwell in New York. Gutierrez speaks with victims, all the while haunted by his own abuse as a child. At the same time, *The Young Pope* turns inward to analyze Pope Pius' own crisis of faith. We see Pius alone, praying for God to reveal himself. The series also does an excellent job of painting a vivid image of the world inside Pius' head through flashbacks and hallucinations. This micro/macro approach allows the series to tell both personal tales, while also commenting on a centuries-old institution—allowing for countless story possibilities in the future.

GAME OF THRONES

The Ultimate Story Tentacle Show?

Eight years after the conflict for the Iron Throne reignited, HBO's phenomenal series appears to be nearing its conclusion. But based on its global fan base, we can absolutely expect *GOT* spinoffs and revivals in the near future. You can't keep a good dragon down. With its enormous cast (one of the biggest ensembles of any TV show, ever), its characters are not only addictive to watch, they've proven to be numerous story tentacles themselves. What's ingenious is that creator George R.R. Martin and showrunners/writers/adapters David Benioff and D.B. Weiss utilize the strategy of pruning back stunted or less vital plot branches in order to encourage dynamic and surprising new growth that can span across seasons.

Most shows try not to burn through plot too quickly by keeping characters and storylines going for as long as possible. But *Game of Thrones* has the confidence to remove anyone, even a group, or have someone disappear for seasons, which each time sets up a whole new set of tentacles and possibilities—and introduces compelling new characters. It means that the series is consistently reinvigorated, like mini reboots each season. The writers never drag out unnecessary storylines and understand it can be an advantage to close doors, as this then results in more doors opening. Meanwhile, the thrill for the audience, as loyal viewers already know, is that anything can happen at any time.

Game of Thrones is a huge and sprawling show, so here are just a select few examples (at press time, ahead of Season 8):

- **Revenge begets revenge**. In the pilot, life is good in the North (if you don't count the looming threat of the undead "White Walkers" from beyond The Wall), until the arrival of King Robert Baratheon (Mark Addy). Baratheon seeks Ned Stark's (Sean Bean) help in running his kingdom. Of course Ned can't refuse, but Robert's reptilian wife Cersei (Lena Headey) loathes the Starks; we sense there's a long history there. Her plotting results in both her husband's and Ned's demise. The vultures circle around the weakened Iron Throne, occupied by a teenaged heir, while the Stark family vows for revenge. These two story tentacles see us through to the final season.
- **The more personal, the better**. The notorious Red Wedding in Season 3 kills off principal figures in the Stark family, thereby creating numerous story tentacles: upping Arya Stark's (Maisie Williams) quest for revenge (she's still working through her kill list, seasons later), later resulting in a full-scale battle in Season 6 between the Starks and the treacherous Boltons, who are among the architects of the massacre. And despite the Stark win (with the help of Littlefinger, played by Aidan Gillen), Littlefinger's constant plotting and disapproval of all leadership in the North besides that of himself and his obsession, Sansa Stark (Sophie Turner), has consequences in Season 7.
- **Change the rules of the game**. The King in the North is actually the second iteration of Jon Snow (Kit Harington). The Night's Watch, protectors against the White Walkers, kill Jon in the Season 5 finale, feeling threatened by his alliance with the Wildlings. The Red Woman, Melisandre (Carice Van Houten), identifies Jon's potential for real leadership and uses magic to bring him back to life. Her actions transcend the laws of time and space. Anyone can come back now, right?
- **Keep us guessing**. Gendry, King Robert Baratheon's bastard son (Joe Dempsie), whose existence is discovered by Ned Stark and ultimately leads to Ned's execution, is not heard of for almost four seasons. When innocent Gendry is imprisoned by his uncle, Stanis Baratheon (Stephen Dillane)— who plans to make a ritual sacrifice of Gendry in order to strengthen Stanis' campaign for the Iron Throne—"good guy" Ser Davos (Liam Cunningham) secretly releases him. Near the end of Season 3, Davos gives Gendry a rowboat, supplies and instructions for survival. In subsequent seasons, one by one, Stanis and all the other known Baratheon children die, but Gendry's whereabouts remain unknown until Season 7, Episode 5. Given that he is a rightful heir to the Iron Throne, might he still have a significant part to play?
- **Reverse our expectations**. Cersei survives the death of her three children, born of incest with her twin brother, Jaime Lannister (Nikolaj

Coster-Waldau). For a long period, she passes off her children as the late Robert Baratheon's heirs. But her enemies' revenge killing of her teenaged daughter, Marcella (Nell Tiger Free) and the suicide of her younger son, Tommen (Dean-Charles Chapman) are both her own fault; he jumps out of a window, grief-stricken at the death of his beloved wife Margaery (Natalie Dormer)—whose demise Cersei masterminded. She (and we) did not foresee Tommen's suicide, and she's naturally distraught. Nevertheless, her grief results in a story tentacle: She seizes the Iron Throne for herself. And why not—his death can't be meaningless, right? Cersei's love for her children was her one redeeming quality; now, there's nothing left but malice. After she crowns herself Queen, we see a brief glimmer of humanity when she reveals she is pregnant again, but her breaking of a vital pledge costs her the respect of Jaime, her one true ally. His arc has been surprising too, from the legendary "Kingslayer" of the first seasons to a man who seems to have developed scruples. Now out on his own, might Jaime even end up allied with Brienne of Tarth (Gwendoline Christie), who's loyal to the Starks and is a woman he truly respects (and may love?)

- *Take time for our protagonists and antagonists to meet*. There's nothing like anticipation (with a few good bits of revenge along the way). Former official enemies, Daenerys Targaryen (Emilia Clarke) and Tyrion Lannister (Peter Dinklage) have killed many on their path, including family, which eventually leads to their meeting in Season 5, when they start to form an alliance. Dany only meets her real nemesis, Cersei, in Season 7. And Dany, the Mother of Dragons, has two new, unintentional rivals much closer to home, of whom she remains blissfully unaware. There's still plenty happening in the show and the pace doesn't compromise the storytelling; rather, the crescendo builds satisfyingly.

As always, the most satisfying plot reversals are the ones we should have seen coming—but didn't. Each carefully earned plot twist keeps us tuned in for more. And the sooner the better.

THE UNRELIABLE NARRATOR: MR. ROBOT

Mr. *Robot*, on the USA Network, started as an anomaly: a subversive, dangerous and edgy show on the Blue Sky network. It was USA's first foray into riskier programming. When we start watching the show, we think it's

about a cyber hacker named Elliot Anderson (Rami Malek). On the surface, we would think he's an incredible tech genius, who happens to be obsessive compulsive; he is also a loner and misanthrope with a drug habit. He hates corporate power; we know his father died, and he blames the evil "E Corp" for it. He always strives to bring down people who are duplicitous, corrupt and greedy; he has a major axe to grind. What's fun about the first episodes is that we get to see how one guy, with pervasive cyber knowledge, can potentially have a huge, global impact on the world economy, much like Edward Snowden.

What we discover is that Elliot suffers from mental illness. He's a little bit of a sociopath, a little schizophrenic. Sam Esmail, who created *Mr. Robot*, has described Elliot's condition as a dissociative personality disorder. What that essentially means is that Elliot, for all his brilliance, is disconnected from reality. He hallucinates, there's a presence in his life he imagines, he doesn't remember things he's done, he isn't sure what's true and what's not. He's an unreliable narrator, who talks to us in voice-over throughout the show.

If we were pitching *Mr. Robot* to someone who's yet to see the show, we could say: It's about an aggressive, morphine-addicted cyber hacker who joins a rogue group of cyber bandits, and together they plan to bring down the largest, most unscrupulous corporation in the world. It's almost a reverse heist/Robin Hood story. What we will learn is that a great deal of what we see unfold, outcomes that Elliot causes, may not have happened. We are then thrust into an existential crisis as an audience, because we discover that our protagonist/narrator/antihero, who we've been rooting for and feel connected to, may have imagined the whole thing. And we don't know what to think about him at the end—we're completely confused, but in a good way. This leaves us wide open for Season 2 and beyond in terms of Elliot's disorder, what's real, what's not and what the impact will be, going forward.

It's a major story challenge for Sam Esmail and his team, because they write themselves into a corner by the end of Season 1. Fortunately he's a brilliant storyteller and they figure their way out. When Esmail first pitched the story, he explained that he wanted to write a show about a character with dissociative personality disorder. He described a show that's designed around a character we *think* we know in the beginning, but by the end of the season realize we didn't know at all. Season 1 of *Mr. Robot* ends on an exciting note: Everything has been wiped, and it's all set up to be a reboot of the whole show in Season 2.

Story tentacles give us lots more places to go with story in terms of our perception and reality, such as in *Homeland*, which had a whole reboot in its 5th season. If we create a show that feels like it might be a limited series, but we plant enough seeds

that we're able to give the show new life each season—so it's the same show but different—we will have done our job. Our shows will emulate *Groundhog Day*, where it's the same day and yet different, and as the story grows, it deepens and expands in an unexpected manner. We can look at story tentacles as strands of longevity that we can draw upon and pull and braid with other story tentacles. Then we'll be able to continue to tell great stories for hopefully 80–100 episodes— or for as long as we desire.

◉ Bonus Content

Further analysis on story tentacles, including **Breaking Bad**, **Scandal**, **Mad Men** and **Taxi** plus the **Switched at Birth** pilot teaser are at **www.routledge.com/cw/ landau**.

See also: *Brooklyn Nine-Nine* (on Fox); *Veep* (on HBO); *Shameless* (on Showtime); *Ray Donovan* (on Showtime); *Catastrophe* (on Amazon); *Archer* (on FX); *Billions* (on Showtime); *Love* (on Netflix); *Vikings* (on History); *Gotham* (on Fox); *Agents of S.H.I.E.L.D.* (on ABC).

"You've got to make some noise and you've got to be brave. I like weird. I like to make bold, bat-shit crazy stories that no one else will touch."

—RYAN MURPHY
EXECUTIVE PRODUCER/CREATOR/SHOWRUNNER/DIRECTOR
AMERICAN HORROR STORY, THE NORMAL HEART
THE PEOPLE V. O.J. SIMPSON: AMERICAN CRIME STORY
FEUD, GLEE, NIP/TUCK

CHAPTER 6
SPOTLIGHT ON
A REBEL

Ryan Murphy Reinvents the
Mini-Series by Embracing
His Inner Outsider

As a gay teenager growing up in Indianapolis, Ryan Murphy always felt like an outsider. And yet, even though he felt he'd never be the prom king, captain of the football team or student body president, he felt a need to fit in—on his own terms. Visiting UCLA School of Theater, Film, and Television in March 2017, just prior to the launch of his latest limited series, *Feud*, Murphy admitted, "Everything I've done can be distilled down to ambition."

On the business side, his ambition was the gateway to power and prosperity. On the personal side for Murphy and his myriad cast of characters, ambition is the prerequisite to earning respect, acceptance and love. It's the ticket to their dreams. And Ryan Murphy dreams BIG. Even as a Catholic altar boy, Murphy's ambition wasn't simply to be accepted by the church. "I wanted to be the Pope," he says with a laugh. Ironically, ambition is also the Achilles' heel of most of his characters. If you don't play, you can't win. But that doesn't mean the game isn't rigged against you. Therein lies the paradox of his sensibility: Outsiders determined to be insiders while remaining true to themselves.

WHY CAN'T I BE
AUDREY HEPBURN?

Murphy began his writing career as a journalist, always on tight deadlines and just scraping by financially; he developed his work ethic based on basic survival. If he didn't meet his deadlines and post a story, he didn't eat. Before he became one of the most prolific, iconoclastic, powerful showrunners in

Hollywood, Murphy couldn't afford the luxury of being an outlier/provocateur. But when his very first screenplay, a romantic comedy entitled *Why Can't I Be Audrey Hepburn?*, sold right out of the gate to Steven Spielberg, Murphy got a taste of being Hollywood's "it boy." Soon enough, however, those delicious, dizzying highs led him into the trap of Hollywood development hell. Even though *Why Can't I Be Audrey Hepburn?* never got produced, it propelled Murphy into working on other rom-coms, including his stint on the ill-fated romantic comedy with a gay twist, *The Next Best Thing*, starring Madonna and Rupert Everett. While Murphy concedes the agony and ecstasy of working with Madonna, he knew he'd never be satisfied being pigeonholed as a rom-com writer when he'd only written one screenplay. "You should never listen to anyone who wants to put you in a box," he reflects. He also knew that as a screenwriter of movies, a medium in which the director is king/queen, he was disposable and powerless.

It's the opposite in series television. In TV, the creator/writer/executive producer (a/k/a showrunner) calls all or most of the shots. Murphy could thereby embrace the themes that most resonated with him. His foray into television was the wry, edgy teen soap, *Popular*, which aired on the now-defunct WB network. Murphy had other options, but he gravitated toward The WB (an early iteration of what has evolved into The CW) because *Popular* felt like a good companion piece to The WB's other hits, *Dawson's Creek* and *Felicity*. Or at least that's how it looked on the surface. But while *Dawson's Creek* and *Felicity* earnestly explored high school and college teen angst, *Popular* was designed to subvert the tropes of the coming-of-age drama series. On the surface, these series fit into the same audience demographic and genre, but only *Popular* had a dark underbelly of satire. Murphy wasn't interested in celebrating and honoring a world in which he didn't fit. A more apt title for his first series might have been *Unpopular*. Or *Pretty Ugly*. To Murphy, the joke was on The WB; they thought they were making yet another teen soap, but Murphy's aim was to make fun of their other shows through heightened style and wry subtext. His first series taught him:

> ## *Tone is everything in television.*

While *Popular* only lasted two seasons (spanning 43 episodes from 1999–2001), it served as Murphy's crash course in, not only running a writers' room, but also in being supervising producer and co-showrunner. Coming from a background in journalism, Murphy was remarkably adept at investigating how all the moving parts of the writing and production machine coalesced. Yes, he was interested in exploring the lives of outsiders in high school, but he also had other obsessions

that excited his artistic soul: from casting and production design, to music choices and marketing. He not only became a master storyteller, but also learned how to make an ambitious TV series on budget and on time. He learned how to fight back against Standards and Practices at The WB network and that, if he was going to devote his life to making a TV series, it had better be something that resonated with him on a deeply personal level.

Popular challenged him to reconcile his ambitious desires with his artistic needs and cemented his subsequent career trajectory. He loved the medium of television, but his aim was not to follow a network mandate. It was to be a disruptor. So rather than conform to Hollywood's expectations of him, he acted from his outsider instinct and did just the opposite. He "leaned in" (his current favorite expression) to societal and cultural taboos and eschewed the mainstream in favor of reviving moribund genres and subjects. Whether it's high school cheerleaders and glee club or classic "old" Hollywood films, Murphy's work is about reconciling and revisiting the past. As he points out:

> ## "The key to my success is trying to reinvigorate a genre that's dead."
> ## —Ryan Murphy

He casts actors that Hollywood has written off as old or out of vogue (John Travolta, Jessica Lange, Cuba Gooding, Kathy Bates) in leading roles. He refers to his approach to luring these stage icons into series television as "talent seduction," and it's all about conveying to actors that he intends to put them in roles they'd never see themselves doing. He approaches each screen legend as a genuine fan and then encourages them to shake up their comfort zones, to do the opposite of what everyone may expect of them.

The same holds true to the way he's built his movie and television empire. Murphy chooses a new project, in part, by the desire to pivot 180 degrees away from its antecedent. Follow a show about high school cheerleaders with an adult *bromance* set in Miami in the plastic surgery industry, toss in the taboos of pedophilia, drug dealers, and envelope-pushing gore and sex scenes, and we have Murphy's breakthrough series, *Nip/Tuck*. His tonal influences were Mike Nichols' classic relationship roundelay, *Carnal Knowledge*, along with some stylistic flourishes borrowed from Stanley Kubrick. Murphy was so convinced he had to shoot the

Nip/Tuck pilot on 35mm film that he paid for the film stock out of his own pocket. He didn't just want to pivot from a difficult, oppressive experience on *Popular*; he wanted to reinvent the look of a TV series—which dovetailed perfectly with FX's brand sensibility not to make anything that could air on a traditional broadcast network.

Nip/Tuck's signature opening line in every episode's teaser, "Tell me what you don't like about yourself," sets the tone and theme of this groundbreaking, controversial series. It also hit the sweet spot of Murphy's outsider themes—but now he was dealing not with coming-of-age, but with *aging* in a youth-obsessed culture. While the characters in *Popular* couldn't wait to grow up, the patients and doctors on *Nip/Tuck* were afraid of growing old, of being unlovable, of being abandoned.

> ## The more specific you make something, the more universal it becomes.

Even though *Nip/Tuck* is a show set in a specific, elite world, Murphy intuitively grasped, paradoxically, that the more specifically he delved into a character's perceived deficiencies, the more universal his or her woes would become to the audience. Is there a human being alive on the planet who *doesn't* "not like" *something* about him or herself?

He got this now iconic line of dialogue, verbatim, from a doctor when he was researching the world of plastic surgeons. As a gay man who's never been thrilled with his own physical appearance in the age of Calvin Klein model perfection, Murphy hit pay dirt by tapping into our collective dissatisfactions with body image and aging, coupled with the glamor and wish fulfillment that anyone can be beautiful and sexy if they have enough money. The tone is as sharp as a scalpel. Murphy wasn't interested in writing a morality tale. *Nip/Tuck* isn't a cautionary treatise on the pitfalls of vanity. For Murphy, it is a heterosexual love story: two rich, successful, straight men who negotiate the power dynamics of a marriage through their partnership in their medical practice; as a gay outsider, this is what interested Murphy most. He was writing as a means to get inside the psyches of powerful, entitled, white alpha males. But Murphy was also doing something more trailblazing in the TV business. He was bucking an established genre: the medical procedural drama, one of the most stalwart stables of the broadcast television networks, from *Marcus Welby, MD* and *ER* to *Grey's Anatomy* and *House*.

Audiences were accustomed to watching shows about eternally well-intentioned doctors diagnosing and curing. Healers with complicated love lives. But *Nip/Tuck* was about plastic surgeons who performed elective surgery for profit. They rarely, if ever, tried to talk a patient out of a surgical makeover. It was a show that worked against the grain of the Hippocratic oath; it wasn't "First, do no harm." It was stoking their patients' insecurities, promising superficial perfection with no money-back guarantees, while never promising that the surgery would lead to fulfillment. Their job wasn't to make patients get well but to feel better about themselves. But Murphy also understands that obsession only leads to more obsession. Beauty isn't only skin-deep; it's also ephemeral.

Ryan Murphy has built an empire based upon characters striving against impossible odds to stay on top. To retain their fleeting fame. To never wake up from the American Dream. He writes stories about postponing the inevitable. If *Nip/Tuck* espouses anything absolute, it's the law of gravity: What goes up, must come down. Nothing lasts forever.

American Horror Story also has its roots in the shame of body image. The horror genre itself emerged from adolescents being horrified by the changes in their bodies, from acne to errant hairs sprouting up, from metabolisms slowing down and the difficulty to stay fit and adorable through awkward growth phases, when size and thighs seem to matter most. As adolescents, we all strive to fit in and belong, and when we stumble or fail, we find ourselves relating to Stephen King's *Carrie*. If only we all had telekinetic powers to bring down those pig's-blood-spewing pranksters at the senior prom.

Murphy recognizes that we all have our dark sides but also that the key to success is not to pit hero against villain, but to pit outsiders against those who seek to persecute and oppress them. In Murphy's case, he considers himself the outsider and the Hollywood studios and networks the oppressors. One would presume that, with Murphy's track record and stature in show business, he can do whatever he wants. But not everything he proposes to FX and Fox execs is an automatic green-light. Ryan Murphy has to endure rejection, too. Not everything grows into a phenomenon. *Scream Queens* was a disappointment. And other pilot pitches failed to launch—which only serves to galvanize Murphy's restless creative spirit and ambition.

> *"No" is just a rest stop on the road to "yes."*

He convinced Jessica Lange to do a TV series, despite her apprehensions, by telling her he wouldn't take "no" for an answer and by promising her he'd move heaven and earth to make the production schedule work for her needs. Thus, a temporary roadblock to securing the Academy Award-winning legend helped shape the parameters of Murphy's winning business model for reinventing the TV mini-series.

If Jessica Lange didn't want to commit to a traditional TV series order of 22 episodes, Murphy would scale the order back to ten episodes per season. That, in itself, was a revolutionary, game-changing approach to bringing movie stars into the TV series business. But Murphy had another strategy in mind that would subvert the audience's expectations of a TV series while surreptitiously transcending them. Murphy isn't solely a showrunner; he's also a *showman*. He has an uncanny barometer for pleasing an audience by *not* giving them what they want or expect. He's not calculating and deliberate in this strategy; it's simply his instinct. If something has been done a certain way for decades, he's not trying to conform. His instinct is to turn convention on its head and do the exact opposite.

When *American Horror Story: Murder House* first premiered on FX in 2011, the audience presumed it was an edgy but "regular" TV series, akin to a show such as *The Walking Dead* (another big influence on Murphy). In *AHS*, each week, as the thrills and chills continued to escalate and become more perverse, all the while paying homage[1] to classic horror movies for the younger, uninitiated viewers (from *Rosemary's Baby* and *The Exorcist* to *The Shining*), audiences kept wondering: How the hell is this show going to sustain for multiple seasons? Our built-in expectations of a weekly TV series provided us with the presumption that a successful ongoing TV series must sustain. *American Horror Story* debunked that convention at the end of Season 1 when everyone died and the (haunted) house burned down.

As viewers, we were stunned. How could that happen? Hadn't Mr. Murphy and his writing/producing partner, Brad Falchuk, written themselves into a corner? How could a haunted house/exorcism story go on with no cast and no house? Now *this* was groundbreaking television. Everything about this Season 1 finale felt wrong—except that it was all by design. This scorched-earth surprise ending was daring, diabolical and mind-blowing. Social media message boards exploded. Everyone was talking about it. Murphy's gambit paid off. He had the most buzzed-about show on the air, and no one knew what could or would happen next. Was this a one-off mini-series? Was it all just a dream and Season 2 would reveal that they were all alive and ready for the next round of latex bodysuits and supernatural

bloodbaths? Like his oeuvre or not, herein lies Ryan Murphy's genius: He provokes and tantalizes us to want more, but he never delivers what we're expecting. That's a given for any showman (or woman).

Use limitation as an opportunity and differentiator.

After the success of *Glee* for the Fox network—which was his customary pivot to the polar opposite of his previous venture (*Nip/Tuck* for FX)—Murphy grew weary of the standard 22-episode order. So when he was able to coerce Jessica Lange into doing a TV series by promising a short-order series, he was also alleviating his own sense of restlessness and obligation by voluntarily selling FX on the idea of a *limited* series. Back then, TV showrunners were all about getting the *largest* number of episodes possible to be green-lit by the network. Bigger orders translate into bigger salaries for the writers, producers, actors—everyone, as well as the stability of more work. Bigger orders also offered the promise of lucrative syndication deals when a popular series goes into reruns.

For decades, the TV business' profitability was entirely based on a deficit-financing model. Up until a given series could bank 80 to 100 episodes, the licensing fee paid by TV networks to the studios would never fully cover production costs. And so the TV studios/production companies would always produce the show at a loss, and it was only the promise of a future syndication deal that yielded big profits. But, as we all know, the TV business has radically changed into an on-demand ecosystem. Streaming and premium cable networks operate not from advertising revenue, but on a steady diet of monthly subscription fees paid by viewers. HBO pioneered this subscription model with their original series, first with *Oz* and later with *The Sopranos* and *Sex in the City*.

Netflix then bested HBO by circumventing the pilot process and green-lighting a show straight to full series order. Netflix also rejected scheduling their series into rigid (linear) timeslots and offered an entire season of a show all at once—which inadvertently gave us the term "binge viewing" (a term that Netflix doesn't embrace because it sounds like an eating disorder). Nevertheless, with viewers now in control of when, where and what to watch, overnight Nielsen TV ratings have become obsolete, and traditional syndication revenue streams have also been impacted. Yes, there are still TV series that make 22 (or more) episodes per season and will score substantial syndication deals from what were once known as "second window" streaming services (such as Hulu). But the TV content landscape

has changed so significantly that the metric for a syndication payday has diminished from the requisite 80 to 100 episodes to as few as 6 episodes.

Yes, that's right. Six episodes. In an on-demand TV ecosystem with (at this writing) over 450 scripted series across multiple platforms, no sentient human can possibly watch everything. There's just too much content to consume. Personally, I don't view too many choices as a bad thing—and that's the secret sauce in a powerhouse operation such as Netflix; they needn't worry about overnight TV ratings. What they must do is keep their monthly subscribers satisfied with something new to watch—constantly. Something "new" may constitute a Netflix original series (*Marseille, El Chapo, Marvel's Jessica Jones*), or it may constitute an episode of *Breaking Bad* for those Netflix subscribers who may have missed its first run on AMC. In this way, anything old can be new again as long as the subscriber hasn't seen it before. It's new to *them*. As *Breaking Bad*'s creator/showrunner Vince Gilligan himself pointed out, they didn't get much traction when they first aired on AMC. "Netflix was our lifeline," Gilligan declares.

THE POP CULTURE JUNKIE

Murphy both follows and sets trends the way only an outsider can: With his face pressed up against the glass. He consumes culture as much as he dictates and programs to it in clever, totally outside-the-box ways. Given that *American Horror Story* airs not on a streaming or premium cable platform but on basic cable, advertiser-supported FX, Murphy knew that a 10-episode series would be an untenable business model for an ongoing TV series. Murphy is a dreamer and striver, but he's also pragmatic and knows that you don't build an audience by killing off all the regular characters at the end of the already attenuated first season. And how many TV studios are likely to burn their main location down to the ground? *Who does that?*

Ryan Murphy had to turn "no" into "yes." The story of his life. So, he came up with a new business model: the limited anthology series.

THE LIMITED ANTHOLOGY SERIES

- Instead of an unsustainable one-season wonder, what if *American Horror Story* could be the umbrella to a new form of anthology series in which each

season would continue not with the same story, but on the same *theme*? The common denominator would be the genre: horror. The opening credits would use the same (chilling) music and (unsettling graphic) imagery to provide a sense of cohesion for the audience. But each season would tell a new horror story set in a new US city and/or different time period. *Murder House* was set in 1978 and 2011 in Los Angeles; *Asylum* was set in 1964 and 2012 in rural Massachusetts; *Coven* took place in both 1834 and 2013 New Orleans; *Freak Show* was entirely set in Jupiter, Florida, in 1952; *Hotel*, present-day LA; and *Roanoke* in present-day North Carolina, with reference points back to the notorious Roanoke Colony mass disappearance, circa 1590. The seasons utilize flashbacks to establish series mythology and backstory.

- Rather than starting over with a whole new cast of characters, what if Murphy invited back several of the same actors in repertory fashion, akin to the films of Orson Welles, Woody Allen and Christopher Guest? They'd be playing entirely different roles, but the audience would still be satiated with one of the main staples of series television: familiarity. It would also be fun to see such famous faces—Lange, Bates, Angela Bassett and the then up-and-coming Sarah Paulson—playing different roles. The idea of using the same repertory company was an idea that had come and gone. "It was dead, moribund. It fascinated me," says Murphy.

- Many of the actors would play all-new roles, but they would stay on Murphy's theme of exploring outsiders. To invigorate his blossoming mega-franchise (*AHS* has already been picked up by FX through at least 2019), Murphy could also lean into stunt casting.[2] So when Jessica Lange needs a break, Lange steps out, and in steps Lady Gaga in Season 5, *AHS: Hotel*.

- Murphy is also into the idea of reinvention. Inspired by William Holden playing Joe Gillis (the drowned screenwriter narrating his own story from the bottom of has-been Norma Desmond's swimming pool) in Billy Wilder's *Sunset Boulevard*, Ryan Murphy loves the idea of taking an actor on the wane or off the Hollywood radar and casting him or her in a principal role. Using this philosophy, Murphy "just knew" that John Travolta would make the perfect Robert Shapiro in *The People v. O.J. Simpson*; to convince the network brass, Murphy even paid Travolta's salary out of his own pocket and gave up some of his back-end points. Murphy's approach to avoiding self-conscious parody when using big-name actors to impersonate real-life people is to encourage his actors not to imitate, but to "find the essence of the person." For when an actor impersonates, he/she tends to lose the emotion. "And emotion is everything."

- For further cohesion, the twitchy, disturbing, *Se7en*-inspired title sequences all use that same catchy, yet disturbing, industrial music and stylized graphics, but with different iconography for each season; these indelible title sequences

are also all about setting the right tone. As Murphy explains, it's telling the audience, "This is how you're supposed to feel, tonally, on a molecular level."

- Murphy and his team carefully embed "Easter eggs" to foreshadow not only what's to come in each season's new iteration of the anthological franchise, but also to simultaneously pay homage to past seasons. This provides the audience with an interactive component, a means for social media interaction, buzzy speculation of what's to come, increased suspense and controversy— ingredients for success in TV.

This format and formula proved to be both financially rewarding for FX by virtue of their ability to repurpose episodes on streaming networks and also by selling each full season into foreign markets, as horror is the most desired and easily exportable genre. Et voilà! Murphy had his ideal sandbox in which to play with his most personal obsessions: ambition, power, outsiders looking for love and validation. Notice the recurring theme of ambition: On *American Horror Story*, even demons, ghosts, witches, cannibals and other restless spirits seek power and dominance. In Ryan Murphy's world, everybody wants to be on top.

Now he has a bona fide franchise and an endless supply of new horror stories to explore. He's married the anthology format of *The Twilight Zone* and its 21st-century British counterpart, *Black Mirror*, with the once tried-and-true TV mini-series (*Roots*, *Holocaust*, *The Thorn Birds*) and has reinvigorated both formats into the hybridized *limited/anthology series*. HBO has tried to jump on the bandwagon with its *True Detective* limited anthology series—which was subjected to the law of diminished returns in its less successful second season, although a promising-sounding third is on the way (more on this in Chapter 2). And FX has cannibalized its own format and provided us with Noah Hawley's richly satisfying TV adaptation of the Coen Brothers' *Fargo*. I suspect we'll see more of this format for years to come.

IMPOSSIBLE = POSSIBLE

Ryan Murphy gravitates toward seemingly impossible-to-produce projects. Case in point: the film adaptation of Larry Kramer's landmark play (first performed in 1985), *The Normal Heart*. Its development languished for more than 20 years as Barbra Streisand's pet project before she let the option lapse, and Murphy fortuitously came to the rescue. Every project of Murphy's is in fact his pet project, but this was his most personal because it dealt with the devastation within the gay community from the AIDS epidemic. Murphy survived, but the losses and impact on his life were immeasurable. He considers it a miracle that he's still alive today. "I never expected to live past 32," he offers. This void has fueled his sense of

urgency to tell the stories he most needs to; he understands that time is fleeting and that every day matters.

Most writers and directors in Hollywood work as outsiders until they achieve enough clout to become insiders. But Murphy's unprecedented success has come from embracing his outsider status. What is arguably his greatest career achievement to date, *The People v. O.J. Simpson: American Crime Story*, came to fruition when, after six seasons of *Glee* (2009–2015), Murphy asked his longtime agent Joe Cohen at CAA to send him the best projects he's ever read that can't ever seem to get made.

When he first read the title page of a script by Scott Alexander and Larry Karaszewski (*Ed Wood, The People vs. Larry Flynt*), Murphy rolled his eyes and thought, "No way. Anything but O.J." Alexander and Karaszewski had written the first two episodes based upon the bestselling nonfiction book by Jeffrey Toobin. Despite the creative auspices of powerhouse producer and former president of Walt Disney Pictures, Nina Jacobson (*The Hunger Games*), *The People v. O.J. Simpson* had never been produced. As Murphy recounts, "I love the feeling of championing a project that seems impossible."

MARCIA, MARCIA, MARCIA

Despite his disinterest in reopening the O.J. trial, Murphy quickly became hooked by the material. Not because it reinforced what he already knew, but because *he discovered new things*. What jumped out at him was the central role not of O.J., but of the outsider: Marcia Clark (Sarah Paulson, who won an Emmy for her portrayal). Murphy saw Marcia as his way into the story: "I understood her. She was an outsider, a woman surrounded by straight, white, condescending men." Murphy wasn't interested in the rise and fall of O.J. He was interested in the race issues and the misogyny. He wanted Marcia Clark to be the lead and also to depict the other attorneys on the case, but with greater dimension. He wanted us to go home with the characters and get a deeper perspective on the case. That was a given. But what elevated this "true crime" story into its own genre was, once again, *tone*.

Just as *Popular* had subverted and satirized the teen angst high school tropes, Murphy knew from the get-go that he wanted to tonally explore this landmark trial as a *satire*. Stylistically, his greatest influence for making *The People v. O.J.* was the 1976 movie *Network*, the Paddy Chayefsky/Sydney Lumet masterpiece. Murphy also knew it was time for him to demonstrate his maturity and confidence as a

now-seasoned director. He began this new approach when directing *The Normal Heart* (HBO, 2014) and continues to evolve as a director. Instead of showy camera work, he decided to utilize a more *cinéma vérité* approach. If he'd been criticized for cinematic acrobatics, of showing off to prove his directing prowess, he now simplified his approach. "I never move the camera anymore. Ever." By not trying so hard, he found his critical acclaim and mainstream acceptance.

It should also be noted that, even once Murphy decided he wanted to make *The People v. O.J.* his next project, he had to audition and campaign for the job. He wanted to do ten episodes and "cast the shit out of it." But it was an uphill battle. And despite all the acclaim, Murphy says that he is confused by its success. "I never understood it. I still don't."

He continues to expand his TV empire with the *American Crime Story* franchise, plus a fresh assortment of limited, anthological true stories to explore in future seasons: from Hurricane Katrina to the Versace Murder. For the next iterations of *American Crime Story*, he's not interested in doing another trial. He wants to explore the looting, politics, inequality and racism of a perfect storm and breached levees. For *Versace*, he wants to explore a social crime that involves homophobia. And with *Pose* (more in Chapter 12), Murphy has made history with the largest cast of transgender actors.[3]

But rather than creating a documentary, à la *Making a Murderer* on Netflix and *The Jinx* on HBO, Murphy is recreating these stories through his own fisheye lens. He does *not* feel the moral responsibility to use his storytelling and TV cache to be a social activist on screen; he's not interested in preaching. "I never consciously think about social activism. My work just contains themes that are important to me."

When structuring the dramatic narrative to a true-life story, Murphy relies on *theme*. He's adding layers to the story, not just plot. His approach as writer/creator is the same as his process for directing. He needs to know his first shot and last shot to establish tone.

> ## "If you can dream within a structure, you can do better things."

Murphy also makes vision boards (à la *The Secret*) and gets obsessed with even the most minute details. He notoriously spent two days choosing the right fish for the aquarium in the *Nip/Tuck* doctor's office. He also gets obsessed with color palettes

and design elements. Being a showrunner is the ideal job for him because he loves making taste-based decisions and delegating to his team—all in the service of tone.

For his most recent limited/anthological series, *Feud: Bette and Joan* (on FX), which focuses on the rivalry between Bette Davis and Joan Crawford during the making of the cult movie *Whatever Happened to Baby Jane?*, Murphy was not interested in doing camp. Instead, "I was interested in the idea of a career being over by the age of 52" (the same age Murphy was when the series premiered). He wanted to explore female competition and how some women tend to undermine each other instead of uniting. This first installment of *Feud* is, in Murphy's words, "A horror show about inequality"—a feeling all too familiar to outsider Murphy.

The *Feud: Bette and Joan* series was inspired by a screenplay Murphy had discovered from The Black List,[4] years earlier. He'd originally acquired that script, entitled *Best Actress* (written by Jaffe Cohen and Michael Zam, who are both credited as co-creators and producers on *Feud: Bette and Joan*). Murphy's original intention was to adapt and direct it as a feature film starring Jessica Lange and Susan Sarandon. Even with both actresses attached, the financing and distribution kept the project in limbo for years.

The next limited season of *Feud* will focus on Princess Diana and Prince Charles, but Murphy says, "My way into the story is Diana, an outsider trying to navigate a system of expectations." He can relate to Diana and mused aloud what he might do in her situation: "Should you stay in this marriage for duty and your love for your kids even though your husband is in love with another woman?" His approach is also less about the chronology of events and more about what Diana was like as a *real* person. "How did it feel to be a like a butterfly caught in a net?" A horror story, indeed.

There is an unlimited supply of famous feuds from which to draw for future limited seasons. How's that for another paradox: the *unlimited* limited series? But paradox and leaning in to what no one else seems to want—outlier, orphaned, fringe projects—is what keeps Murphy flying high. "You can't win anymore by being mainstream, with something for everyone. Now everyone wants niche," he asserts.

When visiting UCLA, Murphy encouraged the storytelling community to share personal stories and to stay courageous. "You've got to make some noise and you've got to be brave. I like weird. I like to make bold, bat-shit crazy stories that no one else will touch." In his parting remarks, he brilliantly summed up his philosophy with a dash of inspiration:

> ## "What's not already on TV is the key.
> ## And what's not on is you."

See also: *Genius* on the National Geographic Channel for another example of the anthology series.

Notes

1 Murphy concedes that, after *American Horror Story: Hotel*, he decided to drop paying homage to (a/k/a "ripping off") horror classics and start creating from scratch.

2 Casting big names in roles for maximum publicity and ratings.

3 Lesley Goldberg, "Ryan Murphy Makes History With Largest Cast of Transgender Actors for FX's *Pose*," *The Hollywood Reporter*, October 25, 2017.

4 The Black List is a website that hosts unproduced screenplays. Founded by Franklin Leonard in 2005, the website publishes an annual survey in December of the most buzzed about, unproduced screenplays in Hollywood. Previously, Leonard was a development executive at Universal and Will Smith's Overbrook Entertainment.

PART II
DEVELOPING ICONIC CHARACTERS
Relatability and Authenticity

"We started out at one point talking about how evolution involves creating ever greater circles of empathy: You belong to your family, then you belong to your tribe, then two tribes link up and now you have empathy for your people on this side of the river, and you're against the people on the other side of the river . . . on and on through villages, cities, states and nations. . . . So what if a more literal form of empathy could be triggered in eight individuals around the planet . . . who suddenly became mentally aware of each other, able to communicate as directly as if they were in the same room. How would they react? What would they do?"

—J. Michael Straczynski, co-creator, *Sense8* on Netflix

CHAPTER 7
CHARACTER EMPATHY VS. SYMPATHY

How and Why We Align With Characters' Wants and Needs

Empathy is key in storytelling: in character development, in how it pertains to suspense and also draws the audience into a story, through our characters' needs and vulnerabilities. On a deeper level, it's also what sustains a series over time.

But first, let's look at the difference between empathy and sympathy:

* Empathy is defined by identification, "walking in another's shoes."
* Sympathy is the pity we feel for another's pain and suffering.

Both are vital attributes not only to sustain a balanced emotional life, healthy relationships and socialization, but also to build and sustain a dramatic TV series. The only reason we return for more episodes is because we relate to the characters via empathy and/or sympathy and invest in them for the journey over time. Their problems become our problems. Their victories become our wins, too. Bottom line: We worry about them and are compelled to care.

To me, all stories are coming-of-age tales, regardless of the character's chronological age. The reason being, our characters enter stories lacking something. The whole reason that there is a story, it could be argued, is because a character is incomplete in some way. A character may have a void in his/her world—whether psychological, emotional, spiritual or otherwise—that is limiting. It limits him/her both in terms of the character's power and results in the instinctive creation of defense mechanisms to protect himself or herself. When we have a void, we feel we're not whole and are broken in some way. When we're broken, we're vulnerable and fragile. Hence the most wounded characters with the largest voids tend to be the most defensive—and

often will be the most aggressive and hostile, because they want to keep people away.

Take the analogy of the injured beast. As we approach an injured animal, it grows more ferocious, because it knows that it's less powerful in that moment. An animal goes on the offensive, trying to scare us and make us back away, in order to protect itself. It's almost paradoxical—animals act more fierce because they are *less* fierce. They create an illusion to feel safer and more protected. This is similar to how characters behave in coming-of-age stories.

TOUCHING THE VOID

Characters with voids are, to state the obvious, lacking something, which might be intelligence, physical strength or attributes that might make them feel more powerful/attractive, business acumen, friends, love or something completely different. Whatever they're lacking, characters often overcompensate by going on the defensive or on the attack instead of accepting their limitations. They try to find weak spots in other people, to diminish others in order to feel better somehow about themselves. In coming-of-age stories, whether in a pilot or series that plays out over multiple seasons, we will witness a gradual progression of the character. As writers, we need to think about this development from the very beginning, from our pilot on. Even on an ensemble show, on some level each character is going to "grow up" and their relationships to each other help facilitate that growth.

On the deeper level of character empathy, every show explores a character's relationship with his or her void—what's missing, what's lacking. For our audience to truly develop a relationship with a character over numerous episodes, there must be such a level of complexity in their character that whatever internal problems they have can only be solved through *external* interactions, with other characters. Adding to the complexity is the fact that what characters need the most is paradoxically often what they *defend* against the most. How characters let their guards down—and who they allow to see their vulnerability—plays into their growth and evolution. All characters, from the broken, flawed or limited to those who are more at peace with themselves, have voids. Maybe it will be filled by some sense of completion through a relationship, through love. Perhaps it's through communication that's honest, sincere and direct, resolving something that maybe hadn't been discussed for a long time, based on estrangements or fear that there was no solution to a problem; when there is one, it's cathartic.

Much of what makes us vulnerable, and the reason we tend to hide our weaknesses and try to protect ourselves, is because we're ashamed of our limitations. It's only our close circle of friends, family and people we feel we've bonded with and connected to on deeper levels, maybe only one person, who we let in to see that true, genuine side of ourselves. That's the key to evolving, growing up and the cycle of coming of age. A coming-of-age story is about self-acceptance. As we live in a world with other people, self-acceptance comes through gaining approval and validation from others. When we're young, we're eager for others to validate us. It may come from our upbringing: If we grow up in a functional household with parents who give us approval, love and acceptance, when we go out into the world, we may be less starved for validation. If we come from a home where our parents are busy, absent or if we come from a broken family, we may not have gotten that validation and thus may seek it from various other sources. And some of these sources might not necessarily be appropriate places to find love and acceptance.

When developing our characters, we may also give them masks that are defense mechanisms in response to the voids and fears they've experienced. They could be literal, superhero or villain masks but more often are metaphorical masks—personas they project into the world in order to protect their "real" selves.

NOBODY'S PERFECT

As we write our pilot, we need to think about the way an audience is going to first meet our characters. What's the first impression of the character? It's not an absolute, but our first impressions are almost always wrong. And we *want* our viewers to be wrong, because if what we see is what we get, there is no complexity, mystery or anything to discover about the character as the series progresses—and it's less interesting. Audiences want to make discoveries and participate in the journey of a character's coming of age. As they solve their problems and get in and out of relationships and trouble, we want to feel there's something beyond the mask, beyond the superficial first impression we developed about the character. We start to sense their vulnerabilities and fears and understand that a lot of the behaviors characters have adopted are actually coping mechanisms, to help them get through life.

At the heart of empathy is the knowledge that nobody's perfect. We all know this; yet we still beat ourselves up when we make mistakes, and we're harsh on other people when they disappoint us. The German writer Goethe said, "Life teaches us

to be less harsh with ourselves and with others." It's something that happens over time, as we experience more rejection and disappointment. People let us down. Life is unpredictable. I believe that the words "life" and "change" are synonyms. Life is change. It's something we can count on. At the same time, pain comes from a resistance to change. All of life's uncertainties make us feel more vulnerable. Sometimes things happen to us through no fault of our own; other times, things happen to us because we do stupid things and make bad choices based on variables that, in hindsight, look like major red flags. We all have self-destructive patterns, behaviors and vices. "Nobody's perfect" as it relates to character empathy means it's universal for us to recognize that everyone has problems and is flawed.

> *The key to empathy is forgiveness, which is one of the most difficult aspects of being human.*

Forgiveness requires us to let something go, something that emotionally has thrown us into some form of turmoil. When we are emotionally out of balance, all we can think of is regaining control. Most characters, whether they are control freaks who have to micromanage everything, or who are more relaxed and laid back, still want to be in control of their emotions. Yet our emotions bubble up; what we try to repress and push down comes up anyway. When we have sloppy emotions we can't control, we cry, we have mood swings, we lash out at people. A situation that happened with someone in the past, which is totally unrelated to someone new, might come up unexpectedly. It could be something we repressed for years, which gets triggered by another person or situation. Likewise, our characters need patience and the ability to look at the bigger picture in order to forgive. And yes, nobody, let alone ourselves, is perfect; we make mistakes. We need other people to forgive us, and need to forgive ourselves as well, for not being perfect.

As we develop our characters, we often find the most difficult challenge for them to face is in the situations where they need to forgive, forget and move on. Characters who tend to be the most iconic and indelible are stubborn, more likely to resist change and make pronouncements that they're never going to forgive or forget something. When somebody crosses them, they'll "never speak to that person again." Tony Soprano might simply torture or shoot them. It's irrevocable, irreparable and impossible to forgive. Of course, although these are the words

spoken in the heat of the moment, as we also know, over time wounds heal. No matter what characters say or how vehement they are, situations change. They'll have other altercations with other people that require them to forgive in a similar way. As a result, they may become truer to themselves and hopefully be able to form closer, more trusting relationships, allowing themselves to be more vulnerable and let love in, without the need to build walls and create defense mechanisms.

But that's at the end of a series—or later in life. Some of the characters in our series will be heavily flawed and self-delusional, tending to create such constructs in order to feel powerful in situations that enable them to function with their usual coping mechanisms. Anyone who challenges any of these things becomes an antagonist. Their instinct is to defend themselves against those people who might want to challenge these power constructs.

Once you locate a character's main coping power, I encourage you to find its opposing force, and then you have some compelling conflict. Don't push it, but opposites attract in a tango toward understanding. And maybe, eventually, empathy.

Examples of Coping Powers

- Don Draper (*Mad Men*)
 Power of Persuasion
 Opposing force: Peggy Olson, who can see right through Don's facade. She has the Power of Truth and Reason.
- Queen Elizabeth (*The Crown*)
 Power of Duty/Honor
 Opposing force: Margaret, who challenges protocol. Margaret has the Power of Passion and Desire.
- Walter White (*Breaking Bad*)
 Power of Deception
 Opposing force: DEA agent Hank, who has the Power of Enforcement (see my piece on *Breaking Bad* in the Bonus Content at www.routledge.com/cw/landau) 🔘
- Elliot Alderson (*Mr. Robot*)
 Power of Truth, Justice and Fairness
 Opposing force: Evil Corp and Tyrell Wellick who have the Power of Deception
- The kids on *Stranger Things*
 Power of Innocence
 Opposing force: The government conspiracy = the Power of Cynicism

- Chip Baskets (*Baskets*)
 Power of Imagination
 Opposing force: Reality

For more on character power dynamics, visit Laurie Hutzler's website, **www. ETBScreenwriting.com**.

THE DANCE

Empathy is also dependent on point of view. Characters naturally look at the circumstances of their lives and base their choices on the limited evidence of what their lives are at that moment. It's circumstantial; there are mitigating factors, and part of what the slow-burn shows do—and part of what *Fargo*'s Season 2 does, for example—is show us an event through the prism of multiple points of view. Our empathy doesn't just go along the expected rhythms and movements. It constantly shifts and pulls us around, back and forth. The tempo changes, characters change and our perspective changes. Each time we tune in, we get to discover something new that both informs and impacts our empathy, which can shift from episode to episode. That's what makes great drama so much fun to watch. (I analyze *Fargo* in Chapter 2.)

REVERTING TO TYPE

Lonely people and loners tend to find fault with everyone. They're alone, but constantly judge anybody they could hang out with or any potential prospects for a romance, listing all the reasons why they would not want to spend time with those people. In truth, the loner doesn't even want to hang out with him or herself. They don't feel worthy themselves. But it's easier to cast blame and create distance with other people, than to admit maybe there's something wrong with *them*. What we often find is that our characters, while they *say* they want to change, while they seek out new situations and take risks in order to change their circumstances and improve their lives, do not change. And this is the way the real world works, too. Characters expand and contract. When feeling threatened, they tend to revert to form, meaning they go back to their *modus operandi*. They may well take a risk and end up scared, out on a limb where they could get hurt. They may fear their risk may not pay off the way they thought. They might open their heart, only for the object of their affection to reject them, leaving their love unrequited.

When such things happen, a character tends to revert to his or her old self like a rubber band. Their void remains. They go back to accessing their power of what

they think is going to protect them. It could be the Power of Ambition, the Power of Enforcement, any number of powers our characters think are their strong suits. They revert because it's familiar and comfortable: "Better the devil you know." Stepping out of their comfort zone is scary and a character's nerves may cause them to mistake fear for the feeling of making the wrong decision. But because it feels wrong initially doesn't mean it *is* wrong. So, we see characters doing an emotional dance: taking risks and changing, then retreating. They're like turtles that stick their heads out, then retreat back into their shells.

The cause is fear. Characters end up going back to old patterns because their fear feels more powerful than the need to change. In this way the true coming of age is the acceptance of the void and being able to share our experience of it. The more we reveal what's missing and how we're wounded and broken, the more likely we are to accept and heal. It's something we recognize in life as well as in fiction. We see people go through this circular journey. They come out the other side stronger and more whole, or they may veer into a form of denial and go back to their lives and—at least on the surface—revert to form. Part of empathy is also when we understand that it's not a weakness to ask for help—it's a strength to admit vulnerability and say, "I need you." But many characters will avoid that, because they're afraid that someone's going to let them down, or reject them. So inevitably they tend to think they're in it alone.

The evolution of a character, over the course of a season or multiple seasons, sometimes is as simple as someone who feels that he or she is all alone becoming able to let one person in. As we've discussed, it can take just one person to fill the void. That in itself can be enough for a complete, satisfying story. Ideally, a character who feels he/she is an island will find the need to connect to a larger group of people and seek their community. But, this is likely going to require their acceptance of other types of people who don't adhere to the same codes of what they believe is acceptable behavior, and the character grows as a result. In dramatic storytelling, catharsis comes from connecting to other people and letting them in. It's not going to come from numbing the pain; it's going to come from *feeling* the pain. Only then can a cathartic release occur for both character(s) and audience.

JUDGMENT, MORALITY AND PERCEPTION

Judgment can separate us, and our characters, from pure empathy and connection with people. It comes from what we perceive to be the truth about something; we judge someone or form an opinion based on something that is

essentially superficial. It could be the color of their skin, what they wear or how they express themselves through their communication style. There's always an aspect of judgment that hinders true empathy. Again, these are just defense mechanisms, because we tend to feel threatened by people who are different. And again, we need to push and force our characters out of their comfort zones, remembering humility, patience and respect.

Our relationship to the void and to ourselves also comes through how we interact with what we perceive to be right and wrong about other people. It's easy to be empathetic toward a person who's just like us, or someone we approve of and admire. That's effortless. The tough part of empathy is when we're called upon to offer our compassion to someone we may not approve of, or who is actively hostile towards us, or may have antagonized us. Yet we need to put our characters in situations where it's neither easy to offer empathy, nor to forgive, nor to make a connection. For that's like real life. As we challenge them in such situations, conflict will arise and bring up exposed aspects of the character we may not have seen before. Both in and beyond the pilot, we need to ask, "What are the situations that will show aspects of the character's emotional life we haven't seen before? How can we put characters in situations that take them out of their comfort zones?" *Orange Is the New Black*, for example, does this to both tense and comedic effect. In comedy, pushing our characters makes the situation funnier, while in drama it boosts the intensity, as we see how a character grapples with a moral dilemma, or with trying to be righteous and yet uncomfortable with what's being asked of them.

THE INSATIABLE APPETITE OF THE EGO

We all have egos to drive our ambitions. However, success that only feeds the ego will never fill our existential voids, as we endeavor to fit into structures and to access our power through approval and acceptance from others. We tend to identify success through the lens of that human ego: in terms of money, materialism, job titles and status. It speaks to much of what is wrong with our world. We define success in materialistic terms as opposed to emotional ones, which include empathy, compassion and kindness. First on the list should be how can I help, how can I listen, how can I be compassionate, how can I communicate better? Yet kindness and empathy are not accorded the same respect as "success," let alone being used in the definition of success.

Consider how the existential pain many characters feel is self-inflicted. Their inner turmoil will only be healed by taking risks, stepping out of their comfort zones and

connecting with other people. It's usually petrifying for a character to do so. So, our first impression of a character in a pilot is not who the character really *is*. We may look for triggers in our plot that are going to cause suppressed emotions to come out. We want to see our characters drop their masks and show us the messy side of their lives, no matter how strong they are. In *Luther*, for example, we see Idris Elba playing the tortured detective John Luther, which is riveting because he's seemingly so powerful and invincible. Yet, it's even more riveting when he is brought to his knees and isn't sure whether he wants to live or die, based on all the suffering he's experienced in his life. He's an extreme, nihilistic character, who needs to learn to develop empathy, much like Sherlock (Benedict Cumberbatch) in the last season of the eponymous series.

In sitcoms, characters behave in self-destructive and self-defeating ways in order to feel less vulnerable.[1] The principal difference is that the things they do are more outrageous, so as a result, the chaos that ensues is funny. Sometimes it's pathetic and we laugh; we've all felt pathetic in certain situations. Sitcoms, especially broader ones, tend to turn up the volume and make the scenes and characters more extreme. If the end of our pilot is going to be our protagonist's worst nightmare, we start off the whole series with a character who's desperate and is going to expand or contract and do *anything* he or she can, in order to avoid having to face the void. That's where empathy comes from. We relate to and understand such feelings and experiences because they are universal. Ideally, other characters also identify this protagonist as being in existential pain, thereby showing empathy and trying to dig deeper into what's really going on with him or her.

INSECURE: AUTHENTIC AS F**K

When I interviewed Issa Rae for my last book, the creator, writer and star of *Insecure* had already produced the successful web series *Awkward Black Girl* and was developing her HBO show with Larry Wilmore. *Insecure*, which contains elements of *ABG*, has since premiered in 2016 to critical acclaim. The first season follows the highs and lows of the life and loves of Issa Dee (Rae) and BFF Molly Carter (Yvonne Orji), as they traverse their quarter-life crises in present-day LA. Issa's navigating through a stagnant relationship with Lawrence (Jay Ellis), who's between jobs and who languishes on the couch most days; meanwhile, she's tempted by high school sweetheart Daniel (Y'lan Noel). She's also experiencing something of a career crisis—after five years, she's still the only black employee at a nonprofit that works to help minority children. But she feels that what they're doing has little impact and continues to encounter stereotypes that shouldn't exist in a progressive organization. Molly is a successful lawyer but clueless when it comes to men, making

terrible decisions due to her immature approach to relationships and love. Fair enough, she's still in her 20s.

The show is sharp, funny and all set to an astounding soundtrack, which is no surprise given that Solange Knowles is a music consultant and most of the episodes are helmed by Grammy-winning music video director Melina Matsoukas. But *Insecure*'s strength is in the universal stories it tells: they're not unique to the black experience of living in LA, but the human experience of anywhere. Life isn't what we thought it would be, and we do realize that in our late 20s. Often couples develop in different directions at different speeds; temptation abounds (sometimes we seek it out; sometimes it comes to us). The job we thought would make a difference turns out to be rife with hypocrisy. And our best friend refuses to take our advice, which gets us exasperated at seeing them repeat the same mistakes over and over again, seeing them get hurt again and again. We all understand humiliation, guilt, shame, frustration, disappointment. Many of us have had to confront stereotypes in our lives. This universal experience is what we quickly fuse with in *Insecure*, plus humor helps us bond. We quickly develop empathy with Issa Dee in the opening scene of the pilot.

```
INT. CLASSROOM - DAY

Issa stands in front of a bored 6th grade classroom
as Frieda hands out brochures for "WE GOT Y'ALL!" the
educational non-profit company they work for. The school's
counselor, JUSTIN, mid-30s, Asian, stands next to her.

Silence.

                    ISSA
          ... WE GOT Y'ALL! offers after-
          school tutoring, mentoring
          programs, community service,
          standardized test coaching, Big
          Brother/Big Sister and just
          general filling in the cracks. As
          Youth Liaison, I can assure that
          whatever it is you need to
          succeed, WE GOT Y'ALL! So do y'all
          have any questions?

Silence.

                    ISSA (CONT'D)
          Don't be shy, guys. Fire away.

A 6TH GRADE GIRL raises her hand.
```

 6TH GRADE GIRL #1
 Why you talk like a white girl?

Other students snicker. Frieda does, too. Issa is unsure how
to answer that.

 ISSA
 (with a "BLAC-cent")
 Haaa ... you caught me. I'm rockin'
 Blackface.

She laughs. Nothing. She turns to Frieda for something.
Frieda mouths, "That's racist."

 ISSA (CONT'D)
 Any other questions?

Another 6TH GRADE GIRL raises her hand.

 6TH GRADE GIRL #2
 What's up with your hair?

 ISSA
 Um, I don't know what you mean?

 6TH GRADE GIRL #2
 My cousin can put some tracks in
 it. Unless you like it like that.

Issa reaches for her hair insecurely.

 6TH GRADE GIRL #3
 You rude. She African!

 ISSA
 We're all from Africa, guys.

 JUSTIN
 Absolutely. Let's stick to
 questions about the program.
 (to Issa)
 Sorry.

A 6TH GRADE BOY raises his hand.

 6TH GRADE BOY #1
 Is this what you always wanted to
 do?

This question actually catches Issa off guard.

 ISSA
Um ... No. But ... I got this job
after college and it fit my
interests at the time.

 6TH GRADE BOY #2
Are you single?

 ISSA
I don't think that's appropriate.

 6TH GRADE BOY #2
 (to his friend)
She's single.

 ISSA
Ok, since you guys are SO
interested in my personal life.
Here it is: I'm 28 -- actually,
29, as today's my birthday. I came
from a great family. I have a
college degree. I work in
the nonprofit world because I like to
give back. I've been with my
boyfriend for five years. And I
did this to my hair on purpose. So
I hope that covers everything.
Does anybody actually have *any*
questions about WE GOT Y'ALL?

 6TH GRADE MIXED GIRL
Why ain't you married?

 ISSA
I'm just not. Right now.

 6TH GRADE MIXED GIRL
My dad says ain't nobody checking
for bitter ass black women
anymore.

Everyone except Justin laughs.

 JUSTIN
Dayniece, that's detention.
Apologize! Now.

 6TH GRADE MIXED GIRL
Ugh! Sorry.

 ISSA
That's OK. And tell your dad that
black women aren't bitter, they're

```
                just tired of being expected to
                settle for less.

A moment of what seems like thoughtful silence turns into an
eruption of laughter.

                      6TH GRADE BOY #3
                HER OUTFIT SETTLED FOR LESS!

Issa sighs as she watches the kids laugh at her in SLOW
MOTION. They don't take her seriously, and why should they?
```

Not only is it funny, but we also cringe right along with Issa. Similarly, in a montage of clips featuring best friend Molly, we quickly learn how she's a hit with everyone at her firm—and basically with people in general, no matter what background or level—but then we cringe again as Molly giddily calls back the guy she's been on three dates with, after he merely texts "Hey." He doesn't pick up the phone and texts again: "Can't talk, what's up?" She replies, "I just wanted to hear your voice :-)" Seemingly knowledgeable about guys, she raves about how he might be "the one" to colleague Diane Nakamura (Maya Erskine), who herself is an Asian woman with a black boyfriend. Naturally, we feel for Molly as she is crushed by his reply a moment later: "Sorry. I'm not looking for a relationship right now :-("

We get it. We've all been there. One minute all is smooth sailing, the next minute everything changes. It's also efficient storytelling: within the first six minutes, Issa and Molly both win us over and keep us feeling for them throughout the season, even when they behave badly, including to each other. (If you haven't heard Issa's hip-hop song inspired by her friendship with Molly, entitled "Broken Pussy," you're missing one of the highlights of the TV season.) It feels like real friendship. Such authenticity is what *Insecure* delivers beautifully. We're all after the same thing: Connection.

BIG LITTLE LIES, GUILT AND SHAME

HBO's multiple Emmy-winning *Big Little Lies* gives us several strong women who have major flaws, and do despicable things, and yet makes us care about them. Although the show is an ensemble piece, Reese Witherspoon and Nicole Kidman are given top billing as Madeline Mackenzie and Celeste Wright, respectively. These two friends, apart from the fact that they both have young children who go to the same school, don't have much in common. Madeline's spunkiness borders on arrogance and would be off-putting if not for the kindness she

shows to Jane (Shailene Woodley), the new mom in town. Madeline constantly puts her foot in her mouth, especially with her husband Ed (Adam Scott). In the first episode she vents to him about the fact that she fears both of her daughters are growing up too fast, especially teenaged Abigail (Kathryn Newton) whose father is now married to a hot, younger woman.

> MADELINE
> I just feel like they're gonna grow up,
> and they're gonna be gone, and it's
> just gonna be you and I, and we'll move
> on to another chapter of our life. And
> you have another chapter, you have a
> business, and I don't, I'm a mom. This
> is my universe, and currently that
> universe is in meltdown because my
> oldest daughter prefers to hang out
> with her fucking step family.
>
> ED
> Hey. You will never lose them. And you
> know that.
>
> MADELINE
> I just thought one day Nathan would get
> his due. For some reason, Abigail would
> love me more. He hasn't paid in the
> slightest. For any of it. Now he's got
> Bonnie and she's younger and sexier and
> prettier ... she probably gives mint-
> flavored organic blow jobs. And Abigail
> likes to hang out with him and his
> buddies. And he got it all. He won.

[Ed digests this.]

> ED
> Well, speaking as the consolation
> prize, we're gonna have a pretty big
> fight.
>
> MADELINE
> Oh, no, Ed...
>
> ED
> But not tonight. Not tonight.
>
> MADELINE
> I did not mean it like that. You are
> the greatest thing that ever happened
> to me, and don't you for one minute
> think anything else. It's just entirely

> possible for me to love you, with all
> my heart, and still feel--

> ED
> Hurt over your ex.

The damage is done. But Ed would be even more hurt if he knew Madeline's big secret: A year ago, she cheated on him with the sexy director of the local community theater company that she oversees, and she can't stop thinking about it. Later Ed confronts Madeline about her lack of interest in sex, which she attributes to being busy and overworked.

It's only when Madeline's "I-don't-take-bullshit-from-anybody" demeanor starts to crack that we begin to empathize with her. She truly feels guilty about cheating on Ed and tells Abigail about it, in a rare moment of self-revelation. Madeline knows that Ed is a wonderful man and feels that she doesn't deserve him. We sympathize with Ed, because he doesn't know that he's been played. But we *empathize* with him when he stands up to Madeline and tells her, "For me, you're the one," In spite of all her faults.

Meanwhile, the beautiful former attorney Celeste, who seems to have hit the jackpot with her rich, handsome husband Perry (Alexander Skarsgård), two adorable twin boys and a closet worthy of a mention in *Architectural Digest*, is not quite the successful stay-at-home mom she appears to be. The truth is that Perry is abusing her, and she actually gets turned on by it. She tells Madeline that they "fight" but neglects to mention that it's physical. Celeste eventually admits what's going on to her therapist, who is horrified and insists that she leave Perry. Celeste is something of a throwback to another time when many women didn't talk as much about domestic violence and explained away their bruises with stories of falling down the stairs. The twist is the element of enjoyment that she's getting from it. We're shocked, although most of us have been in dysfunctional relationships, as well. Celeste is kind to everyone, especially Jane and Madeline, which makes us care about her more. We want her to gather the strength to leave Perry, and rescue both herself and her children.

SYMPATHY FOR THE ROBOT: *WESTWORLD*

Dolores Abernathy (Evan Rachel Wood), a relentless optimist and rancher's daughter, wishes her father a good morning before riding off to town. There she runs into Teddy Flood (James Marsden), a handsome, charming quasi-cowboy, with whom she has some kind of shared past. The two spend the afternoon

horseback riding, and they share a moment of intimacy. Upon returning home, Dolores and Teddy discover that thieves have ransacked the Abernathy home and murdered both of Dolores' parents. Valiantly, Teddy guns down the thieves. But then things take a turn for the worse—the Man in Black (Ed Harris) arrives. He knows our young lovers, but they don't know him. Teddy shoots the Man in Black, but his shotgun shells, so effective just moments ago, vaporize on impact. The Man in Black returns fire, killing Teddy in cold blood, then drags a screaming, petrified Dolores off to the barn with only one thing on his mind: rape.

In the first fifteen minutes of the pilot, we witness the difference between man ("newcomer") and robot ("host") and the fundamental unfairness that governs Westworld, this adult theme park. Our heroes—the robots—seek out change. We see their lot in life, stuck in the same daily loop (they're programmed to follow a script), powerless in the face of callous men, haunted by memories of intense personal trauma. And we admire their defiance. They are "hosts"—robots built to satisfy the sadistic whims of wealthy tourists who are unbound by the moral restraints of the real world. It's easier to empathize with a virtuous robot than it is to recognize ourselves in their human abusers.

Back in 1973, I remember seeing Michael Crichton's big-screen version, *Westworld*, at a drive-in theater. That iteration focused on the human vacationers who paid big bucks for a chance to play in this interactive A.I. amusement park. The premise was pure wish fulfillment: getting the chance to be a "real" gunslinger in the Wild West, with no consequences for killing and debauchery. And the robots could die, but the vacationers could not (the robots' guns were firing blanks). Of course, as in *Jurassic Park* (also created by Crichton), something goes terribly wrong and chaos ensues. In the *Westworld* movie, the A.I. "Gunslinger" (Yul Brynner) goes on an all-too-real killing spree—technology run dangerously amok—and can't be stopped. It's a glitch in his programming, rather than the singularity. The surviving tourists are now trapped in a nightmare, resulting in a suspenseful, terrifying game of cat and mouse. But as humans, we're rooting for ourselves.

Significantly, in HBO's 2016 remake, we find ourselves rooting for the A.I., but since they're identical to us, first we must figure out who the androids are. We, as audience, are now invested in this game of who's real and who's a machine. It's an ingenious adaptation in which the "hosts" evolve toward human consciousness and get in touch with their feelings. They're no longer neutral, at the whim of the tourists. Now they're coming from emotion, and as we all know, try as we may, the one thing none of us can control is our emotions. The robots begin to improvise and invent new storylines and dialogue of their own volition. The line between

"host" and human is often intentionally blurred, and we become engrossed by the search for clues (was that a human flinch or a technical glitch?)

In Season 1, Episode 6 ("The Adversary"), the town madam, android Maeve Millay (Thandie Newton) muses to the human lab techs:

> MAEVE
> At first I thought you and the others were gods. And then I realized you're just men, and I know men. You think I'm scared of death? I've done it a million times. I'm fucking great at it. How many times have you died?

For silver-tongued Maeve, this evolution toward consciousness is often played for comedy. Upon realizing that death is a false construct, she begins to seek out new and varied ways to die. The lab is where she encounters Felix Lutz (Leonardo Nam), the lone sympathetic human on the show, and his lab partner Sylvester (Ptolemy Slocum). Through a series of clever threats and demands, Maeve manipulates the two lab techs into expediting her awakening. In what might be the most enjoyable exchange of the entire show, Maeve coaxes the lab techs into rejiggering her character profile, fulfilling that most human of desires—to acquire a superpower. "What was it—bulk apperception? Let's take that all the way to the top," she says, her eyelids fluttering as she powers up.

We're given permission to revel in this moment because earlier we've witnessed the Westworld lab through Maeve's eyes. For Maeve, the lab is a house of horrors—dead, naked "hosts" strewn about as apathetic staff hose down the blood. For the audience these images are eerily reminiscent of real human atrocities and reinforce our sense of Maeve's righteousness. If hosts can feel pain—and they do—it doesn't matter if hosts are androids created in a lab, the humans' actions are equally atrocious whether inflicted on non-human or fellow human.

Programmer Bernard Lowe (Jeffrey Wright) explains the park's philosophy: "Consciousness isn't a journey upward, but a journey inward. Not a pyramid, but a maze. Every choice could bring you closer to the center or send you spiraling to the edges, to madness" (Season 1, Episode 10, "The Bicameral Man").

Bernard's evolution toward consciousness is tragic. For the bulk of the series, we believe he is a measured, thoughtful engineer doing his best to keep feuding interests at bay. That part is mostly true. The surprise—it's a shocker—is that Bernard is a "host," a recreation of Arnold, the long-dead partner of Dr. Robert Ford (Anthony Hopkins) and co-creator of the Westworld theme park.

Dr. Ford had built Bernard in the image of Arnold but included the tragic memory of Arnold's dead son. "It was Arnold's key insight, the thing that led the hosts to their awakening: suffering," Dr. Ford tells Bernard. Bernard passed as human because his suffering offered him insight into the human experience. His true consciousness comes with the realization that he is both a host and a weapon of Dr. Ford's—a weapon that's already been utilized in two murders.

Dolores' evolution is subtler and nearly impossible to talk about without examining the totality of her arc. The center of the maze which Dolores has been searching for is a symbol of self-discovery and meant only for the robots. For Dolores, consciousness is achieved by plumbing her memory and returning to the site of her original sin. The reveal that she killed Arnold is startling enough, but the knowledge that she was programmed to do so by Arnold (who thought his death would prevent the park from opening) is what finally liberates her.

With our allegiances now fully on the side of the hosts, *Westworld* has one final surprise up its sleeve—Dr. Ford isn't evil; he's atoning. The "Reveries" update, introduced in the pilot, was designed to ignite a string of host awakenings. Humans—particularly those driven by greed, lust or violence—are far more dangerous than robots who cannot opt out of their morality. During her escape Maeve turns to Felix, thanking him for his assistance. "Oh Felix," she says, you really do make a terrible human being. And I mean that as a compliment."

HANNAH, CLAY AND THE RAZOR'S EDGE: *13 REASONS WHY*

In *13 Reasons Why*, high school student Hannah Baker (Katherine Langford) engages in a struggle against mental illness—a silent killer that often no one notices until it's too late. Hannah devises an elaborate suicide note, a series of cassette tapes—anachronistic technology intentional—to inform her loved ones and frenemies, teachers, guidance counselor and parents how they each played a role in her death as oblivious and therefore unwilling accomplices. Hannah is our limited, unreliable narrator, but she insinuates that she was, at various times, cyber bullied, stalked, betrayed, humiliated, abandoned and raped. But the rape was never reported; the rapist is a popular school athlete, and Hannah was too traumatized and fragile at the time to protest or utter the word "No." Until the final episode, it's his word against Hannah's.

Her suicide cassettes are passive-aggressive, narcissistic and cruel, bordering on deranged. For these reasons, while my heart goes out to anyone in pain, I couldn't bring myself to align with Hannah's vindictive quest to posthumously punish the survivors for being so oblivious. My strong rooting interest remained throughout with Hannah's best friend (and crush), Clay Jensen (Dylan Minnette), and with Hannah's parents Olivia and Andy Baker (Kate Walsh and Brian d'Arcy James) who all appeared to do their best to be there for Hannah—but she refused to let them in. Clay bears far less responsibility than her parents, her legal guardians. He truly doesn't deserve this. And her parents were always well intentioned and far from negligent. No one could hear Hannah's silent screams. Hers was an act of violence against herself, and a vengeful hate crime against those who couldn't or didn't realize the depths of her suffering.

After Clay receives the anonymous box of cassettes, he scrambles to find a boom box to play the tape, then hits play. Hannah's message is so disturbing that Clay listens to her opening salvo in three separate scenes, the final sentences after he wipes out on his bike and gets a nasty gash on his forehead. His injury is the first of a number of visual touchstones the showrunners employ to help us keep the timelines straight in our heads. It could have been disorienting, with Hannah dead in some scenes, and then walking into the same setting in a seamless segue to a flashback (when she was still alive).

Clay chooses not to listen to all seven tapes in one sitting. All at once would be too intense. This helps the series' writers spread out the tapes over 13 episodes, which is essential because Clay isn't the only character listening. Other episodes encompass other points of view—and everything eventually overlaps. But Clay, being closest to Hannah, is our guide—our lifeline—from start to finish.

Compounding the suspense and our disorientation is Clay's mental state; as he listens to each tape, his grasp on reality and sanity diminishes exponentially. Fueled by his guilty conscience, he starts hallucinating and sees Hannah's ghost, taunting him. For several episodes, the selfishness of her suicide and the cruelty of the blaming tapes made me think she was trying to gaslight Clay and compel him to kill himself. But *13 Reasons Why* is not after such reductive reactions or resolutions. Sure, the tapes are a clever structural and narrative device—a literary card trick. But let's not forget the context. If you have trouble buying into the premise thinking it's too contrived and implausible, just imagine how troubled a girl like Hannah would have to be to orchestrate it.

Devastatingly, preventable teen suicides happen in real life; *13 Reasons Why* has been immensely polarizing. There have been claims that after watching the show,

two teenaged girls tragically took their own lives; both were in the Bay Area, where it was filmed. Netflix's statement to KTVU was: "Our hearts go out to these families during this difficult time. . . . We took extra precautions to alert viewers to the nature of the content and created a global website to help people find local mental health resources." Peter Chui, father of one of the girls who committed suicide, has a message for young people: "There are other options. There are other resources out there. This is not a way out for you."[2]

For me, the climactic 13th episode is horrifying. You'll see it coming, but nothing can prepare you for the unflinching depiction of the actual suicide. As a parent, it's gut wrenching to witness such anguish and self-inflicted pain. For 12 episodes, we've seen the aftermath of Hannah's suicide from each character's perspective, and how her parents, despite unimaginable grief, have managed to start the healing process and continue living. But at the climax, with the past and present colliding in Hannah's bathroom, it's devastating. Too raw. Too real.

In the book's original ending, Hannah is rushed to the hospital and survives. A happier ending might have worked on a broadcast network or as one of those pedantic "after-school specials" that once served as public service announcements. But the digital television revolution is all about authenticity. So Hannah's end, however tragic, fits with this story.

In playwright Arthur Miller's essay, "The Tragedy of the Common Man," he asserts that the essential ingredient of tragedy is *potential*:

> **The possibility of victory must be there in tragedy** [emphasis added]. Where pathos rules, where pathos is finally derived, a character has fought a battle he could not possibly have won. . . . Pathos truly is the mode for the pessimist. But tragedy requires a nicer balance between what is possible and what is impossible. And it is curious, although edifying, that the plays we revere, century after century, are the tragedies. In them, and in them alone, lies the belief-optimistic, if you will, in the perfectibility of man.
>
> It is time, I think, that we who are without kings, took up this bright thread of our history and followed it to the only place it can possibly lead in our time—the heart and spirit of the average man.[3]

All those named as complicit in Hannah's death confess their sins except Alex (Miles Heizer), the son of a strict military man, who tries to commit suicide by shooting himself in the head with one of his dad's guns. Before leaving his house

to give his deposition in the school negligence lawsuit, photographer/stalker Tyler (Devin Druid) hides various guns and ammunition in his bedroom; this is a plot thread that will surely unravel in Season 2. Or will it?

Meanwhile, at school, Clay reaches out to quirky Goth girl, Skye (Sosie Bacon), whom he'd previously noticed had scars on her wrists. The closing shot is of Clay, his gay best friend Tony (Christian Navarro) and his boyfriend and Skye all driving down the street in Tony's vintage convertible Mustang. Sunny day. Top down. It's a hopeful postscript.

What makes Hannah such a tragic heroine is that she could have made a different choice. Her own potential is cut off prematurely. In her tragedy, however, lies the possibility for a different life for those she left behind.

> *If you are thinking about suicide, please call the National Suicide Prevention Lifeline at 1-800-273-TALK (8255) or the Suicide Crisis Line at 1-800-784-2433.*
>
> *If you have experienced sexual violence and are in need of crisis support, please call the RAINN Sexual Assault Hotline at 1-800-656-HOPE (4673).*

ALIGNMENT AND ALLEGIANCE

Years ago, I attended a screening of auteur Miranda July's wonderful, provocative film from 2005, *Me and You and Everyone We Know*. After the screening, Richard Neupert (professor of critical studies in the Grady School at the University of Georgia) lectured on creating character empathy/sympathy via plot strategies and film style.

Neupert posed this question: How does a movie (or TV series) make us feel something about a character—and why? He discussed how this might be immediate or gradual, but the process adheres to these three steps:

1. **Hypothesis.** Set up a character's positive attributes and corresponding flaws. This happens via the writer assigning a cluster of distinctive traits to each character, and then adding *emotion*. As the story progresses, the circumstances of the story will cause the characters—and us—to evaluate their actions.

 When we first meet a character, we form a hypothesis—based on our life experiences, judgments and his/her backstory/behavior—and our hypothesis tends to shift as the story progresses. Is the show/movie judging a character? Should we?

Our first impression hypothesis then moves to:

2. **Alignment**. Does the story align us with why the characters are the way they are—their goals, motives and psychology? And how readily do we align with these goals and beliefs?
3. **Allegiance**. Do we agree with the character? Do we empathize and/or feel sympathy for their values? Why? Why not?

This hypothesis/alignment/allegiance process is at the core of empathy and sympathy for storytellers. Not only must we emotionally track characters from scene to scene, episode to episode, and season to season, we must also ask ourselves how we want the audience to feel. In this way, all effective storytelling generates an active conversation or debate between the characters' actions and the audience's emotional response (laughter, tears, outrage, fear) to those actions. Ultimately, this is what Aristotle called *catharsis*.

● Bonus Content

More analysis, including **"Empathy and the Female Gaze,"** *Mr. Robot*, *Getting On*, *Breaking Bad*, *Better Call Saul*, *The Young Pope*, *Better Things* and *Animal Kingdom* is at **www.routledge.com/cw/landau**.

See also: *Atlanta* (on FX; see Chapter 1), *Master of None* (on Netflix; Chapter 1), *Patriot* (on Amazon; Chapter 3), *Goliath* (also on Amazon; Chapter 9), *Iron Fist* (on Netflix) and *GLOW* (on Netflix).

Notes

[1] For a good illustration of this, check out the edgy, provocative, darkly comic series *You're the Worst* on FXX (Chapter 1).

[2] KTVU, "Two Families Endure Suicides, Blame Popular Netflix Show," *KTVU.com*, June 26, 2017. www.ktvu.com/news/263334963-story.

[3] Arthur Miller, "Tragedy and the Common Man," *The New York Times*, February 27, 1949.

Episodes Cited

"Insecure as Fuck," *Insecure*, written by Issa Rae and Larry Wilmore; Issa Rae Productions/ Penny for Your Thoughts Entertainment/3 Arts Entertainment/HBO.

"Somebody's Dead," *Big Little Lies*, written by David E. Kelley; Pacific Standard/Blossom Films/David E. Kelley Productions/Warner Bros/HBO.

"The Original," *Westworld*, written by Jonathan Nolan and Lisa Joy; HBO Entertainment/Kilter Films/Bad Robot Productions/Jerry Weintraub Productions/Warner Bros Television.

"The Adversary," *Westworld*, written by Hailey Gross and Jonathan Nolan; HBO Entertainment/Kilter Films/Bad Robot Productions/Jerry Weintraub Productions/Warner Bros Television.

"A moral decision is not the choice between wrong and right—that's easy—but between two wrongs."

—David Mamet, SCREENWRITER, PLAYWRIGHT, DIRECTOR

CHAPTER 8
CHOOSING BETWEEN
TWO WRONGS

Characters Trapped
by Limitation

The expression "Between Two Wrongs" evokes a quote I read in an interview with the great playwright, screenwriter and director David Mamet in *New York Magazine* in early 2008. It was when he was working on *The Unit* for CBS, with co-showrunner Shawn Ryan (*The Shield*). The interviewer, Boris Kachka, asked Mamet whether he'd sold out, because he had recently directed a Ford commercial and admitted it was for the money.

"And you needed the money that badly?" asks Kachka.

"Well, it's nice to have, because you can buy things with it," replies Mamet.

"So the whole business of 'selling out,' you think it's bullshit?"

"No, of course it's not bullshit. One is faced with that every day. All of us. What's a moral choice, what's not a moral choice and so forth. Somebody even more pedantic than I might say that that's the whole question of drama: How does one make a moral decision? And further, that a moral decision is not the choice between wrong and right—that's easy—but between two wrongs."

In this chapter, we'll discuss character development and plotting as it applies to the moral, gray areas in life and the choices we make. Our decisions define us in terms of our moral compasses and the lines we don't cross—or *say* we would never cross—in the complexity of life, which is rarely black and white. Extenuating circumstances, intentional and unintentional ripple effects, inform every choice we make. The decisions we make define who we are, as we move forward in our lives.

Now more than ever, great drama and great comedy series are about putting characters in situations where *both choices are wrong, or potentially have strong,*

negative consequences. These are not clear decisions to make; it's about picking the lesser of two evils. If we present a character—any character—with a simple choice or a difficult one, few would pick the latter. Most take the easy way out, and there's little dramatic interest for our audience. On the other hand, if the character is the sort of person who doesn't take the easy way out, or doesn't naturally do the thing that seems so right versus what's plainly wrong, we as audience find our patience tested. It's frustrating, as we know the other choice is clearly favorable and causes far less heartache and strife. Forcing our characters to decide between two wrongs generates great story and puts the audience in their shoes. As screenwriter/director Audrey Wells (*Guinevere*, *The Truth About Cats and Dogs*, *Under the Tuscan Sun*) once said, "We go from being overwhelmed by an infinite number of choices he/she could make, to the *one* choice the character *must* make."

CREATING THE DILEMMA

Characters cannot unlearn what they already know. We're all held accountable for what we know about ourselves and others. Once we cross the threshold into a situation based on information, or learn the true nature of a person and what they're capable of (whether they're the person who, when the chips are down, proves to be trustworthy and on our side, or they're the person who eventually betrays us), we make subsequent decisions based on this experience. Such experiences create a history for each character. Some are relegated to backstory and maybe in the distant past before the show even begins. But much is the character in *living* history: the accumulation of their choices and behaviors, as the series progresses. Audiences watching a serialized show recall the characters' choices and their histories; we start to anticipate what choices they will make, based on decisions they've made in the past; there are patterns. We begin to chart the course of a character and feel we know what they're capable of, as well as their limitations. Often, great TV series end up subverting our expectations over time, or even transcending them. Perhaps they take a character and put him or her into a situation they've never been in, so we have no idea what they'll do. A challenge the character has never faced before is going to elicit a different response from them. These are engrossing, captivating moments to play in a show.

When plotting, many writers, because we're terrified of the blank page, feel we need to fill up all the space with words. When we outline, we're tempted to include an overabundance of plot. If we do an outline with index cards, or use a whiteboard, we tend to want lots of stuff all over the cards and board. As a result, we create more and more plot events. What can happen is, besides burning through story

too quickly, a plot starts to flatten out; "this happens, then *this* happens and then *this* happens. . . . " The writers of the best television shows that sustain (one of the tests of a great series is that it sustains over multiple seasons), instead of adding more plot that will flatten out, dig in and *go deeper* into a small amount of plot. We have one main event for the A story and dig deep, in terms of how that event affects one character, the decisions they have to make and the ripple effects to others. And, not just emotionally, but logistically and physically. What kind of danger are they in, what's the physical impact on the surface level, what are the emotional underpinnings? The emotional and logistical always go hand in hand. In a true moral dilemma, both choices are extremely difficult. Even our reaction as audience is, "Hmm, this is a tough one." Then, we're in the gray areas, where we have to make lists, as writers, between pro and cons.

HOMELAND: THE LASTING EFFECTS OF DEVASTATING DECISIONS

In "The Drone Queen," the first episode of Season 4 of *Homeland*, Carrie Mathison (Claire Danes) is tasked with quickly deciding whether or not to initiate a drone strike to take down a target in Pakistan. Carrie's in a bunker in Kabul; the military personnel sit at computers. With the push of a button, a drone will dispatch. Carrie's job—and moral dilemma—in the episode is to weigh the pros and cons of the operation, as drone strikes are rarely surgical. Innocent people may die, and she must analyze the collateral damage. A tough, though apt, analogy would be a patient who is considering chemotherapy, which has the benefit of killing cancer cells, but simultaneously, the toxicity poisons the healthy ones. The potential cure could be worse than the disease itself.

In *The Big C*, when Cathy (Laura Linney) finds out she has cancer, she decides *not* to undergo chemo. Instead, she's going to party, live out her days and take her chances (at least, that's her initial choice). But in *Homeland*, Carrie decides to go ahead and authorize the drone strike. They inadvertently end up bombing a wedding inside the building, killing their target but also 40 innocent civilians, including women and children, which creates further terrorist retribution and hatred against the US—plus, Carrie's going to be held accountable for what has happened. When she goes to Islamabad, she starts to get more involved with the US embassy there; all her actions are informed by that one, devastating decision she made and its ripple effects. The situation only grows messier.

Homeland isn't about the good guys and the bad guys. It's more about, "Who *are* the good guys and the bad guys—and how do we identify them?" The show's first season begins right away as a dramatic, suspenseful polemic: Is Brody a war hero or a terrorist who's been turned? Carrie isn't sure and neither are we; we don't know for much of Season 1. Going into the second season, things start to shift, so just as we begin to think we understand what's happening, we discover we don't at all. Plus, people are capable of changing. Brody, for instance, starts to evolve as he re-bonds with his daughter and family. It's not as if we can judge a person based on one action, although we take that into consideration.

By Season 5, Carrie lives in Berlin and is no longer with the CIA; she's the head of security at a philanthropic foundation. She has an adorable daughter, has met a man whom she loves, seems content and is trying to have a "normal" life. Her boyfriend, Jonas (Alexander Fehling), is supportive of her in the new life she's embracing. Carrie has also stopped drinking, takes her meds and is stable. Possibly stemming from her newfound sobriety, she has reconnected with her faith; she prays and goes to church. We don't see her in AA meetings, but we do see that she's surrendered to her Higher Power, as one might do in a 12-step program. The story of Season 5 of *Homeland* has an Edward Snowden-inspired, whistleblower plotline: There's been a major leak of classified information that could potentially put CIA agents and covert operatives in imminent danger. Carrie then finds she's the target of an assassination attempt. As much as she wants to stay out of the situation, the information puts her in peril, and she's compelled to step back into the Agency officially, in order to protect both her daughter's life and her own. This yields another example of Carrie being caught between two wrongs, which crystallizes in Episode 3 of Season 5. She quickly needs to crack open what's really going on, because there's a conspiracy, a leak—a *mole*. She knows she's in the crosshairs and is risking her daughter's life, too, but doesn't yet understand all the components of it. Bipolar Carrie's dilemma is whether or not to go off her meds, to access her manic super-mind, which has helped her solve cases in the past. But, doing so will cost her, leaving her raw, hostile and agitated.

Carrie's bipolar diagnosis was established from Season 1, when we see her take lithium. The Wikileaks situation is almost like a series of dominoes that have been lined up. As soon as the leak happens and the first domino falls, things rapidly start to topple and crumble. When Carrie realizes she's a target, she needs to send her daughter away. She's not sure she can trust Saul Berenson (Mandy Patinkin), who's still with the CIA, and she doesn't know how to resolve the danger. It's a powder

keg, and if she doesn't contain it, it will end in tragedy. So, this is why Carrie decides that, in order for her to gain insight into what's going on with this conspiracy, she's going to go off her meds, and damn the consequences. She chooses to stop taking the lithium, as she knows she'll have a small window where her manic side comes out, which is what has helped her crack open other cases in previous seasons.

As we've discussed, characters cannot unlearn what they know; Carrie remembers the dangers of stopping her meds. Worried about becoming completely irrational and hostile, she convinces Jonas to supervise her while she's off the lithium. He tries to talk her out of it, reminding her there's a good chance she'll become destructive and self-destructive, but she informs him that she's *already* stopped taking them three days ago. He agrees, if this is what she needs to do, he will support her.

Carrie plasters the walls of a room in the house with photos and information. She tries to figure out, of all the people she's dealt with since Season 1 of the show, who are her enemies, the associates of her enemies, the people most likely to target her—and why? She becomes increasingly unhinged, and Jonas tries to help. He takes notes and tries to assimilate and coordinate all this information, to get to the answer she's looking for. Because Carrie's stopped taking her meds, her guard is down and her filter is off. As Jonas learns more about all her past activities, things she's never shared before, he starts to see who Carrie Mathison truly is—and doesn't like it. He now knows she's responsible for the deaths of many innocent people, including women and children.

Although we're in Season 5, Episode 3, Carrie's decision to order that drone strike back in Season 4 proves to have long-lasting ripple effects. Although Carrie was caught between two bad choices and had to make the call, she did so based on what she thought was best for the greater good. We see how one difficult choice generates story, conflict and moral dilemma for a whole season, moving into a whole next season. Then, Carrie's mental illness and ultimate decision to go off her meds is another example of being caught between two wrongs. If she does nothing and stays on the lithium, she'd still have a target on her back. Her daughter would likely grow up without a mother, or, far worse, may be hurt or killed. By stopping taking the meds and going to her manic super-mind, there's a good chance she'll solve the problem—but at what cost? She decides to take the risk, again for what she considers to be the greater good.

However, we begin to suspect the price this time may be losing the man she loves, as well as the part of herself she's been able to compartmentalize. Yet she won't end up actively going back to the CIA either (let's face it, every time Carrie is in the field as an operative, something terrible happens). The CIA cannot let her back in, because it would make the agency look completely ridiculous. So, she's going to have to go rogue. The question now is, will CIA operative Peter Quinn (Rupert Friend) go rogue with her? Is he out to kill her, or will he help her? Carrie's moral dilemmas generate fresh stories in Season 5 of *Homeland*, with new territory for the characters (and us) to explore.

Another example of Carrie's being caught between two wrongs happens in Season 5, Episode 11, entitled "Our Man in Damascus." After going undercover in a terrorist cell to try and foil an attack, Peter Quinn has been injured and is in a coma. When Carrie and Saul discover that Quinn *could* have valuable information to stop a terror attack, they urge the doctor to wake him up before it's too late. But the doctor warns Carrie and Saul that waking Quinn up early *could* irreparably harm or even kill him.

Carrie is faced with the choice to risk the life of her friend (whom Season 4 establishes is a little more than a friend) or risk the lives of possibly hundreds of innocent people. Carrie has often chosen to sacrifice those close to her for the greater good of humanity. She is a character who harbors much personal guilt about not catching terrorists before they harm other people. Early on in the series, we discover she personally feels responsible for the attacks on 9/11 and feels that she could have done more. But Carrie lives in a world of "what ifs" and "could haves," this being a crucial one (which makes for a stressful life, but excellent TV). Waking Quinn up *could* kill him; it could get them information, or it could get them nothing. But will Carrie forever be haunted if she didn't pursue every possible lead to prevent an attack? The weight of this choice plays out in this scene. You see the desperation in Carrie's eyes for Quinn to tell her something, anything to make risking his life worthwhile.

```
              DOCTOR
Eight milligrams per hour. We
should know fairly quickly if the
drug will have any effect.

              CARRIE
Quinn. Quinn, it's me, Carrie. I
need you to open your eyes now,
okay? Can you hear me? It's really
important you wake up. I need to
talk to you. Listen to my voice.
Follow it to the surface. I'm
here, waiting for you.
```

 NURSE
Electrical activity is rising.
It's up from 11 waves per second
to 19. No, 23 waves per second.

 DOCTOR
Hey. Hey!

 CARRIE
Quinn? Quinn, look at me. Can you
hear me? Quinn. Tell me what the
target is. Tell me where the
attack is going to happen.

 SAUL
Keep him awake, Colonel.

 DOCTOR
But, sir, I--

 3AUL
I said, keep him awake.

 DOCTOR
Give him an amp of epi. Now,
please.

 NURSE
Yes, sir, prepping the line.

 CARRIE
Quinn? Quinn, look at me. Quinn.
You're at Landstuhl Medical
Center. You're safe. Blink if you
can hear me. You penetrated a
terrorist cell. They're planning
an attack here in Berlin. I need
to know where. Louder, Quinn. I--I
can't make out what you're saying.

 NURSE
He's going into--respiratory arrest.

 DOCTOR
Stand back, please.

Carrie comes out with nothing.

When we're between two wrongs, both choices are not only bad in terms of the
actual choices we make, but both may have negative consequences. Even if we
make the choice we think is "more right" among the two wrongs—the lesser of two

evils—we will always look back and wonder, "What if I'd made the other choice?" We'll never quite know—and that also gives us more story to explore.

A "WHAT IF?" EXERCISE

In *Sliding Doors*, a metaphysical movie set in London in the late '90s, Gwyneth Paltrow plays Helen, a British girl whose life splits in half after narrowly missing/just managing to catch a subway train. Her life then plays out on two time continuums. In one version, after missing the train going to work, Helen returns to her apartment and finds her boyfriend in bed with another woman, which turns her life upside down. In the other time continuum, she makes it through the sliding doors and gets on the train to work, oblivious to her boyfriend's betrayal—and her life takes a completely different path. Both stories play out on parallel tracks. If we have a character caught between two wrongs, a helpful exercise is to consider both potential time continuums and where both bad choices might lead. Follow each one and see where that choice takes us, story-wise. And not just for one character, but for the ensemble who populate the show, exploring all the collateral damage of that choice. Continue the logical or likely path of what would happen in both scenarios. This exercise can help us right off the bat when we're trying to break story and make a decision, because when a character is caught between two wrongs, we as storytellers are *also* often caught between two wrongs. We need to decide where to send the character next, what he or she is going to be compelled to do and the collateral damage.

Once we make a choice and go into outline and script, there will always be a moment of story where the character will look back with regret at that other choice they didn't make. As writers, we may feel the same—where could that storyline have ended up? It's fascinating when life imitates art, and vice versa, which helps make the characters and their stories feel real and relatable. No matter what choices we make, there's always part of us tinged with regret, because we'll never know where the other path might have taken us.

DILEMMA AND PERSPECTIVES

Let's start with a basic, broad question, which is, "Why do we write?" For me, the answer is, "Because we have something to communicate." But that doesn't mean we "preach." Ideally, we take a holistic approach to storytelling,

to the entire script, the entire season of the show, the entire pilot episode; all events, characters, dialogue, together as a *whole* should say something. It's allegorical. Ideally, we don't put what we're trying to say as a writer into the mouth of one of the characters as an obvious moral or message. We risk becoming pedantic and heavy-handed. The most interesting stories are the ones where we present multiple points of view and let the audience draw their own conclusions.

Often, within an episode, especially a pilot where several storylines are unified by a common theme, one character having to make a tough decision will have dramatic ripple effects on other characters. They might question, "How would I make a decision like that? What are the moral implications? How might that apply to my life?" The ripple effect might cause a supporting character to make a decision in reaction to one that the lead character made, with further consequences to the story.

There's an adage that we should be kind to everyone, as we have no idea what someone else's experience is or what they're going through on a particular day. A character caught between two wrongs carries that burden around with them; this will have implications for other people who may at first be much more impatient, even with trivial things. But their awareness of the character's burden might make them think, "Why are we even arguing about this? It's a stupid thing to talk about, when people are dealing with life, death, pain and crisis." Understanding shifts perspectives. The more we can get characters caught between two wrongs, the more that creates those ripple effects, particularly emotional ones, which radiate outward and impact other people in the orbit of that one situation.

Going back to why we write, it's because we have something to say, but we preach neither to the unconverted nor the choir. In fact, we don't want to preach or convince people of anything. We would like our work itself to stand for something; we want to show all sides of life and its situations. In our own writing, including multiple perspectives in a script doesn't mean we're going to change the audience's own perspective. They may relate to a person we have demonized or to whom we thought was a representation of evil. We may have a viewer who relates to a person for all the wrong reasons. That's simply out of our control. All we can do is tell a good story and show multiple perspectives. Then maybe change can happen, but it's up to the audience.

POLITICS, POWER AND INTERNAL LOGIC: *LEGION*, *THE HANDMAID'S TALE*

C rash, *Traffic*, *Syriana* and *Amores Perros* are movies with a kaleidoscopic approach that present several different aspects of one bigger, complicated issue. The same is true of *Orange Is the New Black*, *Legion*, *The Americans* or any show featuring characters with opposing points of view. *Legion* is political as it deals with opposing viewpoints on power and how to manage it; *Empire* too is political, though within a family; *The Americans* is historically political because Elizabeth and Philip are KGB spies who work in the US during the Cold War. Politics ripples to other spheres of their lives: Now that they have a family, it's more complicated, as they find themselves divided in their allegiance to their country and in their marriage. They inevitably mistrust each other even though they have to pretend they're aligned, which creates plenty of interesting power dynamics. (I discuss *The Americans* further in Chapter 3.)

If we go back to the classic definition of power by Dahl, "A has power over B to the extent that he can get B to do something that B would not otherwise do."[1] We can look again at the above examples in terms of power dynamics. Naturally, *The Americans* has political implications because of the arena it's set in. But if we look at the power dynamics between characters, any time they have to make a decision, it's as part of a bigger power structure. In the earlier example from *Homeland*, Carrie has to seek approval from her superiors to issue the drone strike, because it isn't solely her decision. Once they say it is down to her discretion and judgment, she is empowered to make that decision. When she has to make difficult decisions that are within her control, such as not taking her meds, she still needs to get approval from her partner. She needs Jonas to be there for her, in case she goes totally off the rails. In every decision we make, we look for alliances and often seek permission. We tend to look for somebody to help us make the decision, for validation and approval, so we don't have to bear the full responsibility for it. It all depends on the character and how strong-willed he/she is.

In some shows, a character being caught between two wrongs is part of what the story is about, from its very conceptual level. In the sophisticated and richly layered *Legion*, we have the three spheres of overlapping characters who struggle with dilemmas and power, like a Venn diagram. David/Legion (Dan Stevens) is a powerful mutant who has been the host to a demonic parasite, Amahl Farouk/the Shadow King (Aubrey Plaza) since he was a baby. David longs to rid himself of this parasite, which has been misdiagnosed as schizophrenia for decades, but is torn. Separation is risky and David

himself might be lost in the process. Indeed, David discovers he is telepathic and able to host multiple consciousnesses and their powers, in a "legion," but is only just beginning to understand how. As Amahl blocks him and wreaks mayhem at every turn, feeding off others' fear of David, we seriously worry for David's wellbeing and the safety of those around him. Then there is Melanie Bird (Jean Smart), the fearless psychotherapist who runs Summerland, the facility for nurturing gifted people. Her intentions with David seem to be pure, a maternal figure who just wants to help him control his power and find his true potential, but she also needs his help to free her husband Oliver (Jermaine Clement), whose consciousness been trapped in an astral plane for decades. Oliver's body is in the facility, but it appears as if he's in a coma. Bringing Oliver back also doesn't guarantee that he'll reunite with or even remember Melanie after all these years. Enlisting David's help puts them all in danger, because Amahl is unpredictable and ruthless. Both Melanie and David clash with Clark (Hamish Linklater), the official who runs Division 3, the sinister government facility that wants to contain mutants and quash their powers. Division 3's mandate sharply contrasts with Summerland's, which exists as a safe space where mutants can explore and develop their gifts. Division 3 sees killing as a justified means of protecting the rest of humanity. David, Melanie and Clark all have a history of not trusting anybody else, but by the end of Season 1, they have to learn to trust one another.

David Haller is a mesmerizing character whose own internal logic constantly battles with Amahl's and those around them. David's actions lead to killing, mainly of the Division 3 team which threatens the safety of Summerland and who holds captive his sister Amy (Katie Aselton), though some may be unprovoked murders. My knee-jerk reaction to the massacre of Division 3 was that he must have underlying psychopathic or at least sociopathic tendencies—but is this David acting solely, or Amahl controlling him? It can be hard to say. David believes that his ideals are justified when it comes to protecting those he loves, even if the means involve killing. It's something positive he can do with his extraordinary power, as the end will benefit the greater good. Along the way, there may be unfortunate consequences. But David's not naïve and at his core, he knows he *has* to separate from Amahl, even if he risks death. With David's intrinsic power and Amahl's knowledge of how to control him, plus Amahl's own vast strength and unpredictability, David's choices aren't just for the good of Summerland; they're for the greater good of mankind.

Between David/Melanie and Clark; between Summerland and Division 3 there are the classic deeper issues of fear, insecurity and how to deal with the unknown. There are echoes here of the wider political landscape in real life: how fear and insecurity breed more fear and insecurity. Clark and his evil counterpart Walter/The Eye (Mackenzie Gray) truly believe that containing errant mutants, even execution, are justified to

protect humanity. It's their take on David's concern of protecting those around him. The Eye, a mutant himself, presents a dark version of homeland security. He wouldn't characterize himself as a hypocrite or egomaniac, because he believes his power and position in life exist for the greater good. In their worldviews, both hero and villain think they're doing the right thing. We wonder where The Eye's hatred and repression come from, and look forward to that reveal in future seasons. Meanwhile Clark, having learned first hand in the Season 1 finale that Summerland *are* the good guys, and most definitely on his side, is set up to clash with his "ally" The Eye in Season 2. Therein lies the excellence of the show; it operates wholly in ambiguity, where powerful protagonists and antagonists are given rich backstories and no character is saintly or blameless. They're torn, and their worldviews are mutable.

When confronted with a moral dilemma, what one character might consider to be a clear choice between the lesser of two evils, another with a wholly different worldview and internal logic might make the opposing choice for the same reason. When writing, it all goes back to what the character believes is right or wrong, and what the audience might think is right or wrong, presenting multiple points of view all around to enlarge perspective and focus—and ultimately letting the audience make up its own mind. A perfect example of this occurs in Episode 9 of *The Handmaid's Tale*, "The Bridge," when Offred (Elisabeth Moss) is instructed to talk her friend Ofwarren (Madeline Brewer) down from jumping off a bridge with her baby. Ofwarren has been blinded in one eye as punishment for an offense, and subsequently lost her mind. Offred empathizes with Ofwarren and understands what she's feeling: Ofwarren would rather die than give her baby up to the man who raped her. In the end, Offred makes the choice to obey these men she hates and convinces Ofwarren to give Commander Warren's infertile wife the baby. Ofwarren does so and immediately jumps off the bridge.

Any time one of our characters stands on the precipice of making a decision, as writers we need to remember they were not born as an adult facing that decision. Again, what's their history? What are all the events, relationships and interactions that brought them to this precipice, which are then going to inform their decision? What's their unique internal logic?

Our characters' goals also influence their decisions. What are they trying to gain? We need to evaluate the potential stakes. What do they stand to lose? What decisions are they going to be asked to make, either of their own volition, or as something being demanded of them? Our characters' pros and cons list of all the possible ramifications of each choice needs to be balanced between the two wrongs. Although there may be a potential positive outcome, there's a *lot* of wrong, with negatives that could come from either choice. And there can be no

easy way out, for then characters are not really trapped in a situation. Having a complex, evenly balanced list of pros and cons for each "wrong" choice helps to generate conflict and sustain more drama.

JESSICA JONES: HOW LATE IS TOO LATE?

What if you've lived your whole life feeling like an outsider, at last connect with someone who "gets" and doesn't judge you . . . but you happen to have inadvertently caused the death of their spouse? When do you tell them—or do you never tell them? Such is the predicament creator/showrunner Melissa Rosenberg has engineered for our protagonist Jessica Jones (Krysten Ritter), in the eponymous Netflix/Marvel series. Jessica, who developed superhuman strength and agility following a terrible car crash which killed all her family except her, only occasionally opens up to Trish (Rachael Taylor), her best friend and loving adoptive sister. Most of Jessica's days are spent drowned in work and in neat, hard liquor. Men are fleeting and functional in Jessica's life, until she meets bar owner Luke Cage (Mike Colter). Initially, we have no idea why Jessica spies on him. Unexpectedly for them both, they quickly grow close, become lovers and bond over their mutual superpowers; Luke has unbreakable skin and extraordinary strength. Later we learn that mind-controller Kilgrave (David Tennant) manipulated Jessica to kill and throw Luke's late wife Reva (Parisa Fitz-Henley) into the path of a city bus. We realize why Jessica has spent time watching Luke; despite being powerless to resist Kilgrave that time, she remains consumed by guilt and finds some solace in knowing that this widower is somehow finding a way to carry on living. Luke has always believed that it was an errant, alcoholic bus driver who hit and killed his wife. He's just discovered the driver's name, Charles Wallace (Sean Weil) and goes to confront him. Jessica is close behind.

```
[INT. MTA BUS - NIGHT

Luke sits and waits. One by one, all the passengers get down
as the bus makes stop after stop. Eventually the bus driver,
Charles Wallace, turns to face him.]

                    CHARLES
          Sorry, but this is the last stop.

                    LUKE
          You know who I am?
```

 CHARLES
 No. No idea.

 LUKE
 How about Reva Connors?

 CHARLES
 You're the husband?

 LUKE
 And you're the asshole who killed my
 wife.

 CHARLES
 I'm sorry for what I did. I've been
 sober since the accident. I'm just
 trying to make things right.

[Luke lifts him up by the lapels. Charles is speechless.]

 LUKE
 Time's up.

[Luke hurls him through the front windshield. Jessica
approaches, running, and tries to help up a stunned
Charles.]

 JESSICA
 Get up. Go on, get up. Go, go!
 (to Luke)
 You can't kill him.

 LUKE
 The hell I can't.

[She attempts to hold Luke back but it's futile. She turns
to Charles, who struggles to stand.]

 JESSICA
 Run!
 (to Luke)
 Would Reva want you to become a
 murderer?

 LUKE
 Don't matter. Reva's dead, and so is
 her killer.

[He pushes her aside and goes after Charles. Jessica stumbles
but gets back on her feet.]

JESSICA
Charles didn't kill your wife! I did.

[Luke slowly turns around and moves closer.]

LUKE
Stay out of it, Jones.

JESSICA
It was me. I killed Reva.

LUKE
Bullshit.

JESSICA
Reva was at that warehouse because
Kilgrave and I took her there.

LUKE
Oh, no way.

JESSICA
Reva had something that he wanted. He
made her tell him where it was. He
made me dig it up... And then he told
me... He forced me to...

[Luke screams and pushes her up against the bus.]

LUKE
Shut up.

JESSICA
I hit her... full-strength. She was
dead before the bus even got there.
The driver swerved to miss her body.

[Her eyes well up. Luke yells and raises his fist above her,
but punches the bus.]

LUKE
You slept with me.

JESSICA
I didn't plan that. It just happened.

LUKE
You made me think...I could get past
it. Did Kilgrave force you to do
that?

[She shakes her head.]

 LUKE (CONT'D)
 You let me be inside you. You touched
 me with the same hands that killed my
 wife, while you knew.

 JESSICA
 I'm so sorry.

 LUKE
 If I never found out about Charles,
 would you have ever told me the
 truth?

[She says nothing. Tears stream down her face.]

 LUKE (CONT'D)
 I was wrong.
 (beat)
 You are a piece of shit.

[Luke walks away. Jessica is broken.]

It's no coincidence that this episode is titled "AKA You're a Winner!" It's a line from a subplot, but is also knowingly ironic as Jessica feels anything but. She was Kilgrave's instrument and never wanted to harm Reva, however there was never a right time to tell Luke the truth. Maybe she never would have. Of course, she could have avoided getting involved with him, but she couldn't resist this one good man she connected with. Jessica's remaining consolation is that Charles lives. It may be too late for her and Luke, but it isn't too late to save a man's life.

GUILT, MATURITY AND ASPIRATIONS: *THIS IS US*

Creator/showrunner Dan Fogelman's *This Is Us* was a breakout hit for NBC in 2016. It's about three 30-somethings, Randall (Sterling K. Brown, who became the first black actor to win the Emmy for lead actor in a drama series in 19 years), Kevin (Justin Hartley), Kate (Chrissy Metz) and their parents, Rebecca (Mandy Moore) and Jack (Milo Ventimiglia). The show makes extensive use of flashbacks, beginning with the day Rebecca is about to give birth to triplets, years earlier. It also happens to be Jack's birthday. Although we don't know it yet, the present-day sequences occur on the day that their three children are also celebrating

their 36th birthdays. It's not until the end of the pilot that we discover that Randall was abandoned at a fire station on the day he was born. After one of Rebecca and Jack's triplets dies while being delivered, they decide to adopt the African-American baby who's displayed right beside their own Caucasian children in the hospital nursery.

In the present, Randall has grown up to become a successful commodities trader with a wife and two beautiful children. On this day—his birthday—he receives an email from his biological father, William (Ron Cephas Jones), who reveals that he's dying of cancer and needs his support. Soon Randall feels caught between two wrongs—if he takes William in, it may throw the whole balance off in his own family. Mostly, he seems to feel that William doesn't *deserve* to be allowed in, since he abandoned Randall as a baby. But Randall wants to be a good person, and will feel guilty if he turns his back on his father. When he first meets his dad, he reads him the riot act for never being there for him, saying, "Screw you!" He then turns on a dime and says, "You want to meet your grandchildren?" It's a touching scene, and one that demonstrates we can sometimes make a difficult choice quickly when we go with our heart rather than our intellect. Later in the show, though, Randall's decision will have a cascade of emotional consequences.

Kevin, a hunky actor, is the star of a vapid sitcom entitled *The Manny*, a job a lot of actors would kill for. But every time he has to take his shirt off, he feels that he's losing all his self-respect as an actor. (It must be noted that he's taking his shirt off for *This Is Us*, too!) He knows how hard it may be to get another job. But in the pilot, when the director asks him for one more take with his shirt off, Kevin loses it and quits in front of a live audience. He goes to give his sister Kate the news, wondering out loud if he's even good enough to be a "real" actor. This decision may have been a life-changing mistake.

Kate's dilemma occurs when she meets a nice, overweight man, Toby (Chris Sullivan) at an Overeaters Anonymous meeting. He asks her out, but Kate is terrified of intimacy and turns him down. Toby is charmingly persistent, however, and she gives in without too much arm-twisting. After their date she invites him in and is faced with another choice: "Do you want to fool around?" She says she doesn't but, again, soon changes her mind. She knows that, if she never lets anyone in due to her body shame, she may be alone for the rest of her life.

As I'm all about the slow-burn, I would have loved to have seen the triplets' "torn between two wrongs" choices take longer and for them to struggle, over time, to come to their decisions. Nevertheless, *This Is Us* has been hugely successful for NBC; Fogelman and his staff do know how to go for the emotional tug every time.

Heartstring-pulling isn't for everyone; James Poniewozik writes that watching the pilot felt like "getting beaten up with a pillow soaked in tears."[2] Yet with its traditional "family values," smart humor, diverse cast and universal themes, the show holds strong mass appeal for NBC's multi-generational, broadcast network audience. If "Niche Is the New Mainstream" at the cable and streaming networks, NBC has found the winning hybrid formula, eschewing edgy antiheroes and controversy by delivering a heartwarming yet flawed family. In our tumultuous, unstable political times, the most precious commodity on TV remains laughter and tears.

THE CLEANSE AND CROSSING THE LINE

Mamet once said:

> *All drama is about lies. All drama is about something that's hidden. A drama starts because a situation becomes unbalanced by a lie. The lie may be something we tell each other, it may be something we think about ourselves, but a lie unbalances a situation. And because a situation is unbalanced, as in our life, repression takes over. If you're cheating on your wife, that lie takes over your whole life. Everything gets relegated to repressing that knowledge. If you're cheating on your taxes, or for example if you're neurotic and think "I'm not where I deserve to be" or "my mother didn't love me," or blah blah blah, that lie, that neurotic vision takes over your life. And you're plagued by it until it's cleansed. In a play, at the end of every play the lie is revealed. The better the play is, the more surprising and inevitable the lie is, as Aristotle told us.*[3]

When our characters are caught between two wrongs, we're making them be honest with themselves about who they are and what each choice is going to challenge them to do, perhaps to cross a line they would have never crossed before. If our character is someone who tells herself lies and lives in denial, she's not necessarily going to think of "wrongs" in a negative way. But, if we strip away all the lies and the façade that everything is OK, or the idea that the things she did in the past don't matter anymore because they're in the past, then the character is not owning up to the truth of who she is and is probably not looking at the situation objectively. Being caught "between two wrongs" involves characters owning up to

all they've done that has led them to the precipice of making this decision. And even then, although both choices are still wrong, we have more drama and the sum of all that history informs and adds layers to the character. We find a lot of gray areas, nuance and provocations that will hopefully strike a chord with our audience, causing them to continue discussing the show and its story for quite some time after it's concluded.

The best stories stay with us and pull characters out of their comfort zones, sometimes plunging them into the dark night of the soul. We can only succeed in navigating our characters through the moral gray areas by doing some tough work, which may involve taking a moral inventory on our part. Maybe, on the other side of that, there will be light. Perhaps that's the cleanse of which David Mamet speaks.

● Bonus Content

For more analysis on choosing between two wrongs, including *Bates Motel*, *Breaking Bad*, *Queen Sugar* and *Orange Is the New Black*, visit **www.routledge.com/cw/landau**. *Queen Sugar* is Ava DuVernay and Oprah Winfrey's first collaboration after *Selma* and has already been renewed for a third season. The show follows three siblings who inherit a sugarcane farm in Louisiana. Through a compassionate and all too lifelike lens, it tackles issues of sexism, racism, familial responsibility and the bittersweet experience of going back to one's roots after life on the cosmopolitan coast. Country life sounds blissful, but it's also where generations of the family were oppressed and worse. As viewers, we can't help but contemplate and stay tuned as we follow the impact of the protagonists' choices.

See also: *The Deuce* on HBO, co-created/executive produced by David Simon and George Pelecanos, who previously collaborated on *The Wire* and *Treme*. The critically acclaimed show follows the legalization of the porn industry in the '70s and the drug epidemic. Caught between two wrongs is sex worker Candy (Maggie Gyllenhaal), who is drawn into the world of pornography.

Notes

[1] Robert A. Dahl, "The Concept of Power," *Systems Research and Behavioral Science* 2(3), 201–215 (1957).

[2] James Poniewozik, "Review: *This Is Us*' Is Skillful, Shameless Tear-Jerking," *The New York Times*, September 19, 2016.

[3] David Mamet, speaking on *The Charlie Rose Show*, July 7, 2010.

Episodes Cited

"Our Man in Damascus," *Homeland*, written by David Fury; Fox 21 Television Studios/ Showtime.

"AKA You're a Winner!," *Jessica Jones*, written by Edward Ricourt and Jenna Reback; ABC Studios/Marvel Studios/Tall Girls Productions/Netflix.

"There is no such thing as an interesting character, only interesting character relationships."

—HOWARD SUBER
PROFESSOR EMERITUS
UCLA SCHOOL OF THEATER, FILM AND TELEVISION

CHAPTER 9
THE WILD CARD CHARACTER
Power Dynamics and Motivations

The "wild card" is the element of our pilot, usually embodied in a character, who is an unexpected addition to the audience's expectation of where the plot and story are going. The wild card throws everything off kilter. What's significant is that this unpredictable character tends to destabilize and throw the protagonist off his or her game, more than anyone or anything else. In this chapter we'll analyze wild card examples from several of the best comedy and drama series in this new TV era.

In a world of savvy TV audiences who can quickly spot a show that feels too familiar or a little stale within the genre, how do we shake it up? How do we invigorate it with something unexpected? In great stories, protagonist characters who are always in control or are experts at their jobs need other characters to knock them off balance. And the wild card is that character.

THE WILD CARD WITH A TWIST: *MR. ROBOT*

In the *Mr. Robot* pilot, we're introduced to a mysterious character named Elliot Alderson (Rami Malek), a cyber hacker. He's a young guy who always wears a black hoodie; his enormous eyes are always roving; he's suspicious of everyone and doesn't trust authority. He's a modern, quasi-Robin Hood character, but the difference is he's trying to bring down the 1% of the 1%, the wealthiest CEOs and corporate magnates in America. His plans may extend to other countries in the future. Elliot's main target is E Corporation, which he refers to as "Evil Corp." He has a long arc of

trying to bring down E Corp, though at the same time, within each episode, he has smaller targets. In Season 1 he tries, for example, to protect his female therapist, Krista (Gloria Reuben) from loser guys she meets on Internet dating sites, so he hacks into these guys' email accounts to see if they're suitable for her—or if they're scumbags who are going to hurt her in some way.

We also see in the teaser that Elliot's pursuing a wealthy, entrepreneurial businessman who has a dark secret. Elliot's onto him and confronts the guy. At the same time, while we see Elliot doing what he does best, we're also learning about his own backstory, which has to do with his father. This exposition about Elliot's backstory motivates all of his actions, certainly for the pilot, and for the rest of Season 1.

```
BLACK.

                    ELLIOT (V.O.)
          Hello friend. Hello friend? That's
          lame. Maybe I should give you a
          name? But that's a slippery slope.
          You're only in my head. We have to
          remember that.
                    (then)
          Shit. It's actually happened. I'm
          talking to an imaginary person.

Loud music RISES on the soundtrack. Within the black of
frame, silhouettes begin forming.

                    ELLIOT (V.O.)
          What I'm about to tell you is top
          secret. A conspiracy bigger than all
          of us. There's a powerful group of
          people out there that are secretly
          running the world.

We pull out to reveal we're in an office looking out of a
very tall Manhattan skyscraper. Shadowy figures stand around
a conference table, arguing.

                    ELLIOT (V.O.)
          I'm talking about guys no-one knows
          about. The guys that are invisible.
          The top 1 percent of the top 1
          percent. The guys that play God
          without permission.
                                         CUT TO BLACK.
```

```
              ELLIOT (V.O.)
     And now I think they're following
     me.
```

Later in the teaser, Elliot confronts Ron, real name Rohit, who he's learned is the owner of a child pornography website, in his "Ron's Coffee" shop.

```
              ELLIOT
     See, I usually do this kind of thing
     from my computer. But this time I
     wanted to do it afk. In person. I'm
     trying to work on my social anxiety.
     But there's always the threat of you
     fleeing after I call you out. You'd
     tell your assistant men to take your
     servers down, wipe all the data. So,
     I made sure to include the current
     time and location on my anonymous
     tip--

              RON
        (desperate, nervous)
     Wait, hold on! I will give you the
     money. I'll pay you. How much do you
     want?! I'll pay you!
```

Sirens can be heard. Lights swirl outside the windows.

```
              ELLIOT
     That's the part you were wrong
     about, Rohit.
        (shrugs)
     I don't give a shit about money.
```

FBI AGENTS race into the shop as Elliot breezes past them, heading out, leaving the chaos to surround the destroyed Ron.

Now, when we come out of that teaser scene, we've learned something that distinguishes Elliot from a Robin Hood character, which is that it's not about the money. (Traditionally, Robin Hood characters care about money, though not for themselves.) Money doesn't motivate him—neither do fame, sex and power. So he is a character who is beholden to no one. With his incredible tech skills (he must be among the 1% of the 1% of tech geniuses in the country), he can hack the hackers and is always one step ahead of everybody else. He can break into encryption and manipulate people based on information he's discovered. He holds strong judgments about other people; he's a little like Holden Caulfield from Salinger's *The Catcher in the Rye*, in that he holds most people in contempt and thinks they're phonies.

Elliot feels that most people are fakes, materialistic, greedy, selfish—and full of shit. He thinks that how we present ourselves to the world, through social media, our personas online and humble brags, is all superficial interactions and phoniness. What's vital in new television content is *authenticity*. It's the buzzword that everyone's still talking about at all the networks, especially digital networks.

One of the reasons why the Elliot character works so beautifully is that despite his misanthropic judgments about everyone, he himself tries to lead a life that's authentic. The show uses a voice-over in the teaser and, later, when he's in a therapy session. His voice-over lets us connect with him by giving us direct access to his brain. His brain, incidentally, is brilliant, but he can't turn it off. He's constantly thinking, as if he's a processor with a huge amount of gigahertz working overtime. We learn in the pilot there's this itch in his brain that his cyber hacking activities only tend to scratch. He's a loner, doesn't fit in anywhere and he ends up numbing himself. We know in the pilot that he's addicted to morphine, does drugs regularly, has sex with strangers, smokes cigarettes and suffers from chronic insomnia. As we see that he has all these vices, his voice-over gives us insight into how and why he needs them. We see his intense vulnerability when he's in his apartment at the end of the day, sitting in a fetal position, sobbing.

We understand Elliot is in a great deal of existential pain. The only way to relieve it, because even the morphine isn't helping, is for him to go out and do the things he does. The voice-over makes him a character we connect to, in much the same way the voice-over in *Dexter* allows us direct access into Dexter's inner thoughts, pain and struggles that help us empathize with a serial killer! Similarly, direct address—breaking the fourth wall—helps us connect to the characters in *Modern Family*. The *Modern Family* protagonists are totally different to Dexter, who's a flawed character with dark, manipulative desires, yet voice-over and direct address make us feel they're all confiding in us. As mentioned in Chapter 2, the ahead-of-its time Fox series *Profit* used the same device.

Elliot Alderson always tells us the truth, or his version of the truth. Even if the truth is uncomfortable and takes him down dark, ruthless alleyways, he's authentic and has idealism at the core of his beliefs. We connect to him because he's an outsider who doesn't really fit in anywhere. All of us somehow feel that way—it's why we watch television and are on social media all the time. We want to connect. We want to participate in a storyline. But, ironically, television and binge viewing tend to be solitary activities. The more we engage in social media, play video games and binge-view TV, the more we find ourselves living on islands of technology and

digital content. It tends to isolate us. Ironically, the feeling of isolation is universal, especially now. When it comes to the desire for connection and authenticity, we all feel like outsiders at times.

Part of what makes wild card and iconic characters such as Elliot interesting is paradox. He is always in control, the smartest person in the room and incredibly cunning, yet at the same time he is extremely fragile, broken, wounded and confused by this isolation and how the rest of the world functions. He himself is a wild card character in the world around him, because he's the ultimate outsider. At the same time, what makes him different is:

1. He doesn't try to be likable at all, but more significantly,
2. He doesn't try to conform.

Elliot is one of the next iteration of characters who defy tropes. He's an outsider who revels in being an outsider. He feels superior and it causes him pain; yet, he doesn't want to change or try to fit in. The best TV shows right now have characters who know they don't quite belong. If they're comedies/dramedies (*The Big Bang Theory*, *Baskets*, *Silicon Valley*, *Insecure*, *Atlanta*), they may try to fit in to comedic effect but still fail. In darker dramas, they are so rooted in who they are that, even though they feel ostracized from various communities and have contempt in some ways for those social rituals and conformities, at the same time they choose to take their own path. They're iconoclasts. It makes them interesting, because for years drama was about characters who don't fit in, who struggle (or pretend) each week to adjust and belong. What we're seeing now are characters who want to be true to themselves. From their point of view, it's the *other* people in the world who tend to have the problems. Their desire is that the world will be a better, more authentic and genuine place than it is. Their activities tend to lean towards finding other people who are like them—but there are few people like them.

Elliot may be a wild card character for the world of *Mr. Robot*, but his own wild card in the show is Mr. Robot himself, played by Christian Slater. He is the character who throws Elliot totally off his game, because he's somebody who can out-hack Elliot; he has more information and chooses to destabilize Elliot at every turn. In Episode 2 of Season 1, when he meets Elliot at the boardwalk, Elliot reveals he had broken a promise to his dad by telling his mother his dad had leukemia. Clearly, Elliot has never recovered from the fact that his dad felt betrayed and pushed him out of a window as punishment. Mr. Robot then pushes Elliot off the railing onto the

ground below, as punishment for not trusting *him* . . . destabilizing Elliot in a literal way. Later we find out that Mr. Robot is a delusion and Elliot imagined this entire scene although, his wounds are real.

All this, of course, both challenges and perversely attracts Elliot, for Elliot never feels challenged, since everybody around him is a moron. (His least favorite person would be an *arrogant* moron.) Mr. Robot literally shocks him into *feeling* after all that numbness; he will simultaneously be his mentor, guide and antagonist. Elliot—and we as viewers—don't completely understand what Mr. Robot is up to in the pilot, and this has us hooked. We're not sure if what Mr. Robot is telling us is true. It's much later in the season when we discover who he really is. Mr. Robot's own character paradox is that, despite his disarming personality, he happens to be a version of Elliot's late father and exists only in Elliot's mind.

There are, then, several layers in the show. We have an unreliable narrator who tells us things in voice-over. Generally, we tend to take voice-over as truth, as we instinctively feel that, because the narrator's confiding in us, it *must* be true. But, Elliot's on morphine, and his grip on reality is tenuous; we also know from his therapy sessions that he hears voices and sees things that aren't necessarily there. So we learn as the pilot progresses that it's possible that Elliot's point of view—which is the only POV in the pilot, as we see everything from Elliot's perspective—may be unreliable and the things that he's seeing and hearing might not actually be happening. Or, maybe some are and others aren't? One example of this is E Corporation, whose logo has an "E" at an angle (and strongly resembles the Enron branding). As the pilot progresses, Elliot actually sees the word "evil" in the logo. He sees it everywhere: Is it just his imagination, something he's projecting? He also goes to Mr. Robot's headquarters in a defunct arcade on Coney Island, where he meets the other hackers on Mr. Robot's team. Later in the pilot, he returns to get answers, but he doesn't know where everybody is. The place is deserted. Did he just imagine that all of that happened?

There are elements of the movie *Fight Club* and its Narrator character (played by Edward Norton). Elliot's voice-over gives us a private, all-access pass to his hypersensitivity, perception, paranoia and judgment. Even in one of his mandated therapy sessions, as his therapist observes him and asks questions, his mind is someplace else. In the voice-over, he dissects her.

In recent years, we have seen TV series become much more cinematic. The *Mr. Robot* pilot plays with time quite a bit. The show is structured the way that Elliot's thoughts are structured; the show itself has a meta, wild card element to it. No two

episodes are structured exactly the same, and this too destabilizes us as viewers—which I think is an excellent approach. It's different from the way most television used to be, where we would seek out the comfort of a formula. We knew, for instance, every *Law & Order* was going to start the same way: with a murder. There's the iconic music; we knew the first part was crime, the second was justice and there was always going to be a resolution. TV has moved beyond that now, to mirror real life where there are murky gray areas and few clear answers. Certainly as new content creators, if we want to move beyond that and be leaders, rather than followers, we need to find ways to transcend formula that defy expectations.

One further point to bear in mind when we're writing a pilot is that . . .

> ## The end of our pilot is the beginning of our series.

So, we always want to make story choices that will give us *more* story as the show progresses. The wild card helps us get there.

THE WILD CARD'S WILD CARD: MOZART IN THE JUNGLE

We've discussed how Mr. Robot is Elliot's own wild card. Another instrument in our writer's toolbox is to offer up the wild card's wild card later in the series, as the show progresses and more story is needed, to disrupt everything and surprise our audience. An example of this is found in Amazon's *Mozart in the Jungle*. The character of Rodrigo, played by Gael García Bernal (and loosely based on real-life conductor Gustavo Dudamel), is the new conductor appointed to the New York Symphony in the pilot. He's been hired to replace seasoned pro Thomas (Malcolm McDowell), with a mandate to reinvigorate the audience and increase ticket sales. He's young, brash (mostly charmingly so) and eccentric and threatens the status quo. When a wild card character comes into a story, they often instigate change. They upset the balance of what was harmony and normalcy in the world. In some ways, the arrival of a wild card character shares elements of the inciting incident in a screenplay. Certainly, in the *Mozart in the Jungle* pilot, when Rodrigo enters the story, the stakes, tension and conflict increase dramatically. He is the original wild card in the dramedy.

In this scene, Gloria (Bernadette Peters), the grande dame/patron of the New York Symphony, introduces Rodrigo at a cocktail party welcoming him to the orchestra. Rodrigo, without intending to, fatally threatens the career of Thomas (Malcolm McDowell), the arrogant, older maestro. See what happens when an infuriated Thomas comes in with the new press release and how his contempt leaves the gentlemanly Rodrigo with no choice but to humiliate Thomas—not with guile, but with the truth.

 THOMAS
 Well? Don't you have anything to say
 for yourself?!?
 (cutting)
 Say something--in English.

Rodrigo stops at the door. With his back to the room, he
speaks decisively.

 RODRIGO
 Your first chair violinist, Emily Wu,
 played sharp seventeen times in the
 first movement. French Horns came in
 half a bar late in the adagio,
 throwing off the bassoons, ultimately
 destroying any possibility of
 Beethoven's desired dynamic shift in
 bars forty-five through fifty three.
 And the second chair bass, Bruno
 Cassel, is so old he can barely hold
 his bow. I couldn't tell who you were
 torturing more, me or him.

Long, awful silence.

 THOMAS
 You prick.

Rodrigo turns to face them all.

 RODRIGO
 I'm replacing six chairs immediately.
 (to Gloria)
 Gloria, you've been an exceptional
 hostess.

He drains his glass and turns to Thomas.

 RODRIGO (CONT'D)
 (sincerely)
 Maestro, I hope I don't disappoint
 neither you nor the traditions of
 this great institution.

Rodrigo walks out. Thomas, for once, is speechless.

Rodrigo is the classic wild card: He shakes everything up and unsettles everyone. He doesn't want to do things the way they were done before and bucks tradition. Rodrigo has crazy ideas that get everybody riled up, sometimes in a good way, sometimes not. But he also tends to be right about his instincts. A lot of Rodrigo's behavior, contrary to Elliot's in *Mr. Robot*, comes not from a deep mistrust of establishment rules, but from his gut and instincts and above all from his desire to be true to the music. Like Elliot, however, Rodrigo is authentic. He is not driven by fame, sex, power or money. Rodrigo is driven purely by music and his passion to touch the souls of the audience. So, we respect him, in spite of the fact that he's disruptive and a force that's going to have a strong impact on everybody in the orchestra.

Rodrigo especially destabilizes Hailey (Lola Kirke), who comes into the story as our main point-of-view protagonist. Though *Mozart in the Jungle* is an ensemble, Hailey is initially our window onto this world, and Rodrigo proves to be a wild card for her and everyone else. In contrast, *Mr. Robot* is a singular point-of-view show. We're almost always in Elliot's head or seeing from his perspective. *Mozart in the Jungle*, which is a half-hour, single-camera dramedy, is a multiple point-of-view show. It's about the musicians in the New York Symphony and its behind-the-scenes administration. Although the characters in the ensemble do have different weights, the points of view and stories are spread fairly evenly among four to five different characters. As I mentioned in Chapter 5, *Mozart in the Jungle* is based on a memoir by New York Philharmonic oboist, Blair Tindall. She talks about her experiences and what it was really like: the politics, performance-related injuries and confrontations with unions and other musicians, not to mention the sex, drugs and alcohol-fueled parties. I find it fascinating just as a setting because it's a glimpse into a world that I didn't know. That's one way *Mozart in the Jungle* the series strays from the memoir; the memoir does not describe a power struggle between Rodrigo and Thomas (or even have a character named Rodrigo).

Rodrigo's own wild card—the wild card's wild card—then arrives in the form of his estranged wife, Anna Maria (Nora Arnezeder). She comes back into his life at a time when he's starting to feel things are getting more stable for him. She is completely crazy: an unpredictable, highly strung violin player, who flies into rages at the *slightest* provocation—as well as being a red hot, sexy dynamo who can seduce Rodrigo and pull him away from his music. He doesn't quite know how to please her and is still crazy about her in spite of himself; one minute she pulls him in, and the next she rejects him. The paradox is that the brilliantly damaging and dysfunctional Anna Maria still manages to disarm the disruptive Rodrigo, completely. We see how Rodrigo, the one who's always rising above everything and living his life in an ethereal way that suits him (while destabilizing everybody else), reacts to somebody who deeply destabilizes *him*.

In this scene, Rodrigo goes into Anna Maria's dressing room to "talk" to her after a performance. Hailey waits outside, but when he doesn't come out, she decides to go in and rescue him. She enters and finds the two of them making out.

> HAILEY
> Maestro, the car's--Oh my God, I'm so sorry.

> RODRIGO
> Hey, Hailey!

> ANNA MARIA
> Who is she?

> HAILEY
> Me? I work with the maestro. Below him. Underneath, underneath him.

> ANNA MARIA
> You kissed her?

> HAILEY
> No, no, no...

> RODRIGO
> No, no, no! She plays the oboe. No, no, she is my assistant.

> ANNA MARIA
> Then maybe I'm seeing into the future.

> RODRIGO
> Anna Maria. Calm down. Look into my eyes. Calm down, look into my eyes. Okay. No, breathe in...

[Anna Maria jumps up and chases Hailey out of the room, screaming in Spanish.]

> ANNA MARIA
> The day you left to conduct for Oslo, you became disloyal. And faithless. When you abandoned Mexico, when you broke with my family, you abandoned integrity. For what? Celebrity? The adoration of cheap little women?

 RODRIGO
No! I told you, she plays the oboe!

 ANNA MARIA
Yeah, or maybe for some sickening
pursuit of glory!

 RODRIGO
Glory!

 ANNA MARIA
Yep!

 RODRIGO
You think this is about glory?

 ANNA MARIA
Yeah!

 RODRIGO
Glory is for football players. I'm
about the magic, it's about the
magic, okay?

[He tries to leave; Anna Maria grabs him back and hugs him
close.]

 ANNA MARIA
Wait, Wait. I'm sorry. I'm so sorry.
Let's--let's--not make an old drama
out of it.

 RODRIGO
No, no.

 ANNA MARIA
We're adults now, okay?

 RODRIGO
Of course.

 ANNA MARIA
Please, baby. I have one question.
When you go to sleep, in your luxury
apartment, late at night, and your
noise machine is drowning out all the
sounds of the city below, how do you
feel then?

> RODRIGO
> I see what you're trying to say,
> yeah.
>
> ANNA MARIA
> Does it bring your ego pleasure,
> making dead music in your sterilized
> world, remarkable only for its
> lifeless artifice?
>
> RODRIGO
> Don't say those things.

[She pushes him in front of a mirror.]

> ANNA MARIA
> How do you feel, mi amor?
>
> RODRIGO
> Ow...I see what you're saying.
>
> ANNA MARIA
> You fucking disgust me.
>
> RODRIGO
> I disgust you? Okay. Fine. Let me go.
> Let me go. You know what, I'm going
> to go! Okay? Because I'm about the
> magic. This is going to be TBD, okay?
> This is how they say it in this
> country. TBD.
>
> ANNA MARIA
> TBD! TBD! TBD!

[He exits and slams the door, as she continues to scream.]

The wild card's wild card is a fascinating dynamic. When working on our pilots, we need to ask ourselves: What are the destabilizing influences? As soon as things get too stable and there's too much harmony, we need to shake things up. One thing that can help when devising a show is to start off with a plan to introduce this wild card character, considering when and how they will be most powerful (or most comedic, or both). Alessandra/"La Fiamma," fiery opera singer played by Monica Bellucci, has a similarly disruptive effect on Rodrigo at the start of Season 3.

At times, part of the wild card's nature doesn't necessarily play into a character or plot but is about the style of the show. These characteristics can form an element of the show that is unique and unsettling, but in a good way. In *Mozart*

in the Jungle, the first time Rodrigo is mentioned, we see the great, stylized shots of him, that were created by series executive producer Roman Coppola; there's a heightened aspect to how Rodrigo is presented. Later in the season, there's a wonderful scene where he's in a taxi on a bridge, driving with Hailey, and he hears the clicks and bumps in the road. We start to hear the New York City sounds that Rodrigo hears—and the way he hears them as *music*. He shares that with Hailey and, delighted, she starts to hear it, too. A whole symphony grows out of the cab ride. There's also a scene where Rodrigo leads the orchestra to a vacant lot in the middle of the urban jungle. Again, it's surprising and unsettling, but their performance proves to be beautiful, magical and part of the style of the show.

THE ROOMMATE SOULMATE: UNBREAKABLE KIMMY SCHMIDT

A comedic example of a wild card character is Titus Andromedon (Tituss Burgess) in *Unbreakable Kimmy Schmidt*. He is Kimmy's best friend and roommate. Titus is a unique creation who is, of course, linked to the actor who plays him in some ways. But at the same time, Titus is even more out there. He marches to the beat of his own drum and sees the world in his own way. He desires fame but is an unknown who never seems able to find mainstream success because he's so unusual, and his behaviors tend to work against him. Titus is someone Kimmy looks at as a confidant and somewhat as a role model. And yet, because she doesn't know what "normality" is, particularly in the first season, she thinks the people she meets are representative New Yorkers. That's Titus' wild card character paradox: He is someone who Kimmy learns from and looks up to, yet . . . there's nobody *quite* like him. He's a one-of-a-kind character, and we never know what he's going to do next.

That's what makes Titus' character so fresh. I couldn't compare him to any other character; there are no tropes in *Unbreakable Kimmy Schmidt*. The tone is its own and has recreated the sitcom genre in a way, giving us a protagonist we simply haven't seen before. Kimmy's lived in a bunker for 15 years when she is rescued from captivity; she has an innocence, naïveté and idealism, almost like Pollyanna. She goes to New York to learn about life. In the city she's a complete outsider who revels in being who she is, despite being surrounded by cynical, greedy, materialistic people. Kimmy becomes our view into that form of idealism. Part of her does want to conform because she wants to catch up, as she knows she's out of step with

everyone, yet she remains true to herself. There's always truth to what she says, which is refreshing, because another aspect of that strata of New York is that people can be fake and caught up in materialism and status. Kimmy has depth and soul: She's unbreakable. Titus has the same indomitable spirit—and that makes this wild card character her unexpected, kindred spirit.

It's a delightful dynamic to see them functioning within their own bubble together, even though she's left the bunker, which was another bubble. So Kimmy recreates, in some ways, what she's comfortable with by limiting herself to a certain perspective. Titus, the wild card, becomes the person who unexpectedly invites her in. He's the host of the new "bubble" in which she lives.

THE PUSHY ROOMMATE/ FRIEND/BUSINESS PARTNER/ MENTOR: *SILICON VALLEY*

I n HBO's comedy *Silicon Valley* (created by Mike Judge), Erlich Bachman (T.J. Miller) is the wild card to protagonist Richard Hendricks (Thomas Middleditch). Erlich is not only an antagonizing force for Richard, but also a kind of tech industry id. *Silicon Valley* exists in a world full of nouveau-bro billionaires who drive Teslas or even have a full-time "spiritual guide" on staff. It's a superficial intellectualism that runs diametrically opposed to both Richard and Erlich. Richard, the real-deal genius who creates beautiful code, cannot fake the veneer the tech industry loves. On the other hand, Erlich relishes the role of "tech tycoon" to the grotesque limit. He quite literally leeches off the genius of people in his Palo Alto house/"incubator," drives a car emblazoned with his failed company's logo and has even placed his testicles on a conference room desk as a negotiation tactic (off-screen). If Richard is the embodiment of innovation in the tech industry, Erlich is a commentary on the role presentation and bravado play. As a result, the two characters find they need each other and are inextricably tied to one another. Not quite good cop/bad cop, more like nerdy introvert/ blowhard extrovert.

In Season 1, Episode 4, "Fiduciary Duties," after Richard drunkenly puts Erlich on the board of directors at Pied Piper, only to recant the deal the next morning, Erlich realizes Richard doesn't see what Erlich brings to the company. At the end of the episode, when Richard realizes he can't spew the type of "big picture" BS that Peter Gregory (Christopher Evan Welch) expects in this industry, Richard leans on Erlich for his expertise and their symbiotic relationship is born.

Early in the episode, the two fight over Richard rescinding his offer:

```
                    RICHARD
          I was drunk! You took advantage of
          me!

                    ERLICH
          And after all I've given up for this
          company.

                    RICHARD
          Oh, what have you given up?

                    ERLICH
          I owned ten percent of Dinesh's app,
          ten percent of Gilfoyle's app.
          Multiple potential streams of income.

                    RICHARD
          Sure.

                    ERLICH
          Not to mention that a hundred percent
          of the team that you have were all
          guys that I recruited for this house.
          That must be worth something to me.

                    RICHARD
          It is! Ten percent of Pied Piper!

                    ERLICH
          For which I forewent--yes, that's a
          real word--one million dollars.

                    RICHARD
          Mmm.

                    ERLICH
          I supported you, Richard. I bet on
          you. And now you're just gonna give
          me a seat on the board, only to
          retract that offer?!

                    RICHARD
          I can't even remember doing that!

                    ERLICH
          Oh really? Well you remember this
          particular dickbag I got on video?
          Because you did...
```

[Erlich searches for the video on his phone of Richard
drunkenly offering him the board seat.]

> RICHARD
> Put it away...

> ERLICH
> It's right here.

> RICHARD
> I've seen the video.

> ERLICH
> Dammit...it's the wrong album, just
> give me a sec--you know what? Fuck
> it! You offering me a position on
> this board and reneging it is a
> perfect example of you having no
> vision, no balls and no game.

[LATER: After Richard has a panic attack before going into
an important meeting with Peter Gregory, Richard realizes he
needs Erlich, the Steve Jobs to his Steve Wozniak. When a
repentant, sincere Erlich unexpectedly turns up in support,
Richard is relieved to see him:]

> ERLICH
> Richard, you're gonna listen to me if
> you know what's good for you.

> RICHARD
> Erlich!

> ERLICH
> I may have been wrong about being a
> board member and I may be wrong about
> being the Steve Jobs in our
> relationship. But I do know this, you
> are the Steve Wozniak. And no Woz
> should go into a meeting like that
> alone.

> RICHARD
> No. Actually I--

> ERLICH
> So if you'll just let me come in,
> then I won't speak. And I just think
> you should have somebody in there who
> will actually have your back.

> RICHARD
> Okay, no, Erlich, I want you to be in
> there.

```
                    ERLICH
        Okay--wait, what?

                    RICHARD
        Yes, and I need you to do all the
        talking. Because I feel like if I do,
        I'm gonna puke all over Peter
        Gregory.

                    ERLICH
        Oh, okay. Wow. That was easier than
        I--All the talking?

[Monica steps out of Peter's office to greet them:]

                    MONICA
        Oh, Erlich, you're here too? Okay.
        Come on in, guys.

                    JARED
              (re: his short, wet pants)
        Um, I'm going to stay here, I think.
        Because I look absurd.

                    RICHARD
        Yeah.

                    ERLICH
        Yeah.

                    RICHARD
        So what are you going to say?

                    ERLICH
        Fuck, I don't know.
```

In spite of their altercation earlier, Erlich's got Richard's back. And we get the feeling that, despite their clashes, he always will.

DISRUPTING AN INSTITUTION: *THE YOUNG POPE*

In HBO's opulent and surreal mini-series *The Young Pope*, set in present-day Rome, the wild card character makes quite an entrance. But even before she arrives, writer/creator Paolo Sorrentino uses a subtle trick to give weight to our impending guest. In Episode 1, we see her in flashback, with Pope Pius XIII (Jude Law) talking

about her, awaiting her arrival. Pope Pius has been nothing but serious and standoffish until his maternal figure, Sister Mary (Diane Keaton) steps off a helicopter on the Vatican helipad. She wears a habit and John Lennon-style sunglasses. (Pope Pius drinks Cherry Coke Zero, chain smokes and wears Ray Bans in sunlight, along with his traditional Pope regalia.) Her entrance alludes to an emergency, since she's whisked to the Vatican as soon as Pope Pius is shockingly elected in the papal conclave. Immediately Sister Mary separates herself from the other characters by referring to the new Pope as "Lenny" instead of his new papal name. It signifies a power she possesses over the Holy Father that no one else has: She *knows* him.

With all of the chatter over Pope Pius as a young and mysterious pick for the position, Sister Mary possesses the knowledge the other characters are constantly searching for—which makes her both useful and dangerous to our protagonist. Sister Mary took Lenny in when he was orphaned as a young boy. She raised him and nurtured him. She and Lenny share a long-standing, unconditional love. They also share a devotion to their vows of piety and chastity. As a nun, Mary is, in essence, married to God. And Lenny will never marry or father a child; in this way, as it's pointed out later in the season, Lenny/Pope Pius will never grow up. By design, he'll forever remain God's son.

After she arrives, Pope Pius appoints Sister Mary as his personal secretary. This gives her even more power than in their shared past, unheard of for a woman in the Catholic Church. This highly unconventional decision (and many others he makes throughout the season) mortifies and threatens every man at the Vatican, especially Cardinal Angelo Voiello (Silvio Orlando), who's both a faithful man of God and a cunning political animal. Voiello had a strong hand in Lenny's election, expecting him to be a puppet to his elders, while simultaneously making the stodgy church relevant to the younger masses. Alas, Cardinal Voiello cannot control Pope Pius and thus seeks to reason with Sister Mary and be her ally. But neither Voiello nor Sister Mary ever fully trusts one another. And she proves to be a wild card for him too: There's an allure, a spark, an attraction between them that builds.

We see Sister Mary as an outlier to the rest of the Vatican, with her "I'm a Virgin But this is an old shirt" t-shirt, and her penchant for playing basketball in Episode 2. And although no one comments on this, when she removes her habit, she has a perfectly dyed and styled mane—movie star hair—with not a gray hair in sight. She chain smokes, too. Sorrentino has created a rebellious, yet devoted nun, making her surprising and unpredictable. She throws the whole Vatican into disarray and is one of the most outrageous nuns ever depicted on series television, with the possible exceptions of the sinister Sister Jude Martin (Jessica Lange) in *American*

Horror Story: Asylum or Sally Field as the lovely Sister Bertrille on the ABC series *The Flying Nun* (1967–1970). But that was then, and this is now. And hey, it's not TV; it's HBO.

THE ROLE OF DESTABILIZING CHARACTERS: *BETTER CALL SAUL, THE CROWN AND GOLIATH*

Jimmy/Saul and Chuck

The AMC series *Better Call Saul* (the spinoff/prequel to *Breaking Bad*, created by Vince Gilligan and Peter Gould), gives us a fascinating peek into the backstory of sleazy lawyer Saul Goodman (Bob Odenkirk) of *Breaking Bad* fame. Saul's real name, we learn, had been Jimmy McGill—"Slippin' Jimmy" to those who knew him well as a two-bit hustler in Chicago. Jimmy has moved to Albuquerque, New Mexico, in an attempt to follow in the footsteps of his older brother Chuck (Michael McKean), a highly successful and respected attorney. Jimmy, on the other hand, gets his law degree from the online "University of American Samoa," which is just one of the things that Chuck despises about his little brother.

In the *Better Call Saul* episode in Season 2 of *Breaking Bad*, Saul was originally introduced as something of a wild card himself. Not long after meeting Walt and Jesse, he throws them off their game by announcing that he is now their partner in crime. When he demands a share of their meth business, they can't say no, since he threatens to out them. But in *Better Call Saul* the series, Jimmy McGill hasn't yet developed the future Saul Goodman's chutzpah. He works out of a storage closet in a nail salon and masquerades as his own secretary. When we meet Chuck, he has retired from his law practice due to a debilitating phobia of electricity. Jimmy adores Chuck and takes care of him, in spite of the fact that Chuck can barely tolerate Jimmy. Soon, it's revealed that Chuck resents Jimmy for being their mother's favorite and for generally being the life of the party. Any time Chuck is called upon to give Jimmy a vote of confidence, he refuses. At the end of Season 2, he secretly records Jimmy confessing to a felony, and it's clear that he's going to do his best to use this against Jimmy in Season 3. (Chuck's sad fate at the end of Season 3 is withheld.)

Chuck is not the typical trickster in that he's a stodgy, mean kind of guy. He functions as both a wild card and a vulnerable, needy antagonist with a chip on his shoulder. He has exploited Jimmy's sense of loyalty—brotherly love—as long as Jimmy remained a non-threatening underdog. But as Jimmy develops a backbone and greater self-confidence, bolstered by his on-again-off-again romance with Kim Wexler (Rhea Seehorn), Chuck goes into passive-aggressive retaliatory mode. He turns into the proverbial snake in the grass, undermining Jimmy from the shadows, when Jimmy least expects it. Up until Chuck betrays Jimmy, we'd presumed that senior partner Howard Hamlin (Patrick Fabian) at the firm Hamlin, Hamlin & McGill was Jimmy's nemesis. But then we learn the truth about Chuck—and it's not pretty. A long-festering sibling rivalry blows up into an emotional confrontation, upending the balance of power and laying the foundation for the wronged, still-semi-righteous Jimmy to grow into *uber*-shyster Saul Goodman.

In this scene from Season 1's "Pimento," Jimmy confronts Chuck about double-crossing him at Hamlin, Hamlin & McGill:

```
[Chuck looks down at his feet. Jimmy's anger rising--]

                    JIMMY (CONT'D)
          Speak up! Tell me why! It's the least
          you can do for me now. I'm your
          brother! We're supposed to look out
          for each other. Why were you working
          against me, Chuck?

[Jimmy's endless badgering forces Chuck to mutter--]

                    CHUCK
          You're not a real lawyer.

                    JIMMY
          I'm what?

                    CHUCK
          You're not a real lawyer. "University
          of American Samoa," for Christ sake?
          An online course? What a joke! I
          worked my ass off to get where I am,
          and you take these short cuts and
          think you're suddenly you're my peer?
          You do what I do, because you're
          funny and you can make people laugh?
          I committed my life to this! You
          don't slide into it like a cheap pair
          of slippers and then reap all the
          rewards.

[Jimmy is in complete shock. Takes a moment for him to
process...]
```

 JIMMY
 I thought you were proud of me.

 CHUCK
 I was! When you straightened out and
 got a job in the mailroom, I was very
 proud.

 JIMMY
 So that's it, right? Keep ol' Jimmy
 down in the mailroom, 'cause he's not
 good enough to be a lawyer?

 CHUCK
 I know you. I know what you were,
 what you are. People don't change.
 You're Slippin' Jimmy. And Slippin'
 Jimmy I can handle just fine, but
 Slippin' Jimmy with a law degree is
 like a chimp with a machine gun.
 (a breath)
 The law is sacred. If you abuse that
 power, people get hurt. This is not a
 game! You have to know, on some
 level, I know you know, I'm right.
 You know I'm right.

[Jimmy stares. Devastated. But weirdly calm. A long beat.]

 JIMMY
 I, uh... I got you a twenty-pound bag
 of ice and some bacon and some eggs
 and a couple of those steaks that you
 like. Some fuel canisters, enough for
 three or four days. After that,
 you're on your own.
 (soft)
 I am done.

[Jimmy walks out. Chuck follows after him, regretting his
candor. Grudgingly trying to stop him.]

 CHUCK
 Jimmy... Jimmy.

Chuck has officially become Jimmy's full-blown enemy—and he's not done yet.
(Incredibly, Jimmy will refuse to have Chuck committed to a mental institution
when he has the opportunity.) There will be other *Breaking Bad* antagonists in
Better Call Saul, such as Nacho (Michael Mando) and Gus Fring (Giancarlo
Esposito), the mild-mannered drug lord who'd just as soon kill you as spit on you.
Still, there isn't much worse than a brother who's determined to take you down.

Queen Elizabeth and Princess Margaret

Netflix's *The Crown* makes use of a real-life princess as a destabilizing character. When Britain's beloved King George VI dies of lung cancer, his eldest daughter Elizabeth (Claire Foy) becomes Queen of England at the age of 27. Elizabeth struggles to rise to the occasion of being queen while also trying to be a normal wife, daughter and sister. Her mother—the Queen Mother (Victoria Hamilton)—and younger sister Princess Margaret (Vanessa Kirby) must now literally bow to Elizabeth. However, Margaret is full of life and spunk and seems to delight in throwing her big sister off balance at times. She falls in love with Peter Townsend (Ben Miles), an unhappily married man who proceeds to get a divorce for the beautiful young princess. Elizabeth wants her younger sister to be happy but talks her into waiting to marry Townsend until she turns 25 (as permitted by the somewhat outdated Royal Marriages Act of 1772). The British people closely follow the romance between Margaret and Peter and are distraught when Townsend is transferred to Belgium to prevent him from seeing Margaret for two long years.

Elizabeth and her husband Philip embark on a months-long tour of the Commonwealth, and Margaret is left to take over the queen's appearances at home. She's much less concerned with propriety than Elizabeth is, and the upper class and "commoners" alike love her seemingly spontaneous irreverence. At a state dinner, Margaret fills in for Elizabeth by giving "a little of her own personality" to a speech that's been written for her. (She also insists on wearing Elizabeth's own diadem to the occasion.) Margaret wows the crowd, going off book and telling the crowd that they look "wonderful, and shimmering, and positively exotic." Later she visits a coal mine and even gets laughs there. A reporter asks her if she's missing Group Captain Townsend, and she replies, "Yes, very much." The reporter then asks if she's also missing her sister, Her Majesty the Queen? Margaret answers, "Not quite as much, no." The crowd laughs uproariously.

Since *The Crown* is based on historical fact, it may not be too much of a spoiler to reveal that Elizabeth refuses to allow Margaret to marry Townsend, even after she turns 25. Prime Minister Anthony Eden (Jeremy Northam) explains to Elizabeth that the only way she can allow Margaret to marry Townsend is to have her sign a "Bill of Renunciation," which means that she will be stripped of her title and income and will have to live outside of England for several years. Naturally, Margaret is devastated and begs her sister to reconsider.

Later, Margaret and Peter finally get away for a weekend in the country together. It's implied that they sleep together. The next day, the news reports are all about

Princess Margaret—will she be allowed to marry Townsend, or not? Elizabeth watches TV and sees how the nation is gripped by the suspense. Is she jealous? Elizabeth is still conflicted about what to do and goes so far as to call all the archbishops of the church to Buckingham Palace to discuss the problem. They insist that there is no circumstance under which a member of the church may marry a divorced person while the spouse of that individual is still living—even if the person remarrying is "innocent" of causing the divorce. Surprisingly, it is her Uncle Edward, the Duke of Windsor (Alex Jennings), who abdicated the throne to marry the love of his life—the divorced Wallis Simpson—who talks Elizabeth into "protecting the Crown." Ultimately, Elizabeth must deliver her final decision to Margaret:

 ELIZABETH
 ...I realized--as Queen--that I have
 no choice. I cannot allow you to
 marry Peter and remain part of this
 family. That is my decision.

[Margaret takes her time before responding.]

 MARGARET
 In defiance of the pledge you made to
 our father? And the pledge you gave
 to me?

 ELIZABETH
 Yes.

[Margaret says nothing. Finally Elizabeth sits down beside her.]

 ELIZABETH
 Will you forgive me?

 MARGARET
 If you deny me the man I love?

 ELIZABETH
 If I put duty before family.

 MARGARET
 Would you forgive anyone who denied
 you Philip?

 ELIZABETH
 It doesn't compare--

 MARGARET
 It compares exactly.

Elizabeth has begun her lifelong journey of choosing royal tradition over loyalty to her own family. She refuses to let the destabilizing influence of her sister (or anyone else, possibly with the exception of Princess Diana many years later) get the upper hand.

Billy McBride and Patty Solis-Papagian

The Amazon series *Goliath*, created by David E. Kelley (*Ally McBeal, Big Little Lies*) and Jonathan Shapiro (*The Practice, The Blacklist, Life*), casts Billy Bob Thornton as barely functioning, alcoholic, washed-up attorney Billy McBride. McBride used to be a senior partner at the prominent Los Angeles law firm Cooperman/McBride, but he walked away from the money and power after a murder suspect he got acquitted due to a legal technicality went on to kill a family. McBride now lays low, avoids the spotlight, conflict and commitment, lives in an extended-stay motel by the Santa Monica Pier and drinks his days and nights away at a local dive bar, Chez Jay. His only real companion is a stray dog, with occasional visits from his estranged ex-wife Michelle (Maria Bello), who's still a partner at Cooperman/McBride, and their rebellious teenaged daughter, who both disapprove of everything Billy does and don't mind sharing their judgment. But Billy is too numb and apathetic to listen.

The only person who gets under his skin is Patty Solis-Papagian (Nina Arianda, who's guilty of stealing every scene she's in). Patty is an ambulance-chasing DUI lawyer and part-time real estate agent in the (San Fernando) Valley. It's Patty who brings plaintiff Rachel Kennedy's case to Billy's attention, but at first, he's not at all interested. Patty readily admits, "I suck in court," so she needs his legal prowess and connections. But at first, her plea falls on deaf ears; Billy's not ready to face his past legal partner Donald Cooperman (William Hurt), who's as cunning and paranoid as he is reclusive. Cooperman, whose face was disfigured in a mysterious accident, spends his days in his always-darkened, cave-like office, monitoring depositions and cases via listening devices and surveillance cameras. Billy steers clear of him, avoiding any new entanglements with the mega-law-firm, and with anyone.

Billy's already made a name for himself as a successful attorney and can drink away his sorrows and sulk all he wants. But Patty Papagian can't afford to be so choosy. This woman is a survivor, a force of nature and a kindred spirit to Jimmy McGill (a/k/a Saul Goodman on *Better Call Saul*). Her motto may as well be: *No case too*

small. Or: *Anything for a buck*. The woman hustles from low-rent real estate showings to the courthouse to defend her mostly guilty clients and make ends meet. She's a dog living on scraps, and she's grateful for the work.

In Episode 2, "Pride and Prejudice," Billy gets arrested by a crooked cop on a trumped-up drunk driving/resisting arrest charge, causing him to miss an important court date. Believing that he's a selfish, inconsiderate, careless prick, Patty confronts him the next day in his motel room for blowing the case:

```
                    PATTY
          You're fucked up and you're sick and
          you made me look like a fucking
          idiot!

                    BILLY
          I plan to fix it because I do care.

                    PATTY
          Oh, I understand, I understand
          because you're going to fucking fix
          it cuz I'll tell you what: I didn't
          get to where I am by letting assholes
          like you drag me down.

                    BILLY
                    (laughing)
          Where you are? You got a one-woman
          shop in fucking Van Nuys, honey.

                    PATTY
          FIX IT!!! Or I swear to fucking god
          I'm gonna make your life shittier
          than it is now--believe it or fucking
          not.

She storms out.

                    BILLY
                    (calling after her)
          You'd have to be a goddamn
          magician to do that.
```

If Billy is a total flameout, Patty is the spark that reignites the fighter in him. She calls him out on all his bullshit, with no filter. She's brash and a thorn in his side. But she's exactly what Billy needs to come back to life. He comes to realize that Patty has stumbled upon a multi-million-dollar civil case, and this is a prize bone that neither of these scrappy dogs is willing to give up.

Later in the first season, when things turn dangerous and Patty wants to cash out, it's Billy who cajoles her into staying in the ring. Despite his initial disdain for her, Billy respects her audacity and drive. He also admires her close ties to her large Armenian family. Patty's bark is worse than her bite; deep down, Billy knows she has a kind heart. In spite of his cynicism, he helps Patty because she still believes in working within the system and taking what you can get. He can see the idealism in her hungry eyes, her need to believe in something—winning a case, closing escrow on a real estate transaction—her successes are measured in settlement and commission checks. Billy wishes he could be content with such simple rewards. Patty doesn't expect much from life and she's rarely disappointed. But she doesn't avoid confrontation like Billy does, nor does she numb herself to deny the existential pain. Billy comes to admire Patty because she feels *everything*.

Interestingly, I read the original pilot script for *Goliath*—formerly entitled *The Trial*—and significant changes were made to the produced pilot (a common practice). Nevertheless, it's hard to imagine, but Patty Solis-Papagian was not even in the third draft of the pilot script. The addition of her character must have been David E. Kelley and Jonathan Shapiro's adjustment, going from network TV to streaming Amazon. Fortunately, they decided to slow down the plotting, choosing a more character-driven approach instead. On *The Practice* and *Boston Legal*, we had a case-of-the-week legal procedural. With its season-long case, *Goliath* doesn't need to rush to summary judgment.

The creators' decision to bring in Patty and ramp up to the trial more gradually is a smart move. It not only infuses the show with added humor and dimension; it also provides Billy McBride with a sparring partner, an equal opportunity offender/banterer. Donald Cooperman and Michelle McBride try to destabilize Billy by appealing to his ambition and what they believe is his need to redeem himself. But only Patty truly gets him; he's not after redemption. She's a positive destabilizing force. He just needs to believe in something. Ironically, that something is justice.

⬤ Bonus Content

More analysis on the wild card, including **Luther**, **Big Little Lies**, **Stranger Things** and **Bloodline** as well as more searing exchanges between Elliot and his therapist Krista in **Mr. Robot**, between Elizabeth and Margaret in **The Crown** and between Patty and Billy in **Goliath** can be found at **www.routledge.com/cw/landau**.

See also: Dennis and Agathe in *Patriot* (on Amazon), Luke in *Jessica Jones* (on Netflix) and Joe in *The Man in the High Castle* (on Amazon).

Episodes Cited

"eps1.0_hellofriend.mov," *Mr. Robot*, written by Sam Esmail; Universal Cable Productions/
Anonymous Content/NBC Universal Television Distribution/USA Network.

"Pilot," *Mozart in the Jungle*, written by Alex Timbers, Roman Coppola and Jason
Schwartzman; Picrow/Amazon Studios.

"I'm with the Maestro," *Mozart in the Jungle*, written by Alex Timbers and Nikki
Schiefelbein; Picrow/Amazon Studios.

"Pimento," *Better Call Saul*, written by Thomas Schnauz; Sony Pictures Television/AMC.

"Gloriana," *The Crown*, written by Peter Morgan; Left Bank Pictures/Sony Pictures
Television/Netflix.

"Pride and Prejudice," *Goliath*, written by Jonathan Shapiro and David E. Kelley; David E.
Kelley Productions/Jonathan Shapiro Productions/Amazon Studios.

"I feel like people talk faster than they usually do on screen, and I don't understand why, when somebody asks you if you want a cup of coffee, you can't just say yes or no. Why do you have to have four expressions, and then look and think? You don't. You know if you want coffee, or if you don't want coffee."

—AMY SHERMAN-PALLADINO
WRITER/CREATOR/SHOWRUNNER/DIRECTOR
GILMORE GIRLS, THE MARVELOUS MRS. MAISEL

CHAPTER 10
WRITING SMART DIALOGUE IN THE DIGITAL ERA

There are plenty of books on screenwriting out there that talk about the importance of sharp, crackling dialogue. Since I'm going to be discussing both TV comedy and drama, I'll present dialogue examples from each as I cover practical exercises and core skills to develop in our toolboxes as television writers.

THE OBLIQUE

One of the most frequent notes on beginning screenwriters' scripts is that the dialogue is "OTN," or "on the nose." Although it's my belief that the best dialogue is oblique, often with my own writing, I'll first write the scene on the nose as an exercise, writing just the bare facts of what every character would say if they were to speak exactly what their truth is. Sometimes we can do that in outline, including quotes where the characters say what they feel and what their needs are directly. Then, go back and *dig in*. Digging in is asking ourselves, "Based on the chemistry of these characters, and based on the specific circumstances of this scene, knowing where each character came from and where each character is going after this scene, what's the character's mood? Where is he or she emotionally?" Based on those factors, a lot of what characters might actually say in the scene gets subverted. They're not really speaking their truth, but rather, their words are influenced by many factors that may have nothing to do with the person that they're talking to in the scene. It could be that they had a bad day at the office and they just came from an argument with a co-worker, and now they're in a scene with a person who they have no problem with, but that tension is carried over. So tracking—both logistical and emotional—is a key component in how we approach dialogue. Where are characters coming from, where are they going to and, when they meet in a scene, what is the

main focus of the action? Are they going to speak their truth, or are they going to couch it in softer terms? Are they going to project things into the scene that have nothing to do with the actual dynamics of it?

Secondly, it's important to realize that dialogue is not real speech. Meaning that, even in the most realistic, grounded, gritty series such as HBO's critically acclaimed *The Wire*, where people do speak in ways that *sound* very natural and faithful to who they are as characters, the dialogue is heightened. There's poetry in the words. The writers not only played around with how the more educated, erudite characters speak, but they also gave disenfranchised characters a specific slang that's their own private language. Speaking to a class at UCLA recently, creator David Simon said that the vernacular used among the "corner boys" was a by-product of his own years sitting out on a West Baltimore corner. He also said that he would not attempt to write *The Wire* set in today's Baltimore because the language on the streets, in his view, has changed completely.

Whether a character talks a lot or a little depends on who they are. Some characters are laconic—men and women of few words. Others are chatterboxes, speak in huge volumes of words, and it becomes part of who they are as characters. Take Jimmy McGill in *Better Call Saul*: His words are both his defense and his weapon, and he uses them to manipulate people. They're also what he gets his strength from. Jimmy (a/k/a Saul Goodman, played by Bob Odenkirk) is a wordsmith. The way he plays people and his expertise in the courtroom come from his natural talent for and relationship to language. Other characters in the show, such as Mike Ehrmantraut (Jonathan Banks), are constricted because they can't ever quite find the right words. Even if they're very powerful and have a dynamic internal life, when they have to speak and make connections with other people, they find themselves frightened about it. It's the power of Mike's character to choose to stay silent when he wants.

● Bonus Content

Mike Ehrmantraut and The Profound Power of Silence, plus script excerpt from *Better Call Saul* at **www.routledge.com/cw/landau**.

IDIOSYNCRATIC VOICES: EMPIRE, SILICON VALLEY

Related to the idea that dialogue is not real speech is the fact that every character needs to have a distinctive voice. Your real-life friends may all speak in a similar way, but one of the tools that we use to differentiate between each character is

to give each of them a different cadence, vocabulary and approach in terms of how he or she sees the world and relates to other people. The more we can create distinctive voices, the more the dialogue will pop off the page. It's a good exercise, after writing a scene, to cover the name of the character and just read the dialogue without knowing who's saying what. We—and anyone who's reading—should be able to identify the character just based on how the characters are drawn. If the lines of dialogue are interchangeable, it means they're not idiosyncratic enough. Maybe we don't know our characters well enough yet. That's when it's time to go back and layer it and write things that only one character would say, and things that only another character would say, so that the audience can really get their unique personalities, their relationship to language and how they communicate with other people.

Empire features an ensemble cast of characters who each have very distinctive voices, particularly the character of Cookie (Taraji P. Henson). Cookie has her own way of looking at the world, her own sense of entitlement and her own view of right and wrong. She has her own language in how she talks to people, how she uses her sexuality, her feminine wiles and maternal persuasion in certain situations. She's a diplomat when it's called for, but she's also a person who you do not want to cross, because if you get on her bad side, it's not going to go well for you. Cookie's spent time in prison, has got street smarts and, now, even though she has money and power, and dresses the part, she is somebody to underestimate at one's own peril. In the pilot, she gets out of jail and goes to see her son Jamal (Jussie Smollett) who she knows is gay, but he thinks she's completely in the dark about it. He's at home with his boyfriend Michael (Rafael de la Fuente), and as soon as Cookie's outside, they try to take away any signs in their apartment that would reveal that they're a couple. They're self-conscious and afraid of what Cookie's going to think of them. But she breezes in, and it's almost immediately dispelled in a fresh, unique way.

[Jamal opens the door. Cookie gives him a bear hug, she's missed him terribly. She looks around at his spectacular yet untidy apartment.]

> COOKIE
> For a queen you sure do keep a messy
> place. What you need is a good maid up
> in here.

[Jamal isn't sure how to react. Cookie notices a delicious smell from the kitchen.]

> COOKIE
> You cooking chicken?

 JAMAL
 Oh, yeah--yeah!

 COOKIE
 Did you fry it?

 JAMAL
 No, it's a stew...

 COOKIE
 Stew? Who stews chicken?

 JAMAL
 Come this way...It might be a little
 spicy for you, but we like it that way,
 so, you know...

[He grabs her hand and leads her to the kitchen. Michael
hurries over, a huge smile on his face. Michael instantly
falls in love with Cookie with her heavy mascara, red
lipstick and too tight leopard dress, a gay man's wet dream.
Michael stands there in complete awe.]

 COOKIE
 Uh--who is this?

 MICHAEL JAMAL
 (smiles) Oh, it's Michael.
 Hi. Michael-- We're sorta living
 together.

Giving Michael the once over, Cookie decides she likes him.

 COOKIE (CONT'D)
 Honey you didn't tell me you was
 dating a little Mexican! Look at her.
 She's adorable...
 (then sotto to Jamal)
 You need to get la cucaracha to clean
 up around here a bit.

Jamal shoots a glance at Michael, praying that he hasn't
heard her. Thank God not. His head is still reeling.

 JAMAL
 What are you wearing?

 COOKIE
 What I got locked up in.

Cookie dips her long pink fingernails into the simmering stew on the stove. She pulls out a chicken leg and starts eating it. Michael watches mesmerized by her every move.

> JAMAL
> We're going to change that real quick.
> And why didn't you call me? I would
> have picked you up.

> COOKIE (CONT'D)
> I just got out. Good behavior.

Many thoughts run through Jamal's head as he tries hard to hold his emotions in check.

Michael still stands watching, mouth agape. Cookie hovers at the stove, chewing her chicken leg. She's thinking hard.

> JAMAL
> Alright so...what are you gonna do now?

Cookie ponders a bit. Her eyes turn serious; for the first time you can see this woman has served hard time in prison.

> COOKIE
> I'm here to get what's mine.

In terms of distinctive voices, also check out the pilot episode of *Silicon Valley*. In the teaser, a nerdy venture capitalist speaks at an event at a McMansion where Kid Rock is the entertainment. The guy tries to be cool, but his speech is chock full of Silicon Valley techno jargon. All of the main characters dress, relate to and interact with each other in a certain way—as techno-nerds. The scene speaks volumes about who they are, without having to see them in some kind of prologue that showed us how they got to this point. They don't need to explain the jargon; they just speak that way. Some people, such as my stepson, who is a computer genius, understand everything they're saying about algorithms or what have you. I have no idea what they're saying, but I know that it must mean *something*. What's important is that I know it's important to *them* and that they know what it means. And so they create their own private language.

GET IN LATE, GET OUT EARLY

When writing scenes, try to start in the middle and get out before they end. A general rule of thumb is, after finishing the script, go back and look at every scene. Cut the first two and last two lines, and the scene will almost always be better. One of our instruments in the toolbox of dialogue writing is telling

the story "in the cut"—what we cut from and to in the next scene actually creates momentum and narrative drive. Unless we're writing a multi-camera sitcom, we want to be able to cut away from a scene and don't need to have characters entering and exiting spaces. That's often repetitive. They can be walking and talking, but it doesn't have to start at the very beginning of a conversation. Just drop us in and have things already in motion. It creates momentum in the script.

VERBAL AND NON-VERBAL COMMUNICATION

B ear in mind that when we talk about communication, and we talk about dialogue, in general, about 7% of communication is actual words. There are statistics that say that 38% is vocal elements, such as the tone and pitch of someone's voice—are they agitated, happy, fearful etc.—and the other 55% is *non-verbal*. Non-verbal communication includes facial expressions, gestures and posture. So 93% of our communication is non-verbal. If somebody is leaning back with their arms crossed and we ask, "Are you mad at me?" he/she might say, "No, I'm not mad at you at all," but their words are in opposition to the truth. And the truth often will come out through body language and through lack of eye contact. How we behave and our actions, speak louder than words.

Originally, television had its roots in theater, so early television was just that: theatrical. Characters often made obvious, declarative statements about their thoughts and feelings. The idea was that the TV screen was like a proscenium arch, and all the action would occur within that frame. Later, as TV evolved, it became all about close-ups. In daytime and nighttime soap operas such as *Peyton Place* and *Marcus Welby, M.D.*, the writers were cognizant that TV cameras offered a sense of intimacy by being able to get in extremely close on the actors' faces. That was something new, an added bonus that audiences couldn't get in the theater.

Today, as television has continued to advance, and our TV screens have increased in quality, television has become more cinematic—to the point where many shows, for instance, *Game of Thrones*, are as cinematic as any epic, wide-screen movie. Now, it could almost be a criticism for some single-camera and one-hour dramas, that they're *too* claustrophobic. On shows such as *Orange Is the New Black*, which takes place in an inherently claustrophobic environment, creator Jenji Kohan is always trying to find ways to get them out of the prison. She uses flashbacks to what happened to the characters before they arrived at the prison, and any time she can get them out on a van, on a field trip, out in the yard, or any other exterior location, she does.

The pilot of *The Walking Dead* isn't any different from a movie visually; it is very expansive. But it was also difficult and expensive to produce, so as the show progressed, the writers created more containment on the ranch and in the prison. Multiple locations are costly and such production values are difficult to replicate on a weekly basis with a tight production schedule.

So early television based on theater evolved into the use of close-ups and today competes directly with the cinematic experience. Non-verbal communication became increasingly more important. In today's shows, especially on cable and digital platforms, there's no difference between television dialogue and movie dialogue. Less is more—writers write less obvious dialogue in favor of implied subtext. Description includes visual sequences that reveal much of the story, and the writer also employs more subliminal exposition instead of putting it in the mouths of the characters. The viewer can drop into the story and just see them in action and understand what's going on. If we don't immediately grasp what's going on, we trust (because we are now more savvy television viewers) that we will learn and get all the information we need as the story progresses.

Again, one writing exercise is to compose a first draft where the dialogue is on the nose and gets all the information and facts and the main information of the scene out. After digging in and tracking, the next step is to go back and bury the information and camouflage it, putting in subtext and finding things that are better left unsaid, or better "written" through describing the action and character's body language. Another helpful exercise is the opposite of that— namely, to first write the scene with no dialogue at all. We can try to convey everything in the scene that we need to convey with the fewest amount of words possible. And then, only add dialogue where it's absolutely necessary. I read hundreds of scripts, and often the criticism I have is that they're too "talky." In general, most people—myself included—overwrite dialogue. And that's fine when we're in the drafting process, just putting words on the pages and trying to get people talking. We also overwrite dialogue initially because we're just trying to understand who these characters are and get a sense of their voices and what they might sound like. But bear in mind that we need to then go back and rewrite it. There was a term I learned when working on Steven Bochco's show, *Doogie Howser, M.D.*, Bochco used to talk about "raking your dialogue," like raking leaves. He would say, "Put all the dialogue down that you want, but then rake it, and take out all the unnecessary words. Just keep the essence of what the line needs to be."

In general, I find that less is more, and if a character can say something with a look and no dialogue at all, that's the best. If we can have a character say something in

one sentence rather than five, the one sentence is probably better. In our effort to write only what's necessary in dialogue, we need to remember to write only necessary non-verbal actions and expressions. As Amy Sherman-Palladino points out in the quote at the beginning of this chapter, "Why do you have to have four expressions, and then look and think?" So, it's a fine balance between what's spoken and unspoken. If we stay true to our characters, this will come across on the page in their verbal and non-verbal communication.

POINT OF VIEW AND SUBTEXT: *THE LAST MAN ON EARTH*, *CRAZY EX-GIRLFRIEND*

When we talk about subtext in a scene, point of view is essential. Point of view basically means, does a character know more than other characters, or less? Who has information in a scene, and who doesn't? Good scenes are about power dynamics between the characters. And as we all know, information is power. If a character knows more than another character in a scene, we can get rich subtext out of that. And if two characters know more than all the other characters, we get rich subtext out of that, too. There are all kinds of dynamics in terms of who knows what, and when. The suspense and the subtext of such a scene is all about the audience having information that some characters do not have and playing out the tension, or the fun, of that kind of close call.

An example of this kind of subtext in comedy can be found in "She Drives Me Crazy," in Season 1 of the hilarious *The Last Man on Earth* on Fox. Phil (Will Forte), who thinks he is the last man on earth after a mysterious apocalypse, has met and married Carol (Kristen Schaal), who is not his dream girl but seems to be the last *woman* on earth. So in order to have sex again, and based on Carol's demand that she won't sleep with him unless they're married, he thinks, "What the hell, I'll marry her." Right after they tie the knot, he discovers there's another female survivor, a beautiful blonde named Melissa (January Jones). He recognizes he's made a huge mistake, because if he'd known that Melissa existed, he would have never married Carol. In every scene, Phil tries to find ways to get closer to Melissa. He doesn't really care what happens to Carol at this point; all he can think about is his obsession with Melissa. Then, another man shows up—an overweight, mustachioed, balding guy named Todd (Mel Rodriguez). What makes Todd such a fun character is that Melissa truly seems to love this less attractive, but genuine, man. The

shallow Phil can't believe that Melissa would actually choose Todd over him. All of the humor in the scenes comes from what is not said and from how Phil squirms and all of his facial expressions. After Todd and Melissa go off together from yet another romp, we see how Phil truly feels, when he goes into the back yard and plunges himself face down in a kiddy pool full of tequila. But when he interacts with Todd it's all restrained, and the humor comes out of the subtext.

In the pilot of *Crazy Ex-Girlfriend*, Rebecca (Rachel Bloom) spends hours painstakingly getting ready the first time we see the '90s music video style "The Sexy Getting Ready Song." Then when she meets her date Greg (Santino Fontana), she shrugs off her appearance, to comedic effect. Bear in mind the effort is actually all for the benefit of Josh (Wilson Rodriguez III), the ex she's hoping to see at the party with Greg, even though Greg is her date and ticket into the party. The audience is complicit with Rebecca—we have the information that Greg doesn't, while Rebecca's song keeps us humming. Here's an abridged version of the scene.

INT. REGULAR BATHROOM -- NIGHT

A late '90s style R&B song begins. Rebecca wears a kimono
and sexily saunters into the bathroom.

 REBECCA
 Hey Josh. I wanna look good for you
 tonight. So I'm gonna get in touch
 with my feminine side.

INT. SEXY BATHROOM -- NIGHT

The bathroom is softly lit, candles all over.

 REBECCA
 IT'S THE SEXY GETTIN' READY SONG.

Four BACKUP DANCERS appear behind her. They pose.

 REBECCA (CONT'D)
 PRIMPIN' AND PLUCKIN'
 BRUSHIN' AND RUBBIN'
 THE SEXY GETTIN' READY SONG.

INT. REGULAR BATHROOM -- NIGHT

Rebecca enters the bathroom, which is realistically lit with
harsh, unforgiving lighting.

 REBECCA (V.O.)
 FIRST I MAKE EVERYTHING SHINY AND
 SMOOTH.

INT. SEXY BATHROOM -- NIGHT

The backup dancers pose near the fantasy bathtub.

> BACKUP SINGERS
> *OH YEAH.*

INT. REGULAR BATHROOM -- NIGHT

Rebecca plucks her eyebrows, wincing with each pluck.

> REBECCA (V.O.)
> *'CAUSE I WANT MY BODY TO BE SO SOFT*
> *FOR YOU.*

In the bathtub, she violently exfoliates the heels of her feet.

INT. SEXY BATHROOM -- NIGHT

> BACKUP SINGERS
> *BYE-BYE, SKIN.*

INT. REGULAR BATHROOM -- NIGHT

> REBECCA (V.O.)
> *I'M GONNA MAKE THIS NIGHT ONE YOU'LL*
> *NEVER FORGET. AND BOY I KNOW YOU LIKE*
> *AN HOURGLASS SILHOUETTE.*

Jump cuts as Rebecca tries to pull on some Spanx, but it's too difficult. Finally one of the backup dancers walks into the regular bathroom and helps jerk it up.

Rebecca looks at the camera.

> REBECCA (V.O.)
> Let's see how the guys get ready!

INT. GREG'S APARTMENT -- NIGHT

Music cuts out. Greg is lying in his apartment, asleep on the couch, TV on, half eaten burger on the coffee table.

INT. SEXY BATHROOM -- NIGHT

Music back in. Rebecca rejoins the BACKUP DANCERS. They are all wearing Spanx.

Quick cuts of Rebecca:

1. Putting eyeliner on her tear line by turning her lower eyelid inside out. 2. Using a Clarisonic-type face scrubber.

3. Accidentally burning her neck with a curling iron.

> REBECCA AND GIRLS (V.O.)
> *THE SEXY GETTIN' READY SONG.*

EXT. TOWNHOUSE -- NIGHT

A beautiful night in the 'Cov. Greg leans against his Toyota waiting for Rebecca. She walks out of her building. Whatever she did fucking WORKED. Greg stares at her.

> GREG
> Wow...*You look amazing.*

> REBECCA
> Oh, I totally just woke up from a
> nap.

Writers Aline Brosh McKenna and Rachel Bloom effectively communicate story through song. Their choices of sultry, dated tune—and even rap in the unabridged version—maximize the irony and wit of the smart lyrics. It's a monologue set to music that happens to rhyme. Sarah Silverman's new Hulu series *I Love You, America* also uses lyrics in the place of a monologue, but from an overtly political standpoint. Silverman's satirical lyrics in the title song are simultaneously an ode to the country and an appraisal of the issues it currently faces, from prejudice to agricultural subsidies. The song's subtext, which Silverman eventually admits in verse, is her personal ignorance of key issues, which is indicative of the wider population's, too. Optimistically, she sings that she wants to improve.

SHOP TALK:
BROOKLYN NINE-NINE

Another example of strong dialogue can be found in shows where each character has a highly specific expertise and point of view. Again, when writing a pilot and creating the ensemble, we need to make sure they're all very different and hopefully diverse—different ages, backgrounds, perspectives. They don't all have to be righteous and have politically correct ways of dealing with situations. They can be edgy, desperate and make their own mistakes. They can all have unique relationships with the boss and their own unique relationships with each other. So the way they talk to their boss is going to be different from the way they

talk when alone. On the Emmy-winning, fast-talking *Veep*, for instance, the way that Amy (Anna Chlumsky) and Dan (Reid Scott) speak to each other changes significantly when Selina (Julia Louis-Dreyfus) is present, to comedic effect. For her role as Selina, Louis-Dreyfus became the first actress to win an Emmy category six years in a row. *Veep's* sweet spot is when political plans go awry and Selina throws a hissy fit—i.e., frequently. It's heightened shop talk.

On *Brooklyn Nine-Nine*, Detectives Jake Peralta (Andy Samberg) and Amy Santiago (Melissa Fumero) are masters of cop speak. Their exchanges are sharp and funny. Late in Season 1, Jake and Amy are concluding a year-long bet on who's the better cop and can make more felony arrests during the 12 months. If Amy wins, Jake's Mustang is hers; if Jake wins, he gets to take Amy out in the Mustang. They haven't realized they like each other—yet. With moments to spare, it's neck and neck.

```
INT. BULLPEN - LATER

Amy hurries in with A PERP in tow. She is out of breath.

                    AMY
          Ladies and Gentlemen, I present Carl
          Laudson, who stole 3000 dollars!
          Santiago takes the lead with one
          minute left! Suck it, Peralta!

                    JAKE
               (unconcerned)
          Oh no.

                    AMY
          That's right 'oh no'--
               (realizing)
          Oh no, you don't seem worried. Why
          aren't you worried?

                    JAKE
          Bring in the johns!

Jake stands. A UNIFORMED COP brings in TEN JOHNS.

                    JAKE (CONT'D)
          I ran a prostitution sting through
          Vice, and arrested thirty guys for
          soliciting.

                    AMY
          That's not a felony.
```

```
                    JAKE
      It is if it's your second offense.
      Which is the case for ten of these
      gentlemen. Little trivia--four of
      them are actually named John! Ironic.
      Anyhoo, ten more for Peralta. Accept
      your fate!

                    AMY
      Never!

                    JAKE
      Five... four... three... two... one!
      It's over. Jake wins! Amy loses!
```

He hits play on A BOOMBOX: "Celebrate" by Kool & the Gang
PLAYS. Jake's given everyone noisemakers, confetti, etc. He
flips the DRY ERASE BOARD, it reads: "PERALTA WINS." Amy
sits, defeated. Jake drops to one knee and produces A RING.

```
                    JAKE
      Amy Santiago, you have made me the
      happiest man on Earth. Will you go on
      the worst date ever with me? You have
      to say yes!

                    AMY
      ...Yes.

                    JAKE
      She said yes! She said yes!
```

NATURALISTIC DIALOGUE: PROFANITY IN *THE WIRE*

Some dialogue is written to feel naturalistic; the writers don't want to draw any attention to it. They want us to feel as if we're eavesdropping on realistic situations—such as in the infamous scene of "all fucks" from *The Wire*. As they keep using the word over and over again, it becomes almost like a game between the two detectives. And then they want the only words to be the f-bomb in the scene. So it starts with the writer's agenda; the audience then starts to realize, "Oh, wow, these are the only words that are being spoken in the scene." Then the detectives start to play off each other, and it becomes that game. If writing the scene first just on the nose to get the text out, there's certain information that has to come out in the scene. But then we can go to our toolboxes as writers and ask ourselves, "What would be a fun, interesting, unique way to show the relationship between the two detectives, to make

it more than a typical, dry procedural that we've seen a million times?" Since *The Wire* (2002–2008) was an HBO show, the writers had the freedom to use the f-word. And this was fairly early in premium cable. On a cable show, we're not limited by Standards and Practices, which controls what curse words can be said on a network. So hey, let's cut our characters loose and let them talk the way they really would. For good measure, here's the playful scene from Season 1, Episode 4, entitled "Old Cases":

```
[Bunk and McNulty enter the apartment.]

                    BUNK
             (looks at the crime scene photos)
        Ah. Fuck.

                    MCNULTY
        Motherfucker.

[Bunk lays out the crime scene photos on the kitchen floor.]

                    BUNK
        Fuck fuck. Fucking fuck. Fuck. Fuck.
        Fuck. Fuck.

[McNulty examines the autopsy file.]

                    MCNULTY
        The fuck?

                    BUNK
        Fuck.

[A tape measure snaps back on McNulty's fingers.]

                    MCNULTY
        Fuck!

[Bunk places a photo on the window. Circles the spot of
the bullet hole. Jimmy stands in the middle of the kitchen
trying to measure where the gun would have had to have
been held to get the victim's entrance and exit wounds. It
doesn't make sense.]

                    BUNK
        Fuck.

                    MCNULTY
        Fuck it. Mother fuck.
```

[Bunk looks back to the photo on the window and the bullet hole he's drawn.]

 BUNK
 Mother fuck.

[Bunk notices the glass is on the INSIDE of the window, not the outside. The shooter was outside.]

 MCNULTY
 Ah, fuck. Ah fuck.

[McNulty leans up to the window to test the theory. Yep.]

 MCNULTY
 Fuckity fuck fuck.

 BUNK
 Fucker.

[McNulty and Bunk begin to search for the bullet.]

 MCNULTY
 Ah fuck.

 BUNK
 Fuck fuck fuck fuck fuck fuck.

[In the crime scene photos they see some plastic debris by the body.]

 BUNK
 Mother fucker.

[McNulty finds a lump in the fridge door.]

 MCNULTY
 Fuckin' A.

[McNulty uses some pliers to pick at it.]

 MCNULTY
 Fuuuuuuck.

[They find the bullet.]

 MCNULTY
 Mother fucker.

 BUNK
 Fuck me.

[They line up the shot to see where the casing would have
landed. They step outside to find it. McNulty taps on the
glass as if recreating the shot.]

 MCNULTY
 Pow.

[Bunk measures from McNulty's gun to find the casing. They
dig in the grass. There it is!]

BACKSTORY:
WHAT THEY DON'T SAY

In addition to giving every character in an ensemble a point of view, remember, characters always have history. Novice writers often write scenes as if characters never existed before that scene. But we need to remember that characters have a whole life, a whole backstory that informs the present. They bring and carry that around everywhere they go. In pop psychology, this is called our baggage. Some of this is helpful to us, while some just bogs down and limits us. But if we don't have an ensemble, let's say we just have a scene with two characters, bear in mind that history can be 20, 30 years into the past or more— or maybe just from last week.

Characters don't need to speak in complete sentences. They will have inside jokes and their own shorthand with each other, based on other characters' histories and their own, and it's perfectly fine not to explain what those things mean. The audience will understand that part of the relationship is these inside jokes, and the shorthand between characters. That's going to speak louder about a relationship than having characters say, "Well, you know, we've been married for 25 years now, and this is something that has come up a lot in our relationship." Just have them react to each other in a way that shows they're annoyed, and have it convey those 20-plus years of marriage. It's going to be far stronger than having people explain things. Trust that the audience is going to understand what's going on. If they don't, that's OK too. So much of what makes scenes rich and interesting is a sense of mystery.

An example of *not* writing what the characters are thinking is in Season 1, Episode 8 of *The Handmaid's Tale*, "Jezebels." In this scene, the Commander (Joseph Fiennes) has

dressed Offred/June (Elisabeth Moss) in a slinky gown and asked her to put make-up on, saying that he has a surprise for her. They're in the back seat of his car, being driven by his chauffeur Nick (Max Minghella), who is having a forbidden affair with Offred. And unbeknownst to the Commander, Nick and Offred have real feelings for each other. Look at how Kira Snyder, the writer, forces Nick into this uncomfortable situation:

```
[The Commander leads Offred to the back entrance to an
unmarked warehouse, followed by Nick. The large metal door
creaks open; they enter and go down in the elevator. The
door opens again and they emerge.]

                  THE COMMANDER
          Let's take this off.

[He helps Offred/June take off her cloak, revealing the sexy
dress underneath. Nick stares in spite of himself; Offred
looks around nervously.]

                  THE COMMANDER
          Almost forgot.

[He puts a pair of earrings on Offred's ears.]

                  THE COMMANDER
          There. Doesn't she look beautiful?

                  NICK
          Yes, sir.
```

Nick's response is both respectful and contemptuous. The two words are loaded with subtext, informed by his history with Offred.

ACTIONS—AND TRIANGULATION

Aristotle, in his classic work on dramatic theory, *Poetics*, talks about how characters are defined by their actions. Characters are not defined by what they say. They are defined by what they do.[1] If we look at our own lives and relationships, often people will say all the right things—"You know I love you, baby"—and then they'll do the most inconsiderate, selfish thing, with their actions in direct opposition to the words they tell us. It's more than body language; we know from life that actions speak louder than words, and it doesn't necessarily matter what somebody tells us. It's all about the follow-through.

In terms of conflict and power dynamics, any time we have two characters on the same side in a scene with a "weaker" character on the opposing side, we create triangulation. And that's always interesting, because the audience naturally wants to see who's going to win. They may root for the underdog, or not, but if the show is well written, they'll be rooting for one side or the other. The *Fargo* Season 3 pilot, "The Law of Vacant Places," gives us a great example of triangulation, as well as character history and point of view. In the following scene, Ewan McGregor plays twin brothers Emmit and Ray Stussy. Emmit has become extremely successful as the "parking lot king of Minnesota"; his brother Ray is by contrast, a struggling parole officer. Ray has fallen in love with one of his parolees, Nikki (Mary Elizabeth Winstead). He's come to Emmit for money that he feels Emmit owes him, and he's forced to do it while Sy (Michael Stuhlbarg), Emmit's right-hand man, literally looks down on Ray.

[Emmit sits at his desk, dressed in a tux; Ray sits across from him. Sy stands nearby, watching.]

> EMMIT
> How's the Corvette?

> RAY
> It's a car. Look, I'm gettin'
> engaged.

> EMMIT
> Again?

> RAY
> Don't say that.

> EMMIT
> I'm sorry.

> RAY
> She's real sweet. Nikki. We're in—
> you know.

> SY
> You meet her at work?

> RAY
> At work, yeah.

> SY
> So, embezzler? Drug mule?

```
              RAY
          (to Emmit)
     Why is he here? He doesn't need to
     be here.

              EMMIT
     Sy's always here when the
     conversation's about money. That's
     what this is, right? A
     conversation about money.
```

As we all know, money is power. Emmit's choice to have Sy present is a subtle action that speaks volumes about Emmit's relationship to his brother, as well as to Sy himself.

OVERLAPPING DIALOGUE: *STRANGER THINGS*

C haracters, much like real people, are often bad communicators. Meaning that, we like to think we're all good listeners and good communicators, but the reality is, most of us don't listen well to what other people are saying. So another part of our toolboxes as screenwriters is overlapping dialogue—characters can interrupt and talk over each other.

In this scene from "Chapter One: The Vanishing of Will Byers," the *Stranger Things* pilot, four 12-year-old boys talk excitedly while playing Dungeons & Dragons. (Note that they are interrupting each other throughout, even though there's only one actual example of "dual dialogue.")

```
The four boys sit in a circle, their knobby knees buried
in carpet. A map is spread out between them, along with an
empty pizza box, canned cokes and the all-important DUNGEONS
AND DRAGONS MONSTER MANUAL.

              MIKE
     A shadow grows on the wall behind
     you... swallowing you in darkness...
     it is almost here...

The other boys lean forward. Riveted.

              WILL
     ...What is it?
```

 DUSTIN
 The Demogorgon?

 WILL
 We're screwed if it's the Demogorgon--

 LUCAS
 It's not the Demogorgon--

Mike waits for them to settle down. Then:

 MIKE
 An army of Troglodytes charge into the
 chamber!

He slams SIX WINGED MINIATURES onto the map.

 MIKE (CONT'D)
 Their tails drum the floor. Boom! Boom!
 Boom!

 DUSTIN
 Troglodytes?!

 LUCAS
 Toldja!

 DUSTIN
 Easy.

Mike looks over his shoulder. His eyes grow wide.

 MIKE
 Wait... do you hear that? Boom! Boom!
 BOOM! That sound... it didn't come from
 the *Troglodytes*. No. It came from
 something behind them...

Mike slams a LARGE TWO-HEADED MONSTER MINIATURE onto the
map.

 MIKE (CONT'D)
 THE DEMOGORGON.

The boys stare. *Shit.*

 LUCAS
 We're all gonna die.

 MIKE
 Will, your action.

Will swallows. God, he wishes it wasn't his turn.

 WILL
 I--I don't know--

 LUCAS
 Fireball him--

 WILL
 I'd have to roll thirteen or higher--

 DUSTIN
 Too risky. Cast a protection spell--

 LUCAS
 Don't be a pussy! Fireball him!

 DUSTIN
 Protection spell--!

 MIKE
 The Demogorgon is tired of your silly
 human bickering. It steps toward you.
 BOOM!

 LUCAS
 FIREBALL HIM, Will!

 MIKE
 Another step. BOOM!

 DUSTIN
 Cast protection!

 MIKE
 It roars in anger--

 LUCAS DUSTIN
Fireball--! Protection--

 MIKE
 And--

 WILL
 FIREBALL!

ECONOMY WITH WORDS

There should never be a line of dialogue in a script that doesn't have a reason to be there. No line can just sit there because it's a piece of information that needs to come out. Every line needs to be special and merit its existence on the page. Even when a line serves a function in a plot, it needs to be special in that it's coming from a character's unique voice. Any time dialogue starts to feel generic and interchangeable, it starts to feel flat. Specificity is highly important in dialogue. Think of setting as another character. Where characters come from, their ethnicity, education levels, how they speak, do they have an accent, how is their vocabulary? Do they use malapropisms? Do they speak differently in different situations depending on who they're around? All these things add up and when we're going through our scripts, even if we don't know the solutions at the time, circle any line that feels as if it doesn't have any sense of personality or anything distinctive about it. And think first, does that line need to be there, could I cut it? And second, if we can't cut it, could it be a non-verbal action line, communicated through body language? If it can't be cut verbally, what's a unique way for that character to say that specific line?

E-COMMUNICATION

Actors will make dialogue uniquely their own. I find that the better the actor, in general, the more comfortable they are with not having a lot of lines of dialogue. The best actors I've worked with feel they can convey what they're feeling with a look or a sense of attitude. There's the joke that actors go through a script and say, "Bullshit, bullshit, bullshit, my line, bullshit, bullshit, bullshit." But I think that's just a stereotype. I think that actors have realized just like audiences have that the way we communicate has become much more sophisticated and technological. Consider how we communicate with texts and emails. If I'm going to call somebody, or have a phone conversation, it has to be important—because texting, email, Instagramming and Facebooking are more efficient. Our efficiency in communication crosses over into how we communicate in our daily lives, because if we have something important we want to discuss with somebody, often their response is, "Well, didn't you get my text?" A USA Network show from a few years back, *The Starter Wife*, was about a woman whose Hollywood executive husband breaks up with her in a text. Computers and smart phones have created a sea change in how we communicate; we communicate in fragments, soundbites and pieces of quick information that can be exchanged through little acronyms of text and emojis. It's also affecting how we speak when we are together. In Netflix's *13 Reasons Why*, at least 30% of all communication between teens is via text—which

often leads to misunderstandings and hurt feelings. Electronic communication is efficient and constant, but is it more empathetic? Does it facilitate better understanding and bring us closer together or have the opposite effect: alienation? Texting is exchanging information, not a pure dialogue. There's no eye contact, no sense of inflection, no facial expression. In rare cases, it can be dangerous, the inferred leading to a subsequent actual conversation—as damage control. Even Facetime and Skype video cannot replace the joy and necessity of in-person communication.

LISTENING TO OUR CHARACTERS

The best dialogue comes from people who are good listeners. Screenwriters need to be *great* listeners. We need to eavesdrop on conversations, listen to how people talk, listen to the rhythms. Go out if feeling blocked, stuck or incapable of writing sharp, authentic dialogue. Go to a shopping mall, go to a restaurant and just eavesdrop on people. How do they speak, what's the subtext in the scene, what's the body language? That level of specificity adds layer upon layer to a script that starts off flat, maybe with text that's obvious, then we camouflage and layer it with subtext and nuance. That's the goal, and that's what we're hoping to nail in every script before it goes out.

⊚ Bonus Content

Further analysis on dialogue, including **Bones, Orphan Black, The Americans** and **Scandal**, is at **www.routledge.com/cw/landau**.

Note

[1] Aristotle, *Poetics*, with an introductory essay by Francis Fergusson (Hill and Wang, 1961).

Episodes Cited

"Pilot," *Empire*, written by Lee Daniels & Danny Strong; Imagine Television/20th Century Fox Television.

"West Covina," *Crazy Ex-Girlfriend*, written by Rachel Bloom and Aline Brosh McKenna; Lean Machine/Black Lamb/racheldoesstuff/The CW.

"The Bet," *Brooklyn Nine-Nine*, written by Laura McCreary; Universal Television/NBC Studios/20th Century Fox Television.

"Jezebels," *The Handmaid's Tale*, written by Kira Snyder; Temple Street Productions/Hulu.

"The Law of Vacant Places," *Fargo* (Season 3), written by Noah Hawley; MGM Television/FX Productions.

"Chapter 1: The Vanishing of Will Byers," *Stranger Things*, written by the Duffer Brothers; 21 Laps Entertainment/Monkey Massacre/Netflix.

PART III
CAREER STRATEGIES IN THE EVOLVING TV MARKETPLACE

"I'm honored that I get to play a part and be able to contribute to support such artistic voices and there are so many that need to be heard, and am dedicated to continue this legacy of inspiring people through art. I don't believe in very many things but art is definitely one of them, on the top of that list . . . arts influence our culture in a way that many of us don't understand or fully respect.

Art doesn't belong to the few but to the many."

—MEGAN ELLISON
ACADEMY AWARD-NOMINATED PRODUCER
ZERO DARK THIRTY, HER, AMERICAN HUSTLE

CHAPTER 11
TO I.P. OR NOT TO I.P.?
THAT IS THE QUESTION

The Value of Intellectual Property
in the Scripted TV Ecosystem

QUESTION: What do each of these hit TV series and their showrunner/creators have in common?

- *Game of Thrones* (HBO, David Benioff and D. B. Weiss)
- *The Walking Dead* (AMC, Frank Darabont)
- *UnREAL* (A+E, Marti Noxon and Sarah Gertrude Shapiro)
- *Orange Is the New Black* (Netflix, Jenji Kohan)
- *Fargo* (FX, Noah Hawley)
- *Homeland* (Showtime, Alex Gansa and Howard Gordon)
- *Legion* (FX, Noah Hawley)
- *The Man in the High Castle* (Amazon, Frank Spotnitz)
- *Buffy the Vampire Slayer* (WB/UPN, Joss Whedon)
- *Friday Night Lights* (NBC, DirecTV, Jason Katims)
- *Parenthood* (NBC, Jason Katims)
- *Fresh Off the Boat* (ABC, Nahnatchka Khan)
- *Shameless* (Showtime, Paul Abbott)
- *The Office* (NBC, Greg Daniels)
- *The Leftovers* (HBO, Damon Lindelof and Tom Perrotta)
- *Sherlock* (BBC, Steven Moffat and Mark Gatiss)
- *Elementary* (CBS, Robert Doherty)
- *American Gods* (Starz, Bryan Fuller and Michael Green; new showrunners tbd)
- *Jane the Virgin* (The CW, Jennie Snyder Urman)
- *Code Black* (CBS, Michael Seitzman)

- *Mozart in the Jungle* (Amazon, Roman Coppola, Jason Schwartzman, Paul Weitz and Alex Timbers)
- *11.22.63* (Hulu, Bridget Carpenter)
- *The Handmaid's Tale* (Hulu, Bruce Miller)
- *Bones* (Fox, Hart Hanson)
- *Ugly Betty* (ABC, Silvio Horta and Fernando Gaitán)
- *M*A*S*H* (CBS, Larry Gelbart)
- *All in the Family* (CBS, Norman Lear)
- *Better Call Saul* (AMC, Vince Gilligan and Peter Gould)
- *Bates Motel* (A+E, Anthony Cipriano, Carlton Cuse and Kerry Ehrin)
- *Animal Kingdom* (TNT, Jonathan Lisco)
- *Hawaii Five-0* (CBS, Peter M. Lenkov, Alex Kurtzman and Roberto Orci)
- *The Night Manager* (AMC/BBC, David Farr)
- *Pretty Little Liars* (The CW, I. Marlene King)
- *Gossip Girl* (The CW, Stephanie Savage and Josh Schwartz)
- *Big Little Lies* (HBO, David E. Kelley)
- *Dexter* (Showtime, James Manos, Jr.)
- *Star Trek: Discovery* (CBS All Access, Bryan Fuller and Alex Kurtzman)
- *The People v. OJ Simpson: American Crime Story* (FX, Ryan Murphy and Aaron I. Naar)
- *13 Reasons Why* (Netflix, Brian Yorkey and Diana Son)
- *Masters of Sex* (Showtime, Michelle Ashford)
- *The Night Of* (HBO, Richard Price and Steven Zaillian)
- *Twin Peaks* (the revival, Showtime, Mark Frost and David Lynch)
- *Jessica Jones* (Netflix, Melissa Rosenberg)
- *Daredevil* (Netflix, Drew Goddard)
- *Luke Cage* (Netflix, Cheo Hodari Coker)
- *Gotham* (Fox, Bruno Heller)
- *Scandal* (ABC, Shonda Rhimes)
- *The Punisher* (Netflix, Steve Lightfoot)
- *Z: The Beginning of Everything* (Amazon, Dawn Prestwich and Nicole Yorkin)
- *Westworld* (HBO, Jonathan Nolan and Lisa Joy)
- *Alias Grace* (Netflix, Sarah Polley)
- *Queen Sugar* (OWN, Ava DuVernay and Oprah Winfrey)

ANSWER: They're all based upon source material (a/k/a Intellectual Property), such as a movie, novel, comic book, graphic novel, nonfiction book, memoir or magazine article, or they were spun off, revived or rebooted from a former TV series by their showrunners/creators/adapters.

INTELLECTUAL PROPERTY GLOSSARY

Before we analyze the pros and cons of creating content based on I.P., let's briefly define our terms. (I'm not a lawyer—nor do I play one on TV—so please do your due diligence before adapting a series based on I.P.)

Intellectual Property (I.P.) is the result of creativity. By law, the owner of a "creation of the intellect," such as a comic book, is assigned a monopoly. The owner is thereby granted rights to—in other words, the *protection* of—their intellectual property.

Copyright is the exclusive legal right granting the creator/originator of a "work," for instance, a novel or memoir, to print, publish, perform, film or record it, often for a limited period. (Copyright does not cover ideas and information; it only protects the form or manner in which they are expressed.)

Option and Purchase of Rights: Securing the rights to develop a work—an "option" to develop it over a period of time into a series, or to purchase the rights and then sell and exploit the resulting TV show. Options often run for 18 months; longer can be negotiated, as well as exclusive extensions (though locking in the price of any extensions is best done in the initial agreement). So, why not purchase rights from the start, rather than an option, which is only temporary? Rights can be expensive, and the acquirers may wish to limit their costs at the early stages, when it's uncertain if the show will even be made. Options are by nature cheaper than rights; sometimes they can be negotiated for a nominal sum, depending on the standing of the writer/owner and the acquirer. Every deal varies. The fee paid for an option can also be written into the agreement as redeemable against the purchase of the rights, if made at a later date. When an option expires and the rights aren't purchased, they usually revert back to the creator/owner.

Copyright Infringement refers to the use of the "work"—e.g., an article—*without* permission from the copyright holder. It's also known as piracy. The copyright holder may be the creator(s) themselves or perhaps their employer or another owner. The responsibility for enforcing copyright generally rests with them. There are limitations and exceptions. Certain limited uses of copyrighted works are allowed: "**fair use**," for example, for educational purposes. (Remember those photocopies of books we used to receive in high school?) Fair use is also how shows such as *Saturday Night Live* can parody celebrities, movies, TV shows, politics, commercials and more.

Public Domain: Works that are in the "public domain" are not held under copyright, trademark or patent law. In terms of intellectual property, these are works whose exclusive I.P. rights have expired, were willingly given up ("dedicated" by the owner) or never applied as they were created before copyright law. Works may also be unknowingly given up if registering for copyright is required in a certain country. Copyright law varies by country. What's in the public domain in one country may be under copyright in another. The works of William Shakespeare are all in the public domain, for example, as the creator/owner died more than 70 years ago and the copyright has expired (again, it all varies by country: For instance, 70 years is the British law but in the US, some works remain under copyright for 95 years). And if the creator/owner of a work retains residual rights, such as a songwriter, lyricist and music publisher owning the rights to a song, they do not have to sell the rights outright but rather a **license** to use the song with permission: "under license." The user makes an agreement with the owners to use their song. Visit www.NewMediaRights. org for a handy chart of public domain terms, years and other applicable conditions.

Life Rights: The rights to a person's life story. Generally, the acquirer of life rights secures a waiver from lawsuits related to defamation or the invasion of privacy. If the person in question is deceased, it's still best practice (and simply kind) to inform the heirs/relatives/estate and seek their blessing before proceeding. Or else even big shot TV moguls such as Ryan Murphy (and the FX network) may face the wrath of say, legendary actress Olivia de Havilland, who (at 101 years old) felt she was negatively portrayed in the limited series *Feud*.

Again, I'm not an attorney and urge anyone looking to option or purchase rights to seek counsel from a reputable entertainment lawyer. Here's the guidance of Professor Richard Walter, who's been Head of the UCLA MFA Screenwriting Program for over 40 years:

> As an instructor and a writer, it's foolhardy to encourage or enable students to write scripts based on material whose copyright they do not own. The copyright to any original material automatically belongs to the person who creates it, as it is created. It does not even have to be registered with the Copyright Office at the Library of Congress nor, say, even registered with the WGA [Writers Guild of America].
>
> Simply by writing a [wholly] original script, the right to sell it belongs exclusively to its author. A memoir is an interesting notion. Presumably it's based on historical facts that belong to no one. If it's a published memoir that is in any way seen as "the basis" or part of the basis for the script, it can get sticky.

Also murky is the fact that we don't need anyone's rights to write about him/her factually, but different people have different ideas regarding what constitutes "facts." This has never been truer than today! Moreover, lacking a signed agreement regarding "life rights," one can always be sued—successfully or not—for defamation, character assassination, libel and more.

Is the script about a public figure? In this case, the bar is much lower. It would be difficult for, say, Barack Obama to successfully sue someone for writing about him, even if it were lie after lie. There would need to be "reckless disregard" for the truth, demonstration of damages, clear intent to cause harm, etc.

I feel I would betray students in my class if I enabled or encouraged them to work on a script where there was any question regarding the writer's rights to market the material. Writers can do what no director, actor, producer, editor, cinematographer, etc., can: create from nothing, something they own, that has value, that can be bartered, sold, produced. It is a mistake, therefore, to do anything else.[1]

It's sound advice. Only if writers possess the rights to material, own an option to develop it or are hired to write by the option/rights owner is there a different scenario. In Hollywood, manuscripts and comic books are often bought before they're even hot off the press. These sorts of literary transactions happen on a weekly basis. As content creators, if we're looking to bring some secret I.P. to the attention of potential buyers, chances are they've not only already heard of it, they may have already brokered the deal between author and studio/network (who are then tasked with finding a screenwriter for hire to adapt/develop the I.P. into a TV series). I wouldn't let that discourage anyone from continuing to scour newspapers, magazines and booksellers for hidden literary treasure. But once again, I highly encourage doing due diligence to determine who owns the underlying rights to the material, before investing months or years developing it. That can be a waste of time when buyers realize someone else actually owns the rights.

In rights acquisition, timing is everything.

Several decades ago, a friend was captivated by a profile buried in the back pages of a New York newspaper, about a feisty, middle-aged, New York family court judge. My friend sought out the judge's life rights but decided to let them go when she found little traction from the scripted network TV executives. Years later, this same New York judge retired from the bench and became the star and executive

producer of her own *unscripted* series. The judge is Judy Sheindlin. To date, the series—*Judge Judy*—has produced 5,882 episodes over 21 seasons, generating millions of dollars in revenue for Big Ticket Entertainment and Judy herself. The moral of the story when acquiring and holding any I.P. rights? Timing.

A viable alternative to securing life rights or literary licensing is to write an original script that's *inspired* by another work but bears no literal resemblance to the original: new characters, new setting, new story out of whole new cloth. Any similarities would open up vulnerability to a potential copyright infringement lawsuit, so be mindful of changing *everything* except the initial inspiration for the series. But how can someone even prove theft from the original work? If anyone opens up the channels of communication by inquiring as to the rights holder, they create a paper trail that could leave them exposed—even if they've substantively changed the story for a TV adaptation. For this reason, even series that take the core idea from a book and then create a brand-new show still attribute the source material. If a producer or studio/network has deep pockets, it's always better to be legit and transparent up front, than to get derailed later. And, trust me, the lawsuit generally rears its ugly head only when and if the series becomes profitable. Success breeds legal challenges. Where there's money, there are lawyers.

There have been numerous films and TV movies (a/k/a biopics) based upon the lifestyles of the rich and infamous, from Marilyn Monroe to Bernie Madoff. But streaming on-demand viewership has transformed the biopic into the *ongoing* TV series. *Scandal* premiered in 2012 and at press time has begun its seventh and final season. Shonda Rhimes partially based protagonist Olivia Pope (Kerry Washington) on the press aide to the George H.W. Bush administration, Judy Smith. Smith consults on the series and is credited as Co-Executive Producer. But *Scandal* is a wholly fictional political soap opera, replete with that affair, whiplash-inducing plot twists and steep cliffhangers. The Fox procedural crime-dramedy series *Bones*, created by Hart Hanson, ran from 2005–2017 and was loosely based on the life and writings of novelist and forensic anthropologist, Kathy Reichs (also a consulting producer on the show). Lead character Temperance Brennan (Emily Deschanel) is named after the heroine of Reichs' crime novel series. In a meta turn, Dr. Brennan also writes successful mystery novels featuring a fictional forensic anthropologist named Kathy Reichs. Got that? With its procedural case-of-the week structure, along with co-star David Boreanaz's fan base, it's no wonder that *Bones* was the longest-running one-hour drama series produced by 20th Century Fox Television.

Before the Digital Television Revolution and on-demand/binge-viewership, TV networks tended to want their crime dramas to offer up "closed-ended," new

cases each week: crime investigation, with justice meted out in the resolution of the same episode. But now audiences and many broadcasters crave a slow(er) burn; a serialized approach. I explore the slow-burn, season-long procedural in Chapter 2, but while we're discussing Life Rights, I'd like to honor one of the best crime-drama serials of 2015–2017: *Narcos*.

Narcos was created by Chris Brancato, Carlo Bernard and Doug Miro. Season 1 aired during the summer of 2015, as a "Netflix Original." Set and shot in and around Medellín, Colombia, it tells the story of notorious, sadistic drug kingpin and family man, Pablo Escobar (Wagner Moura), who made billions in the cocaine trade, from the late 1970s through his death in 1992 (in a blaze of glory, *Scarface* style). Tonally, the series makes two bold choices from the get-go: It seamlessly intercuts archival footage of the real Escobar's operation with newly imagined and/ or recreated scenes. The compulsively watchable series gains momentum from its mix of fact and fiction, narrative drive (courtesy of dramatic license) and stranger-than-fiction twists and turns. Most of us know from the start that Escobar is doomed. Nevertheless, we remain invested in his self-destruction by diving deep into both his personal life and the inner workings of his drug empire. Martin Scorsese used the same approach in his masterpieces, *Goodfellas* and *Casino*.

It might have been merely an excellent Colombian version of *The Sopranos*, but *Narcos* exceeds our expectations through its second bold move: point of view. While *Narcos* is "All About Escobar," it offers a two-pronged approach: one from the POV of Pablo and his crew, the other from real-life-based DEA agents Steve Murphy (Boyd Holbrook) and Javier Peña (Pedro Pascal). The series has been so popular that Netflix has already renewed *Narcos* through 2019. It's natural to wonder how a series ostensibly about Escobar can continue after his death. With its DEA perspective, Seasons 3 and 4 will focus on Escobar's Colombian rivals (at least, the ones still standing) and later, or perhaps simultaneously, the cartels in Mexico. Like Ryan Murphy's limited anthology series (*American Horror Story*, *American Crime Story*, *Feud*), each new season of *Narcos* will adhere to the common theme of busting open the drug trade. The reality that the drug war is unwinnable (see: *Traffic*) makes this series all the more sustainable.

The Spinoff

There are two main types:

1. When a TV series achieves high ratings and buzz, networks have astutely capitalized on its popularity by taking beloved (usually secondary) characters and building a whole new series around them. Some examples include: *The*

Jeffersons and *Maude*, which spun off from *All in the Family* and also aired on CBS; *Rhoda* and *Phyllis* both spun off as sitcoms from *The Mary Tyler Moore Show*, as did *Lou Grant* (a rare case of a one-hour drama being spun off from its original sitcom). All three were produced by MTM Enterprises and also aired on CBS. *Buffy the Vampire Slayer* gave us *Angel* on The WB/UPN; *The Vampire Diaries* brought us *The Originals* (both on The CW); *Frasier* spun off from *Cheers*, both on NBC; *Melrose Place* spun off from the original *Beverly Hills 90210*, both on Fox; *Major Crimes* was a spinoff from *The Closer* (both on TNT).

2. A new series can also be spun off the basic premise of the original show, but in a new location, such as *Fear the Walking Dead*, which moved to post-apocalyptic Los Angeles from Atlanta, Georgia). The *CSI* franchise spun off to Miami, New York, and the world of the Internet. *The Good Fight* (on CBS All Access, featuring Christine Baranski in her reprised role as attorney Diane Lockhart) is a spinoff from *The Good Wife*. Both shows are located in Chicago, in different firms.

Reboot: A classic TV series that's updated—mostly recast, repackaged and relaunched as a new series. Examples: *Hawaii Five-0* (CBS), *90210* (The CW) and *Melrose Place* (Fox), *Dynasty* (The CW), *Star Trek: Discovery* (CBS All Access), *Battlestar Galactica* (Syfy).

At the age of 93, Norman Lear rebooted his classic 1975–1984 CBS sitcom, *One Day at a Time*, which now airs on Netflix and centers around three generations of a Cuban-American family, who live under the same roof. The setting has been transported from the original Indianapolis to Los Angeles. The 2017 reboot features the same multi-camera style and laughing studio audience, with the same catchy theme song, "This Is It," now reinvigorated with a salsa beat by Gloria Estefan. Justina Machado (*Six Feet Under*) plays Penelope, a recently divorced military mother with a teen daughter and a tween son. Her mother is fabulously played by EGOT[2] Rita Moreno.

Talking about the issues that matter in today's world was a must for liberal political activist Lear. So, instead of divorce and single motherhood being the hot button issues, the reboot deals with immigration and elements of PTSD. Says Lear: "This is an entirely different and original show. As a matter of fact, we didn't even revisit the old scripts."[3] Lear's current producing partner, Brent Miller, had the idea to revive *One Day at a Time*, and "Lear, who was a pioneer in championing racial diversity on television, was enthusiastic about focusing on a Latino family."[4] While Lear played an active role in developing and promoting the reboot, he brought in seasoned showrunners Gloria Calderón Kellett (*How I Met Your Mother*) and Mike

Royce (*Everyone Loves Raymond*) to create a wholly new series. And Lear is pleased with the results:

> *What Mike and Gloria [who coincidentally have the same first names as Archie Bunker's son-in-law and daughter] have rendered here is a gloriously warm family, and there is no family of any other stripe, or color, or religion, or anything that can't relate to it because of our common humanity.*[5]

Remake: Generally refers to a series that was originally produced and aired in another country. This could be a series from the UK being remade (recast, reset) in the US: *The Office, Shameless, Queer as Folk, Getting On*; or from another, non-native English speaking country: *The Bridge* (Sweden/Denmark), *Homeland* (Israel), *The Killing* (Denmark), *Ugly Betty* (Colombia), *Jane the Virgin* (Venezuela); *In Treatment* (Israel). Norman Lear and Bud Yorkin's classic *All in the Family* was very loosely inspired by the British series, *Till Death Us Do Part*.

Incidentally, *Fauda* (Israel) was remade just with a new opening and English-dubbing option. Netflix is pushing the boundaries in terms of streaming shows in their original language, un-remade and almost untouched, such as *Nobel* (from Norway; with only the new "Netflix Original" opening added, no English-dubbing option). This builds on their longstanding policy of showing original British series: *Happy Valley, Broadchurch, The Fall, Chewing Gum, Luther, Last Tango in Halifax*. Amazon has followed suit with its half-hour comedies *Catastrophe* and *Fleabag*. Some of these shows originally aired in the US on BBC America (which also broadcasts the Canadian hit, *Orphan Black*).

In our SVOD (Streaming Video on Demand) TV landscape, the TV business has become a global enterprise, and happily, subscribers now have the opportunity to watch a series in its original, unadulterated form. When Netflix Chief of Content Ted Sarandos was approached by his team several years ago about the prospect of remaking the British series *Broadchurch* for the US, Sarandos' response to his team was: "You know it's in English, right?" He was right; the remake, *Gracepoint*, was canceled after just one season.[6]

Revival or Sequel: This is when a classic TV series decides to bring back the original cast for a reunion series, usually set in present day. Examples include: *Will & Grace* and *Gilmore Girls: A Year in the Life*. *Fuller House* is a hybrid reboot/revival, with both a new cast and several of its original cast members recurring in their roles. Showtime's revival of *Twin Peaks* is a hybrid reboot/revival, with Kyle MacLachlan reprising his role as FBI agent Dale Cooper—the Lynchpin (pun intended) of the whole enterprise.

A controversial, cultural phenomenon when it first aired on ABC in 1990, *Twin Peaks* was ahead of its time. The show was a surreal game-changer, influencing a number of other TV series, from *The X-Files* to *Lost*, from *Mr. Robot* to *Riverdale*. It became an instant cult classic, but this was back in the days when "niche" was considered pejorative. As a result, the trailblazing, tough-to-categorize series was canceled after just 30 episodes (that was poor performance at a time when all network series were at least 22 episodes). In today's streaming, on-demand TV landscape, *Twin Peaks*, with its 18-part first season order (David Lynch prefers the term "parts" to episodes) has found a better fit, albeit with Agent Cooper in a more peripheral role.

Jumping networks is not uncommon in the series revival business. While *Gilmore Girls* originally aired on The CW, and *Full House* had aired on ABC, Netflix brought us their revivals. Such sequels are usually written and produced by the original creator/showrunners. *Twin Peaks'* creator/director/iconoclast David Lynch and co-creator Mark Frost own the underlying creative rights, but when it was time to shop the project, they approached not original broadcaster ABC (Disney), but the parent company of Showtime—CBS—which holds the series' distribution rights. Fortuitously, Showtime's President of Programming, Gary Levine, had developed *Twin Peaks* with Lynch and Frost when he was a development exec at ABC. For Showtime CEO David Nevins, the revival package was irresistible. Auteur Lynch has said that cable is the new art house cinema.

At the same time, Showtime has tended to be a little less reliant on acquiring I.P. for their "originals" than its main competitors, Netflix and HBO. HBO's programming is heavily I.P.-based: *The Wire*, *Sex and the City*, *Game of Thrones*, *Boardwalk Empire*, *True Blood*, *Big Little Lies*, *Olive Kitteridge*. Over at Showtime, *Homeland* is based on the Israeli TV series *Prisoners of War* (original Hebrew title *Hatufim*, translation: "Abductees"), created by Gideon Raff and adapted for American TV by Alex Gansa and Howard Gordon; *Masters of Sex* was adapted by Michelle Ashford from the 2009 book *Masters of Sex: The Life and Times of William Masters and Virginia Johnson, the Couple Who Taught America How to Love* by Thomas Maier; the first season of *Dexter* was derived from the novel *Darkly Dreaming Dexter* by author Jeff Lindsey (adapted for TV by screenwriter James Manos, Jr., who wrote the pilot). And yet, when we think of Showtime's distinctive brand of "No limits," its edgy, entirely original (non-I.P. based) series are what tend to come to mind: *Weeds*, *Nurse Jackie*, *Californication*, *Ray Donovan*, *The Affair*, *Penny Dreadful* and *Billions*.

Prequel: This seems to be the latest trend and can take many forms. As discussed in "The Wild Card" chapter, *Better Call Saul*, the prequel to *Breaking Bad*, takes us

back to Albuquerque and introduces us to Saul Goodman (Bob Odenkirk) back when he was still Jimmy McGill. *Bates Motel*, the prequel to the cult classic Hitchcock film *Psycho*, transports us to the opening of the Bates Motel in *present-day* Oregon, with Norman Bates (Freddie Highmore) as a nerdy, creepy high school student living with his possessive single mother, Norma (Vera Farmiga); yes, she's still very much alive. *The Big Bang Theory* prequel, *Young Sheldon*, features adorable tyke Iain Armitage (Ziggy from HBO's limited series, *Big Little Lies*) as nine-year-old Sheldon Cooper, who as a grown-up is played by Jim Parsons in the CBS megahit. Parsons provides the voiceover commentary from his older perspective, *The Wonder Years* style. The prequel, created by Chuck Lorre and Steve Molaro, airs on CBS. As discussed in Chapter 1, the one big change from the multi-camera *The Big Bang Theory* is its single-camera format.

BREAKING (THROUGH THE NOISE) AND ENTERING (THE ZEITGEIST)

In each of the above examples, the motivation from the networks is to launch a new series with built-in brand recognition. At this writing, as mentioned earlier, there are over 450 scripted series across multiple platforms. For the foreseeable future, the biggest challenge facing all content creators and providers is: How do we break through all the noise and get noticed?

Having a known property can provide a boost to marketing any new series, especially if the source material was a high-grossing movie (*Taken, The Fugitive, Parenthood, Friday Night Lights, M*A*S*H, Fargo, Animal Kingdom, Hanna, Westworld*); bestselling book (*Game of Thrones, 11.22.63, The Handmaid's Tale, Pretty Little Liars, Gossip Girl*, the *Sherlock Holmes* mysteries); a popular TV series (as discussed above); a bestselling comic book or graphic novel (*The Walking Dead, Arrow, The Flash, Jessica Jones, Daredevil, Luke Cage, Legion*, etc.); a popular cartoon series (*Riverdale* on The CW is based on the Archie Comics); or even a hit song. Dolly Parton has licensed some of her catalog to NBC, including her songs "Coat of Many Colors" and "Jolene."

With sequels and franchises dominating the movie marketplace, it's only natural that the TV networks (vertically integrated into entertainment conglomerates)

would want to exploit the momentum and name recognition of their successes. At Comcast NBCUniversal, this is known as the "symphony" approach, as the corporate behemoth uses all its subsidiaries to generate buzz. With control of roughly one-fourth of the media universe, this level of synergy can create unprecedented awareness levels in the increasingly fragmented TV landscape. But because many millennials no longer own traditional TVs, these vertically integrated companies are faced with the ever-increasing conundrum of marketing TV series to an audience that doesn't watch television (or when they do, it's on demand, often binge-viewed while multitasking on smart phones and laptops.)

I.P.-based series can grab an audience's attention but also cause backlash. Given the short-lived TV adaptations of such blockbuster movies as *Limitless* and *Training Day*, the audience clearly preferred the original cast and packaging and rejected the remake. No doubt movie studios and TV networks will continue to try (especially when both properties are owned by the same parent company), but it's rare to capture lightning in a bottle *twice*. Or is it? Sometimes, the TV adaptation can equal or transcend its cinematic predecessor, e.g., *M*A*S*H* (CBS' multi-award winning series, as discussed in Chapter 1); Marvel's *Daredevil* (on Netflix), which bested the Ben Affleck box office dud; and *Buffy the Vampire Slayer* (written by Joss Whedon), which barely made a ripple as a 1992 feature film but achieved cult status on TV.

There's also the example of HBO's *Westworld*, which emerged from the 1973 movie, written and directed by the iconic sci-fi author/screenwriter, Michael Crichton (*Jurassic Park, Andromeda Strain*). HBO aired the five-episode dud, *Beyond Westworld*, back in 1980, based upon both the 1973 movie and its sequel, *Futureworld* (1976). Now, the current HBO series, adapted by co-creators/ showrunners Jonathan Nolan and Lisa Joy, ingeniously shifts the main POV, with the emphasis not on the humans, but on the robots. In this new iteration of *Westworld*, it's not so black and white.

What started out as an interactive, branded theme park has evolved and devolved into anarchy and chaos. (Just add dinosaurs and we've got *Jurassic Park*.) *Westworld* is an example of I.P. colliding with A.I.

While it's obvious that films spawn TV series, the reverse is of course also true, such as the classic and/or cult TV series which are regularly turned into feature films, some stronger than others: *Mission: Impossible 1/2/3/4/5, Charlie's Angels,*

Twilight Zone, Baywatch, 21 Jump Street, Starsky and Hutch, The Addams Family, The Beverly Hillbillies, The Brady Bunch, CHiPs, The A-Team, myriad *SNL* sketches and more.

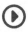

THE LITERARY APPROACH

I n other cases, the source material may not have high, name brand recognition but provides us with a window into a compelling new world—which is a mandate for network and studio execs. As discussed in earlier chapters, *Mozart in the Jungle* (on Amazon) and *Orange Is the New Black* (Netflix) are strong examples of taking a first-person account via a published memoir, then populating a TV series around a central setting and conceit. *Mozart in the Jungle*, which takes us behind the scenes of a fictitious version of the New York Philharmonic, is based on Blair Tindall's memoir, *Mozart in the Jungle: Sex, Drugs, and Classical Music. Orange Is the New Black*, set in a Connecticut minimum-security women's prison, was adapted by series creator/showrunner Jenji Kohan, with Season 1 based on the memoir *Orange Is the New Black: My Year in a Women's Prison* by Piper Kerman.

ADAPTING AUTOBIOGRAPHICAL MATERIAL

UnREAL: Co-created by showrunner Sarah Gertrude Shapiro, *UnREAL* (on Lifetime) is based upon her short film, *Sequin Raze* (2013), which was about Shapiro's time served as a segment producer on *The Bachelor*. The "time served" analogy is fitting, as Shapiro was only let out of her iron-clad (in perpetuity) contract with *The Bachelor* after she suffered a nervous breakdown. *UnREAL* Season 1, which premiered in 2015, was honored with a Peabody award for its dark, edgy, satirical depiction of what goes on behind the scenes of a so-called unscripted "reality" series.

The Lifetime hit show, developed by Shapiro with Marti Noxon (*Buffy the Vampire Slayer, Girlfriends' Guide to Divorce*), follows the behind-the-scenes events of a reality series, *Everlasting*, where hyper-ambitious producer Quinn King (Constance Zimmer) will stop at nothing to remain at the top of her game. Quinn's exploits

ensnare her protégée, Rachel Goldberg (a superb Shiri Appleby, as Shapiro's alter ego), who is first seen in the pilot wearing a sweaty T-shirt emblazoned with the words: "This is what a feminist looks like." It's a case of life imitating art imitating life. Rachel slowly unravels into madness. Now, Sarah Gertrude Shapiro counts each day a blessing as she's relatively sane, running her own show and staving off potential lawsuits from ABC (which continues to air new episodes of *The Bachelor*). In 2017, the ABC series featured its first African-American bachelorette. Was this "first" inspired by Quinn's trenchant line of dialogue in Season 1, when she orders her staff to nix a black contestant—"It is not my fault that America's racist"?

Peaky Blinders: Steven Knight, the prolific screenwriter and creator/showrunner/director, set his terrific historical series in late 19th- and early 20th-century Birmingham, England. *Peaky Blinders* was originally produced for the BBC and first aired in the UK before coming across the pond, as a Netflix "Original." When I interviewed Steven Knight for my last book, *TV Outside the Box* and asked him how he came up with this unique premise, he told me that it is based upon the family stories he'd been told as a young lad, passed down from his elders.

Knight bolsters his memories with imagination and swagger. *Peaky Blinders'* tone mixes a Steampunk sensibility with elements of a classic western, and a catchy, discordant (in a good way) contemporary soundtrack by Nick Cave & The Bad Seeds. It sounds like it shouldn't work. But it does. Magnificently. Don't be dissuaded by the thick English accents. Watch it with the subtitles on if needed. But tune in. Part personal family history, part childhood mythology, blended with history, Knight has created an indelible series retold with the ethos of a great legend. His personal I.P. and history resulted in a compelling, original drama script.

Peaky Blinders demonstrates what all of today's buzziest series share:

> ## The most valuable I.P. of all
> ## is the original spec script.

Whether we search ahead for what's next (usually too late), search backward for hidden gems and undiscovered masterpieces in public domain or invent from scratch, whatever path we choose, I encourage everyone not to follow trends or endeavor to predict the future marketplace. Audiences and trends tend to be fickle.

Instead, write from personal passion. Whether based upon I.P. or not, find a niche and place within each potential new project—a personal sensibility. Write something *you* would love to watch. Don't replicate or emulate a genre: Transcend it. Whether your creative process is from the outside in or the inside out, it has to be your own.

● Bonus Content

A deeper dive into putting a new spin on various forms of I.P., from comics to musicals, is at **www.routledge.com/cw/landau**.

Notes

[1] Conversation with Professor Richard Walter, UCLA.

[2] EGOT = Emmy, Grammy, Oscar and Tony Award-winner.

[3] Christine Champagne, "How 'One Day at a Time' Managed to Successfully Revere and Reboot the Original Series," *FastCompany.com*, January 9, 2017, www.fastcompany.com/3066999/how-one-day-at-a-time-managed-to-successfully-revere-and-reboot-the-origina.

[4] Ibid.

[5] Ibid.

[6] I interviewed Sarandos for my last book, *TV Outside the Box: Trailblazing in the Digital Television Revolution*.

"Bible documents are French for 'Can we trust you?'"

—TOM NUNAN, FORMER NETWORK PRESIDENT AND PRODUCER OF THE ACADEMY AWARD-WINNING FILM *CRASH*

CHAPTER 12
THE SHOW BIBLE AS AN ESSENTIAL SALES TOOL

In 2000, veteran TV writers/producers Joel Surnow and Robert Cochran (who'd worked together on USA's *La Femme Nikita*) went into the Fox network offices with a groundbreaking new format for a one-hour political conspiracy/drama series. It was a simple pitch: What if each season is comprised of 24 episodes—with each episode constituting one hour in a single 24-hour day?

When Surnow first discussed the idea over the phone with Cochran, his initial response was, "Forget it, that's the worst idea I've ever heard, it will never work and it's too hard." Nevertheless, the two met the next day at an IHOP in the San Fernando Valley to discuss the idea of this action-espionage series that used the format of real time to generate dramatic intensity with a race against the digital clock.

Based on one pitch meeting, bolstered by Surnow and Cochran's track records and reputations, the Fox network commissioned the pilot script. And then, on the strength of that script, according to Surnow: "They ordered the pilot film. We did not have to pitch anything more to them until after the series was ordered."[1] The rest is multiple Emmy and Golden Globe Award-winning history.

Back then, there was one path to selling an original series: You had to pay your dues working your way up the totem pole on a writing staff and amass a list of reputable credits as writer/producer. Only then would the networks even consider inviting you to pitch your series. And despite the development ratio at the networks being roughly 10 to 1, it was still a long shot to sell a pitch, much less get a green-lit pilot episode.

Pilots were sold on the basis of a verbal pitch and were seldom written on spec, and broadcast networks rarely bought spec pilots; the big four were almost exclusively in the business of working with established TV writer/producers and, occasionally, an A-list screenwriter crossing over from movies into TV (which was considered slumming only a couple of decades ago). The chances of an unknown writer, with few or no TV credits, selling a pilot to a network were slim to none. And virtually all pilot scripts were developed from pitches, so the network execs could participate in the development process from the get-go according to their current mandates. Of course, those mandates were almost always based on what worked last season. Viewers being notoriously fickle and picky, it's why most of the new series that premiered in the fall were summarily canceled by Christmas. It was trial and error every season.

In those days, the primary network development strategy was creative auspices first, premise second. In fact, many shows were produced under lucrative "blind" development deals for top TV writers. In a blind pilot deal, the network or studio enters into an arrangement with a hot writer to come up with series ideas and then, by mutual agreement, the writer/producer is commissioned to further develop one of these ideas into a pilot script. This tends to be more of a political strategy than a purely artistic one; when studio and network executives are working with established creators/showrunners, this insulates the execs from failure. Hey, it's always easier to blame the biggest name on the call sheet.

Before Google and Wikipedia, the "series bible" was simply a big binder (or many binders) kept in the writers' office to keep track of each episode; it usually contained episode synopses compiled by the show's Script Coordinator, and it was referred to for continuity. The original use for the series bible was actually to help new staff writers and producers quickly get up to speed on every past episode.

THAT WAS THEN. THIS IS NOW.

Today, the series bible is often used as a selling tool. Many networks are asking to see a bible along with a one-hour drama spec pilot before buying it. (For half-hour situation comedies, it's a different process and may only involve a treatment or "story area document"; more details to follow.)

Now, spec pilots are all the rage, with new writers selling their speculative pilots to broadcast, cable and streaming networks and, in many cases, starting their TV careers at the Co-Executive Producer (or, in rare cases, at Executive Producer)

level. In these instances, the network recruits an experienced showrunner to oversee the writers' room and production, so the nascent writer/creator can learn and grow into the eventual showrunner.

In the case of *Mr. Robot*, creator/writer/director/showrunner Sam Esmail was granted the opportunity to run his own show—despite his complete lack of any TV writing experience. As Esmail tells it, when the executives at UCP (Universal Cable Productions) first read his *Mr. Robot* pilot script, "They didn't get it and passed." But the young assistants at UCP were so enamored with the script that they all rallied to their bosses to pick up the show for the USA Network. Even though USA was still airing light comedy "blue sky" series (à la *Royal Pains, White Collar, Suits, Psych, Burn Notice*), the assistants' passion convinced management to green-light the show. And Esmail had such a strong vision for his series that he and his powerhouse managers at Anonymous Content (Steve Golin and Chad Hamilton, who serve as Executive Producers on the show) further convinced USA to allow him to direct the Season 1 finale entitled "eps1.0_zer0-day.avi."

Esmail had originally conceived *Mr. Robot* as a feature film. But when his work-in-progress ballooned to an untenable 190+ pages at the midpoint, his managers suggested he consider turning it into a TV series. Having such a detailed blueprint certainly worked in Esmail's favor when he closed the deal at UCP. He already had most, if not all, of the Season 1 character arcs worked out. He'd inadvertently written a series bible to bolster what would become his 64-page pilot script. Even though it would ultimately air on the basic cable, advertiser-supported USA Network, Esmail's pilot had no teaser, no act breaks, and was written like a movie. The two quotes in the epigraph established the tone for the show:

> *"Our democracy has been hacked.*
> *The operating system has been taken over and turned to uses that*
> *are somewhat different than the ones our founders intended*
> *to emerge."*
> *—Al Gore, 2013*

> *"Give a man a gun, and he can rob a bank.*
> *Give a man a bank, and he can rob the world."*
> *—Internet Meme, c. 2011*

I met Sam Esmail just after the conclusion of Season 1, when he appeared at an event sponsored by the Writers Guild. During the Q&A, someone asked him if he'd known from the start that Elliot Alderson (Rami Malek) was delusional, or was

that something that emerged in the writers' room? Esmail's response was just short of "Duh!" It was there from the get-go, the entire basis of both his original screenplay and the TV series: a cyber hacker with dissociative personality disorder takes on E Corp in an effort to cripple the financial markets and topple "the 1% of the 1%."

This was baked into his whole concept. Without Elliot's delusions, there is no *Mr. Robot*. The Season 1 plot twists and turns were all premeditated, à la *Fight Club*. *Mr. Robot* wasn't a case of one-premise pilot that was sold on its own steam. Rather, it was a fully imagined world, and Esmail knew where it was going. He had vision and confidence. He was also adamant that the show be shot on location in New York City. He won just about every battle, and the critical and artistic success of the series has helped pave the way for other blossoming writer/creators.[2]

In the midst of the Digital Television Revolution, the spec pilot has even more value than a great pitch, with emerging, first-time showrunners and series creators catapulting to the top, in seemingly overnight success. Of course, in most cases, these writer/creators were toiling in the trenches for years writing unsold and/or unproduced material, until one day, the anticipated "No" turned into a "Yes." Zander Lehmann (*Casual* on Hulu) and Sarah Gertrude Shapiro (*UnREAL*) have similar success stories, but they were both shepherded through the process by Academy Award-nominated writer/producer/director Jason Reitman (*Juno, Up in the Air*) and *Buffy the Vampire Slayer* alumna Marti Noxon, respectively.

THE NEED FOR REASSURANCE

From Closed-Ended,
Stand-Alone Procedurals to
Open-Ended, Slower-Burn Serials

Once upon a time, broadcast networks strongly favored series with episodes that could be watched in any order and assiduously avoided "premise pilots."[3] The reigning programming philosophy was building an audience, and before on-demand viewership, networks were justifiably fearful that, if the audience missed the premise pilot or one or more episodes of a serialized show, they'd never come back. It was hard to catch up, back then, as reruns were offered outside Network Sweeps[4] periods and during the summer.

Today, given that most shows are serialized and that audiences tend to watch series on-demand, at their own pace (often binge viewing), TV networks take a different approach to development. Of course, this approach varies from network to network, and broadcast networks, like CBS and NBC, are still programming closed-ended, case-of-the week, plot-driven procedurals (*Code Black*, *Criminal Minds*, *Hawaii Five-0*, *Chicago Fire*). The majority of networks are seeking not only a great pilot script, but also a roadmap as to where the series is heading. If the series creators have a solid track record, the intended Season 1 character arcs and principal plotlines (which almost always change once the writers' room is up and running) can be discussed in a meeting or conference call.

If the show is sold on the basis of a verbal pitch, then the big four broadcast networks (ABC, CBS, Fox, NBC) will next ask for a story area document that describes, in a fair amount of detail, the A, B, and C stories for the pilot episode. In the movie business, this document is referred to as a treatment.

If the series creator is relatively inexperienced, then the network may further ask for a series bible to elaborate on the world of the series, character backstories, character arcs and future story engines. The goal for the series bible, or in many cases, a mini-bible (5 to 10 pages, maximum) is to convince the buyer that you have a vision as to where your series is going post-pilot.

Producing television is costly and notoriously inefficient, even wasteful. Of the dozens of pilots produced each year at a cost of tens of millions of dollars, most never see the light of day. Produced and abandoned. Orphaned. Busted pilots. Call them whatever you want. They're developed, nurtured and, more often than not, shelved. (Semantics are important in politically savvy Hollywood; at CBS, they never "pass" on a pilot, they "push" it off for future consideration—which is a diplomatic form of rejection that leaves less blood on anyone's hands, lest the rejected creator/writer becomes the next Shonda Rhimes or Ryan Murphy.)

IF THERE'S A CENTRAL MYSTERY, THERE NEEDS TO BE A SERIES BIBLE

Serialized one-hour dramas that contain a central mystery require series creators to know whodunit—the solution to the mystery—in advance, before the network green-lights the series. You can't simply say, "I don't know yet."

As mentioned in Chapter 2, there are two kinds of mysteries: open mysteries that reveal who the perpetrator is from the get-go (*The Fall, Fargo, Bloodline, Hannibal, Happy Valley*) and closed mysteries—which present myriad suspects, but it's up to the investigators (and us) to figure out whodunit (*True Detective, The Night Of, Big Little Lies, Twin Peaks*). The anticipation of the big discovery by the hero in an open mystery, or the revelation of the perp in a closed mystery (ideally by the end of Season 1), is tantalizing to viewers. But when a series creator doesn't know the answer to the central mystery, it doesn't inspire confidence in a buyer. In fact, it's just the opposite. The series mini-bible is designed to communicate both setups and payoffs. Can the payoff change after the series is ordered? Of course! But only if the new direction is better, more satisfying, and network-approved.

Audiences love surprises. Networks don't. They're paying you a large sum of money, so they want to be in on the process. When in doubt, communicate with your producer and/or network/studio executive. The TV business is highly collaborative. Be a good team player and engage in a dialogue. It never pays to be recalcitrant or adversarial. You need them on your side; they're your investors.

Below you'll find the current business development models at many of the leading networks (subject to change as the business continues to evolve). I've divided them into those networks that still make and test pilots versus those that go straight to full series production order.

It should also be noted that the days of the 22- or 24-episode series are rapidly disappearing, in favor of shorter orders of 10 to 13 episodes. This translates into smaller writing staffs, lower salaries, fewer and much lower residuals (royalties for TV writers based on reruns), and shorter story arcs. With shorter orders, the networks are less likely to simply trust that the show will eventually find itself in the writers' room, and more likely to ask for either a series (mini-)bible and/or story area documents to assuage their anxieties.

In the old days, success was determined by the overnight Nielsen ratings system. Today, the metric is breaking through all the noise and capturing an audience—which might not happen overnight, or even in the subsequent three days (known as LIVE+3 in the TV biz). In many instances, viewers don't discover a "new" series until it's been on the air for several weeks, months or even years. But when they do, a few passionate fans can create a word-of-mouth buzz that turns a sleeper show into a hit.

NETWORKS THAT CIRCUMVENT THE PILOT PROCESS (TEND TO) COMMISSION SERIES BIBLES

These networks include:

• NETFLIX

Game-changing, trailblazing, global streaming giant Netflix eschews the traditional network pilot process because, as Chief Content Officer Ted Sarandos puts it:

> The pilot process is the dumbest thing in the whole business. Of all the things wrong with the creative process, that's the most broken. The only thing worse than a survey is to use it to create; use this unscientific methodology to make decisions on peoples' lives. What people will get to see, whether people will work or not based on 17 people in a focus group—it's crazy. . . . Seinfeld took four years to hit its stride. In today's landscape it wouldn't last.[5]

Given that Netflix circumvents the pilot process and goes straight to series, I asked Sarandos how much written material is submitted before he green-lights a series. Sarandos replied:

> It depends. Orange Is the New Black was a pitch—it was Jenji's track record and unique voice, and the book [the memoir written by former inmate Piper Kerman]. Jenji came in and said, 'Here is what I'm going to do with the source material and how it's not going to be a typical prison show.' [In addition to the success of the British version], House of Cards was three scripts, a bible that laid out the show for five or six seasons, and a very strong package. From directors, producers, writers—it was a fully formed package. Hemlock Grove was a book. Lilyhammer we acquired after we watched the produced pilot.[6]

The bottom line: Netflix, which now owns and produces most of its new "Originals" in-house (via Netflix Productions), puts less emphasis on development, and more on

acquisitions of both I.P. and original material. It also works with its existing I.P.; a *House of Cards* spinoff may be on the way, possibly focusing on Doug Stamper (Michael Kelly) and penned by Eric Roth, who's an executive producer on the show. The company tends to buy packaged series from established movie and TV writers, directors and producers. It's highly unlikely that they'll buy something that's half-baked.

• AMAZON

The world's largest retailer, Amazon reinvented the traditional network pilot season, but may be moving away from that model. Each new season, their Amazon Prime audience rates the new batch of pilots and votes online for the finalists in different categories. A spokesperson for Amazon Studios explained their online, interactive approach to pilot season:

> *Over the course of the year, we have a look at a lot of ideas and scripts, and the most important thing we do, prior to online voting, is which deals to make in the first place, and which projects warrant further script development. And then we have to decide ultimately which ones we're going to make. Most of the year, when we're not producing pilots, we are focusing on pitches and scripts and so on. And then we get to the point where we want to pick pilots, and we choose them, taking into account the strength of the script or scripts, who the team is, what the show's about—and then we just go into production.*

Casting is always a factor:

> *When you say that you're green-lighting a pilot, you're just doing that on the assumption that you're not going to be disappointed in the casting process. Because if that doesn't work out right, you're not going to be shooting the pilot.*

Going forward, Amazon is making more orders straight to series, and shifting focus to bigger, event series. It's common knowledge that they're looking for the next *Game of Thrones* and also appointed an executive dedicated to this area. Their Head of Event Series, Sharon Tal Yguado, is a Fox TV veteran. There are however mixed feelings about Amazon's decision to develop such event series as *Lord of the Rings* (an even slower burn?).

Why, when the behemoth is doing extremely well in e-commerce, does it persist in developing TV shows and movies? When Amazon reported successful earnings in late 2017 that were well above market expectations, CFO Brian Olsavsky shed

some light on the question. Amazon Prime members spend more than other shoppers and are more active on the site. "We have a lot of data. We see viewing patterns and sales patterns. We can see which video resonates with Prime members, and which doesn't. . . . We're always looking for more impactful shows, more shows that resonate with our customer base and what they want to see." Apparently, their data will help determine both their programming and overall approach to cyber commerce. Amazon remains "very bullish on the video business . . . we will continue to invest in video in 2018," Olsavsky confirmed.[7]

One of the main reasons I believe the broadcast network pilot model is defective is that they're all on the same schedule and everybody's chasing after all of the same actors, all at the same time; it creates gridlock and diminishes choice. But Netflix and Amazon are not on that timeline; they can make as many pilots as they want, when they want, and they're not beholden to network affiliates and advertisers. Amazon's affiliates are their e-commerce shoppers and subscribers. In the pilot process, the consumer gets to vote and chime in—which may or may not be a factor in a series going forward. And then it's not a 22-episode commitment, but rather 6 to 13 episodes. That freedom helps enormously in securing talent both in front of and behind the camera.

Arcs and overall direction remain important. In order to get the green light for shooting his pilot for *Patriot*, creator/director/showrunner Steven Conrad had to prove to Amazon Studios that he knew how many seasons he was planning and that he had a clear payoff in mind at the end of each season, as well as at the end of the whole series. Morgan Wandell was the Head of Drama Series at the time. From Wandell's experience of working in a similar capacity at ABC during the run of *Lost*, he knew he wanted to avoid having *Patriot* be open-ended with no clear-cut endgame. Wandell has since moved to Apple as their Head of International Content Development.

Conrad verbally pitched the main arcs and intended plotlines for several seasons for *Patriot* (without a written series bible document) and convinced Amazon he knew where he was going and what he was doing. But had he not known the full trajectory up front, he would never have been granted the go-ahead.

The bottom line: Amazon Studios makes pilots based upon both pitches and spec pilot scripts. Mini-bibles are appreciated but not mandatory, depending on the creative auspices of the creator(s). David E. Kelley's *Goliath* received a straight-to-series, eight-episode order in late 2015, premiered on Amazon in the fall of 2016 and by early 2017 had already been renewed for a second season. More shows will continue to be ordered straight to season. On the other hand, Amy Sherman-Palladino's pilot for *The Marvelous Mrs. Maisel*, which debuted in Amazon's

spring 2017 pilot season, was such a huge hit with its customers that it got an unprecedented two season order. Amazon has signed a deal with *The Walking Dead* creator Robert Kirkman; the more niche *I Love Dick* was not renewed. The young studio is evidently in flux. Will Amazon Studios soon end their interactive approach to pilot season? Given their deep pockets and that they seem to have all the data they need to make decisions on green-lighting, they may well do.

• AMC

"We don't ask for [a series bible] upfront. Usually it's something we ask toward the end of the development cycle/process of a project, if we feel that project has potential to move forward," says Stefano Agosto, AMC's Manager of Scripted Programming. He continued:

> It's not unusual for cable/digital platforms to ask for a mini-bible. Unlike [the broadcast networks], you have more chances to get a show picked up or renewed on Netflix or Hulu. And since they need content and places like Netflix do straight-to-series orders, it's important for them to have that mini-bible. They [the big broadcast networks] still shoot pilots, so for them the series bible is less relevant.[9]

Matthew Weiner, creator/showrunner of AMC's *Mad Men*, has said that his process is not to break more than five episodes at a time (i.e., no long-form story arcs) to allow for the creative discovery process. Weiner and many other series creators/showrunners have expressed that they don't want to lock themselves into a rigid long-range plan. Each episode we "break" in the writers' room leads to new discoveries about the characters, so it has to be an organic, fluid process; even on *The Walking Dead*, where the zombies never change, but the living, breathing humans do.

The bottom line: AMC buys both pitches and spec pilots and appreciates series bibles for dramas.

• HULU ORIGINALS

Beatrice Springborn, Head of Originals, reports that Hulu goes straight to series:

> With *11.22.63*, which came to us as a book [by Stephen King], as well as a pitch and a series bible [by series adapter/showrunner Bridget Carpenter],

we went straight to series because it was J.J. Abrams and Stephen King. With the Jason Reitman project [*Casual*, created by Zander Lehmann], what was really interesting was that they came to us with two scripts. It's much easier to go straight to series if you have a second script. The pilot's one thing, but the second script shows you that they can deliver. It's not a magic 8-ball that predicts what the series will be, but shows you they can carry on the arcs. So we went straight to series after seeing a second episode with first-time writer [Lehmann] and Jason overseeing.

On *Difficult People*, we got that as a rough pilot that came out of turnaround from USA [Network] because they stopped doing comedies. It's always good to see that proof of concept, but if there are auspices who can deliver and bring in an audience, we'll typically go straight to series. We do have a development process. We haven't shot a pilot yet. If we did it'd be for a variety show, which we've been talking about or something that we need to tweak the format of before we launched it. And I don't know that we'd call it a pilot. It would be shooting some episodes to get the format right and then go.[10]

The bottom line: Depending on the creator(s)'s reputation and bona fides, Hulu wants at least a pilot script and a mini-bible. A second episode is also a big plus. Incidentally, their big hit *The Handmaid's Tale* easily warranted a second season, but Season 1 has already burned through the source material of Margaret Atwood's sensational novel. Now they're—more or less—creating from scratch.

In 2017, Hulu hired Fox television executive Randy Freer as CEO, taking over from Mike Hopkins, who moved to head up Sony Pictures TV. Hopkins, also a former Fox executive, shepherded Hulu to Emmy glory in 2017. I look forward to seeing where Freer takes Hulu next.

• SONY CRACKLE

I've been working with Sony Crackle for five years as an instructor/facilitator for a one-hour drama development workshop in the MFA Screenwriting Program at UCLA's School of Theater, Film and Television. The class operates as an incubator to generate potential drama series for Crackle, according to their current programming needs. Crackle executives play an active role in the class, listening to and approving pitches, reading and commenting on outlines, and reading and considering the pilot scripts and mini-bibles for further development and production. Each year, TV-focused UCLA graduate students apply (via written pitches and writing samples) for one of the eight coveted slots in the class; those accepted sign first-look deal agreements

with Crackle that basically grant Sony Television a six-month first right of refusal from the date they first receive the completed pilot script and mini-bible.

The bottom line: The UCLA/Crackle workshop operates according to Crackle's "real-world" professional mandates: pitch, outline, pilot script, and mini-bible OR a spec pilot script and mini-bible are all mandatory. Sony Crackle does not make and test pilots and instead goes straight to series, with 10-episode seasons, launched all at once (a/k/a the full episode drop). Crackle is an AVOD (Advertiser Supported TV On-Demand) digital network—which means it's free but you need to watch commercials. (I'm happy to report that Crackle has acquired several pilots from this highly productive UCLA initiative for further development. Stay tuned.)

THE FOLLOWING NETWORKS STILL MAKE PILOTS, BUT DO THEY REQUIRE SERIES BIBLES?

• ABC

At ABC, the need for a series bible is on a case-by-case basis, reports ABC network President Channing Dungey-Power:

> With some projects, where it's less clear where the series will be going, a bible is requested at the same time as the pilot. The bible gives the showrunner and producers a chance to sell the overall series which, with some high-concept premise pilots, can be hard to glean from just the first episode. That said, the bible at this stage is more of a selling tool than anything else. Once the writers get into the writers' room, many things can change. The initial *Lost* bible is famous for bearing little or no resemblance to the series that ultimately followed.[11]

Did superstar showrunner Shonda Rhimes need to provide an extensive series bible to convince the network brass to green-light her shows? More likely it's a conversation, because Rhimes is a story wizard and has been known to walk into the writers' room at the beginning of the season and lay out the character arcs, major plotlines and themes to be explored over the course of the full season. And, just like everybody else, she changes her mind and stays open to new, better discoveries—sometimes blessed by the story gods, and sometimes necessitated by production demands (such as Kerry Washington's pregnancy on *Scandal*). Or both. Now over at Netflix, Rhimes is likely to have even more creative freedom.

• CBS

"We do not ask or pay for bibles in the traditional development cycle," says CBS Executive Vice-President of Drama Development, Christina Davis. "We do, however, ask for six episode ideas (that can include character arcs) with delivery of the series creator/executive producer's rough cut. For our summer series, we do ask for a roadmap of where the series will go. Those series have been exclusively serialized and we go straight to series off of a pilot script so we need to know what we're buying," she added.

• THE CW

The network produces 13 to 22 episodes per season and makes and tests pilots before going to series.

According to Gary Pearl, Executive Producer of *Jane the Virgin*, adapter/creator/ showrunner Jennie Snyder Urman wrote a series bible document before the show was picked up. Pearl adds:

> Because all CW shows are serialized, a bible is a natural product. On the pilots I'm working on, I'm the one asking writers for bibles ahead of the studios and networks because I want to see if the versions that are being written on my behalf have the legs to go five seasons or more.[12]

This is consistent with the rest of the The CW. But thriving showrunner/impresario Greg Berlanti (*Arrow, The Flash, Blindspot, Riverdale*) falls into a similar category as Shonda Rhimes and Ryan Murphy and can be granted more latitude and autonomy. Instead of providing a written series bible document that lays out all the character arcs and subplots, Berlanti can choose to verbally pitch a series' intended trajectory to the network for their approval. Of course, as always, the path can and will change as individual episodes are "broken" (structured, expanded into acts) in the writers' room.

• FOX

A newer trend is for networks to first put together a writers' room as an incubator to expand and further develop the pilot into at least half a season of scripts before deciding on the initial production order. This is a more

cautious and cost-effective approach that I wholeheartedly support. The Fox network, which began as a disrupter to the holy trinity of broadcast networks (ABC, CBS, NBC), likes to shake things up and find new approaches to traditional development and programming models. Fox used this approach for their series *Wayward Pines* and others. Syfy and AMC have also been known to use this approach. Fox has also bucked the trend of pilot season and likes to develop shows year-round. Still, Fox makes and tests pilots and promotes them at the Upfronts each May in New York.

The bottom line: Fox asks for series bibles on a case-by-case basis for their serialized dramas—but not for their sitcoms, where the emphasis is on the laughs, not necessarily on the long story arcs.

• FX

Unless you're mega-writer/producer/showrunner/impresario Ryan Murphy, FX still makes, tests and reshoots pilots. I'm thrilled and delighted to report that one of my talented past grad students, Steven Canals, wrote the initial pilot for the forthcoming new FX Original series, *Pose*, in one of my one-hour drama series workshops at UCLA. The musical drama is set in the world of New York City drag queen bars in the 1980s (think *Paris Is Burning* meets Madonna's "Vogue"). Ryan Murphy acquired Canals' original pilot script and came on board for some retooling as co-creator/showrunner/head writer (with his longtime producing partner Brad Falchuk) for the 10-episode, straight-to-series order. No pilot episode was shot to warrant the green-light to series. No series bible was required. Canals' first staff writing gig was on the Freeform limited series *Dead of Summer*, but *Pose* is his official, well-deserved big break. He serves as first-time co-executive producer on the series.

Ryan Murphy is the exception over at FX, not the rule—which is not to say that FX has a flawed system. On the contrary, network chief John Landgraf is a programming genius, and they've been absolutely competitive with HBO and Netflix with some of the best and most provocative series on TV.

Nevertheless, they still make and test pilots, and the process can either go smoothly (*Fargo*, *Legion*) or encounter some speed bumps along the way. *Snowfall* is one example, as *Deadline* described in 2016:

> FX is moving ahead with *Snowfall*, giving a 10-episode series order to John Singleton's [*Boyz in the Hood*] drama inspired by the early days of the crack cocaine epidemic in Los Angeles in the early 1980s. The series

pickup comes after the cable network saw the second pilot for the project, originally piloted last year. The first pilot was written/executive produced by . . . director Singleton and Eric Amadio, and directed by Singleton. Dave Andron was then brought in as executive producer/showrunner. He co-wrote the new pilot with Singleton and Amadio. It was directed by the Belgian directing team of Adil El Arbi and Bilall Fallah (*Black, Image*), with veteran Thomas Schlamme joining as executive producer. There were also casting changes, with new actors brought in alongside returning leads Damson Idris and Sergio Peris-Mencheta.

Snowfall is executive produced by Dave Andron [*Justified*], who will continue as showrunner, [and] Thomas Schlamme, John Singleton, Eric Amadio, Michael London, and Trevor Engelson. Evan Silverberg is producer. [. . .] *Snowfall* joins several other FX drama pilots that have scored series pickups after undergoing rewrites, reshoots and sometime recastings. The list includes hits *Sons of Anarchy, Justified* and *Rescue Me.*[13]

• NBC

According to Robert Greenblatt, Chairman of Comcast NBCUniversal, NBC never formally commissions series bibles. It's more of a conversation between development executives and series creators. To Greenblatt, all decisions are made on the strength of the pilot script and the creative auspices of the creator and/or showrunner. The real magic happens in the writers' room after the series has been picked up. To Greenblatt, it's ridiculous to develop a long-range series bible for multiple seasons because no one ever adheres to it. To him, and most content creators, it's an evolving, mysterious creative process that can't be preordained by a series bible. But remember, NBC still makes 22 episodes per season, with many of their one-hour procedurals (*Law & Order, Chicago Fire*) offering closed-ended, non-serialized episodes.

The big exception, of course, is 2017's breakout hit drama series *This Is Us*; Season 1 offered us 18 time-jumping episodes, heavily serialized, but with a central mystery (what happened to Jack?) as a long, ongoing story arc.

Did *This Is Us* creator/showrunner, Dan Fogelman, have a long-range plan? According to Fogelman,

> We've had a plan since the beginning. The last three episodes of this season were very much the plan. In the same way, the where and how of Jack's death is in our heads about how the audience is going to watch that.

The episode revealed Jack's ties to the Vietnam War. Has Fogelman considered going that far back in a future episode?

> We can go really far back should we want to; it depends on where we want to live. The show has now opened people up to our former story time and that gives you a wide berth to fly around in time in different ages, as long as we think we can execute it well. I don't put it beyond us that we might want to go and see a young Dr. K (Gerald McRaney) at some point. That's very much thematically in thinking with the show. . . . It's a little open-ended since it's not just my decision but I definitely have a number in my head: 100 seasons. (Laughs.)"[14]

• HBO and SHOWTIME

Both still make pilots, and with so many series in the development pipeline, these networks tend to offer the stiffest competition among content creators. They're still the gold standard (along with Netflix). One veteran TV writer referred to HBO's process as a "bake off." Or consider this circuitous pathway to series pickup of *The Chi* over at Showtime:

> Showtime has given a series pickup to the Fox 21 drama The Chi, a coming-of-age story revolving around a group of people living on the South Side of Chicago. Jason Mitchell (Straight Outta Compton) has joined the cast, playing a young man with ambitions of opening a restaurant but conflicted by his responsibilities to his mother and teenaged brother in Chicago. The series hails from Emmy award-winning writer Lena Waithe (Bones, Master of None), who will exec produce and serve as showrunner with Elwood Reid [The Bridge]. A pilot was shot last year that was redeveloped. Dope helmer Rick Famuyiwa has come onboard to direct the first episode. Common, Famuyiwa and Aaron Kaplan are also exec producers. The Chi is based on Waithe's experiences growing up in Chicago [and was] one of several new projects in contention for series orders at Showtime, including comedies SMILF and Mating.[15] The former, by actress Frankie Shaw, premiered in October 2017.

To avoid what she feared would be a long, drawn-out development process at HBO, *Transparent* creator/showrunner Jill Soloway decided to steer clear of an HBO pilot deal in favor of a series commitment at Amazon Studios.

A premium cable network with critically acclaimed, award-winning, provocative shows is only beholden to its loyal subscribers. Unlike broadcast and basic cable

networks that still need to fill timeslots, premium cable outlets can make shows whenever they choose and air them in any format that fits their needs. HBO's *Olive Kitteridge* offered only four one-hour episodes. *Big Little Lies* spanned eight one-hour episodes. But the traditional order remains at 10 to 13 episodes, and a series bible is usually required—even though, in every case at every network, once the writers' room is up and running, the story always changes course in favor of new discoveries and creative breakthroughs.

HALF-HOUR SITCOMS RARELY, IF EVER, REQUIRE A SERIES BIBLE . . .

If you're looking for an example of a sitcom series bible, don't bother. For a sitcom, the networks are most likely seeking a hilarious pilot script and, perhaps, three to six potential future episode ideas—and these can be brief one-sentence loglines. Barring that, networks may commission story area documents—several pages for pilot and potential future episodes. If you can get your hands on Kenya Barris' story area document for ABC's *Black-ish*, it's an excellent example.

In this respect, it's important to make the distinction between serialized drama series, procedural drama series (doctors, lawyers, cops); multi-camera situation comedies (*Big Bang Theory, Mom, Two Broke Girls, Fuller House*); single-camera sitcoms (*Modern Family, Black-ish, Silicon Valley, Unbreakable Kimmy Schmidt, Master of None*); and half-hour dramedies (*Transparent, Baskets, Louie, Atlanta, Better Things, Insecure*). In general, as we consider in Chapter 1, characters on multi-camera sitcoms, including animated series, change little if at all from season to season. (On the longest-running sitcom of all time, *The Simpsons*, not only do the characters not change; they also don't age.) Given the lack of or slow character evolution, sitcoms tend to be about indelible, set in their ways, flawed but lovable characters getting into and out of trouble from episode to episode. At the end of each episode, it's as if someone hits the reset button and all is right in the world again.

> *Make 'em laugh,*
> *but don't forget to make them feel.*

These characters humorously drive each other crazy and push each other's buttons, but there's never any doubt that in spite of everything, they truly care about each

other. The only expectation of a great sitcom is that it's going to make you laugh and that the characters are going to maintain their core personality traits. Even if they yearn for better lives and want to change, we don't want them to—because their foibles make them funny, relatable and dependable. Multi-camera sitcoms are designed to be comfort food, with the occasional controversial episode that hopes to tackle an important issue. But comedy is about the escalation of chaos. It's the characters' desperate need to be accepted on their own terms—failing and flailing—that makes us laugh. And what makes us come back for more is our emotional connection. We empathize and care for them.

Single-camera sitcoms tend to offer more character development and season-long relationship arcs, but if the characters change, it's usually temporary, and they boomerang back or "revert to form." We don't want them to overcome their problems because then there's no show. But some do change: Detective Jake Peralta (Andy Samberg) on *Brooklyn Nine-Nine*, who has matured since the start of the series, for example.

Given sitcoms' more or less "fixed" nature, sitcom creators are usually not tasked with crafting a series bible but instead are asked to pitch potential future episode ideas via story area documents.

According to veteran Emmy Award-winning comedy writer/producer/showrunner Ellen Kreamer (*Friends*, *The New Adventures of Old Christine*, *I Hate My Teenage Daughter*, *Trial & Error*), she and her longtime writing partner, Sherry Bilsing-Graham, have never written a series bible.

Many comedy writers I talked to, including Kreamer, had no idea what a series bible is, because they've never been asked for one. She recounts:

> Here's what we've had to do in the past. When you've finished the pilot [script] and they're trying to decide if they're going to pick it up or not, they ask for a story doc. It's about six to eight pages. You start with what the 'theme' of the show is overall. Then you write up four or five potential stories [future episode ideas]. Some people think this is a waste of time because you never really use them, but Sherry and I work hard on them. They [broadcast networks] also like potential arcs for the characters, where they are headed for the season, etc., just to show them that there is a potential show here, that can go the distance.

I've been told that, at the Fox network, the story area document itself is tested (market research with a focus group) along with the pilot.

Dramedies vary, and tend to operate on a season-long theme, as characters face their problems in more grounded (a/k/a nuanced, realistic) ways. In dramedies, it's less about three jokes per page and more about authenticity. Check out today's dramedies, and you'll notice they'll go for the emotionally raw moment over the laugh. Sitcoms can do this too, but funny always trumps drama. Many comedy writers I talked to for this book had disdain for dramedies. One disparaged the lack of traditional plotting in favor of cringe and quirk—"that adds up to a whole lot of nothing."

For me, dramedies are among the most compelling series on TV today for their edgy, audacious, provocative premises and the creators' willingness to take risks. If sitcoms on broadcast networks need to appeal to the widest possible audience and play it safe, most dramedies find their sweet spot appealing to a niche audience.

In today's TV landscape, niche is the new mainstream, and a series need not appeal to everyone as long as it appeals to a loyal core audience. We now live in an on-demand world of choice. And niche shows operate on the specificity and authenticity of a unique, niche setting: a women's prison (*Orange Is the New Black*), a struggling hip-hop producer and his rising-star cousin and client in *Atlanta*, a n'er-do-well rodeo clown and his selfish identical twin brother in Bakersfield, California (*Baskets*), and on the superhero scale, even the contrasting idyll of camp-like Summerland and the horror of Clockworks Psychiatric Hospital in *Legion*. These aren't your "typical" dysfunctional families. But we're pulled into their struggles based upon the universality of the human condition.

DRAFTING THE SERIES MINI-BIBLE

Some series bibles and mini-bibles include visuals or pitch decks to bolster the presentation and further entice the network. Networks enjoy visual aids (a/k/a "look books"), but the words must carry the day. Even though TV has become increasingly cinematic, TV is still a writer's medium, whereas film remains a director's medium.

Longer-form series bibles (a/k/a maxi-bibles) can be extensive documents. David Simon's series bible for *The Wire* is just shy of 80 pages! Bridget Carpenter's highly absorbing series bible for *11.22.63*, adapted from Stephen King's 830-page novel into an eight-episode limited series for Hulu, is 53 pages long. Nic Pizzolatto's series bible for *True Detective*, Season 1, is also rich and multilayered. If you can find *The Wire* or *True Detective* series bibles, they are well worth reading.

If the series you're creating has heavy mythology and/or supernatural rules, I always encourage my students to draft a 1- to 2-page mythology document. For more on this, see "Dystopias, Multiverses, Magic Realism" (Chapter 4) and "Trips, Traps, Tropes" (Chapter 13).

The bottom line for all content creators: When in doubt, simplify. Stay on point and on theme. Have a roadmap—a series bible or story area document(s)—as a selling tool but prepare for the inevitable, delicious detours that follow.

● Bonus Content

To consult examples of series mini-bibles by UCLA MFA Screenwriting alums Chris Grillot (one-hour drama, *Deluge*) and Alice Dennard (half-hour dramedy, *Junked*), plus my guidance on how to create a story area document, visit **www.routledge. com/cw/landau**.

Notes

1 Conversation with Joel Surnow.

2 It should be noted that there was precedent for this arrangement on the USA Network series *Burn Notice*, for which creator Matt Nix was given the chance to run his own series right out of the gate. *Burn Notice* and *Mr. Robot* could not be more different, but Esmail definitely owes a debt to Nix, whose success opened the door to breaking in without first climbing the ladder.

3 In a premise pilot, Episode #1 must be Episode #1 because it sets up the series' concept; *Lost* is a premise pilot because it starts with the plane crash. *Grey's Anatomy* is a premise pilot because it is the residents' first day at Seattle Grace Hospital.

4 Network Sweeps are the months when advertisers assess ratings and adjust ad buy rates. The higher the rating during February, May and November sweep periods, the greater the ad revenue. These periods are when networks air their strongest, most buzz-worthy episodes and cliffhangers.

5 Interview with Ted Sarandos.

6 Ibid.

7 Matt Pressberg and Sean Burch, "Amazon Delivers Blowout Q3 Earnings, Stock Jumps 7 Percent After Hours," *The Wrap*, October 26, 2017, https://www.thewrap.com/amazon-delivers-blowout-q3-earnings-stock-jumps-7-percent-hours.

8 Conversation with Stefano Agosto.

9 Interview with Beatrice Springborn.

10 Conversation with Channing Dungey-Power.

11 Conversation with Gary Pearl.

[12] Nellie Andreeva, "*Snowfall* Cocaine Drama Picked Up to Series by FX," *Deadline.com*, September 30, 2016. http://deadline.com/2016/09/snowfall-picked-up-series-fx-john-singleton-1201828949.

[13] Amber Dowling, "*This Is Us*: Milo Ventimiglia, Mandy Moore on That Finale Cliffhanger," *The Hollywood Reporter*, March 14, 2017.

[14] Cynthia Littleton, "Showtime Gives Series Order to Drama *The Chi*," *Variety.com*, January 9, 2017. http://variety.com/2017/tv/news/showtime-the-chi-lena-waithe-jason-mitchell-series-order-1201956428.

"The last thing I want to do is make a television show. I want somebody who knows New Orleans, somebody who knows the drug wars, somebody who knows the CIA. Those are the valuable voices I'm always looking for. So when guys send me their resumes—'I did three seasons here and I was story editor there'— hey, what do you know about the world?"

—DAVID SIMON, CREATOR/SHOWRUNNER/EXECUTIVE PRODUCER
THE WIRE, TREME, SHOW ME A HERO, THE DEUCE

CHAPTER 13
TRIPS, TRAPS, TROPES
Avoiding Rookie Mistakes

I'm a pilot junkie. I love watching every new pilot, across various platforms—broadcast, basic/premium cable, digital—and I devour a great number of pilot scripts each year, written by both students and professionals. When creating our pilots, there are a number of trips, traps and tropes to be aware of as potential weaknesses. This checklist can also be helpful as a diagnostic for why a pilot may not be as strong as we would like it to be or why some of the notes we might be getting from industry professionals perhaps aren't the positive responses we were hoping for. Often, it comes down to originality.

Many series offer us the same story over and over, with minor variations. There are stereotypes or characters we've seen frequently; sometimes we've seen them not only on TV, but in movies and literature. The challenge for content creators now is to find ways into shows and explore unique, one-of-a-kind characters. This is vital for the protagonist character, and even more relevant if writing a pilot that begins to feel stale or commonplace within a genre. We need to avoid, as Mindy Kaling puts it, "certain tropes getting recycled. Not just familiar characters ("boozy mother-in-law," "hyper-articulate child of dumb-dumbs," "incomprehensible foreigner") but also basic premises."[1]

BECOME EXPERTS
IN THE GENRE

In the desire to create pilots that are wholly fresh and devoid of tropes and formula, we need to become experts in the genre we're writing. It is extremely frustrating for a writer to finish a script, only to realize that it's unintentionally derivative. He or

she may be proud of a script and think it's super fresh. Then somebody reads it and remarks, "It's well written, but have you ever seen [fill in the blank], because your pilot is exactly like it?" And the writer is blindsided and devastated. They had no idea, because they didn't know about that show. It's happened to many of us—hopefully earlier in the process for most!—and it feels like a punch in the gut. Being unintentionally derivative immediately devalues a pilot, no matter how well it's written. So, we need to do our reconnaissance and be experts in the genre we're writing. Even then, competing projects that derail us are just a reality in this business; blame it on Carl Jung and the "collective unconscious." Don't let it destroy you. At the end of the day, we need to keep a healthy perspective on our endeavors. We are, after all, creating entertainment, not curing cancer. Shit happens. Write on.

• "Great Pilot, But What's the Series?"

By far, this is the most common "trip" among my students' pilots: The pilot is all set up. We read the pilot and the whole story sets something in motion, but what the series is actually going to be, going forward, is not clearly articulated in the pilot.

Fix: When I interviewed Glen Mazzara, who was the showrunner of *The Walking Dead* for Seasons 1 and 2, he gave me this great quote:

> *"Great television series are about cool people doing cool shit."*
> *—Glen Mazzara, showrunner*

The "doing" is key here. Pilots may be strong on exposition and orientation of the world and its characters, but if they're purely setup, they're not showing us what the characters are going to be doing each week. When the pilot ends, the reader or viewer has no real sense of the series. A pilot is supposed to be a prototype for the series. Maybe half the pilot at most is setup, particularly if there is a lot of mythology and it's densely packed with backstory and information. But then we need an A-story, a plotline that shows the characters actually doing what they're going to be doing in future episodes. This shows the idea can sustain, that it has "legs," meaning it can keep marching on and move forward over time.

In moderating the degrees we set up in our world—what our characters are "doing" in the pilot—pace is crucial. *The Wire*, for example, was so far ahead of its

time, it didn't find its global audience until more recently. On-demand television helped that discovery. Viewers are relishing a nuanced, deep-dive, slow-burn storytelling, where resolutions are gradually delivered over time. As we're developing our own shows, we need to ask ourselves: "Are we being slaves to formula, putting too much in the pilot in service of a desperate need for approval?" Or, can we have faith and trust the intelligence of the audience, by giving them a taste of the characters' inner conflict and what the show is going to be like going forward, without making the audience feel it's moving too slowly, *or* at breakneck speed?

• "It's Too Wrapped Up"

Another "trip" is when a pilot feels too complete. It has such a clear resolution that when we give the script to others to read, they think, "This is a great piece of writing and the characters are engaging, but when the pilot ends, it feels kind of satisfying to the point where maybe we don't need to watch any more." Our pilots need to be open-ended, setting the stage for the series to follow. If a pilot doesn't have "legs," feels finite or too limited, that tells us it may be an idea better suited as a screenplay for a movie, or it may be a limited series that comes to an actual conclusion. Both are fine, of course, but as writers, we need to understand what we're writing, especially if we're aiming to create an actual series that's going to sustain for multiple seasons. Your idea may have potential, but for it to be viable to a network (which wants a series that's going to sustain over a period of time—the value being added to the studio's library of content), it's crucial to think carefully about how to expand the world.

Fix: All great TV shows are about families. They don't have to be related by blood. It could be a workplace family, business associates, friends who are not related but form a unit that's like a family and has family dynamics. It could be a team, pretty much anything that mirrors those dynamics of family, with somebody in the role of patriarch/matriarch and others as siblings or offspring. Within a family dynamic, even if the backdrop is an idea that feels a bit finite, there are multiple entry points for an audience to connect to the show and its unlimited story engines, because each character will have problems, crises and challenges, and we can explore these in subsequent episodes. So avoid the pilot that's too similar to a feature and has too clear and clean of a resolution, since it's better to end with more questions than answers. That's what a good pilot does—it hooks us in and entices us to come back for more. Writing a "family" helps us get there.

• "What's the Franchise?"

Lacking a clear franchise is another common "trip." It's similar to the pilot being too finite, with a subtle difference.

Fix: Strong story engines give us the answer to, "What's the show going to be every week?" The show needs to be different in each episode and yet the same, meaning that, in every overarching story, for example, the characters are trying to survive while fighting off zombies. Or, they're trying to cure people of illnesses while dealing with their messy, personal lives. Writers need to be able to explain: "This is what the show is every episode, and this is how the story engine will continue to be fueled with ongoing complications to keep the show fresh." That's the franchise of the show. Without it, the pilot is going to have an inherent weakness.

• "Who Are We Rooting For?"

Another common "trap" is the passive protagonist. If great TV shows are about "cool people doing cool shit," we need to demonstrate this in the pilot by giving our protagonists proactive goals: something they must accomplish for a positive result. They need stakes, which means that if they fail, there will be consequences (more on this below).

Fix: We need to generate this kind of heat dramatically in our pilots, because a great pilot is suspenseful. Suspense is the audience's emotional investment in the outcome of what's going to happen to these characters. It doesn't matter if it's a comedy or drama, a thriller or a horror genre piece, we always need suspense because we want the readers of our pilots to be filled with anticipation. Our scripts must be page-turners—we want to make the reader sweat. There's no suspense unless a character is proactive, and they're not proactive unless they have an urgent problem that needs to be solved. So that's the currency of the drama pilot. Urgency makes comedy heightened and funnier too, because a desperate protagonist is more comical than a relaxed, calm protagonist who has nothing to lose.

Our active protagonist needs to be relatable, or if the show is about an ensemble, there needs to be somebody we're going to root for. A common comment from a producer or an executive when they pass on a pilot is, "There was nobody for me to root for on the show. I didn't care about anybody or what happened to them." Of course, we're not going to care about and root for all of our characters. Some are antagonistic people we're going to actively dislike—although that's great when

creating antagonists. We can even connect with antagonists, however. On a show such as *Daredevil*, the nemesis Wilson Fisk (Vincent D'Onofrio) is vicious, yet in Season 1, Episode 8, "Shadows in the Glass," we see his vulnerability. Unexpectedly, we connect with him. So, "rootability" is vital in our script. When giving the pilot to an industry expert to read, it's often the first question we get: "Who are we rooting for? Not necessarily who we like, but who are we invested in?" Not having an answer to that question is a trap we can fall into.

One of the ways this is accomplished with Kimmy (Ellie Kemper) in *Unbreakable Kimmy Schmidt*, and with many characters we end up rooting for, is by making her an underdog: a character who struggles through adversity. We admire this in characters such as Kimmy, who's a fish out of water, and root for her because she's escaped from a bizarre, horrific situation. (She was kidnapped, held hostage underground for years and then released.) She's an innocent who's just trying to survive in New York City. No matter how challenging it is, she always has that bright, cheery, sunny attitude. She's the ray of sunshine on the cloudiest of days. Her spirit is truly unbreakable, and we root for her.

• "There's No Sense of Place or Time"

Another potential "trip" in pilots involves the arena of the show. I define arena as the principal setting of the show, and its principal time period. In some pilots I read, I don't get a strong sense of place and time, and that removes an important layer of the script. Sometimes I'll ask my students, "Which city are we in?" And they'll reply, "Oh, just any city. It could be any major city." That's not specific enough.

Brooklyn, the setting of HBO's *Girls*, is a place that writer/creator/director/actress Lena Dunham knows extremely well. But it's not just Brooklyn; it's specifically Bushwick, Williamsburg, Park Slope. We instinctively feel as an audience that she understands this borough with all its texture, flaws, beauty and subtleties. It adds another layer to the show and creates authenticity, which is imperative in today's TV landscape.

Fix: Research, far from being a burden or afterthought, on the contrary is fulfilling and gives us story and characters. It also grounds our series in specificity. It's not a waste of time; it's essential. By the same token, doing too much research can be a crutch and a means of procrastination (the bane of the writer's existence). So do your research and due diligence but know when enough is enough and start writing.

For example, if we were writing *Atlanta* and went behind the scenes of the rap/hip-hop world to interview people there, our research would give us more than what the city looks like. We'd interact with locals and observe nuances first-hand that are less obvious and superficial, which we can excavate and use to absorb the place and the people who inhabit it. Such first-hand experience or research gives us rich texture and detail, all of which informs the pages in our script. Hence I strongly discourage the generic arena unless mandated by budgetary limitations.

• "It's Confusing"

I often read scripts that are in the supernatural or sci-fi realm or a similar genre, where there's too much mythology and the rules are inconsistent. It becomes confusing. What the characters' powers and abilities are, their weaknesses, what weapons they have, how those work and much more, all form part of the arena.

Fix: When writing a fantastical, supernatural kind of a show, set in a place that's not real—created purely from imagination—there needs to be a mythology document in which we clearly spell out the rules of the supernatural, fantastic world. We need to keep those rules succinct and consistent throughout the pilot. The mythology document makes up part of the research for our sci-fi/fantasy/supernatural pilots, which includes verisimilitude. This means we don't have to be 100% authentic, technically and historically correct, but the pilot has to *feel* as if it's credible within the reality of the world we live in. If we're creating a world, it still has to have that ring of truth, as if it's grounded in real science. Our relatability with a show in any supernatural world comes from our perspective of the world we live in now. If we go so far out of reality, without a concrete set of rules, we may feel lost and lack that point we can connect to. Thus we not only need to avoid the generic arena, when we do create a new arena from scratch, specificity, authenticity and verisimilitude are vital.

• "The Premise Is Weak"

A common mistake among weak pilots, right out of the gate, is that the ideas they're based on are weak. Usually, the idea is weak because it's a trope itself or too derivative. I've seen it and heard it a million times. The writer's take on the arena and premise don't feel fresh and there's no new spin. That's when I tend to say, "The writer is piling on the tropes." Meaning, they've seen and studied the genre and then created something that hits on all the basic touchstones of that

genre, but they're not doing anything new, not updating nor transcending it. Or it's not coming from a personal place, where the writer's voice and personal perspective on the idea and arena are what's unique. It's not that a writer can't create a show based on or inspired by something we've seen before, but they need to find a way to make it their own, and make it fresh.

Fix: Just as a great way to start a pitch is with a personal anecdote, that same personal connection matters for a pilot. What's the genesis of this idea, why are we writing this idea, why now, why do we think it's timely? That's a big part of choosing a strong idea. No matter how much skill and talent a writer may have, when he or she is actually executing the idea on the page, it's essential to take the time to come up with an idea that feels innovative and well suited for their abilities as a writer and their voice. I always tell my students, "Write the pilot that only you could write." That way, I feel they will be writing to their strengths, and it will come across on the page.

• "It Doesn't Feel Authentic"

Another potential "trap" is that everything in the pilot feels too far removed from the writer's experience. Right now, particularly in the wake of the digital television revolution, both buyers and viewers want authenticity. And if a writer is creating something that doesn't feel authentic to the world, people can sense it. We now also have such ease of access to information that if writers fudge the facts, trying to present themselves as experts, or try to write convincing medical, legal or criminal procedure, or science fiction based on science they know nothing about, it feels false. For instance, if a writer is 19 and has never been married but is writing a show about people in their 50s who are dealing with empty nest syndrome because their kids have gone off to college, it doesn't necessarily mean they can't do it, but it does mean they are likely unable to capture the texture and specificity of a writer who has actually lived through that, or done first-hand research.

Fix: Without living it or knowing something personally, there's a great deal of research to do. We as writers need to interview people, go out into the field, try to discover that authenticity for ourselves and bring that to the page.

I'm not one of those people who says, "If you're not a woman you can't write female characters, and vice versa." If a writer is talented and can research any subject or gender, he or she has the ability to write well about it. But don't take for granted that anyone can just make up and/or fudge the details and the level of specificity that's required. Anyone reading will know or somehow sense it's

inauthentic, and it makes the writer look bad. For me, the best compliment anybody could ever give a writer after reading his or her script is, "That writer really knew what he/she was doing. It's just so clear the writer knows the subject, these characters and this world." If we don't know it, we need to learn it before we start writing.

Once again, make sure to research carefully. Shaky research that lacks particulars and accuracy, even for minor facts, will result in the writer being surprised by how many people recognize errors in little details that the writer didn't fact check were accurate. A writer may think nobody will notice a small mistake in his or her script about Fukushima, but given Murphy's Law, the script reader will just happen to be an expert on both nuclear physics and Japan. Never take for granted an industry professional is not going to know something about the subject matter. Not bothering to fact check is sloppy and careless. If an agent/manager/producer/ studio wants to work with a writer, they want to make sure the writer is painstaking about detail and research. Or they also end up looking bad, later on down the line. There's no excuse not to research, other than laziness. And by doing the research, we can end up being surprised by the varied, interesting nuggets we come across that can further enrich our writing.

• "The Dialogue/Style/Tone Are Uninspired"

A weak pilot lacks a signature writing style. There is a music and a rhythm to language. And it's not just all about the dialogue; the way characters are described, the action lines and the very read of the script itself, are all important.

Fix: There has to be a style on the page. Even if the script or story isn't superb overall, readers can spot writing ability in the first few pages. They understand, "Wow, this writer really has a style. These words, even the descriptions, pop off the page. There's a rhythm and a music to the language that make it an entertaining read." We never want our readers, no matter how good our ideas are, to feel as if reading the script is a slog—that they're just turning the pages, and it's not coming alive for them. Weak style means that the script is not painting vivid pictures with words. There aren't dynamic verbs describing the action. There are big chunks of overwritten exposition, action lines and paragraphs that are daunting to anyone reading the script. People want a script to be a suspenseful ride, a page-turner.

So, we need lots of white space on each page. Descriptions need to be succinct and economical but still need to have that personality that is part of the writer's

individual voice. The voice of a writer doesn't just come out through dialogue and through the characters' voices. It comes out from Page 1, from the opening description. I always look for that; I love reading scripts by writers whose prose shines throughout the script. We need to go through and edit our action lines; there's no need to overwrite them or overdescribe things. As the writer Elmore Leonard famously said, "If it sounds like writing, rewrite it." When dialogue is overwritten, it lacks subtext and tells instead of shows. TV is a visual medium; it's also become more cinematic. If we can get away with no line of dialogue at all and just tell the story through action and a character's look, as discussed in earlier chapters, this can be even stronger than writing huge chunks of dialogue. If it's easier as an exercise, we can overwrite our dialogue in our early drafts, say everything we want to say but then, in later drafts, go through it, rake/delete/streamline it and make sure there's economy of words and subtext. Our script needs to be a visual picture that's painted on the page.

With the best pilot scripts—just like the best novels—I forget I'm reading, and I'm in the world, just inhabiting it. When I'm lost in that world and just part of that experience, it's fuller and more satisfying. And when I'm pulled out of the world, it's usually because it's not vivid or there are repeated bumps in the road that jolt me out. Something doesn't feel authentic, or the writing feels forced. A writer needs to have a signature style on the page, yet paradoxically, the reader shouldn't be overly aware of the writing, because a reader needs to be more focused on the story and how it unfolds. There's a fine balance between those two things, as readers consume pilot scripts before they go into production. The script, as we know, is the blueprint for what will eventually be a produced pilot. So the page itself is where everything starts. The script has to get heat and attention from all those who read it, and that comes through our words, which have a distinctive style but are never distracting.

As mentioned, verbs are our friends in a script. When using the right verbs and nouns, there's little need for adverbs or adjectives. If we pick the right words to convey an action, we don't have to say, e.g., "She runs fast behind the buildings." We can say, "She sprints down the alley." It's cleaner and crisper. Also, be mindful of segues and transitions between scenes. Often, the narrative drive of a pilot comes from what we cut from and to. It's elliptical. Weak pilots are not elliptical enough. They lose narrative drive by showing people entering and exiting, saying hello and goodbye. We can cut right into the middle of the scene and cut out before the scene is over. We need to create momentum in the script so that again, it's a page-turner. Flat, non-existent, or overcomplicated transitions or segues between scenes are the marks of a pilot that still needs work and is not yet ready.

There is the pilot we write, the pilot that gets developed, and (if we're lucky) the pilot that gets made. Many things change from that initial pilot to the production draft, but think of the initial pilot as a writing sample, whether the writer sells it or not. It's a representation of the writer and needs to be a written document first that can stand on its own. Then, it will be interpreted by the director and producers and throughout the production process. But never underestimate the value of writing style on the page. Some writers assume, "Well, it's screenwriting, I'm not a novelist, I don't have to describe things. I don't have to do it in an interesting way, I just have to get the facts down on the page." Yes, economic descriptions are part and parcel of the screenwriting trade, but succinct descriptors that crystallize the essence of a character, setting, action sequence are key. "A man in his 30s" could be anyone. Tell me more. What are his most idiosyncratic, defining characteristics? What is he doing/saying when we first meet him? Why is he special and deserving of our attention?

Another potential weakness is tone. The criticism that the script is "all over the place" or the show is about "too many things" is common. Think about the tone of the show and try to keep it consistent, so that it feels cohesive. The writer needs to avoid wide personality swings of their voice within their pilot.

• "It's Too Long"

Script length is important, particularly if the writer is a novice or just breaking in. A single-camera half-hour will be between 30–35 pages; the target length for a one-hour is around 60 pages. It could be less, it could be a few pages more. Writer/creators such as Aaron Sorkin or Armando Iannucci write long scripts because the dialogue happens at a very fast clip and get away with that because they're established. When starting out, however, when industry readers analyze the script, one of the first things they notice is the length. Trust me, a longer pilot is not usually a positive, especially if a reader is being paid a flat fee per script to read. It sounds mercurial, but it's a practical consideration. If it's a 90-page, one-hour drama, there's a subconscious strike against the writer before the reader even starts Page 1. It can also look amateur—as if the writer should already know the script should be a certain length.

Fix: I recommend sticking within those prescribed lengths, because many people do take such things seriously. It's part of one's reputation of being a professional, and such rules can be broken later on if needed, when more established as a writer.

• "The Plotting Is Tepid"

Another potential trap is when the plot of the pilot episode is not special enough. The pilot is just "meh." In other words, it's too by the numbers, a familiar plotline we've seen on other shows, or too predictable. If I start reading a pilot and am captivated by the setup, likely somewhere around the middle of the script, I start to formulate a positive opinion in my mind: "This is a really cool setup. I wonder where it's going." But if I immediately think, "Well, this is where the pilot's going, and that's the way it's obviously going to resolve"—and then it does exactly that, it's disappointing. I don't want to be right; I want to be surprised. Of course I don't want to be disappointed because my prediction of how it would turn out is just what happened—it's anticlimactic and removes any fun sense of discovery when reading.

Fix: When choosing the actual plotline (a/k/a "breaking story") of the A and B stories for the pilot episode itself, do everything in your power to ensure that you're mining original territory. I recommend applying one's personal perspective where possible. Make sure there's something, particularly by the end of the pilot, that's going to surprise us. Think about it. Over the first 10 pages, hopefully the writing is so strong we pull the reader right in and they're impressed. They keep reading. And if the pilot ends on a powerful, surprising, captivating note no one is expecting, that's the strongest way for them to finish the read. They end on a high and instinctively want to recommend the script to other people. They're going to put the writer's name on a list that's going to propel them forward for staffing and assignments. If the first half of the script is solid, but then it kind of fizzles out, no matter how well crafted that first half is, the script won't gain traction. So the strong finish, particularly with a surprise, is a great way to go.

Similarly, a potential "trap" is not capitalizing and delivering on the promise of the premise. Sometimes we read the first act or half of a pilot and honestly think, "This is so cool, what a great idea." But then the second half proves disappointing because it just doesn't capitalize on that setup. We need to ensure there's nuance that grows out of that central core concept that's established. In addition to the story unfolding in an unexpected way that is not obvious or superficial, we need to take our readers and audience into areas that explore aspects of the characters and their situations in surprising, innovative and compelling ways. Even if we have a good idea for a premise, we still need to make sure that where we take the reader and audience in the pilot isn't just where they're expecting to go, not just a superficial treatment.

For example, at the end of the *Legion* pilot, protagonist David (Dan Stevens) has had a day from hell. His girlfriend, who may be the love of his life, is missing—and it's his fault. He's accidentally killed his only other friend. He may have gotten his sister into trouble, and there's no sign of her. And he's escaped a strange mental asylum only to end up imprisoned in a stranger government facility. At the end, David discovers that what he thought were his disorders and hallucinations might be neither liabilities nor imaginary, but real-life, badass superhero abilities. If we can end the pilot on an unexpected note—yet one that's inevitable because of everything that came before—we're in a great sweet spot for the show.

• "The Stakes Are Not High Enough"

The lack of stakes, which I briefly touched upon above, can be a major weakness in virtually every early draft of a script that doesn't quite live up to its potential. Characters want to win. They're always trying to achieve something, to get ahead and have success. Stakes, on the other hand, are defined as the consequences of failure. What will happen if our characters don't get what they want?

It's not enough to say, "So this character really, really wants to accomplish something." That's only half the creation of a narrative drive. Better if this character needs this and if he/she doesn't get it, there will be negative consequences.

Fix: We need to be specific about what such negative consequences or stakes entail. They need to be relatable, so that, even if we don't know what it feels like to be a pregnant virgin after being accidentally artificially inseminated, we can understand what's at stake for *Jane the Virgin*. On shows such as *The Walking Dead*, or police procedurals or medical shows, the stakes are consistently as high as possible: life and death. But of course, not all shows have life and death stakes, particularly comedies or dramedies such as *Master of None*. So, we need to be mindful that, in the pilot, if we don't have a show with life and death stakes, there still need to be stakes that *feel* like life and death to the character. We see this a lot in comedy. We watch, cringing in situations in which a protagonist truly feels, "If that email gets out, it will destroy my career." Or, "If that person discovers I said that thing about them, they're never going to forgive me. I have to stop them from finding out." Or, "If she breaks up with me, my life will be over." Whatever it is, our characters must react to it and be proactive in terms of avoiding those bad consequences, as if their lives depended on it.

High stakes—or perceived high stakes—create urgency and suspense and heighten the storytelling. In a pilot, we need this narrative drive. So, whether it's a comedy

or drama, we need to make sure that, even if it's running under the laugh-out-loud, funny, organic jokes, every scene needs to have a through-line of tension, the characters and reader/audience are aware of time, and there's a sense of urgency and desperation. It'll make the read more exciting, instead of monotonous. Professor Richard Walter, Chair of the UCLA MFA Screenwriting Program, has a credo he's been repeating for the last 40 years:

> ## "We have one rule at UCLA for screenwriters: Don't be boring."

We must be honest with ourselves when we look at our pilots. Is any part boring? Give it to somebody trusted to read and pose the questions, "Where were you most engaged? Were there any places in which you were bored? Did the plot go slack anywhere, and did you start to lose interest? Was it because you were confused or because you weren't caring enough about anybody? Were there too many plotlines, and you weren't sure which one to follow? Who were you rooting for?" We need to make sure there's a narrative drive, meaning that, for at least one character, it's clear exactly what he/she needs. There are clear consequences if they fail, and we care about the outcome of those consequences.

• "It's Just Talking Heads"

Another common "trap" is when the pilot feels too claustrophobic. Sometimes I read scripts where it feels as if every scene is talking heads, people just sitting in restaurants or offices, having conversations.

Fix: Remember, television is more cinematic now, and most shows are shot digitally (and more cheaply) than before, so we can open up the story and arena as needed. In most single-camera shows, characters have the ability to go anywhere. So—have them go places! Granted, in multi-camera sitcoms, we are more confined and constrained, because we do need to set scenes in two or three main locations— then, we need to come up with new and interesting activities for our characters, as well as clever things for them to say. In dramas, single-camera comedies and dramedies, we are free to open up the world as much as we can. Get them out driving in a car, into the park, places where they won't be tempted to sit and have static conversations. Talking heads used to be what television was about, and now that it's more like cinema, we can relish the challenge of finding ways to realize dynamic scenes.

• "It's Too Superficial"

Superficiality is another "trip." As discussed, we introduce characters in a pilot who are hopefully going to be people in a show that sustains. So, we live with them over seasons and years. They must be relatable characters we root for, but at the same time, they need to be somewhat enigmatic. Like an onion, there needs to be a lot of layers to our characters, with a complexity that's only hinted at in the pilot. It's the tip of the iceberg in the pilot, because we're then going to tune in/log in for subsequent episodes as we try to unravel the mystery of who these people truly are.

A note that writers commonly get on a script that still needs work is, "Dig deeper." This means the writer needs to go back into the past of the character, to the psychology and emotional life of the character.

Fix: Through interesting, proactive, provocative storylines, hopefully each episode will reveal another tiny piece to the puzzle of who these characters are, and why they are the way they are. Go as deep as you can. On a sitcom, character evolution happens gradually, and sometimes they don't change at all over the course of the show. However, in dramas, and in some sitcoms—e.g., the characters in *The Mindy Project* do evolve and exhibit more depth over time—we need to consider, "How can we dig deeper into who these people are, and into the mystery of what makes them tick on the inside?"

• "There Are Too Many Characters"

Introducing too many characters in the pilot episode is a common "trip." That's especially the case when they're not differentiated sufficiently from each other. Sometimes even the characters' names are too similar. The pilot ends up feeling muddled and confusing, and it's hard for the reader to keep track of who everyone is, just from seeing their names on the page. Names don't tell a reader much, as they need to remember actions and backstory. In the produced pilot, of course the audience is going to be able to put faces to names and track live action/animation, but even then, it can be confusing if there are too many characters and they are not distinctive enough. On the page, even if a writer introduces five characters in an ensemble and names each one, even if they explain gender, appearance and quirks, they can't assume a reader will remember which character matches which description.

Fix: What's more important is to make sure that how the characters behave, what they say and how they appear are emblematic of who they are. Remind the reader

throughout the script who the characters are through their actions. And it's sensible to avoid having too many characters in the first 10 pages of the pilot. For me, it's as if I'm snow-blind, and I constantly have to go back, to remind myself of who people are. If we want our pilot to be a page-turner, the reader is turning the pages forward and not constantly rifling back to reference things due to getting confused. Simplicity works—and don't worry, that doesn't mean simplistic. Keeping the pilot simple and streamlined as much as possible is helpful, not just for the story, but for readers and the audience.

• "The Good Stuff Appears Too Late"

Another mistake that comedy writers in particular can make is backloading, instead of frontloading, the script with their best jokes. Busy Hollywood execs and producers often only read the first few pages of a script. If the best stuff happens toward the end of the script, that's a missed opportunity. A strong and surprising conclusion is ideal but of course, the whole script has to be strong. And the bad news is that gem of an ending of the script might remain unknown, because the reader probably stopped reading before Page 10.

Fix: When writing a drama with thriller elements, or cool epic battles, or awesome creepy monsters, any aspects that feel exciting, urgent and suspenseful, don't save them for the end, after a slow lead down the road there. Or if that's absolutely necessary because of the way the show is structurally mapped out, I recommend using the *Jaws/Breaking Bad* strategy we previously discussed. We're on the edge of our seats no matter what's going on, because of that strong, tense opening. When writing a sitcom, put your funniest jokes—some of the best jokes—in those early pages. Of course, strong jokes need to continue throughout the script, but remember, making a good impression on those first pages is what will lead the reader to that fantastic, hilarious ending.

KNOW THE INDUSTRY— YET BE INNOVATIVE

It's important to stay up-to-date with the marketplace and current industry trends. While coming up with an idea for a pilot and writing it, make sure to be aware of the potential networks where there may be a chance to sell it. In other words, ask yourself, "Which network would this show be suited for?" If it's only suited for one network, that means we're putting all our eggs in one basket. By Vegas odds, the

chances of selling it are very slim. On the other hand, when coming up with an idea, if we consider, "This could sell at any number of networks. There may be a version of the show where I focus on the younger characters for The CW, or the female characters for Lifetime, or there may be a darker, edgier version of the show for FX, AMC or premium cable," that gives us more possibilities.

I always encourage students to ask themselves, "Where can I sell this? Who's the target audience? Where do they live, and how could they be targeted? What would be the access point for the audience, for this particular pilot?" But of course, no one should be overly aware of the marketplace when creating their pilot, to the point that it dictates the setting and dialogue. We need to write original material that's our passion. At the same time, when we're ready to go out to sell it, we need to have an idea of where it will fit and why. The first thing a network or studio executive is going to ask about the pilot is, "How do we market it? Who's the audience?" So, I think it's useful to already know when starting the process where the show might live, who's going to watch it and why.

In the same vein, another "trip" is that the pilot we write is outrageously expensive. And here's a caveat. My training as a writer was "Don't think about budgetary concerns. Just write from your imagination. Your imagination should be your only limitation. Let production figure out how to make it happen." I think that still holds true. Through CGI and green screen, there are now several ways to shoot more affordably that in the past would have been prohibitively expensive. However, in a climate in Hollywood where few people have the power to say "yes," and most gatekeepers mainly have the power to say "no," if a show feels *excessively* pricey, naturally it's a harder sell. It's not a project that can easily elicit the response, "Oh, we can produce this for a good price." The risk involved for a very expensive project understandably makes executives nervous. The same goes for producers, who have to raise more money. If we manage to create a world that feels full and unique and it's inexpensive, it's just easier to get those in power to say yes, because it's a lower risk.

At the same time, of course, writers still need to avoid those talking heads and extreme claustrophobia, even if the lack of movement could cut costs. Another "trap" is writing a pilot that feels too safe (i.e., broadcast network-y), perhaps thinking that this is what will sell. When writing a pilot, we can write anything we want. This is a chance to put a stamp of originality on an idea. I always advise, "Write your pilot as if you're writing for premium cable." There can be nudity and swear words, and we can do what we want. Be a daring rebel. Even when being considered for the writing staff on a network show, more often than not, they're

going to read a sample that's been written for cable. Broadcast networks—and it's starting to change a little—have to appeal to the widest possible audience, so they have Standards and Practices; writers for broadcast always have to be aware of potentially offending an audience. But when writing an original pilot, why restrict yourself artistically? Write a pilot that could be made on premium cable, FX or AMC. Don't play it safe, unless broadcast network is genuinely the pilot style you want to write.

Cost and risk come down to what feels strongest for the pilot story, and there are always exceptions. *Boardwalk Empire* was an incredibly expensive pilot, because the production had to build the entire boardwalk on stages. Since Martin Scorsese—who helmed the pilot—is an A-list director, his involvement and Terence Winter's idea warranted HBO's investment in that epic, expensive period piece. But, for a new writer trying to break in, an extravagant pilot might be a tougher sell. It's just wise to note how big and ambitious the show will be and, in the pilot, to try to contain it to something that feels a little more manageable.

There's that fine line between imagination and industry practicality. A common "trap" is when a writer follows the marketplace too closely, instead of innovating. Being a follower results in derivative work, imitating other things that have been successful. To be true trailblazers, we need to tell stories that need to be told and that nobody else has done quite in the same way. So, tread this line: Be cognizant of the market, yet innovate. Use that as a starting point to lead and create fresh content we haven't seen before, that breaks the rules and is out of the box—that can excite people. If the idea is too far out there, it may turn people off, but I'd rather see writers take risks and be bold and provocative, than play it safe. There's so much material out there that our biggest challenge is to stand out from the pack, break through the noise and connect to an audience. And it all starts on the page.

THE TEMPTATION TO RUSH

Last—and it's less a weakness of the pilot script than of the writer's tendency to self-sabotage/self-delusion/laziness—one of the biggest mistakes a writer can make is sending out a script before it's ready. After we've revised and rewritten the story until we're confident it's the best it can possibly be, and have received the advice of a few trusted reader friends, we also need to fix superficial issues, such as typos, grammatical errors and format problems. If it's sloppy on the page, it's not ready to go out. (But those kinds of things are correctable—we can always spellcheck

and proofread.) I recommend printing and proofreading on the page, because on computer screens, we tend to not see mistakes. Our eyes jump over them. On the page, with a pen, we catch more typos and inconsistencies. So, it is worth printing when getting to that final polish stage. Plus it's immensely satisfying to hold a physical script we've created in our hands. At that point, we need the script to have successfully avoided all the trips, traps and tropes. We need compelling characters we root for and follow, suspense, stakes, narrative drive, a strong franchise, the right pacing, a strong and surprising ending and more. All those elements have to be the best they can be. Remember—and this is another trope, but knowingly proffered— we don't get a second chance at making that great first impression.

The bottom line is:

> *Be cognizant of the market, yet innovate.*
> *Originality and authenticity remain key.*

● Bonus Content

My essay on **"The War Against the Kitchen Sink Pilot,"** a/k/a "The Premise Pilot Blues," is at **www.routledge.com/cw/landau**.

Note

1 Mindy Kaling, "Coming This Fall," *The New Yorker*, August 17, 2015. www.newyorker. com/magazine/2015/08/10/coming-this-fall.

"Just because this isn't in your life plan doesn't mean this isn't exactly where you're supposed to be."

—NAHNATCHKA KHAN, WRITER/CREATOR/SHOWRUNNER, *FRESH OFF THE BOAT, DON'T TRUST THE B—IN APARTMENT 23*

"A lot of people ask how to get to where I am, and the single biggest thing, which is not profound, is that I work like a dog."

—MINDY KALING, WRITER/CREATOR/SHOWRUNNER/ACTRESS, *THE MINDY PROJECT, THE OFFICE*

"I had never worked with other writers [before Nashville]. It's a lot less lonely. The luxury of having all those people there to help you, it's like the best deal ever. Really? Everybody's gonna help? Wow. Great."

—CALLIE KHOURI, ACADEMY AWARD-WINNING SCREENWRITER, *THELMA AND LOUISE*, AND CREATOR OF *NASHVILLE*, ON HAVING HER OWN WRITERS' ROOM

CHAPTER 14
THE CREATIVE ENTREPRENEUR
From Kickstarting a Web Series to Hitting the Big Time

The digital television revolution has completely up-ended business as usual. Given the role of social media and crowdfunding, and the efficiency and low cost of shooting video on our own, everything now sits in a more level playing field. We can create and distribute our own content and gain attention through less mainstream, unconventional methods. Increasingly, visionary first-time series creators are circumventing the lower rungs of the staff writer ladder and leap-frogging straight to the upper ranks of co-executive producer, and even showrunner.

So how *do* you break in to the TV business in today's cluttered marketplace? Let's start with the conventional path.

"CALL MY AGENT"

Sam Esmail, the creator/showrunner of *Mr. Robot*, is represented by the powerful Creative Artists Agency (CAA) and the influential management company Anonymous Content. And yet, he offers this guidance to new and aspiring TV writers: "The biggest mistake you can make is to think that all you need to do is get a big agent and then sit back and let them do all the work." Esmail is always generating new material and fostering his own business relationships; he doesn't just rely on an email or a phone call from his agent. "You have to be proactive," he says.[1]

The reality is, as invaluable as agents can be with packaging and access to studio/network executives and producers, agents can also present delays because they represent a full roster of clients, and you're not always their top priority. They're

well intentioned—your success is their success—but many of your jobs are going to come through contacts of your own. Of course you'll want to be communicative and transparent with your reps (if you're fortunate enough to have one). Don't alienate them by overstepping into their territory; writers write and agents/managers sell. But the simple fact is that you're always your own best advocate.

Over the years when I've landed jobs on my own steam and called my agent, the reaction has sometimes been skepticism. One time a conversation went down like this:

Me: I have a job offer on the table. Business Affairs is going to call you to do the deal.
My agent: What? What are you talking about?
Me: Well, such-and-such show just offered me a staff position.
My agent: No, they're done staffing over there, they're not bringing anybody else on.
Me: Well, that's because they're bringing me on and they're calling you to make the deal.
My agent: Oh! Great.

Agents, like all power players, want to feel like they're 100% dialed in and in control of the ball, that they're pursuing the leads and are the ones who are giving you the information and fielding offers. But now that there are so many platforms, it's difficult for them to know *everything*. And with so many viable writer submissions being made through proper, "official" channels (to the gatekeepers via agents and managers), sometimes that coveted writing staff job comes through a side door.

GETTING AN AGENT

The most common question asked by aspiring TV writers is: How do I get an agent? And my answer is always the same: When you write a great script, *the agents will come to you.*

When a piece of material is that fresh and inventive, when the voices of the characters are distinctive, when the plotting is smart and surprising, when everything just pops off the page, there's so much excitement and heat that will be generated from that particular piece of material that everyone will start to talk about it. They'll talk about it on tracking boards and in staff meetings, and people will read the material. It will probably be an assistant, whose job it is in development to track down the hottest scripts out there and bring them to their bosses. Trust

me, everybody's constantly on the lookout for great material. The biggest challenge is reaching that level of originality, authenticity and quality.

To get on their radar and break in, it's not about being "persistent" and constantly hounding them to read your material. As mentioned, the material will work its way to them. It's their job to find it, and they will find it. At UCLA, we have showcase contests; I have agents and managers and studios always asking me, "Have you read anything great lately? Who's exceptional? Who's hot?" And when I recommend students to some of these people, they also ask me, "Not only are they great writers, but what is the person like, are they easy to work with, are they agreeable, are they collaborative, are they perfectionists in a good way?" Although you may not be in film school, there are many other ways to get noticed and contests that you can enter (more on this later).

AGENTS VS. MANAGERS

Once you do have at least one piece of good material, you might put out some feelers and try to find a manager. (Again, I wouldn't waste your time trying to get an agent early on.) Managers tend to be more open to nurturing talent and getting you to a point where you have a body of work that is viable. At that point, a good manager who has connections with agents can lead you to getting your first agent. Some writers opt to work with a manager only. The manager can send your material out, get you meetings and introduce you to people. The only thing a manager cannot do is negotiate deals; they're not allowed to do that by the Writers Guild of America (WGA), the Screen Actors Guild (SAG) or the Directors Guild of America (DGA). So even if you do have a manager who's representing and guiding you, you will eventually need a licensed agent or a literary or entertainment attorney to negotiate your deals since a manager is not sanctioned to do that. That's the way it works. Managers can still be extremely valuable in other ways, especially if you can find one who's adept at giving notes and can help you strategize what you should write and how to specialize (more on this below).

ADVICE FROM THE (STAFF WRITER) TRENCHES

Each year in my Writing for Television lecture series at UCLA, I invite a panel of former students who are all now staffed on network shows. In some cases, it's their first staff job; in other cases, it's their second or third staff gig. On a recent panel, there were several especially sharp insights that stood out for me:

Pay Your Dues: Don't underestimate the value of working as an intern, personal assistant, writer's assistant, production assistant, researcher—anything—as a means to get your foot in the door. And if you're lucky enough to land one of these entry-level positions, *make the job they hired you to do be your top priority*. Everyone knows you have higher aspirations, but that's not their problem or concern; if your primary tasks are to make coffee and go on lunch runs, be the best runner you can be. Be the first one to arrive in the production (or writers') office and be the last one to leave. If you're there for two weeks and expect them to read your pilot and promote you, you're going to be disappointed.

One of my former students worked at Shondaland (Shonda Rhimes' production company) for years before he was given the chance to prove himself as a writer, but his first writing gig was *not* on a Rhimes show. So did that writers' assistant job on *Scandal* have any value to him? Absolutely. That job provided him with a behind-the-scenes education of how a TV series runs on a daily basis; he learned how to be a better writer by observing—via osmosis—how to be a professional. When he did earn his first staff writer job on a half-hour comedy series, he wasn't just being thrown into the deep end of the pool without floaties; he'd already learned how to swim. He'd also been humbled and had learned gratitude. He learned how to function as part of a team and how to make himself more valuable in a writers' room. The grunt work galvanized him to work harder and perfect his writing samples. He made contacts and acquired essential political and socialization skills. He also learned one of the most valuable lessons of all for any TV writer or any human being: How not to be an asshole.

Lean in to Your Strong Suit: A showrunner is not expecting you to come on staff and be every color in the spectrum. They're expecting you to do what you do exceptionally well. So you may sit there quietly for hours or days until they need the color green in the story. And they know that you're the color green because of your background and what you specialize in. It could be connected to humor, genre, gender, race, politics, knowledge of a place, culture—when they need green, they're going to turn to you, and you'd better give them green. Lots of shades of green, vibrant and smart. So know your role and your strength. It doesn't mean that's the only thing you can ever do, but really develop that and become a specialist, particularly if it's a specialist in a field that's fertile, such as horror or thriller. Those are the genres that sell the best internationally. If you're a comedy writer, what kind of comedy? What's your brand? Are you a joke writer? Are you a physical gag writer? Are you particularly good at writing relationships and the heart of the story?

Marta Kauffman, the co-creator and showrunner of NBC's long-running, Emmy Award-winning series *Friends*, and currently of *Grace and Frankie* on Netflix, will

be the first to admit that she's never been a joke writer. She's the person who gets to the heart of the story and the emotion, and she likes to dig in and explore the characters. So she brought in Howard Morris on *Grace and Frankie*, and he put in the jokes. She's smart because good showrunners know how to delegate. They know what they can do and what they should bring people in to help them do.

Specialization is important, but all in good time. Another mistake people who are breaking in make, in addition to prematurely sending the material out, is that they define their specialization and limit it *too soon*, before they've had a chance to explore everything they're capable of. So give yourself a chance to explore different genres and tones before you pronounce, "This is who I am and what I'm specializing in." My writing partner and I used to think we were sitcom joke writers. I'll be honest—that's never been my bailiwick. What I thought I was good at and what was going to be my bread and butter was not at all how I've succeeded in my career. It's actually come through scripts that I didn't even know I was capable of writing. Early on in my career, I wrote a hard-edged procedural crime story. I wrote a legal drama. I wrote things that I didn't know anything about, but I researched and immersed myself in the field and stretched myself as a writer. And people's response was, "Hey, you're awesome at this. Why haven't you written this before?" And I replied, "I don't know, I'd never tried. I didn't think I could." So don't limit yourself too soon, and don't pick a color and stick to it immediately. Give yourself room to grow and explore and experiment. You may discover that you're actually better at some things than you realize. It might not come as naturally at first, but the more you do it, the more you may say, "Hey, this is actually more my thing than the thing I thought was my thing."

Be a Perfectionist: Revise, refine, rewrite. Rinse, repeat. Set the bar high and reach for it. Each of the panelists' success stories had a common denominator as they transitioned from student to professional: It wasn't just about pleasing their instructor anymore. At this point, it was about pleasing themselves and creating a body of work of which they could be proud. They didn't care how many drafts it was going to take. They didn't say, "Can't I just be finished? I'm tired! Leave me alone." They said to themselves, "No, no, I want to go further, I want to make it better, and I'll work as long and as hard as it takes." Bear in mind that your spec material doesn't have an odometer, meaning that nobody cares how long you worked on it. If you wrote it in a weekend or if you wrote it over five years, when a professional reads it, they're just reading the script. I wouldn't necessarily *tell* them that it took you five years, but the point is they're judging it purely on the quality of the script, not how long it took you to write it. So ideally you will not send out any material until it's been through a significant vetting by trusted advisers who have told you

that they don't have any more notes. And even at that point, hopefully you've set the script aside for a week or two, gone back to it with fresh eyes, and even *you* don't have any more notes. As mentioned previously, you don't get that second chance to make a first impression. So again, don't send stuff out too early. Be a perfectionist and be willing to put in the time and the hours to get it where it needs to be down to those final drafts. Every detail matters. And the hard work pays off.

Be a Self-Starter but Seek Advice: So there's a paradox in the writers' room—and you know how much I love paradox when it comes to characters. You need to absorb information and find your own way through observing how other people behave in the room, reading draft after draft to see how they evolve and come up from that early writer's draft through network notes through the process of refinement. If you get an opportunity to go on a location scout or to sit in on a music spotting, color correction or editing session, take advantage of it. Just sit there and absorb.

Don't make the big mistake I made. I remember one of the times I was invited into the editing room on *Melrose Place*. I was arrogant and young and stupid enough to think that since I'd written the episode and I was invited, that I was on an equal playing field with everybody else. It was a huge mistake. I even contradicted one of our executive producers about something. It was bad form; I just didn't know. If only someone had said, "By the way, you need to have a seat and observe and listen and learn," I would have kept my mouth shut. It was entirely my fault, and I should have paid better attention to the successful writers around me instead of being cocky. But, as we all know, although hindsight is a wonderful thing, foresight is better (William Blake).

So not only do you need to learn to do things without people teaching them to you, you also have to be smart, politically savvy and diplomatic enough to know when to keep your mouth shut and when to open it. You need to learn, not only how to write for a given show, but also how to read a room. Painful lesson learned. What I should have done (which I can recommend to you) is say, "I take it that I'm here to observe and learn. If you'd like me to participate, please let me know. Tell me what's appropriate." That's a good question to ask on staff, because if you just assume things, you can alienate people and commit career suicide without even being aware that you've done anything wrong. Ideally, mentorship should naturally emerge in a writers' room from a hierarchy. It behooves them and the show for the more seasoned people to take the new writers under their wings and mentor and explain things to them. On some shows, in some writers' rooms, that does happen. But more often than not, people have their own scripts to write, their own problems, personal lives and multiple projects. You're not necessarily a responsibility

they want. They want you to come in, be low maintenance, fend for yourself, not get in the way and be a professional. That means being a humble listener and a humble learner, and that's how you learn without anybody actually teaching you anything.

Diversify: Several former students on my panels have participated in TV network/ studio/fellowship programs, i.e., NBCUniversal's Writers on the Verge, CBS' Diversity Program, ABC/Disney's Fellowship, Fox and HBO Diversity Initiatives, etc. Such fellowships and mentorship programs are extremely competitive but worth pursuing. In some cases, you needn't be a woman or from an ethnic minority to apply; they're seeking diverse *voices* on the page, not necessarily race or gender based. The initial screening process is often blind.

● Bonus Content

A list of the top screenwriting and/or writing for TV contests and fellowships is available at **www.routledge.com/cw/landau**. Always remember to do your own due diligence on each competition's legitimacy before applying.

My main point is not solely to rely on the hope of securing an agent or manager. These programs, festivals and contests can also generate heat and buzz to attract a representative. The greatest advantage is that diversity programs and writing fellowships are designed as a means to nurture and discover new talent—and the reward is getting staffed on one of their series. Showrunners are incentivized to hire fellowship writers because these writers' initial salaries are paid not out of the show's budget but by the studio/networks' diversity and mentorship budgets. So the show gets another fresh voice and perspective in the writers' room, and the writer gets his/her first gig. It's a win-win for everyone lucky enough to be selected.

If you're not picked, apply again and again. According to Grace Moss, who currently helms NBCUniversal's diversity programs, "You actually increase your odds by reapplying with new original and spec material each year."[2] You have everything to gain and nothing to lose, so be prolific and tenacious. Be aware of their evolving eligibility requirements and deadlines. Mark them on your calendars. This needs to be part of your breaking-in strategy. Be your own agent/manager until you have one.

Naturally, this presumes that you're uniquely talented and have the writing chops to back up your networking prowess. Great writing samples (original pilots and/or screenplays) are essential but so is your personality and how you "present" in a room: Are you a good listener? Do you have a worldview? Are you confident, but

also a humble team player? Your words on the page count for A LOT, but no one is going to hire you if they don't like you. They're going to be spending more time with you than with their own families. Don't be a kiss-ass but be genuine, enthusiastic and gracious. If they hire you, your #1 job is to make their jobs easier—and that means writing solid first drafts, being able to generate fresh story ideas in the writers' room and being able to implement notes with alacrity and verve.

To break into television you're going to need an exceptional, wholly original pilot. You may also need a spec episode of an existing show because, while showing that you can create a pilot and characters is the key skill, to work on staff you also need to demonstrate that you can capture the voices and the style of another show. More likely than not, you're going to get hired off of an original pilot and then go to work on a writing staff of someone else's show. So if you don't yet have the skill of writing in someone else's voice, you're going to find that, to please the showrunner, you're going to need to learn those skills while in the early stages of pre-production. Once production starts, the machine starts moving so quickly that there is little time to learn on the job and still meet the deadlines. So ideally you will write at least one spec episode of an existing show, just to develop that muscle, which is vital.

MORE OPPORTUNITIES THAN EVER—YET IT'S NEVER BEEN MORE COMPETITIVE

Back in the days when movies were the be-all, end-all, one great pilot script or spec TV episode could open every door for you. That can still be the case. However, buyers are more cautious and tighter with the money. And it's much harder to get through the door. The streaming, premium and high-end cable networks are not necessarily going to get that excited by one script. At Hulu, Netflix and Amazon, a great pilot script will get our attention, but a pilot script, a series bible, a look-book and maybe another episode will usually also be required to make the sale (see Chapter 12). Now that shows on streaming and premium/high-end basic cable networks have shorter orders and are highly serialized, the buyers will want to see how the show is going to sustain over the course of a season—or even over multiple seasons. They may to want to see at least one future episode to understand how that's going to play out. Depending on the show and the auspices of the creator and/or showrunner, these could be written documents or via a more informal conversation.

Just because you've written one pilot, don't expect every door to open, no matter how good it is. Yes, the agencies will find you if you write one great script, but they might not necessarily sign you. The first question any reputable agent or manager is going to ask is, "What else have you got?"

SHOW THEM YOUR PROOF OF CONCEPT

roof of concept is the caution under which the network gatekeepers operate. As we are already aware, few people in Hollywood are empowered to say "yes." Proof of concept is all about making your show so irresistible that they're not going to be able to reject it. It means showing them the "evidence" that your show is exciting, sustainable and viable. Show them your proof of concept, and they'll show you the money.

THINK LOCALLY, ACT GLOBALLY

hen I travel and lecture in other countries, people always ask, "How do we break into Hollywood?" My advice is usually to break into the industry in your home country first. Get a show on the air in your native language; cast actors well known in your country. Tell universal stories that can be adapted for different cultures but emphasize the universal themes with local specificity. A hit show overseas can "incubate," build local buzz, and that becomes your proof of concept to export to Hollywood. So don't think you can only break into the TV business by living in Hollywood and writing in English. There are many ways that both I.P. and formats from foreign countries can come into the US and other countries and find great success. (See Chapter 11.)

WHAT I REALLY WANT TO DO IS DIRECT (A WEB SERIES)

or decades, the above cliché used to be the joke about every disgruntled screenwriter in Hollywood. Having languished in studio development hell for years and/or seeing their screenplays ruined by others, many screenwriters segued behind the camera to take control. But with astronomical production costs and the high risks of filmmaking, this is an untenable approach for most. On the

other hand, a web series can be short (5- to 15-minute episodes) and relatively cheap to produce. Web series are fun to make but difficult to monetize; they're a satisfying creative endeavor but rarely, if ever, profitable. Of course, there are exceptions.

Broad City began as an indie web series, created by and starring Ilana Glazer and Abbi Jacobson, in 2010. The funny, edgy, provocative tales are based on Glazer and Jacobson's friendship and the trials and tribulations of finding success in New York City. The audacious web series, which consistently pushes the boundaries for a comedy, was built on a loyal core audience via clip-sharing and crowdsourcing; the duo attracted the attention of Amy Poehler, who was one of the series' biggest champions and came on board as executive producer. The TV series premiered in 2014 on Comedy Central and went into its fourth season in 2017. Glazer and Jacobson are now bona fide TV stars.

The sketch comedy show **Key & Peele,** created by and starring Keegan-Michael Key and Jordan Peele, also had its roots as a web series—bolstered by Key and Peele's popularity on the late night, SNL-inspired *MADtv* on Fox. The series spanned a total of 53 episodes over for 5 seasons, from 2012 through 2015. They took their good fortune (notice, I didn't say "luck") and parlayed it into featured roles on shows such as *Fargo*. Jordan Peele went on to write and direct the wildly successful *Get Out* (2017).

Sure, *Broad City* and *Key & Peele* are outlier success stories. But Glazer and Jacobson and Key and Peele blazed the trail for other talented content creators in the future. Here are a few select case studies:

High Maintenance

Format: 30 minutes. Multiple short episodes encased in a half-hour timeslot.

Genre/tone: Dramedy.

Ben Sinclair and his wife Katja Blichfeld had an idea to do a web series about a contraband weed dealer in Brooklyn. Katja was the casting director on *30 Rock*; Ben's an actor and plays Guy, the weed delivery dude, in the show. Have bicycle, will deal. He's the way into each short anthological story, and most of them are two-handers; Brooklyn, marijuana and O. Henry endings are the show's mainstays. We find out why people are using, how it enhances their lives or how it may detract from their lives. Based on this simple premise, Katja and Ben wrote the web episodes, called in favors from friends, begged and borrowed equipment and locations and self-financed the first season. Instead of a dedicated YouTube

channel, they decided to put their web series up on the more curated site Vimeo in 2012—and hit pay dirt.

High Maintenance became a Vimeo "Staff Pick"—at the time, a sacrosanct process with a few staff members choosing the picks. (Vimeo now allows filmmakers to submit their work for Staff Picks.) This recognition increased the web series' traffic and views and catapulted it into the zeitgeist. For Season 2, Vimeo did something that was unprecedented at the time—they gave Katja and Ben an advance, or what's known as a "minimum guarantee," whereby they covered all or the bulk of the show's production costs.

Vimeo also launched a major *High Maintenance* ad campaign, with the slogan, "The best show not on television." Season 2 garnered positive reviews and word-of-mouth, and when the pot smoke cleared, Katja and Ben had a lucrative deal at HBO. And they'd written their own ticket.

From *Awkward Black Girl* to *Insecure*

Format: *ABG:* 5 to 15 minutes. *Insecure:* 30 minutes.

Genre/tone: Dramedy.

The Mis-Adventures of Awkward Black Girl (a/k/a *ABG*) was a self-financed web series, created by actor/director/writer/showrunner Issa Rae. Rae first launched her web series in 2011 on her YouTube channel, gained traction and then migrated to Pharrell Williams' platform, I Am OTHER. *ABG* was so good and buzzed about on social media that ultimately Rae got a deal to develop a new series with a similar tone and voice for HBO. The result is her award-winning, critically acclaimed series *Insecure*—which was quickly picked up for Season 2. Both the web series and HBO series capitalize on the brand that Issa Rae built for herself, which is *authenticity*—the experience of being a highly educated, modern black woman in a patriarchal world of inequality. Each episode finds the fictionalized Issa trying to fit in and find validation on her own terms. And the title is *Insecure*, obviously indicating that's easier said than done.

The Skinny

Format: Web series, 6 minutes each. Hulu series = 30 minute episodes.

Genre/tone: Edgy dramedy.

The Skinny creator/writer/director/star Jessie Kahnweiler is a force of nature who naturally gravitates to edgy, controversial material. And her web series, a dark comedy about her eating disorder, is no exception. How did she go from struggling in obscurity to nabbing *Transparent* creator/showrunner Jill Soloway as mentor/executive producer—and eventually, the big time with a development deal at Hulu? In Kahnweiler's own words:

> So I actually met Jill [Soloway] by stalking her on Facebook back in 2012. I was an intern at Bad Robot and PM'd her on Facebook asking her if I could send her a short film I had made. She actually watched the film and wrote me back! We had eggs in Silver Lake and she told me to quit my day job and put everything into my art. She even helped me get a grant from the foundation for Jewish culture so I could make my web series, *Dude, Where's My Chutzpah?* We kept in touch throughout the years, and she's always been an incredible mentor to me and so many female filmmakers.
>
> Around 2015, I wrote the script for *The Skinny* but it stalled out. No one was into this weird bulimia/comedy thing. Refusing to let my script die in development, I shot the pilot presentation for *The Skinny* and sent it to Jill for feedback. She offered to distribute the series on her site Wifey and suggested I hire one of her editors to sharpen the cut. That's when I did the Kickstarter to raise money to finish it. Her co-producer at Wifey (Rebecca Odes) showed my Kickstarter trailer to Amy Emmerich at Refinery29 and they offered to make the series, and so Wifey and Jill came on as EPs. Jill will not be a producer on the show at Hulu but she remains an amazing source of support and inspiration to me.

Jessie's blossoming success story is the very definition of being a proactive, creative entrepreneur.[3] While we can't all quit our day jobs, we can emulate Jessie's passion, drive and originality.

37 Problems

UCLA MFA Screenwriting grad Lisa Ebersole created the web series *37 Problems*. Having raised funds via the crowdfunding and video on-demand platform for filmmakers Seed&Spark, Ebersole is the writer/director/showrunner/star of this funny show about a struggling screenwriter whose career drive is colliding with her biological clock. Ebersole independently launched the first 9 Episode Season on

Amazon Prime and Seed&Spark. She's gotten rave reviews from Bust Magazine, The Scriptlab, NerdyGirlExpress and had an article in *The Huffington Post*. *37 Problems* was an official selection of the Tribeca Film Festival Creator Marketplace and the Austin Film Festival. Stay tuned. . . .

Keep Giving Them You
Until You Is What They Want

EastSiders

Format: Web series; approximately 10 minutes each.

Genre/tone: Dark comedy.

Created, written, starring and directed by Kit Williamson (another UCLA School of Theater, Film and Television alum), *EastSiders* premiered on YouTube in 2012 and subsequently began streaming on Logo TV's website in Spring 2013. Williamson, who you might recognize from his recurring role as nerdy copywriter Ed Gifford on AMC's *Mad Men*, set his web series in hipster Silver Lake, on the "east side" of Los Angeles. Williamson was inspired to create his own show after years of having to play it straight in Hollywood. In contrast, *EastSiders* centers on a gay couple Cal (Williamson) and Thom (Van Hansis) as they navigate their rocky relationship. It also explores the relationship between commitment-phobic Kathy (*Fresh Off the Boat*'s Constance Wu), Cal's best friend, and her boyfriend Ian (John Halbach) as they reach their six-month anniversary.

When Kit Williamson visited my class at UCLA, he charted the trajectory of *EastSiders*—from Kickstarter-financed passion project on YouTube in 2012, to the Logo TV website in 2013, to Vimeo in 2015 and onto mainstream acquisition at Netflix—which now offers all episodes on-demand and will present *EastSider's* future season as a Netflix Original. Williamson's guidance on the steps to take for success with a web series is:

1. Have a flexible format
2. Appeal to a niche market
3. Build a following/press/acclaim
4. Withhold the content so it can be sold
5. Keep pivoting and reinventing the show

"The biggest piece of advice I can offer," Williamson says, "is to think of the launch of your series as more than a one-time event—get your show out there in as many ways as possible and more and more opportunities will come to you."[4]

● Bonus Content

More of Kit Williamson's excellent advice is at **www.routledge.com/cw/landau**.

Creative entrepreneurship is more than just creating superior content; it's about creating superior content and then connecting to an audience. Popular bloggers are called "influencers" because they wield influence. But their currency is *authenticity*, so there's no use trying to influence them other than creating authentic, awesome, original work. Create that itch and they'll scratch it.

WORK BEGETS WORK

A writer is a person who makes an appointment with him/herself to write—*and keeps it*. As a creative entrepreneur, that needs to be your modus operandi. You have to always be looking forward and thinking about what you're going to do next, because that's going to create the momentum that's going to propel your career. Your "big break" is more likely going to be a series of smaller breaks. Work with people who challenge and inspire you. Gain experience and learn how to work well with others. Don't make money your primary goal. Instead, focus on the process of assembling a body of work of which you can be proud. Take chances and be bold. Make a game plan. What are your career writing goals in one, three, five and ten years from now? This is a collaborative business built on relationships, networking, synergy, synchronicity, kismet, strategy and timing—never solely just dumb luck. First and foremost, this is a business of talent, and content is always king. You may believe that you've already got what it takes, that you're a *wunderkind* or a misunderstood genius and that it's all about the gatekeepers shutting you out. But the truth is, new doors open every day. It's up to you to be ready and use your power of storytelling to connect people, to bring them closer together.

Now is not the time for any of us, whether just starting out or even seasoned pros, to rest on our laurels. Both our writing and the industry have a long way to go. At

the 2017 Emmys, which were historic for ethnic minorities and women, Bruce Miller, showrunner of *The Handmaid's Tale* put it best: Everyone needs to go home and "get to work—we have a lot of things to fight for."[5]

Notes

[1] Sam Esmail, speaking at the Writers Guild of America, 2015.

[2] Conversation with Grace Moss.

[3] Conversation with Jessie Kahnweiler.

[4] Kit Williamson, "How I Sold My Web Series to Netflix," *Indiewire.com*, July 1, 2016. www.indiewire.com/2016/07/eastsiders-lgbt-web-series-sold-netflix-kit-williamson-1201701822.

[5] Maureen Ryan, "Emmys Review: Sleek, Sincere, But We've Still Got a Long Way to Go," *Variety.com*, September 17, 2017, http://variety.com/2017/tv/columns/2017-emmy-awards-review-stephen-colbert-1202562279.

ACKNOWLEDGMENTS

Senior Editors/Project Managers: Sharon Rapose and Roxanne Beck

Contributing Editor: Alice Dennard

Contributing Researchers: Eric Mallory Morgan, Brenna Galvin

Endless thanks to the following wise, kind and generous souls for their invaluable insights, guidance and help: Stefano Agosto, Tiffany Alexander, Zach Bianco, Steven Canals, Ed Cha, Steven Conrad, Christina Davis, Channing Dungey, Rhona Foulis, Simon Jacobs, Nate Kohn, Andrei Konst, Ellen Kreamer, Damon Lindelof, John Makowski, Heather Marion, Ryan Murphy, Guido Segal, Joey Siara, Joel Surnow, Rosario Varela, Lizzy Weiss and Kit Williamson.

To all my amazing past, present and future students, along with my brilliant and dedicated UCLA colleagues. You all inspire me every day. Go, Bruins!

My deepest gratitude and love to my family for their patience and support, especially Trent Farr, Walter and Kiko Wanger, Debra Riva and my sons Noah and Zach.

ABOUT THE AUTHOR

Neil Landau is an award-winning screenwriter, producer, author and professor. His screen credits include the cult comedy *Don't Tell Mom the Babysitter's Dead* starring Christina Applegate, *Melrose Place*, *The Magnificent Seven*, *Doogie Howser, M.D.*, *The Secret World of Alex Mack*, *Twice in a Lifetime*, *MTV's Undressed*, *The Young & the Restless*, *Monarch Cove* and one-hour drama pilots for CBS, ABC, ABC Family (now Freeform), Warner Bros, Disney, Lifetime and Fremantle. His animated movie projects include the feature *Tad: The Lost Explorer* (a/k/a *Las Adventuras de Tadeo Jones*) for which he earned a Spanish Academy "Goya" Award and a Cinema Writers' Circle Award for Best Adapted Screenplay (2013). *Tad Jones and the Secret of King Midas* was released in August 2017, by Paramount (he is working on the sequel, *Tad 3*). Neil co-wrote the animated feature *Capture the Flag* (also for Paramount) and the animated movie *Sheep & Wolves* for Wizart Animation (*The Snow Queen*). He is currently writing a pilot and developing digital content for DarkLight Productions.

As Associate Director of Screenwriting in the Department of Film, Television and Digital Media at UCLA School of Theater, Film and Television (his alma mater), Neil runs the MFA in Writing for Television Program where he also facilitates a first-look Writing the One-Hour Drama development workshop in conjunction with Sony Crackle, now in its fifth year. Neil is honored to be on the leadership team of UCLA TFT's inaugural Storytelling Institute and Residency, in partnership with the Université Côte d'Azur, City of Cannes, Cannes Film Festival and sponsor Vivendi.

Neil is the author of several bestselling books: *101 Things I Learned in Film School* (Grand Central Publishing, 2010); *The Screenwriter's Roadmap* (Focal Press, 2012, now in ten languages); and *The TV Showrunner's Roadmap* (Focal Press, 2014, now in 7 languages). His fourth book, *TV Outside the Box: Trailblazing in the Digital Television Revolution*, published by Focal Press in 2016, was the first book sponsored by the National Association of Television Program Executives (NATPE).

For several years, Neil served as Executive Script Consultant in the international divisions of Sony Pictures Television and Columbia Pictures.

He gives lectures and hosts workshops around the world on the art and craft of screenwriting, including USC School of Cinematic Arts, NYU Tisch School of the Arts, La Fémis in Paris, Met Film School in London, University of the Andes in Santiago, Alexander Mitta Film School in Moscow, Hebrew University in Jerusalem, Shanghai Film Art Academy and Accademia Nazionale del Cinema in Bologna. Neil is an active member of the Writers Guild of America, West, the Academy of Television Arts & Sciences and PEN West and serves on the Advisory Board of the French Film & TV Office in Los Angeles.

ABOUT THE EDITORS

Writer/producer Sharon Rapose was a BAFTA LA Newcomer in 2014/2015. She produced auteur Joanna Hogg's *Exhibition*, which received five stars in *The Times* and *The Guardian*. Sharon's short film *Konnichiwa Brick Lane* has played around the world from Tokyo to Berlin, including the Oscar-qualifying Tampere Film Festival, BAFTA-qualifying Aesthetica Short Film Festival and was distributed internationally. She has a Masters with Merit in International Development from the University of London, and graduated from the Professional Programs in Screenwriting and Writing for Television at UCLA. Sharon has taught television writing as a post-graduate TA at the UCLA Department of Film, TV and Digital Media and edited Neil Landau's book *TV Outside the Box: Trailblazing in the Digital Television Revolution*. Previously, she worked for the United Nations; her scripts have social justice at their heart. Sharon's short screenplay *The Silent Waltz* was a Finalist in the 2017 Austin Screenwriting Competition and she won a 2017 John Brabourne Award.

Roxanne Beck is a Los Angeles-based screenwriter and children's book author. A graduate of UCLA's MFA in Screenwriting (2013), her awards there included a Humanitas Drama Fellowship nomination for her one-hour sci-fi pilot *The Intenders*, the Four Sisters Award for Comedy or Animation and the Oliver's Prize for Best Family or Animated Screenplay. Roxanne wrote the adaptation for the short dramedy *Miss Famous*, starring Kristen Wiig and executive produced by James Franco; the film was an official selection at six festivals, including the prestigious Palm Springs International Shortfest, and was chosen for the Tribeca Film Festival's inflight content for United Airlines. Her first children's book, *Caterpillarland*, was published in 2015. Also an internationally known voice actor (*Pokemon*, *Doug*), Roxanne lives in the infamous Valley with her wonderful dog Truman. More information is available at RoxanneBeck.com.

Alice Dennard is a Los Angeles-based TV writer who specializes in stories about glamorous women up to no good. She has received recognition such as the Rett Nearburg Fellowship for outstanding work in media, the Jack K. Sauter Award for artistic merit in television and was given the title of Young Master in Performance and Media Arts by the Texas Commission on the Arts. Alice received her BFA in Film and Video Arts from the

Maryland Institute College of Art and worked under famed Baltimore casting director Pat Moran. While receiving her MFA in screenwriting at UCLA, Alice's half-hour comedy, *People Like Us*, was awarded "Best TV Comedy" in the 2016 Screenwriter's Showcase. Her work has been featured in many juried screenings and shows, including exhibitions at the Lawndale Art Center and the Contemporary Arts Museum of Houston. Most recently Alice's half-hour pilot *Junked* was featured as part of the FEEDBACK Female Film Festival. Most days you can find Alice wrapped in a leopard coat and talking about Dolly Parton.

INDEX